OCCUPATION CULTURE

ART & SQUATTING IN THE CITY FROM BELOW

Alan W. Moore

<.:.MinOr.:.>
.cOmpOsitiOns.

Occupation Culture: Art & Squatting in the City from Below
Alan W. Moore

ISBN 978-1-57027-303-2

Cover artwork & design by Seth Tobocman
Interior design by Margaret Killjoy

Editorial support: Joanna Figiel & Stevphen Shukaitis

Released by Minor Compositions 2015
Wivenhoe / New York / Port Watson

Minor Compositions is a series of interventions & provocations drawing from autonomous politics, avant-garde aesthetics, and the revolutions of everyday life.

Minor Compositions is an imprint of Autonomedia
www.minorcompositions.info | minorcompositions@gmail.com

Distributed by Autonomedia
PO Box 568 Williamsburgh Station
Brooklyn, NY 11211

www.autonomedia.org
info@autonomedia.org

This project funded by Creative Capital | Warhol Foundation Arts Writers Grant Program.

CONTENTS

ACKNOWLEDGMENTS

Without my comrades of the artists' group Colab, my own occupation adventure would not have been possible. Becky Howland and Robert Goldman (aka Bobby G) continued to work with me on the result – ABC No Rio – for three event-filled years. Props to Clayton Patterson, with whom I organized a show at the 13th Street squats in '93, and who invited me to work on his book project *Resistance* some 10 years later. Howie Solo has steadfastly supported these and many other projects with his wild wit and solid advice. Present-day ABC No Rio's visual arts committee hosted the first show called "House Magic." Some of them, especially Steven Englander, Mike Estabrook and Vandana Jain, worked hard to make it happen. Michael Cataldi and Nils Norman brought it to the Sculpture Center in Queens.

I am grateful to schoolmate Jennifer Farrell for inviting me to talk at the symposium she organized at Yale University in October of 2008. (I have to admit my talk had next to nothing to do with the ostensible occasion... Still, lunching with the CIA man was pretty cool!) Nato Thompson heard that same talk later, and invited me to the Creative Time Summit. I am

grateful for that break.

In Europe, I have to thank Jim Graham, writer, translator and high-class vagabond, who nerved me to make the jump over here. Miguel Martinez, who made the SqEK group project happen, has been nothing but generous with me. I have taken much important information and turns of phrase from his notes and reports, and from his revisions of my notes on SqEK meetings. Eli, Edward, Thomas and many others have since become friends. The late great Neil Smith helped us all so much at a crucial moment in butt-breakin' New York City.

For this book itself, my first thanks go to the anonymous reviewers at the Andy Warhol-funded Artswriter grant panel, which made this whole thing much easier. All the writers and researchers, cited and not who have built the base of knowledge upon which this shanty stands deserve props, as do all the photographers and artists who have shared their work in its pages. Stevphen Shukaitis took this book on during a difficult time, and has been a sturdy friend.

And always, my love for Malena Conde Diaz who has made life here in Spain not only possible, but very sweet.

for my Mother

INTRODUCTION

This is not a book of analysis, although there is some. It is not a scholarly account with a conclusion of policy recommendations, nor a philosophical rumination on the signification of determined aesthetic acts. Both sociologists and aestheticians may be disappointed. This book is mainly a travelogue, an annotated record of a long series of journeys around and into a little-known territory, obscure and shifting: the occupied world, the world of squats. It is obscure because it cannot be explained in the terms we normally use to describe cultural and political activity in a world ordered by capital and governance. It is an international region of no-money people, operating in ways and toward ends that Adam Smith might not admit form a part of the immutable general economy of self-interest.

This book begins with the working title "Art + Squat = X." But it will not explain that dependent variable, neither as a recuperable part of the ordinary workings of cultural governance, nor as the ceaselessly regenerative tendrils of the coming insurrection. It is both a part of what is and how it works, and a foreshadowing of what is yet to be. It is also a

remembrance of what was not allowed to happen, of what was cut down to size, or cut back to the root.

For me it is a very personal journey, starting with childhood adventures amidst the great wasted lands of urban renewal in Chicago and Los Angeles, university activism inspired by the sit-ins of the Civil Rights movement, and in 1980 an unexpectedly significant collective exhibition-as-occupation in New York City called the Real Estate Show, which led to an art space we named ABC No Rio. [Moore and Miller, 1985] This life trajectory has put me in the way of wondering, and my research has positioned me to listen to others explain their reasons, experiences and results with the work of occupying vacancy and producing cultures off the economic grid.

At the same time, my approach is reflexively academic. I am trained that way, as an art historian. While my researches formally began as an art exhibition – "House Magic" in 2009 – I fell in straightaway with a group of European squatter academics and activists called SqEK, the Squatting Europe Kollective. None of this bunch care much about art, at least not as a subject or method of inquiry. They're sociologists, political scientists, anthropologists, criminologists, and students of social movements. But they know squatting! Over several years, SqEK has been meeting in different European cities, sharing research and learning from squatter communities that have engaged with and often hosted the group.

When first I met them in London in 2009, I nominated myself as a kind of scribe to take notes at the meetings insofar as I was able. What I have learned since then has been invaluable. This project would be pretty poor without those presentations by members at meetings of SqEK.

Once one begins to look intently into this hidden world, particularly when regularly sharing with other researchers at conferences, it turns out there is a lot, too much indeed, to be told. After five years of working, I have mountains of notes, recordings, photographs, products of direct observation, and culling the web. Books, pamphlets, DVDs, posters and ephemera I have deposited mostly with the Interference Archive in Brooklyn. The rest is in boxes in Madrid. I carry much of it with me in my computer.

How to make sense of all this? How to put over, comprehensibly, a galaxy of stories that make up the squatter experience, the resolute, defiant and irrepressible self-fashioning of lives? I can only figure to

tell my story, about the progress of my researches and evolving understandings, since that at least is coherent. And as I move along through that, many places will be seen and many people and the groups they belonged to will appear as characters.

It is not that I believe my work to be so important, and my insights so invaluable that I tell this in the egotistic first person. It is mainly because I cannot see any other way of organizing it. At this moment, at an early phase of this kind of study, I must hope that this sequence of anecdotes, these chains of references, and my occasional insights will somehow amount to a useful beginning for others who will succeed with the interpretive and analytic work I do not undertake.

<div style="text-align:right">

March 2015
Barxa, Lugo, Spain

</div>

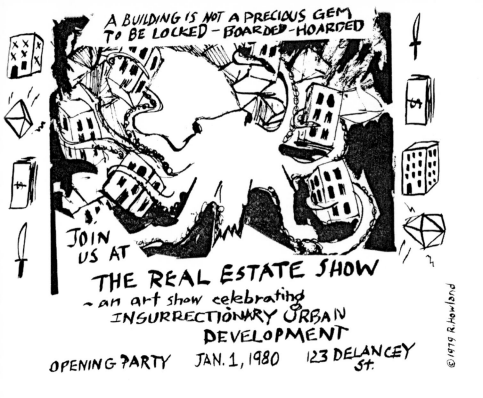

A BUILDING IS NOT A PRECIOUS GEM TO BE LOCKED - BOARDED - HOARDED

JOIN US AT
THE REAL ESTATE SHOW
~ an art show celebrating
INSURRECTIONARY URBAN
DEVELOPMENT
OPENING PARTY JAN. 1, 1980 123 DELANCEY St.

© 1979 R. Howland

ONE
IN OLD NEW YORK

I was a hippie in high school in Los Ange-les. Or, rather, I wanted to be one. I dressed that way. At university, when I first had the chance, I hooked up with stoners and we rented a big old house together in Riverside, California. Good parties, good times. When I was offered an internship in New York City working for *Artforum* magazine, I hitchhiked east with a Kerouac book in my backpack.

In the mid-1970s, it was still possible to live cheaply in downtown New York where the artists were and to do what you wanted. I wanted to write about art and make it too. The high criticism of *Artforum* was simply too serious. *October*, the spin-off alternative,

was even more humorless. I worked with a newsprint zine called *Art-Rite*, and quickly fell in with a circle of artists who were forming a group called Colab. They were doing group shows and film screenings in their studios, and working up to bigger projects. Everyone I knew was doing their own thing, as we said then. No one was waiting for permission from anyone, only looking for congenial collaborators.

My friends in this group had an idea. We would occupy a vacant city-owned building and make a show about real estate. Most of the artists we knew in the downtown Tribeca neighborhood were being pushed out by the residential development that was running through the former warehouse district. Soho rents had long been impossible for us to afford. The only place left to go in downtown Manhattan was the Lower East Side. The Real Estate Show [Moore, 2014] would start a public discussion about the arrival of artists in the neighborhood.

Not surprisingly, city officials evicted the exhibition hours after it was mounted. But to our surprise, the city of New York's housing agency offered us a deal, a "relocation" to another nearby storefront with a letter of permission to use it. We took it, and started running the ABC No Rio art gallery, museum, and cultural center in February of 1980.

Things went well there, and in the summertime Colab had its big moment. The group produced the Times Square Show in that central district of the city, where redevelopment was being planned. Artists came down from the Fashion Moda gallery project in the South Bronx, and up from ABC No Rio on the Lower East Side, together making a show that was sensational in its direct embrace of a potent mix of popular culture and social issues. The success of an exhibition entirely organized by artists themselves was novel. The Times Square Show would inspire many other artists to try and do the same.

In the next few years, during the first term of Ronald Reagan's presidential administration, the art market waxed hot, and many Colab artists left the group to show in galleries. As personal career topped many members' agendas, the wind went out of our collective sails. Meanwhile, a new wave of artists came to the Lower East Side, opening galleries of their own. Many of these were self-organized artist-run spaces styled as businesses emulating traditional art dealerships.

My trade in those years was typesetting. It was a great way for a writer to get paid, and stay close to the production process of

publishing. I worked for the *East Village Eye*, the monthly tabloid that covered the scene. I walked to work at the *Eye* from my other "job," at ABC No Rio through a non-stop open-air heroin supermarket on Avenue B. When my companions left ABC, I turned it over to a group of performing artists who would manage it in turn.

Life settled down as I worked and played, wrote about art and made it (videotapes and installations), then showed and distributed the video of others. I spent a fair amount of time at a couple of occupied vacant lots near my apartment, on Rivington Street. There, two very different groups of artists had done work on these sites of demolished tenement buildings. One was a beautifully planted garden, the other was a raucous sculptural assemblage. These projects adjoined a small row of art galleries. The whole complex and the artists who worked there were loosely called the Rivington School.

By the end of the '80s, however, the East Village art scene began to come apart. The nightclubs that supported the *Eye* with their ads started to close, and competition from a well-funded vanity project called the *New York Talk* pushed our paper over the brink. This happened after the mainstream art world had abandoned the East Village art gallery scene. This seemed to have happened almost overnight, in 1987. It became clear that the artists had been used to "whiten" a working class neighborhood with a high population of poor people of color. As the city began to sell off its immense holdings of tax-defaulted properties, the squatting movement began.

At the same time, the city government directed the police to clean up the drugs in the East Village and Operation Pressure Point began. A lethal mix of factors was making the city inhospitable for the poor and working classes, including deindustrialization, a moratorium on social housing, deinstitutionalization of the mentally ill, and unrestrained gentrification. Homeless people thronged the streets. Eventually, they organized into encampments, the largest of which was in Tompkins Square Park. One August night in 1988, a confrontation between squatters and police around the park escalated into a nightlong riot. Thereafter repression in the district increased, and finally the large public park was enclosed with a fence.

The Tompkins Park riot marked the start of open combat between squatters and police in what I later called the "battle for bohemia." [Moore/Cornwell, 2002] Friends of mine from the Rivington Street scene and ABC No Rio were involved directly as artists who were

squatting in abandoned city-owned tenement buildings that dotted the Lower East Side. These had suddenly become the focus of intense real estate speculation as the city decided to sell them off.

During these years squatters were networked for mutual defense against eviction through "telephone trees," and organizers worked to support the movement out of places like storefronts of Anarchist Switchboard, Blackout Books, and a newly embattled ABC No Rio. Artist squatters regularly performed their music, exhibited artworks, and plastered posters on the streets. Squat culture was punk culture,

Metal storage area around Robert Parker's forge in the yard between squatted buildings on East 13th Street in Manhattan in the 1990s. He called the place Sucker's Hole. (Photo courtesy Robert Parker and Margaret Bazura)

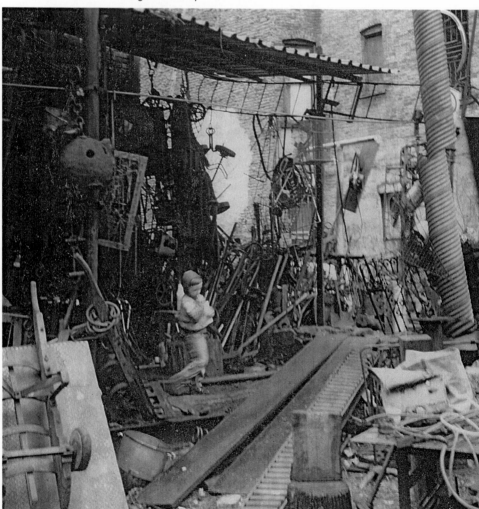

hard-bitten, confrontational, and smelly. (The buildings the squatters were renovating had only rudimentary plumbing.)

Although the decade of the '80s saw the rise of many kinds of politicized art in New York City institutions – Group Material is a prime example – the creative activism of the squatter movement was ignored. Artists who lived in squats and showed their work in marginal subcultural venues never received any larger recognition. Theirs was a local struggle, and their art only ever found a neighborhood audience.

Between 1987 and 1989, Martha Rosler organized a series of discussions and exhibitions about homelessness in New York City called "If You Lived Here," a reference to a roadside billboard slogan for housing developments. Installed in a capacious Soho storefront owned by the Dia Foundation, Rosler's authorial project was an establishment nod to community concern over the urgent crises of urban restructuring and its unpleasant results.

The show was an important early example of a project exhibition, crucially informed by the innovative work of the collective Group Material. Rosler invited many activists' projects relating to the theme of housing crisis into the gallery space. Many of them were provided with desk space in the gallery during the run of the show. One of these was an exhibition of work by squatter artists and sympathizers under the collective aegis of the Bullet Space gallery, the storefront of a squatted building.

Bullet Space was a vital node in the art squat network. The group turned out an imposing book of silkscreened posters on the themes of gentrification and the AIDS epidemic, together with a tabloid newspaper full of related texts called "Your House Is Mine." The slogan was a line from the band Missing Foundation, whose upside-down martini glass graffiti was ubiquitous on the streets during these years. (The band was the brainchild of Peter Missing, a squatter musician and painter in New York. He later moved to Hamburg, and finally Berlin, where he was recently evicted from his backyard container studio when the giant art squat Tacheles was cleared out in early 2013.) Bullet Space, which celebrated 25 years in 2010, is a project firmly guided by artist and former commercial gallery director Andrew Castrucci. Bullet Space maintains a rigorously stark exhibition aesthetic, and foregrounds Castrucci's own work, spare sculptural and graphic statements, many of which derive from his squatting experiences.

In 1994 I worked with the photographer and artist Clayton Patterson to organize a show in the café of a complex of squatted buildings on East 13th Street. These had begun as urban "homesteads" under an earlier city program of the 1970s that allowed residents to claim their buildings after fixing them up. The program had ended, but the residents – now calling themselves squatters – had stayed to assert their right to live there. The show, "Inside/Outside: The Artworld of the Squats," combined work by artists living in the buildings on 13th Street with art by homeless people participating in two art programs, one run by Hope Sandrow and the other by Tina White.

In the "Inside/Outside" show, different kinds of art service and curation came to bear on the question of the cultural production of the homeless and the precariously housed – squatters. For a graduate seminar run by sociologist Sharon Zukin and anthropologist Setha Low, I wrote a paper on homeless artists, the art galleries run in the squats, and the surge of interest by art dealers and researchers in the genres of outsider art. As an artist, photographer and collector, Clayton had concentrated on the ever-changing street culture of the Lower East Side. Hope worked in a womens' shelter, pairing housed artists and homeless people under a grant to provide cultural services, while Tina was a partner in the commercial art gallery, American Primitive, which specialized in outsider, untrained and folk art.

The show itself, mounted in the squat café, was unmemorable and brief. We were critiqued. A group among the squatters called it a misrepresentation and demanded that it be taken down. The catalogue for the show lived on as a zine, however. It contained texts by Ray Kelly, the *jefe* of the Rivington School, that spectacular jungle of welded metal, stone and wood built on an empty lot. Kelly coined the term "primitive property" for the art squatting he and his compadres were doing. [Moore and Patterson, 1995]

The impetus for our show, the artist who made it possible, was my friend Robert Parker, a sculptor and ironworker who lived on 13th Street. Also a veteran of the Rivington School sculpture garden(s), Robert had configured the yard between buildings as a site for his forge, the biggest he had ever built. The garden contained several cages, where roving fowl like chickens and geese could hide from dogs. Robert's children roamed the site wearing crash helmets to protect them from falls on the many salvaged building stones laid about in the ground.

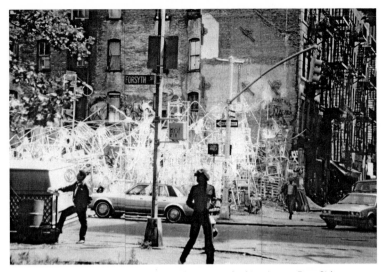

The Rivington School sculpture garden painted white, Lower East Side, New York, 1980s. (Photo by Toyo Tsuchiya)

Thom Corn, an ebullient African-American artist who had helped to start the Bullet Space art gallery in a squat on 2nd Street was included, as well as Siobhan, a transgender cartoonist. Sue Strande, Carla Cubitt and other artists who lived in Lower East Side squats were also featured in the show. The catalogue contained a text on the homeless street artist Curtis Cuffie who made fence shows around the Cooper Union art school. Using pickings gleaned from the rich garbage of Soho and the West Village, Curtis constructed elaborate personages in the tradition of the yard shows of the rural South where he had been raised. These would be almost immediately cleared by sanitation workers, with whom he waged perpetual combat. Curtis had a sure decorative touch and a rich assemblage sensibility, and his ephemeral work soon attracted attention from artists like Dan Asher and me, and from then-nomadic gallerist Kenny Schachter. Curtis was given a job in maintenance at Cooper Union, found an apartment, and was on the verge of beginning a funded residency with the Lower Manhattan Cultural Council when he suddenly died.

There was also an image in the "Inside/Outside" zine of Jorge Brandon (1902-1995), *aka* El Coco que Habla (the talking coconut), a key figure in the emergence of the Nuyorican school of poetry. For decades Brandon wandered the streets of the barrio Loisaida, reciting poetry

in the *declamador* tradition of the islands of Puerto Rico, and pushing a shopping cart of the supplies he used to paint shop signs. He was active in the Tompkins Square Park encampment of homeless, and lived for a time in a squatted building. Jorge Brandon's whole-hearted participation in the squatting movement put the lie to their political enemies' contention that they were simply spoiled middle class white kids who felt the world owed them a living. El Coco's presence connected the struggles of the '80s and '90s to the occupations by Puerto Rican nationalist groups in the 1970s, most notably the Charas group who were turned out of their social center El Bohio in 2001.

Jorge Brandon's image appears on the cover of Seth Tobocman's graphic novel *War in the Neighborhood* (1999), declaiming from a balcony in the face of the police. Indeed, the artists who most purposefully represented the Lower East Side squatting movement were working in the graphic medium. Seth Tobocman founded the anthology *World War 3 Illustrated*, with Peter Kuper and other artists in 1979. (It was then still called a "comic book," as the graphic novel genre had not yet been widely recognized.) Over the years, the Lower East Side-based publication featured many stories, polemics, nightmares, and informative texts relating to the squatting movement. Seth's book *War* is the most nuanced and complete story of the NYC squatter resistance, based as it is on research, personal experience, and the bold propagandistic images Seth produced over many years of poster-making for the movement. It is a rare combination of graphic propaganda, imaging the force of collective action, and careful exploration of the psychological dimensions of marginalized resistors in collective life and struggle.

While Seth's work focuses on themes of solidarity in resistance in the face of inhuman policing, Eric Drooker concentrates on the festive aspects of squatter culture. He also uses traditional female personifications, like the giant nude who towers over a toy army of police, to symbolize squatter resistance. Like Seth's, Eric Drooker's work is popular with squatters internationally, who have adapted many of his images as their own.

Fly, most prominent among the women artist squatters in New York, came from Toronto to New York in 1988, at the height of the movement, as part of an inter-city exchange with ABC No Rio. A

Opposite: This photo montage by Fly shows ABC No Rio in the 1990s. (Courtesy of Fly Orr)

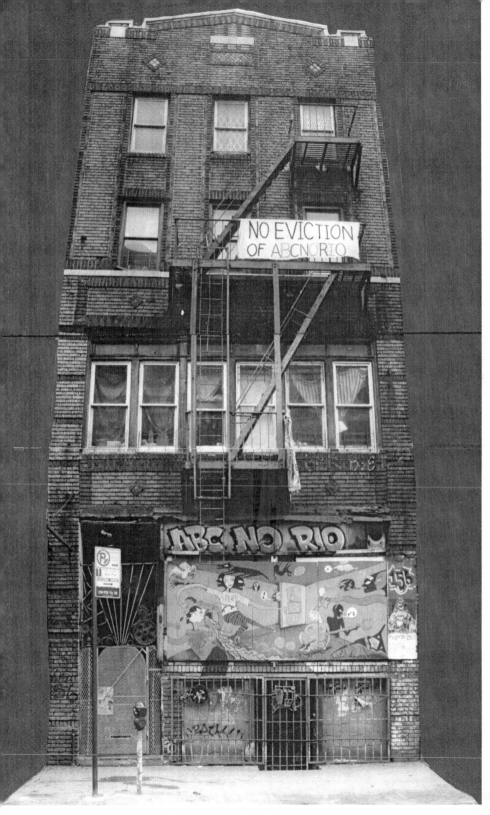

constant traveler, Fly navigated the international culture of punk rock music and squatting during the later 1990s as a musician, cartoonist, muralist, and zine-maker, recording that world with humor and personability. [Fly, 1998] Fly is a flaming punk, one of a cohort of "Cement Mixin' Squatter Bitches" during the years she worked on her building. (The title of that memorable zine appropriates a street corner insult). In her narrative graphic work, Fly explicates the situation of women in a culture of resistance dominated by aggressively posturing men. She spells it out, not as a counter-argument to the aesthesis of machismo, but rather as an exuberantly lived female position.

In 1998, Gregory Sholette curated "Urban Encounters" at the New Museum, for which he asked a number of artists' collectives to reflect on the pasts of groups they felt were important for them. It was the first time that squatter artists had been invited into a New York City museum. Bullet Space was included, and constructed a "squatter's shack" filled with a dense assemblage of objects they had made and shown. ABC No Rio also presented their own past, in the form of three eras of work at the place, including the final phase of struggle to legalize their tenure. Seth Tobocman built a simple standing painting in two conjoined panels, one triangle imaging a bolt cutter clipping a chain to free space, and the other a fist clasping a microphone with the legend: "Free speech must have a material basis."

The exhibition coincided with a landmark in the history of ABC No Rio, since the artists had at last been granted legal tenure in the building provided they could raise the money for its renovation. It was the end of the militant struggle, and the beginning of a long march through the jungle of funding for a capital campaign. The end of the '90s was a moment of reflection, not only for ABC No Rio, but for squatters themselves since many of their buildings had also been legalized as low-income cooperative apartments. In 2000, in celebration of the 20th anniversary of the Real Estate Show, Fly and ABC director Steven Englander put together a show of squatting-related memorabilia called "Dangerous Remains." Others began to assemble the documents and images that would later become the Squatter Rights collection in the Tamiment Library of labor history in New York University's Bobst Library.

Although they had largely succeeded in obtaining legal social housing and venues to show their work, the squatter artists of the Lower East Side have continued to organize their history and insist

upon its importance, at last even founding a museum. (See Chapter 33) The close, leading engagement of artists in the NYC squatting movement influenced my research in squatting thereafter. It's the New York model.

Inside the No Se No social club, Lower East Side, 1980s. The club, in a rented storefront, adjoined the squatted lot that held the Rivington School's giant welded metal sculptural construction. Center, in hat, is Ray Kelly, chef d'ecole. (Photo by Toyo Tsuchiya)

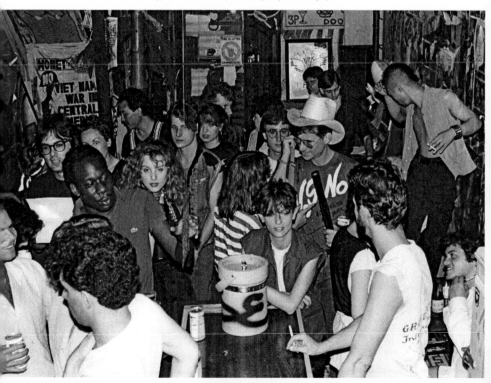

Opposite: Installation view of the "Critical Mass" exhibition at the Smart Museum of Art, University of Chicago, 2002 shows collage wall prepared by Temporary Services group featuring names of collective formations, t-shirts from groups, and a dense montage of related images. The furnishings is a piece by Laurie Palmer, entitled Land Mass (2002). (Photograph ©2014 courtesy of The David and Alfred Smart Museum of Art, The University of Chicago)

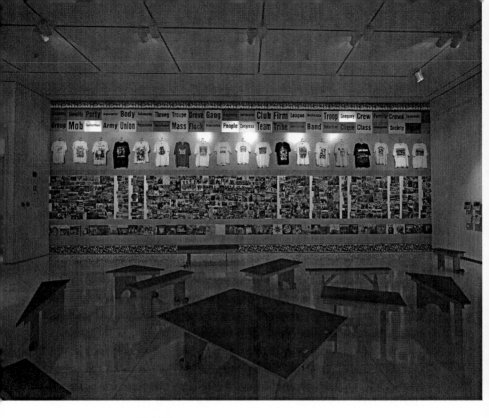

TWO
9/11
& THE CHICAGO GANG

I was in graduate school for art history in New York until 2000, and more or less ignoring the world as I tunneled through modernist studies. The huge Seattle demonstrations against corporate globalization in 1999 caught me by surprise. I hardly knew what globalization was!

The al-Qaeda attack on the World Trade Center in New York in 2001 shocked us all. Our young son witnessed one airplane impact from his classroom window. The auditorium of his school soon filled up with boxes of stuffed animals sent to New York children from schools all over the country. Manhattan

peace demonstrations began immediately and soon became massive. Yet the slogan "Our grief is not a cry for war!" went unheeded, and the 9/11 attacks were quickly exploited as a tremendous boon to the security state. When the U.S. invaded Iraq for fraudulent reasons soon after, the gravy train went into high gear. Across the country the most aggressive, venal and reactionary elements swaggered and paraded, empowered by a full-scale fear industry and a fat little war. Revanchist government was riding high, and cultural institutions were knuckling under. I was naively astonished at the bold-faced lying of U.S. officials, and the willingness of intelligent people to accept it.

I felt it was imperative to understand the global political currents that were so quickly reshaping our lives. I began to read about political developments avidly, mostly on the internet, since the mainstream media was so clearly in cahoots with the trumped-up war. My wife, the artist Mary Campbell, was active in the Unitarian Church in Staten Island where we lived. They hosted a strong series of speakers who pointed out the complexities of Middle Eastern politics and the incessant overt lies of the U.S. government. We protested the xenophobia and anti-immigrant violence that was sweeping the region. I was awed when the priest Daniel Berrigan, who had been imprisoned for anti-nuclear activism, addressed us. An anarchist friend admired the "crustiness" of the Pax Christi group meeting he attended, many of them octogenarians.

In the academic art world, very few seemed to be paying attention to what I felt was an urgently deteriorating situation. A war-empowered government was giving an ugly new shape to the American polis, and that demanded a strong positive response. Looking around, I found my interests and concerns were shared by younger artists, many of whom were working collaboratively, or in formal collectives.

In 2000 I filed my dissertation, which concerned New York City artists' groups of the 1970s and '80s. Later published as *Art Gangs*, this was a political genealogy that foreshadowed the more widespread collective formations that came with the AIDS crisis of the '90s, and the advent of digital platforms. My colleagues in art history seemed largely uninterested in this work. My support came from erstwhile comrades in artists' groups of the 1980s. Julie Ault, who had worked with Group Material, invited me to write about the Lower East Side for her anthology on self-organized artists' culture in New York. [Ault, 2002] Gregory Sholette, who worked with Political Art Documentation/

Distribution (PAD/D) and RepoHistory in the '80s and '90s, invited
me to talk at a show he had organized at the University of Chicago's
Smart Museum of Art called "Critical Mass." [Moore, 2002a]

This 2002 show in my natal city spotlighted a number of artists'
groups, and artists who worked with groups. But, unlike most of the
art world exhibitions and texts which dealt with the subject, the work
these artists did was explicitly political, and resolutely engaged with
a larger public on questions of common concern. In my researches, I
had become intrigued by the rapid growth of creative activism, much
of it driven by artists. I was especially interested in art projects that
directly engaged the public, an emerging way of working that curator
Mary Jane Jacobs called "new genre public art." "Critical Mass" was
all about this. While it was a modest show, it seemed to me to be, at
last, a curatorial effort on the right track.

A key group taking part in this show was Temporary Services. This
three-person collective specialized in publication, that is, diffusion
of information in numerous ingenious and simple ways. Temporary
Services had recently launched a web-based project called "Groups +
Spaces" as an online hyperlinked directory of artists' self-organized
projects worldwide.[1]

I also met a group of Gregory's students assembled in a class he
called "extreme curating" at the Art Institute. The year before, a group
of them had undertaken an extraordinary project they called the De-
partment of Land and Space Reclamation.[2] During a few brief but

1 The New York based collective 16 Beaver Group, together with an English group
 called c.cred, launched a nearly simultaneous effort to hyperlink global artist-or-
 ganized initiatives called "counter/cartographies." While that was broader in
 scope, the Temporary Services site was better maintained. I attempted to aggre-
 gate and annotate all these sites during a seminar in Florida (the website, called
 Collectiva, has been demounted). Later Basekamp's Scott Rigby and Christo-
 pher Kennedy created an open portal website called "Groups & Spaces" (HTTP://
 GROUPSANDSPACES.ARTISCYCLE.NET/). This kind of networking project is not new,
 but rather a continuous impulse. Numerous directories of artists' spaces, projects,
 and venues for traveling artists were published during the 1970s and '80s. The
 Artists Space Archive Project, another open portal encyclopedic website, concerns
 itself with spaces past (WWW.AS-AP.ORG/). The Chicago curatorial group Incubate
 continues to work on artists' self-organization (HTTP://INCUBATE-CHICAGO.ORG/).

2 Gregory Sholette, who advised many of the participants, wrote: "The DSLR hub
 has been a space for developing a radical community that began in Chicago,
 was reborn in San Francisco, and finally in Los Angeles. Its mission includes
 plotting actions, meeting others interested in reclamation, attending inspirational
 discussions and gleaning hints of more socially charged modes of existence." He

hectic days, they had animated a series of occupations, stenciling and graffiti parties, and other extra-legal interventions across the city working out of a central hub. Among this bunch of obstreperous creative troublemakers were Josh MacPhee and Dara Greenwald, who would soon move to New York, and Nato Thompson, who took a curatorial job at the Mass MoCA museum in North Adams, Massachusetts.

Many of these artists had participated in demonstrations like the one that rocked Seattle, and made anarchists the subject of a feature-length article in the *New York Times* for the first time since the early 20th century. This wave of agitations against the large-scale government-corporate free trade meetings in capital cities has been called various names, but I like the term global justice movement. The post 9/11 national security apparatus was exploited to put a heavy damper of repression on all who organized and participated in these demonstrations. Violent police attacks were met with a stream of delightfully inventive street strategies.

Back in New York, a group of people led by East Village pizza parlor king Phil Hartman produced a summer festival in 2003 called Howl!, named after Allen Ginsberg's famous poem. Phil spoke eloquently about his intention to recognize and valorize the bohemian past and the present spirit of the district in the face of the ever-accelerating gentrification, and an influx of students and bourgeois residents indifferent to its culture. The event was grandly conceived, with street festivals, carnivals, book fairs, and performances taking place over several days. One important success of the Howl! festival lay in opening many community gardens as venues for events. The community garden movement had begun throughout New York City's five boroughs in the 1970s, and was particularly successful in planting and maintaining vacant lots in the park-starved Lower East Side. The festival's uses of the gardens alone animated the neighborhood to an extraordinary degree. It showed how valuable these occupations could be, not only for the birds and gardeners who could visit their locked-up precincts, but also for the general public when allowed in.

Historical recollection was the leading theme of the Howl! project,

provides the following links:
HTTP://CRITICALSPATIALPRACTICE.BLOGSPOT.COM/2006/02/DEPARTMENT-OF-SPACE-AND-LAND.HTML; HTTP://WWW.COUNTERPRODUCTIVEINDUSTRIES.COM/DSLR/DSLRIDEAS.HTML; and HTTP://WWW.SPACEHIJACKERS.ORG/HTML/IDEAS/WRITING/DSLR.HTML (in the packet for "Art in the Contested City" conference, November 3, 2006, Pratt Institute).

and much valuable work along these lines took place. Giant plaster heads of local heroes Allen Ginsberg, Keith Haring, and Emma Goldman were carried through the streets. (None of these figures is recalled with any historical marker in the Lower East Side today.) The performer Penny Arcade was a leading voice in festival planning meetings, purveying her strong interpretations of the social substructure of bohemian culture. [Arcade/Ventura, 2009] Working with a group of editors, Clayton Patterson produced the first of his telephone book-sized anthologies, *Captured: A Film and Video History of the Lower East Side* (2005).

The Howl! programming also made gestures towards the Puerto Rican and African-American community, although it stopped short of celebrating squatting. Unfortunately, Phil Hartman promised more than he could deliver. Business setbacks and personal problems drove Phil out of the festival game, and today Howl! is a modest event mainly involving theaters.

In 2004, I moved into the Ganas commune on Staten Island at the invitation of Jeff Gross, one of its founders. This remarkable community was built on the principle of "feedback learning," an encounter group-type process that is intended to build individual self-knowledge through close observation by one's neighbors. While I did not participate in this, my brief seven months of commune living changed my mode of social interaction, and deeply impressed me with the value of this kind of life [Woolard, 2014] I began to learn more about communes worldwide, many of which are networked through the Federation of Intentional Communities.

I also attended the Free Cooperation conference put on by Trebor Scholz of the media studies department at the State University of New York at Buffalo. Trebor had invited Geert Lovink,[3] the Amsterdam author and media activist, director of the Institute of Network Cultures. Lovink was an organizer of the Next Five Minutes conferences of the late 1990s, which more or less defined the genre of creative activism known as tactical media. The notion of "free cooperation" was advanced by the German theorist Christoph Spehr

3 Before he emerged as an internet activist and theorist, Geert Lovink was deeply involved with the squatting movement in Europe. He was editor of *Bluf!*, a journal covering the squatting movement in Amsterdam (Alan Smart, interview with Geert Lovink, excerpted in A.W. Moore and Alan Smart, eds., *Making Room: Cultural Production in Occupied Spaces*, forthcoming from *Journal of Aesthetics & Protest*, 2015).

as an alternative to the normal "forced cooperation" of labor under capitalism.[4] Spehr narrated a humorous pastiche of monster movie clips to make his point.

I don't think I fully appreciated what might have been expected to take place at this conference. Maybe most of us were groping in the dark. The theme of free cooperation was, more or less, a sideways approach to engaging the reconfiguration of labor under semiotic capitalism. This discourse in its political form is based in Italian autonomist thinking on precarious labor (Antonio Negri is the best known of this cohort). Trebor's approach, however, was rooted in problems of media studies, particularly media art, in which SUNY Buffalo has a strong program. The internet manifests itself as placeless. As I think back on it, the key question never raised had to be, where was free cooperation supposed to take place?

At least I was introduced to a number of other politically minded artists, and heard the fascinating discourses of Brian Holmes for the first time. Brian had published an important article called "The Flexible Personality," which like most of his texts he circulated online (most started life on the list-serve called nettime). In the article he argued that artists served the purposes of a rapidly mutating capitalist economy by providing a crucial example of a flexible worker who enjoys her status. Artists don't need unions to protect their rights to stable employment that they don't desire. This new mode of laborer, as an "entrepreneur of the self," is the ideal model for a system that no longer wants to pay workers any kind of social security. Artists were being used in the emerging economy as much more than simply the blockbusting gentrifiers of historically working class inner-city neighborhoods. Art, as a key component of the so-called creative economy, was providing a helpful pretext for overhauling and eliminating the post-war welfare state.

That same year, Nato Thompson opened a major exhibition of political and social art at Mass MoCA, the huge contemporary art museum in the faded mill town of North Adams, Massachusetts. The show was called "The Interventionists," and the stars were creative activists who had designed devices for demonstrations by the global justice

4 Trebor Scholz is now working on the question of online labor, i.e., distributed labor (given out in the form of what is commonly called "human intelligence tasks" or HITs) managed by intermediary websites. The "free cooperation" of the conference a decade ago is taking place online, but it has been recuperated by capitalism within algorithms of competition, and is economically coercive.

movement. "Ready to wear" street fighter fashions and a subversive ice cream truck were among the exhibits. Nato had put this show together with his teacher, Gregory Sholette, and it was a revelation of a global movement of creative political and social art.

The show included social projects of investigation, like the "garage science" laboratory of the Critical Art Ensemble, which was intended to assay supermarket foods for genetically modified contents. Just before the show, the tragic nighttime death of CAE principal Steve Kurtz's partner precipitated an FBI investigation into the biological paraphernalia he had assembled for the project. Steve was arrested, the lab at Mass MoCA never opened, and a long, expensive punitive prosecution of Kurtz for bio-terrorism ensued. This galvanized a national support campaign for the artist victimized by the most directly chilling state intervention against politically oriented creative work in memory. (Arrested in 2004, Kurtz was cleared in 2008.)

I presented one day at the show along with members of the 16 Beaver Group. I had been attending their meetings for some time. Hosted by Rene Gabri and Ayreen Anastas, 16 Beaver was the site of numerous important discussions. The space had a kitchen, and the markedly casual events often included a meal. Artists and theorists visiting New York would often meet at the space to present and discuss in a comfortable and informal atmosphere. I was always glad to visit and discuss with the 16 Beaver Group. Theirs were the kind of events you always hope for, but rarely find in formal academia.

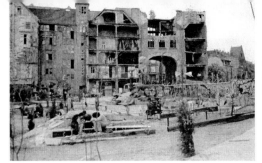

In the yard behind the artists' squat Tacheles, Berlin, 1995. (Photo by Traumrune)

THREE
BALTIMORE, BERLIN

Not long after he finished the *Captured* film and video anthology for the Howl! festival, Clayton Patterson asked me to write an essay for a book of posters he wanted to publish. In the end, these posters, a collection that documented the squatter movement, were never published. But Clayton's book project rolled forward, gathering steam and ambition, and culminated at last in a fat compendium entitled *Resistance: A Social and Political History of the Lower East Side* (2007). In working on this sprawling document of New York radical movements, which included much on squatting, I learned a great deal. What remained obscure, however, was the nature of the obvious international connections that New York's squatters had with movements overseas, particularly in Europe.

As I began working with Clayton in 2005, I conducted a multi-year search in the Lexis-Nexis database of English language press at the CUNY Graduate Center. The search turned up nothing about squatting except some stories of riots and evictions. It seemed incredible that what I knew to be an

important European radical movement had until then never been the subject of an English language article in an indexed periodical. Whatever was happening over there had been blacked out from mainstream view in the U.S. I was determined to find out more about it.

Also around this time Ayreen Anastas and Rene Gabri of the 16 Beaver Group were invited to Baltimore to participate in a project exhibition called "Headquarters: Investigating the Creation of the Ghetto and the Prison Industrial Complex." The show was a follow-up to an earlier museum-based project exhibition in which artists, activists and thinkers had been invited to consider together the urban situation in the city. Chris Gilbert had organized "Cram Sessions" the year before at the Baltimore Museum. I knew Chris as a researcher on the Art & Language group of New York in the 1970s, a band of mostly English and Australian conceptual artists who developed a strong critique of the gallery/museum system of contemporary art. "Cram Sessions" had been styled as an open university project with invited theorists – a kind of a show as learning opportunity. It was all about the meetings and encounters that would take place during its duration. I was sorry I missed it – it sounded intriguing, and a radically different use of museum resources. I arrived to see "Headquarters," at any rate, which was put together by Chris's partner who was working at another art space called the Contemporary. Cira Pascual Marquina is Spanish. She briefed me on the project, and then told me in her office, "I am not really a curator. I am a political organizer" who is using the art institution as a means to do political work.

"Headquarters" was in essence a gallery-based study and discussion center for analyzing and strategizing resistance to the processes of urban renewal and gentrification that were taking place in central Baltimore and adjoining districts. Ayreen and Rene had filled a blackboard with a schematic record of conversations they had led on these topics. Cira and I went for a coffee at a nearby bookstore café, Red Emma's, an anarchist center named for Emma Goldman, a radical heroine of the early 20th century Lower East Side. The members of the Red Emma collective were the activists who were helping to make the "Headquarters" project work.

I stayed in a sunny, open loft with a group of young artists and architects. They took me on a scary nighttime ride through one of the Baltimore districts targeted for urban renewal. The neighborhood was clearly distressed. It contained scores of abandoned row houses.

One could only imagine the long process of decline, impoverishment, and demoralization that had led to this grim state. Along some of the streets with the most "board-ups," or closed buildings, police had mounted searchlights. These illuminated the street at night with a blinding glare, intended to discourage the drug trade (and sleep for those who still lived there). Signals at intersections in the area were crowned with flashing blue-lit camera devices, and slogans about police vigilance. Cops were everywhere, parked and cruising. This wasn't John Waters' ludic Baltimore, but the Baltimore of *The Wire*.

During the "Headquarters" project, this group of artists built a mobile platform that they moved around the locked-down neighborhoods. They used it as a site for producing floating festive events: open-air sewing workshops, book-making sessions, and kitchens for cooking and serving food. Along the way they discovered the project they would work on over the long term – a vacant land occupation where they started a farm and a community kitchen. They called it Participation Park. I visited a year later, on the road returning from a job in Georgia. The group still had not been evicted and the project was going strong. In time they changed their name to the Baltimore Development Cooperative, won an important art prize, and became regularly active in city development debates, contesting "neoliberal urbanism." They have also educated many Baltimore art students in community-based participatory practice. [Thompson, 2009]

The whole "Headquarters" experience impressed me deeply as an example of how art institutions could collaborate with activists to make a real difference in public civic affairs, and how curators could make their institutions available as platforms to both discuss and affect social change. Chris Gilbert and Cira Pascual Marquina soon moved on. Chris took a job in Berkeley, California, where he organized a media exhibition about Venezuela under Hugo Chavez. One of the wall labels he wrote expressed solidarity with the "Bolivarian revolution." The museum board insisted he take it down. He refused, and both he and Cira decamped for Venezuela. That was a sad loss for the U.S., which has never had a surplus of formally and politically daring museum curators.

Although it seemed quite adventurous to me, "Headquarters" would not have been such an unusual show in Europe. Openly heuristic exhibitions, gallery-based projects of investigation, and carefully orchestrated formal "interventions" into urban affairs were

increasingly being tried there. By now they are common, if not so
politically radical. This is in large measure an outgrowth of the in-
creasing academicisation of the arts. Newly fledged doctoral programs
in studio art require that their students demonstrate original research
that can be evaluated by professors in fields other than art. In addi-
tion, the late '90s saw a gathering vogue of "social practice art."[1] In the
U.S. today, numerous new programs teaching what was formerly an
academically neglected form called "community art" have sprung up.
Still, very few of the projects and programs these institutions sponsor
are as explicitly political, that is, intend so directly to intervene in the
economic and political processes of cities as "Headquarters."

The German artist Stephan Dillemuth was an early exponent of ar-
tistic investigative work. He organized an artists' space called Friesen-
wall 120 in Cologne during the early 1990s, together with Josef Strau.
The work shown there consisted largely of research findings by artists.
What has since become mainstream practice in contemporary art was
then called "neo-conceptual." Dillemuth and Strau made a show at
the Pat Hearn Gallery in New York in the '90s, which investigated the
then-defunct East Village art gallery scene. Only a few years after its
demise, this anomalous episode in artists' self-organization had been
largely forgotten by the New York art world, and artists were taking
East Village shows off their resumes in the 1990s as if it were a stigma.
[Kirwin, 1999]

I loaned work to the Pat Hearn show, so Stephan contacted me
some 10 years later to help him with a show he was planning in Ber-
lin. He wanted to put the history of 1980s New York in conjunction
with that of Berlin during the same period. He asked for loans of work
from the Colab and ABC No Rio collections I managed. The show

1 The notion of a socially engaged creative practice – a "social practice art" – is
 a linchpin of this book. That is, it is a component of art that I take for grant-
 ed. Social practice is also the name used for a type of creative work taught in
 a number of academic programs in the U.S. It is a tradition arising from late
 modernist participatory art, developed strongly in the later 20th century. The
 most politically engaged versions were recognized as community art. (A key on-
 line resource, with many instructive essays, was the Community Arts Network
 [CAN], archived at Indiana University at HTTP://WWW.APIONLINE.ORG.) In the
 1980s and '90s, curators and critics applied other names: among them "new
 genre public art," "relational art," and "dialogical art." (For a recent rundown
 of the form, see Randy Kennedy, "Outside the Citadel, Social Practice Art Is
 Intended to Nurture," *New York Times*, March 20, 2013. For my attempt to
 trace its early origins, see Moore, 2008.)

happened at the KW Institute for Contemporary Art under the direction of Axel Wieder in 2004. I did not go. Only much later did I find out that, finally, "Jetzt und zehn Jahre davor" ("Now and ten years ago") was not much like what Stephan had described. Josef Strau had decided not to illustrate the relation between the Rivington School sculpture gardens of the Lower East Side, which by then had all been destroyed, and the giant metal constructions built in the Berlin park of Kreuzberg in the '80s – also mostly no longer extant. The planned catalogue had not appeared. The work I loaned had come back to New York, but I had not been reimbursed for the shipping, as promised. It was a good excuse to go to Berlin and squeeze poor Axel for the money.

I had been in Berlin 20 years before then working on an art show. In 1986 the city was still divided into East and West zones. We were a group of New York artists doing an exchange exhibition, and we lived in a collective house with our German artist hosts. In the high courtyard bullet holes from the war were still visible. The eastern sector that I visited was riddled with them. The Chernobyl nuclear plant was still spewing fumes, and no one would eat blueberries except me. My hosts pointed out the squatted buildings, painted with huge angry murals and ringed by clots of punks drinking beer. Our hosts were artists in schools, and this wasn't part of their scene at all. Although I had "punked out" in NYC in 1978, I was an art punk. To the casual visitor, the public face of Berlin squatters was showing a dangerous rage shot through with addiction.

I spent the academic year of 2005-6 teaching near Atlanta. One of my seminars investigated the organization of artists and art institutions there. We discovered that for years artists had been continually used to develop reuses of vacant industrial property in the center, and then were evicted. The lively strip of drag queen nightclubs, where RuPaul got her start, had been shut down by the city. Speeding cars traversed block after block of empty stores, an urban superhighway through the guts of the most sprawling city on earth. The year I was there coincided with the centennial of the Atlanta College of Art. As an anniversary present, the institution was sold to a private college and everyone was fired. Kennesaw State did not re-hire me.

After weird wild Georgia, I felt relieved to leave George Bush's new America for the freer air of Europe. Of course, it ain't utopia, and in Berlin everyone always seems depressed, but at least I didn't have to

know the details. And there *is* a radical culture – the Rosa Luxembourg Foundation, Bertolt Brecht house, and more. As a traveler I was rusty, and no longer young. I nerved myself by watching videos of Rick Steves' Europe TV show, in which the beaming host charms Europeans with an absolute lack of their language. He insists it isn't needed. Dollars help, of course, of which I didn't have so many. Nor did they go very far, since the market for the European currency that launched at parity with the dollar had long since expressed its verdict on the latter. For years the dollar has hovered around 75¢.

It took me some time to adjust to another country, traveling alone, with few contacts, and on a tight budget. In 2006, I had no particular objective for the trip, only a general curiosity about the famous squats of Berlin that I hoped to satisfy in between trips to museums. After all, I'd been teaching art history for years. I began in a hostel in Kreuzberg, the district near the former Wall where most of the West Berlin squats had been. I visited a weird smelly old army surplus shop hung with backpacks, camouflage outfits and gas masks. A myriad of radical pamphlets, buttons and stickers were on display, and I bought a copy of a new book, *Autonome in Bewegung* ("Autonomists in Motion") [Grauwacke, eds., 2003] from the grizzled proprietor in a wheelchair. I later learned this man was the famous supplier of street-fighting gear used by the Autonomen in their battles with police. In the hot times of the '80s and '90s he had kept all those pamphlets under the table and out of sight. Later, my copy of the book was to be one of the few things stolen from a public display.

As I gradually uncovered more signs of the now-dormant squatting movement of the past, I conceived an idea for an exchange exhibition between Berlin and New York of the visual culture of squatting. Posters, cartoons, photographs, fashion, videos – most could be exchanged virtually over the internet and printed out in the two cities. The only question was where to exhibit these, and how to pay for it?

I didn't meet many folks I didn't already know in Berlin, and almost none who were directly involved in squatting. I chatted with a gal from Hamburg who bunked in my room at the hostel, and mentioned my interest in the Autonomen in that city. "Ah, the Haffenstrasse," she said, referring to the famous squatted street that runs by the harbor. "Now they are all having babies, more than any other housing project in the city." The squatting movement, she said, had also popularized the idea of people living together collectively in apartments.

I did visit Tacheles, the most famous squat in Berlin, on a bicycle with an informative university student leading a tour group. (The squat was evicted in 2013.) Behind that giant former department store building in the east, half-destroyed during the war and squatted when the Wall fell, was a large open yard full of sculptures, wooden terraces and open-air bars. When the bike tour passed by in the late morning, drunken patrons were still lying about, sleeping it off from a night of partying. I met a man in a café nearby who told me his parents were artists who lived there. People who ran those very successful bars in the ground floor, themed with pop-style images of revolutionary heroes, were at war with the artists who lived in Tacheles, he said, and refused to pay any rent.

I met with Gene Ray, an expatriate cultural critic and a Joseph Beuys scholar, who took me to New Yorck in Bethanien. This is a large squat in a building that is part of a huge former hospital complex in Kreuzberg. Their part of the place had been squatted as a protest after the contested 2005 eviction of Yorck 59, a collective house project on Yorckstraße. After 72 hours passed, a court case would have been needed to evict them, and they eventually stayed. Political working groups were there immediately, concerned with anti-racist action, immigrant support, a city planning group and more. New Yorck in Bethanien has evolved to house a large vegan kitchen and dining room, and a substantial kindergarten. I would see it again several years later during a meeting of the SqEK group.

A grumpy American photographer who was living there toured us briefly through New Yorck. "The only real squats left in Berlin," he said, "are the Bauwagenplatzen." These are encampments of the trucks and trailers specially fitted out for living that have long been a feature of nomadic European culture. The "travelers" who live in them encamp where they can. One group was on the grounds of the Bethanien. Their "house-wagons" were barely visible, hidden behind the leafed-out summer trees, just beyond a rickety clutch of mailboxes.

Another part of the Bethanien complex holds the Georg von Rauch Haus, squatted in the early 1970s. Von Rauch was a member of the June 2nd movement during the RAF days; a radical action group named after the day Berlin police killed a first-time student demonstrator. Von Rauch himself was killed in one of the first shootouts of the notoriously violent '70s in Germany. The house was founded as a very political one, Gene told me, but today it is mostly people having

kids. Their street fair happened at the same time as an art opening in the adjacent Kunstlerhaus Bethanien, and I could see it out the window. I left the art opening, went into the street fair and bought a piece of cake; then I browsed the display of panels marking the house's 30th anniversary.

It was clear from this visit that the squatting movement in Berlin, as in New York, was over. There were remnants, like Tacheles, that played an important role in the cultural life of the city, and helped Berlin to maintain an image attractive to young people as a city with a vital alternative life. But the famous squats of Berlin had mostly disappeared from view. When we met, Axel Wieder showed me images from the show he had made with Stephan Dillemuth, some of which dealt with the city's squatting past. One I recall was a metal cabinet documenting an artist's squatting years. It was spotlit in a darkened room, as obscure and inscrutable as any classic work of conceptual art. The experience of squatting was subducted in these works, hidden, not directly engaged. What kind of history lay hidden here? And how might it be uncovered to view?

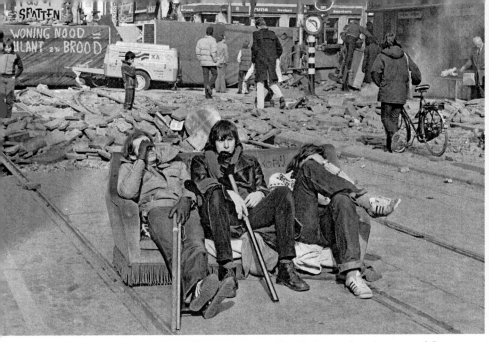

Amsterdam squatters guarding the barricade at the corner of Constantijn Huygens Street and the Overtoom, 1980. (Photo by Reinder van Zaanen)

FOUR
LONDON, AMSTERDAM

After my visit to Berlin, making some kind of show, a research exhibition, in a New York art venue about the European squatting movement became a goal for me. I needed to prepare and learn more. After teaching in Tampa, Florida,[1] I traveled to Europe to investigate squats again. I was not especially interested in squatting for housing. I fixed instead on

1 At University of South Florida in Tampa I ran another seminar on artists' self-organization, working with the list cited in chapter 2, note 1. I did the first for a year in Atlanta in 2006; the outcome of this class was a website, "Art Worlds of Atlanta" (demounted). I was excited about the findings, the experience, and the possibilities of developing a historical picture, with a nationwide scope, of artists' communities, and gave a couple of talks on this pedagogy to art historians and visual culture academics at two conferences. Disinterest was total.

the social center form; a mode of political squatting that had arisen in Italy in the 1970s, and was generalized across Europe. In fact, I felt certain it had arisen in New York as well, in the 1970s when Puerto Rican poets called the East Village "Loisaida." This Latino activism had inspired the mostly Anglo squatters of the '80s and '90s.

I met a Spanish woman at a party in New York, and she invited me to Madrid. My flight connected through London, so I took a day or so to visit an infoshop called 56A near the Elephant and Castle tube station in the south of the city. In the cramped quarters of the tiny shop, I perused the files they had on squatting, over six feet worth of papers containing many flyers and communications the shop had received over the years. In looking through these documents of a European movement, it became clear to me that the squatted social centers in different cities had played a major part in the organization of anti-corporate globalization protests and the large-scale street demonstrations that successfully disrupted many ministerial meetings.

Two Canadian friends studying in London, Kirsten Forkert and Peter Conlin, were involved in a real-life squatted social center – two of them, actually. One of them, the Bowl Court, was a sunny 18th century warehouse building standing in the path of ravenous development. High-rise buildings were advancing on the small enclave of ancient edifices like enormous stone soldiers. The feeling was that this squat was very close to eviction. (In fact, this happened the following month, when most of the squatters were away at the Climate Camp environmental activist convergence.) I met an Italian living there who took me to the ASS – the Advisory Service for Squatters. The ASS is located in the same building as the venerable Freedom Bookshop founded by a group including Peter Kropotkin. ASS produced the Squatters Handbook, which was then on its 12th edition. This office of volunteer paralegals received and responded to queries from squatters all over the UK. I watched as a bearded 60-something man padded about the place chatting on the phone, perusing correspondence, and picking up faxes.

"Well, this case looks hopeless. Still, you never know. It's all about time, gaining time."

Kirsten and Peter arranged for me to talk about artists' collectives in another center they worked with, a grubby rundown building called rampART. [Conlin, 2013] It was in a solidly built three-story warehouse with a café on the ground floor, and a gallery and offices on

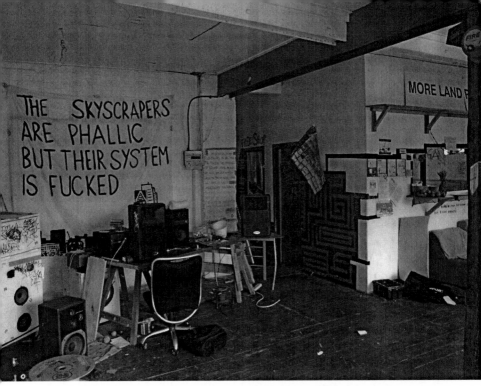

THE SKYSCRAPERS ARE PHALLIC BUT THEIR SYSTEM IS FUCKED

MORE LAND

Evicted Bowl Court social center, London, 2008. (Photo by Taylor Moore)

the second and third floors. The night I spoke there also saw a heavy party for a traveling art show full of fancy-dressed folks. It seemed a little incongruous, very non-leftist movement-like. The show was called "The Archetist," based on a psychological cyberpunk story about a psycho-architect who analyzes nomadic buildings. Despite the arch language, the content of the work was quite suited to present in a social center. This strange bit of social science fiction gained in social significance by being held in a space that had exhausted its appeals and hung perilous awaiting eviction.

Why the bailiffs hadn't yet come was a mystery to the squatters. Their forbearance was attributed to "the crisis," the meltdown of the global financial system that took hold with the collapse of Lehman Brothers the year before, in 2008. It costs money to stage an eviction, and then some more to seal the building. I spoke about my work researching artists' collectives. The artist Nils Norman showed up for the first part. Nils was to play a role in the House Magic project later on. I had some interesting albeit brief conversations with rampART people – like all squats in winter, the place was bone-chillingly cold. I

learned of an artists' project place in Peckham called Area 10 that was having a big event on the weekend. They had stopped paying rent due to lack of services, edging towards the status of a squat.

I moved on to Amsterdam across the Channel to research for a few days in the Institute for Social History. Its grand, imposing building is one of the premier destinations in the world for library research into left wing movements, and contains a special section – entirely in Dutch – on the squatting movement in Holland. The archive was assembled by Eric Duivenvoorden, a major historian of Amsterdam squatting, who also put together a book of posters, *Met emmer en kwast* ("With bucket and paste"), many of which are on the ISH website.

The squatting movement – called "kraken" in Dutch – began in the 1960s, during the time of the Kabouters, the band of radical politicians who came after the infamous Provos (for provocateurs) of white bicycle fame. [Kempton, 2007] I watched *De Stad was van uns* ("It was our city"), a film about the Amsterdam squatters' movement 1975-1988, made in 1996. (Duivenvoorden co-wrote the script.) The story told in the film (subtitled in English) is both inspiring and cautionary. The squatting movement began in earnest in Amsterdam in the 1970s to address the crisis in social housing – too many vacant buildings were being held off the market for speculation, and young people needed places to stay. The government's housing bureaucracy was swamped and ineffective. Once the "kraken"-ing of empty houses got underway, it was full speed ahead. The first defense of a house from eviction was entirely passive. The defenders were beaten with clubs. Then the squatters got real about their defenses. In the film, one squatter tells how they barricaded the doors and windows, and as cops started climbing ladders, the squatters poured oil on them. When they ran out of oil, someone shouted, "It's all gone, come and get us!" The event turned into a kind of slapstick.

The police tactics dismayed many older people. "This is like the war," they said, as if the Nazis who had occupied Holland had come back. The squatters wore helmets and leather jackets, and trained with defensive sticks and gloves for the next confrontations. A kind of apogee was reached with the defense of the Big Keyzer squat in 1978, a massive building owned by a large corporation, OGEM, with ministers and ex-ministers financially involved. The "squatting surgery" group barricaded the building with a medieval ingenuity.

First wooden sheets went up on the windows, then steel plates and pipes (these were welded), then scaffolding and sandbags. There's much more to the film, but this brief description is enough to clue you to the uniquely combative and entitled nature of the early Dutch squatting. The movement *De Stad* describes ended in dissension and violence, with squatters fighting amongst themselves. The split in the late 1980s came over the question of cultural versus political usage of squats.

While *De Stad was van uns* is important and revealing, another video I saw in the ISH archive was more intriguing. "Opening kraakmuseum [sic] Zwarte Kat" ("Opening of the Black Cat Squatting Museum," 1994) records a tour through a museum which had been set up in a squat. Squatters escorted journalists – represented as a point-of-view camera – through the place, explaining the pirate radio station, the hacklab, and other features of the squat. Finally, police arrive and throw everyone in the paddy wagon.[2] If squatters themselves could conceive of their movement as being somehow the subject of musealization, then the idea of a show about squatting in an art venue might not be so far fetched.

I visited with the artist Renée Ridgway whom I had met at 16 Beaver when she was working on questions around the original Dutch squatting of Manhattan. Renée lived in a squatted building which had been legalized, a grand old former type foundry, built to industrial standards, and simply fitted out for living with a common toilet and shower in the hall. We hung out with Rick van Amersfoort, her collaborator, drinking Dutch whiskey. Rick runs a project called Buro Jansen & Janssen which investigates and reports on repressive actions of the state. An ex-squatter, Rick had also worked on the ISH archive.

Finally, I had a dinner in a squat, the weekly "Voku" or people's kitchen at Joe's Garage. Anthropologist Nazima Kadir, who was writing her dissertation on the squatters' movement in Amsterdam, recommended the place. Joe's Garage is a storefront in a small building. The place is far from grubby like the English joints. It's cozy and tidy, with tile-lined walls like a butcher's shop or charcuterie, and well appointed with blond wooden tables and chairs. There were a bunch of regulars around the bar. At a table a bald-headed 30-ish gent in leather pants was seated unsmiling – the very picture of a street fighting man.

2 The Kraak museum project is discussed in a sidebar in Grupo Autónomo A.F.R.I.K.A., *Manual de guerrilla de la comunicación* (Virus, Barcelona, 2000), pp. 55-56.

The soup was very good, with water cress and mushrooms, butter and flour. I popped a fiver into the "donatie" box, and the barkeep smiled and asked if I wanted a beer.

Everyone ignored me. Unlike at rampART, I was not giving a talk, and I knew no friend of the space. Two French girls entered and ordered beers in English. Some young men attended their entry with interest, but the girls ignored them, sat by themselves, and took no soup. More folks arrived. The crowd was multi-generational. One elderly lady arrived bearing a fat package. Dinner was some kind of a bean fry-up with pineapple, "an experiment," said one of the cooks.

Outside a raffish looking gent was smoking a cig. "Lovely meal," I said. "The best café I've been to in Amsterdam." He replied, "It's not a café. It's a social center for squatters." Okay, got ya. I must have missed my tour bus...

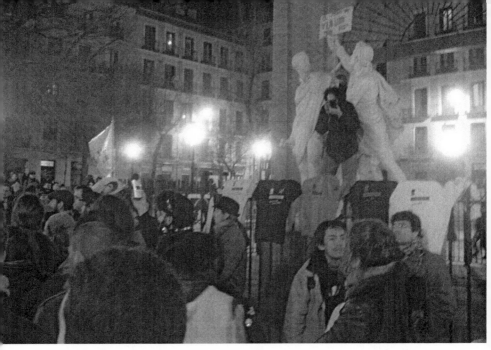

Demonstration in support of the Patio Maravillas social center in the Plaza del Dos de Mayo (May 2nd Square) in the barrio of Malasaña, Madrid, 2009. A photographer climbs up on the 19th century statue commemorating heroes of the war of independence against French occupation. (Photo by the author)

FIVE
SECO AND THE CITY FROM BELOW

On my first trip to Madrid, I visited a left wing bookstore called Traficantes de Sueños ("Traffic in dreams"), gathering many books and videos on the squatting movement in Spain for the exhibition I had in mind. Unlike Het Fort van Sjakoo, the remarkable leftist bookstore in Amsterdam, almost nothing in the store was in English. There also didn't seem to be many posters associated with the Spanish movement. The Dutch and Germans crank out images which they distribute by placing piles of them in their bookstores.

While I knew that most of the New York audiences wouldn't read the books and magazines in Spanish, these were at least liberally illustrated. The videos were subtitled, and I realized I could organize public programs around screenings of them for my imagined show. In two films, performance in defense of squats is prominently featured, providing a major part of the entertainment value of the film. The documentary film, *Laboratorio 3: Ocupando el vacío* ("Laboratory 3: Occupying the emptiness") [*Laboratorio*, 2007; Charlon, 2003] records a performance by occupiers appearing in the windows of the building in the Madrid neighborhood of Lavapiés. This public performance is similar to the *Facadenaustellungen* (facade exhibitions) Axel Wieder had described as characteristic of Berlin squats, mobilizing the building itself as a dramatic stage or canvas. Another video from Barcelona, *Okupa, crónica de una lucha social* ("Squat, a story of social struggle"), [Royo, 1996] opens with a long shot of the fireworks display – an episode of symbolic anarchist bomb-throwing – that met the police charge that evicted the squatted movie theater Cine Princesa.

Barcelona had a reputation for squatting, but, as I was to learn, the movement in Madrid was strong and would gain significantly in the years to come. On my first visit, with my bad Spanish, I didn't get far. On my second visit, just after I arrived, while strolling with my host around the Lavapiés district in the older part of the city, we ran into a raucous demonstration. It was in support of Patio Maravillas, then the largest squatted social center in Madrid, which was under threat of eviction. In the Plaza Dos de Mayo, in front of a statue of revolutionary heroes, many hundreds of people had gathered to support the Patio in the face of an eviction threat. It was an excited crowd, listening to speakers on megaphones, and whipped up by the big drums of a samba school band – a festive event attended by over a thousand. Eviction would clearly be noisy. In fact, Patio was evicted soon after. But, as is usually the case, the collective running the project then occupied another building in the center of the city, and remains there as of this writing.

On my second visit, Traficantes de Sueños was buzzing, with customers and people working at computers in office suites just visible from the second floor of the bookstore. It is an architecturally curious place, built around and over a meeting hall. I met Pablo Carmona there, *aka* Panzer, who took me on a tour. First, we visited the offices of the *Diagonal* fortnightly, a publication that has a bright modern

storefront not far from Traficantes. Like the bookstore, its office is a multi-functional space. It includes a tiny store selling T-shirts and media items. In the back of the offices, a fellow was folding aprons printed with a Constructivist-style, bright red and black design that read: "keep the kitchen clean!" In the basement, a meeting was slowly getting underway of organizers of the *sin papeles* community (immigrants without papers), preparing for an upcoming demonstration. It would be a march from Lavapiés to Sol, the historic city center of Madrid. Many of the *sin papeles* are Senegalese and other sub-Saharan Africans who have been coming into Spain in increasing numbers in the last decade. Outside, we chatted about New York with a Pakistani activist on his way in. Many immigrants to Spain speak English, so many that flyers advertising free Spanish classes for them may be written in English.

After our visit to *Diagonal*, we went on the Metro to the edge of the Retiro neighborhood to visit the Seco social center. The pink panther is the logo of the center, and I envied the cool T-shirt with "Pink Panther Party" printed over a big paw print. This center was a squat, but was then located in a city-owned building, an amply designed rounded modern structure set beside a major highway. Inside Seco, a clutch of kids played on the internet, and a small group of youths was conferring as part of the center's hacklab. A small room held bicycles and parts for a bicycle workshop, which supports the Bici Critica, the Madrid convocation of the global Critical Mass movement. The social centers in Madrid are vital to supporting this transportation activism and hosting end-of-ride parties. (See Chapter 31)

Classes in Spanish at three levels were held here for recent immigrants. Seco is near a working class district of looming housing blocks, which is 35% immigrants, and the activists at Seco strive to relate to these populations. (The project continues today in a new venue.) The day I visited was the social hour, and Pablo introduced me to Bernat as he emerged from the classroom where he had been teaching Spanish. A personable Catalan wearing a black and white keffiyeh, he was a writer for *Diagonal*. Bernat sees the predecessors of the social centers of today as definitely rooted in the *ateneos* (athenaeums) of the Republican era of the 1930s, cultural centers where working class people could educate themselves. They therefore have deep historical roots that the class-conscious Spanish recognize. (As I learned on a later trip to Barcelona in Catalunya, old-time anarchist *ateneos* still exist in

the barrios of that city.) I also met Guillermo, a researcher mapping the social movements in different Spanish cities. I would encounter map-makers in social centers later, working with the Observatorio Metropolitano group to record citizens' memories and perceptions of their neighborhood.

Pablo Carmona was one of the main authors and editors working with the Universidad Nómada on an issue of the Austrian e-zine *transversal* called "Monster Institutions." [Universidad Nómada, 2008] The introductory text explains that participation in the activities of social centers generates and requires new mentalities beyond capitalism. It is a matter of "creating new mental prototypes for political action." I asked Pablo about this question of subjectivities. For him, the most challenging work of the Seco social center lies in the conversations of diverse people – as he put it, making the "mixtape," or "building the Esperanto of our movement."

I later met Jay, a hacker and musician from Miami, who was participating in a "Garage Science" workshop at the institutional center Media Lab Prado. There I found him huddling over his project amidst a swirling crowd of hackers. In the middle stood Steve Kurtz of Critical Art Ensemble directing the action, or as he put it, trying to help out on various techno projects. After suffering through an intricate technical presentation on the electrical properties of various fruits, Jay and I repaired to a Turkish café nearby. He had been working with a group called SinAntena, also based in the Traficantes space, a media outfit that has been covering political events in Madrid, including squatting. Jay told me that in his view, the social center squatting in Madrid came out of the shantytowns on the city's periphery. These arose in the '70s and '80s. Most were destroyed. Some were replaced by permanent housing. (This is the solution recommended by the United Nations, according to Mike Davis in his book *Planet of Slums,* although Paul Mason avers in his recent book that this outlook is changing.) [Davis, 2006; Mason, 2013] Since the needs of these communities remained largely unaddressed, squatting gradually moved into the city center. The task of building a social center is arduous, and many folks cannot sustain it. Many of the people Jay knew squatted only for housing, not to make a social center.

My European sojourns enabled me to amass a great deal of material – books, videos, and ephemera – to display in the exhibition I planned to produce. I felt confident this would be well received. The

Poster for the City from Below conference in Baltimore, 2009. (Courtesy of Alec Dunn/justseeds.org)

student movement against the drastic cuts in public education fund-
ing had swept through the University of California system using the
tactic of occupation. Students at New York University and the New
School had also launched occupations. As the bank-centered political
response to the economic crisis of 2008 unfolded in the U.S., shanty-
towns of dispossessed mortgagees and jobless renters were springing
up around the country. The first signs of the political gridlock, ranco-
rous class politics, and racial suspicion that still hold the country in its
grip were starting to emerge, as it became clear that the new President
Barack Obama was not a fighter. The idea of popular direct action
seemed to have a political future.

Just before the exhibition I proposed was to open, I returned to
Baltimore for a conference called "The City From Below." Produced
by anarchists around the Red Emma's bookstore, this was an effort
to bring together community organizers with political and cultural
activists. Baltimore is one of this country's shrinking cities. Since de-
industrialization, the city on the Chesapeake Bay has lost a third of
its inhabitants. As I wrote a blog post on the train, 15 minutes out
of town, we passed high-tech factories and a military air base, signs
of the "rimming" of business – moving out to the suburbs – that has
affected many U.S. cities.

The eminent Marxist geographer David Harvey, who taught for
many years at Johns Hopkins University in Baltimore, gave a talk to
a group from the conference at the top of Federal Hill. This unique
promontory overlooks downtown Baltimore and the Inner Harbor.
From this hill Lincoln's Zouave army trained cannons on the city be-
low to keep the state of Maryland from seceding from the Union
during the Civil War. David Harvey pointed his finger towards a score
of undistinguished or plain ugly high-rise office towers that litter the
landscape, the results of decades of "public-private partnerships."
While these heavily subsidized and now largely vacant buildings were
constructed, the city's neighborhoods, especially its schools, were sys-
tematically starved of funds.

In 2009, the repression was creating jobs. Inner Baltimore, the
depopulated city of the bourgeois, was simply, almost comically, be-
coming a police state. Running the police force seemed to be the only
growing industry in town. Large black signs with white letters post-
ed on the streets proclaimed: "BELIEVE." The blue flashing lights I
recalled from years ago still marked surveillance cameras, and across

from the tiny nightclub and bar strip a large set of klieg lights were still set to blast nighttime crowds with a military daytime.

"The City From Below" conference was held in an old Methodist church, a grand basilica with stained glass and a light-filled community room behind. The church was crumbling, its congregation unable to support the place. They had invited the radicals of Red Emma's bookstore to help maintain the building in exchange for using it for special events. Now they ran the front of this grand religious assembly hall, and had installed a bar and kitchen. The diminished congregation with a transgender minister met every Sunday in the back. An adjunct building where the conference took place was a beautifully restored public library run by community volunteers. The city defunded many neighborhood libraries years ago, including this gem of the Carnegie library era.

The conference was filled with interesting and unusual presentations. It had the substance of an academic symposium without its stultifying rituals and constraints, and the networking intensity of neighborhood organizing. The keynote speech was a recording by Mumia Abu Jamal, the imprisoned black journalist. The co-host was the Baltimore United Workers Association, building their spring campaign for low wage workers in the city center. They sported bright yellow t-shirts and posters bearing the stern visage of Harriet Tubman, the slave-freeing heroine of the 19th century Underground Railroad.

Several of the sessions were animated by the prospect of direct action squatting by the recently dispossessed on foreclosed properties and vacant lands. A strong thread of permaculture and urban farming packed in the clear-eyed crusties and would-be hayseeds, like one gal wearing a vintage fox pelt as a hat. This movement – call it a kind of neo-ruralism – is strong in the shrinking cities, most famously in Detroit. The braiding together of these urban and rural movement strains made the conference exciting. If there was in fact a grassroots revolution in the making, a true insurrectionary urban development, this could have been its planning meeting.

A number of activist artists presented, including Scott Berzofsky and Nicholas Wisniewski, who had started Participation Park, Brett Bloom of the Chicago group Temporary Services, and Daniel Tucker of the *AREA Chicago* journal. A crew from Not an Alternative, the dynamic activist art group in New York, built a stage set alongside the church to videotape interviews with conference participants. The

poster collective Just Seeds was also "tabling" – exhibiting and sell-ing their prints. I co-hosted a panel entitled "Occupy and Resist! Ex-amining the European Social Center," together with Lynn Owens, a sociologist from Vermont and expert on the Amsterdam movement. [Owens, 2009] Neither of us had much to say, me from ignorance, Lynn from a deep shyness. Our session was crowded, however, and members of the audience with direct experience spoke up, including a squatter from Barcelona and another from Rome.

Stevphen Shukaitis, my host in London, convened a panel on art-ists in the creative city.[1] This is a key issue. Artists play an important role in the reconfiguration of post-industrial cities. Cultural commu-nities are directly implicated in state-supported processes of gentrifi-cation. Analysis and critique around artists' changing roles in urban life has grown in importance as both a motivation and explanation for political and cultural occupations.

1 In my year-long seminar at Kennesaw State University called "Art Worlds of Atlanta," we investigated local art history in Atlanta. We discovered that artists were being systematically used to create value for the new housing market in formerly industrial areas of the city. I gave two talks, at the Visual Culture conference and the College Art Association, promoting the value of research in local art history, which is sorely neglected in the U.S. My extempore talk in Baltimore reprised this appeal.

Opposite: Street art show in the hallways of the old Patio Maravil-las social center, Madrid, 2009. (Photo by the author)

Opposite: Installation view of the "Signs of Change" exhibition at Exit Art, 2008. (Photo courtesy Josh MacPhee)

SIX
"WE LIKE THE NAME"

There seemed no better place to present an exhibition focused on European squatting than ABC No Rio, a lower Manhattan art space with a historical connection to the squatting movement. I was a "founder," as they say, active on the board of directors, and also part of the visual arts committee. I proposed the project, and in January of 2009 the show "House Magic: Bureau of Foreign Correspondence" was approved for the spring.

I wrote in an early draft of the press release: "The House Magic exhibition will be an open structure, a channel for a continuous flow of information from the social centers themselves. Bulletins will be posted,

banners will be painted, soup will be served. Video documents will be screened, and guests will discuss their experiences within the squatting and social center movements.... This ongoing project invites public participation as we share the stories and synthesize the lessons of the vivid life and often spectacular depths of these temporary autonomous zones."

My scheme for a month-long research exhibition turned out to be more complicated – and would be a good deal more extended – than ever I thought.

"House Magic" began in an art gallery, and was subsequently exhibited mainly in art-related spaces. At this point it is useful to ask that perennial question, "Why is this art?" The fast answer, often seen as flippant and elitist, is that it is art because it is something that artists do. Long explanations may not even clear up a spectator's incomprehension, confusion, or disbelief.

But why would artists do this? For two reasons: First, this information is something artists in the U.S., particularly those working on political and social issues, need to know about, and there is no better way to get the information to them than to present it in an art context. Second, the idea was in the air, that is, making the "House Magic" show at that moment fed into a larger movement of politicized artists working on related topics. (Hopefully the preceding chapters of this book many have given some sense of how that might be so.)

In late 2008, "House Magic" was not the only project in which artists engaged questions of squatting. The 'mortgage meltdown' of 'toxic assets' which knocked the globally networked financial system off its pins had widespread devastating consequences for poor and working people. Shantytowns sprang up across the U.S. of jobless former homeowners. Informal and orchestrated defenses against the wave of foreclosure and evictions were occurring nationwide, supported by new grassroots community organizations. The ideas of squatting and occupation were often discussed as political strategies in the U.S., and a number of artists were working with affected people and activist groups on these issues.

The third reason in specifically related to cultural institutions in the United States, and that is the show's utilitarian function. There is no easy route for information about minoritarian radical movements to find an audience outside of political subcultures. The circuits of the art world can lead to a larger audience. Ideological sequestration, or

the bottling-up of minoritarian political and subcultural information and ideas, is a legacy of the Cold War era during which cultural institutions played an important role. [Moore, 2011] Now many more researchers are taking on the job of reversing the flow, but this process in the U.S. is slow.

The movement of the 21st century politicized American artists' groups has still not received any serious institutional attention in New York City. Few exhibitions themed around new artists' collectives have been mounted in other cities. An exception took place at the Institute of Contemporary Art in Philadelphia in 2007, entitled "Locally Localized Gravity." [Porter, 2007] Significantly, it was organized by museum interns, and the politics of the groups was played down. Why? Extensively privatized U.S. institutions primarily owe their existence to subsidies from wealthy merchants, financiers and investors in real estate, and derive their program funds from corporations and politically vulnerable municipal, state and federal governments. Self-censorship, and a turning away from any political project, is a nearly unconscious reflex for curators in the U.S. The status of cultural institutions in most of Europe is very different, since most are primarily state supported, and rarely subject to the kind of direct ham-fisted political censorship that Americans find common.

In late 2008, a major show of political graphics and media was mounted at Exit Art, a large alternative space for contemporary art in New York's Chelsea gallery district. Josh MacPhee and Dara Greenwald, two artists from Chicago who traveled the world gathering posters and videos from various extant and historical social movements, curated the show. "Signs of Change" differed from most political poster shows – rare as they are in New York City – in several respects. The catalogue, which appeared two years later, explains that the works come from autonomous social movements, i.e., not ideologically social democratic, Leninist or anarchist. They express what George Katsiaficas calls the "eros effect" of moments of dramatic popular social upheaval.

In their brief essay, Greenwald and MacPhee advance the important notion of "social movement culture" which broadens the frame around the conception and production of political graphics to include, among other things, the social formations movements create, and their relationships to communications technology. They also advance new conceptions of the artist: the artist as an agent of change,

and the amateur turned artist in service of a movement. The social movement culture Greenwald and MacPhee talk about is particularly developed through the egalitarian operations of quotidian life which take place in encampments. They adduce as evidence the numerous women's anti-nuclear peace encampments, although the exhibition included graphic work and documentaries in video dealing with political occupations by Native Americans, and the Provo-initiated squatting movement in Holland. [Greenwald and Josh MacPhee, 2010]

Exit Art, the venue for "Signs of Change," was run by Jeannette Ingberman and her partner the artist Papo Colo, and had a long commitment to activist art projects, politically oriented work, and counterculture history. (See Chapter 27) They were advised by Mary-Ann Staniszewski, an art historian who has written on the politics of exhibition. The "Signs of Change" show began a U.S. tour of college art galleries thereafter, and Josh and Dara began work on a new project called the Interference Archive. This independent movement archive, modeled on those they had seen overseas, would later play a role as a collaborator in the "House Magic" project.

My scheme for a month-long research exhibition turned out to be more complicated than I anticipated, and the local organization of the "House Magic" show proved difficult. I had devised an improbable two-part agenda – to represent a large number of the most significant European social centers, and further to emulate stereotypical activities of squatted social centers in the gallery. ABC No Rio's director Steven Englander grew impatient with me doing preparatory work in the space, and assigned me a manager, a young curator who controlled access and never seemed to be around. My relation with Steven was not improved when Clayton Patterson, upset at not being included in the show, launched an email campaign against him and his partner Vikki Law.

I moved my preparatory work away from ABC, to the nearby back office of Tribes, a cultural center run in the apartment of Steve Cannon, the blind Lower East Side writer and irascible hipster saint. My expectation that social centers would participate by sending material turned out to be a vain hope. The response from European friends and comrades was silence. Only New Yorck Bethanien in Berlin sent digital files, and Christiania sent videos. Another letdown came when I asked a friend living in the Ganas commune in Staten Island if he would speak at the show about collective living. Earlier, another

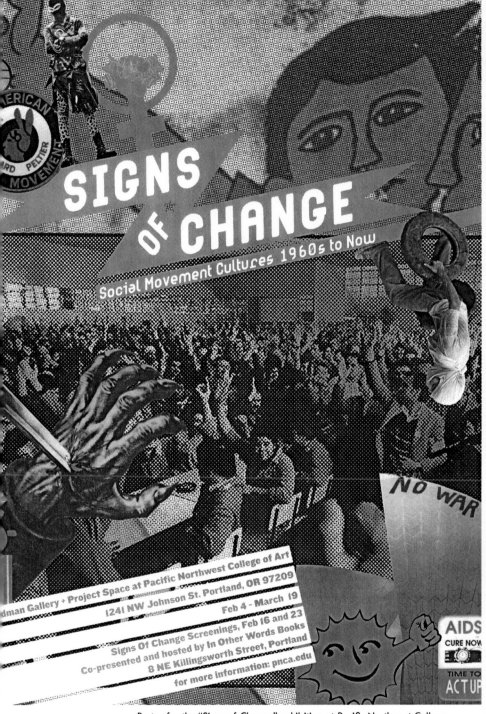

Poster for the "Signs of Change" exhibition at Pacific Northwest College of Art, 2009. (Courtesy Interference Archive)

Ganas member had declined, saying they didn't want to be identified with squatters. My friend more or less repeated the line, and then went further, criticizing the show plan in its parts and in concept. He said it would be a "fuck you!" in the face of any general audience. This response baffled and saddened me. Collective living is at the heart of many political squatting movements. (In Berlin they are called "house projects.") Ganas has a great method and lots of experience that they could share with progressive people. Their governing assembly, however, has never seen a reason to overcome their reticence to do so.

A few weeks before the show, the ABC No Rio visual arts committee met again. I was berated for disorganization, and my scheme for the show was taken apart and put back together again. The new format would try for graphic and punchy – to provide "eye candy" for the casual viewer. Information relevant to different social centers would be clipped to boards mounted next to the stenciled images of social center logos. The focus of the show would be on the events, the screenings and discussions. Each member of the group would take a different social center, and try to gather information about them online. With this collectivization came relief for me – I could relax, as the whole load for the show came off my shoulders.

Discussion event at "House Magic" show at Basekamp, Philadelphia, 2009. (Photo by the author)

SEVEN
"HOUSE MAGIC" OPENS

The "House Magic" show was quite mod-est in comparison to "Signs of Change." The exhibition was designed by the ABC No Rio visual arts collective to include logos of different European squats stencilled onto the wall, dossiers on clipboards with information printed out from social center websites, and materials needed for painting copies of banners hung on squats – paint, cloth and a projector. There was also a library of books and videos collected on my travels.

The stencil plan reflected the kind of artwork many at ABC No Rio had made on the streets. Stenciling is a "poor" medium that yields a complex

BUREAU OF FOREIGN CORRESPONDENCE

House Magic zine logo, 2009, by Suck Zoo Han

result – a representational image and an accompanying text. It requires only a stiff material from which to cut the stencil; some Argentine artists use discarded x-rays from hospital trash. These are easily applied to public walls using spray paint, allowing the artist a quick getaway from police patrols. Stenciling has become a mainstay of the repertoire of techniques used by international street artists, and has been especially important in subversive political campaigns to publicize ideas and images barred from public print controlled by authoritarian regimes. [MacPhee, 2004; MacPhee and Reuland, 2007; Cerisola, et al., 2012]

The show opened with the stencils on one wall and the clipboards on the other. I also made "social center wallpaper," consisting of photocopies of handouts I had gleaned from squats in Europe that emulated the look of walls there. The idea was that with this wallpaper, you could convert any space into looking like a European social center.

Despite its modest design and low attendance, the exhibition succeeded in generating some discussion. The show, and the rundown building of ABC No Rio itself, were a backdrop for the conversations that took place between artists who had experienced the European social centers or had an interest in them. (Oddly, this did not include Lower East Side squatters, very few of whom visited the show.) Small audiences heard first-hand from artists with stories from the squatting

movement very different from any which had been heard publicly in · New York before.

One of the first to present was Michel Chevalier, an American from Washington, D.C. living in Hamburg. Michel was deeply involved in the politicized German art world. He spoke about his work with a group of folks from the New Yorck Bethanien squat I had visited in Berlin. The AKSB (Archiv Kultur und Soziale Bewegung, or Culture and Social Movement Archive) formed in Hamburg in 2005. The group was comprised of artists, media activists, and students who traveled to political events with material like videos, books, and workshops. They had been visiting Social Forum gatherings in Europe, bringing materials about the Russian Revolution, the Russian avant-garde of the '20s, Dada, and the Situationists. They were trying to present something other than what they saw as the "boring, stereotypical" cultural presentations at Social Forums. They were trying, as Michel put it, to "redistribute cultural capital."

In 2006 the AKSB group met people from the New Yorck squat at a Social Forum in Erfurt. The NYB group had run into problems with their neighbors, the art center Künstlerhaus Bethanien. The Künstlerhaus during the '70s and '80s was famously experimental. But in the '90s, Michel told us, they became more art market-oriented and socially conservative. They took corporate sponsorship from Philip-Morris. Their open call residency program was changed so that only embassies of countries could nominate artists. The director of the Künstlerhaus launched a campaign against the New Yorck squatters next door. He started a petition and gathered signatures from corporate sponsors and prominent people in the Berlin art scene, protesting against "the self-empowerment of the squatters and their sympathizers. They plan to turn Bethanien into a playing field of ideological class war." The squatters had to go because they were a threat to culture.

The AKSB commissioned documentary videos about the squats Forde (in Geneva) and La Générale (in Paris), and the filmmakers came to Berlin to discuss their perspectives with the New Yorck activists. The screening and discussion event reversed the attack, manifesting what Michel called "an artistic critique on self-declared cultural projects that actually represent the interests of capitalists."

Other squatting stories that Michel presented concerned the Rhino in Geneva and the Rote Flora in Hamburg. Rhino was a large apartment complex squatted in 1988 and evicted in 2007. Michel

screened a video called *Rhino féroce: un squat a Genève,* simultaneously interpreting its French soundtrack into English. [Egli, et al., 2006] Rhino was a late flowering of a squatting movement that began during the collapse of the real estate bubble in the 1980s. Young people began to take over the many empty buildings. Police at first repressed the movement, and then organized a squat brigade with the job of maintaining contact between squatters and the owners. The Rhino center, like many squats, housed both activists and artists – 500 diverse people in all. They held many street actions to call attention to vacant buildings, and Rhino became a prime location for cultural events.

At its height, Rhino had a bar and a concert venue, which hosted avant-garde music. Then a bistro opened, with lunch, concerts, parties and film projections. The squat became a popular symbol of alternative culture, and was called by media friends the "cultural lungs" of the city. Communal living and self-management were part of consciously developed models for a kind of community life lived against and outside society. The rules were open: People chose their neighbors; there were places for artists and travelers to stay overnight. Decisions were made democratically at weekly meetings. Each inhabitant paid just 67 Euros a month as a member of the association.

A former resident of Rhino – an artist named Myk – was in the audience. He explained that the eviction of Rhino happened on a day many people were out of town for music festivals. It was also pouring down with rain, so few turned out to protest. Police tied a rope around the bright red horn on the corner of the building, which was Rhino's symbol for many years, and ripped it off. It was like the toppling of the statue of Saddam Hussein after the invasion of Iraq, said Myk, as if to say, "this is the end of the squat movement.... We were considered kind of the mothership of the squat movement." Two years later the building remained empty, all the windows cemented, the toilets all smashed.

The association had accumulated about a quarter of a million Euros from monthly rents that was used to pay for maintenance, renovations, and lawyers to defend their case in court. They were winning regularly until the right wing took over the courts. They declared the association illegal, and, since the money was in a post office account run by the Swiss government, all of their assets vanished overnight, the day after the squat was evicted. They couldn't defend themselves

or look for another house. People were out on the street. "It was a horrible end to a beautiful scene. Even so, 18 years is pretty good," Myk concluded philosophically.

Michel Chevalier had also brought along a number of posters from the long-running Rote Flora social center in Hamburg, announcing events there. Thomas Beck, a musician who works with the silkscreen group at the Rote Flora that does a lot of political printing, contributed the posters. There are a few jokes here, Michel explained. One is printed on the real estate page of the newspaper, and the text is printed backwards. During the demonstrations at Heiligendamm against the G8 summit of world leaders in 2007, the police raided many squats. The door of the Rote Flora was soldered shut. One poster was cut out in the shape of the portable grinding tool used to reopen the door, and advertises an anti-repression party. Another is in the shape of a hand holding a TV remote control: the static is the person holding the device. There was another in the shape of a bandage. Monika Hardmeier, a Swiss working with the ABC group, explained that this joke might be about squatting as the "plaster," or bandage of a partial

Michel Chevalier discusses the posters from Rote Flora at the "House Magic" exhibition, ABC No Rio, 2009. (Photo by the author)

solution to the housing crisis. Another poster was cut into the shape of a blood-sucking tick, and is captioned "Rote Flora 'ticks' regularly." Again, Monika suggested that this could be based on a characterization by right wing politicians of the squats as parasites on society – so, as the poster says, the Rote Flora "ticks" with their activities.

We screened the elegant short *Take Over* [Montevecchi, 2009], about a group of squatters in Brighton, England, who took over an abandoned church. The film is slick and clean, but the action itself wasn't. This wasn't a political collective – rather, many "crusties", latter-day hippies and travelers who lacked discipline and clear intention, were involved. It is a portrait of one of squatting's subcultures.

Vivian Vasser, a performance artist in Staten Island and organizer with the Day de Dada festival, told me about a film by a group she had met in Zurich. *Dada Changed My Life* [Lou Lou and Daniel Martinez; 2004] is a peculiar docu-drama about an important squatting action by artists that saved the Cabaret Voltaire from development. The Cabaret Voltaire was the site of important manifestations of the Dada movement in 1916, today it is a museum of Dada. Olga Mazurkiewicz, who worked on the film, talked about this eccentric movie and the action itself, a classic of what Hans Pruijt calls "conservational squatting," intended to preserve historically or architecturally interesting buildings from imprudent destruction.

The Spanish movement was well represented. We showed *Laboratorio 3, Ocupando el Vacio,* [*Laboratorio,* 2007; Charlon, 2003] a dramatic initiative in the old neighborhood of Madrid. During the waning days of the socialist government in 2009, a group, some of whom had worked on the three successive Laboratorio occupations, finally achieved a legal permission to use a large vacant government building, the Tabacalera. (See Chapter 13)

Okupa, Crónica de una Lucha Social ("Squat, chronicle of a social struggle") [Octavi Royo; 1996] opened up probably the longest discussion. It was accompanied by the short "Tactical Tourist," [Greenwald, 2008] documenting Dara Greenwald and Josh MacPhee's visit to squats in Barcelona, Miles de Viviendas ("Thousands of homes") and Can Masdeu, the rural squat on the edge of the city. Emily Forman, who is seen dancing in Dara's short film, was on hand for the screening, along with her friend Marina Monsonis. Emily was involved, along with Dara and Josh, in the DSLR project in Chicago (see Chapter 3), and carried her enthusiasm for disobedient creative

activism into the Barcelona squatting scene. She became involved with the Miles de Viviendas occupation of an empty former police barracks [Vilaseca, 2013] – which had been a union hall before the Franco era. This heavily contested squat was in the Barceloneta, a working class portside neighborhood under heavy pressure of gentrification. Marina grew up there. She and Emily told exciting tales of resisting cops and goons in the course of this struggle.

"Tactical Tourist" includes a short interview with an organizer of a "pirate university" project at the Miles *okupa*. At Miles, the Pirate University produced Josh MacPhee's talk on street art. Regular programs of instruction outside the walls of established institutions is one of the many kinds of workshops set up in social centers. I met Emiliano Morra at rampART in London who had done a Pirate University project there. He staged a talk on Jacques Derrida's concept of nothingness while seated on chairs in the middle of a street. It sounded like the perfect combination of post-structuralism and activism, mixed to the pitch of absurdity, the kind of thing that appeals to an ironic London academic crowd, drawing students and intellectuals into the squatting movement. The more purposive Spanish activist climate involves other kinds of brainwork. They believe that real political change is possible, as the sudden arising of the Podemos political party demonstrates.

Nils Vest, filmmaker and historian of Christiania, the venerable "free city" of Copenhagen, sent along his *Christiania You Have My Heart*. [Vest, 1991] Rebecca Zorach, an art history professor from Chicago who had attended a conference there commemorating 1968, gave a talk. She focused on the struggle that community has waged to maintain its independence from successive government attempts to re-assimilate the squatted former army base into the rest of the city. Christiania is a major tourist attraction, and early on achieved the status of a much-studied social experiment in self-organized living. It is a beacon for squatters and free-livers throughout Europe, a community which foregrounds art and theater as part of its daily life. Christiania has also created rituals, drawing on Danish folk traditions, alongside its political performances. For example, an *axis mundi*, a decorated pole to signify a center of the earth, was ceremonially erected during the Climate Summit in Copenhagen in 2009. Christianites staged this event as part of a "Climate Bottom," together with representatives of indigenous nations who had come to the conference.

Home to the famous "Pusher Street," discussion of Christiania inevitably raises the issue of drugs, addicts and criminals, and the flow of black money that comes with the trade. The film by Vest deals with this issue, telling how the community banded together in the 1980s to expel the heroin dealers and users from their community. Thereafter, while marijuana and other organic hallucinogens are traded, a strict rule against hard drugs was enforced. This is more or less the same bargain European governments themselves have made with the explosion of drug users that began in the 1960s. Police have tended to push socially problematic drug users towards squats and social centers as a disruptive tactic, where the self-organized communities strive to contend with them. "But it isn't democratic" to expel addicts from your community, someone opined in the ABC No Rio conversation, expressing the feeling that makes the subject so divisive. Another compared Christiania to the favelas of Latin America controlled by drug-dealing gangs. This is a large-scale issue for squats and occupations, a problem that never goes away.

A great deal has been published on Christiania, but not so much in English. The "House Magic" zine catalogue that came out of this exhibition published a timeline and a detailing of the political and economic structure of the community compiled by Jordan Zinovich of the Autonomedia publishing collective. Jordan prepared it for a conference on radical urbanism held at the City University of New York Graduate Center, produced by their Center for Place, Culture and Politics. This academic unit is the home of Marxist geographers David Harvey – author of *A Brief History of Neoliberalism* – and the late gentrification analyst Neil Smith. Together with the retired Columbia University urbanist Peter Marcuse, these academics used their resources to support grassroots organizing of the kind associated with the international Right to the City network. The center was presenting leading international activists, and engaging key questions, including privatization and commons. In 2009, squatting and occupation were more and more emerging as key tactics in activists' toolkit.

Collective living – commune life – is a key component of political squats and social centers. The Federation of Intentional Communities rushed us a copy of their new release *Visions of Utopia,* a magnum opus on communal living in the U.S., by filmmaker Geoff Kozeny. [Kozeny, 2004-09] This was the film's the New York premiere. (Kozeny passed away just before the release.) We screened the first part, on the

historical background of this kind of living, and part of the second, concerning urban communes, among them Ganas. As noted above, several key Ganas members had refused to participate in the "House Magic" show. One who had volunteered to speak did not show up.

I had gathered and advertised other important videos by artists, the kind that would be included in an international exhibition or film series on the question of occupation held at a major institution. These were not screened formally, and were only available for on-demand viewing in the gallery. Consequently, some of the richest and most interesting material by European moving image artists was not seen or discussed – only its existence was noted. The library held collaborative documentaries by Oliver Ressler concerned with the Italian Autonomist movement (*Disobbedienti*), [Azzellini & Ressler, 2002] and the Global Justice movement (*What Would It Mean to Win?*), [Begg & Ressler, 2008] Marcelo Expósito's, *Primero de Mayo: La Ciudad-fábrica* ("First of May: The city factory"), [Expósito, 2004] about activism in the factory town of Turin; and a video installation by Democracia from their project "Sin Estado" ("without the/a state") in the Madrid slum, or *chabola,* called Cañada Real. During the run of the show at ABC, and subsequently in Queens, no one asked to see these productions. Audiences for these films would need to be educated. In New York, "House Magic" opened a kindergarten.

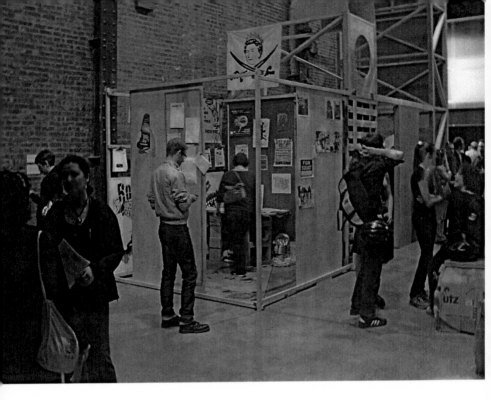

EIGHT

RESEARCH BUREAU AT THE "UNIVERSITY OF TRASH"

"The University of Trash" was a whole
building installation running all summer of 2009 at
the Sculpture Center in Queens, New York. The pro-
ject, a collaboration of English artist Nils Norman and
New Yorker Michael Cataldi, was described as a "plat-
form." It was the grandest instantiation of the artists'
university idea to date in a U.S. institutional art venue.
Michael was involved with the ABC No Rio visual arts
committee, and had invited me to put up the "House
Magic" project inside their installation. When the
show closed at ABC, we packed it up and brought it

Low frequency FM transmitter building workshop at the "University of
Trash" at the Sculpture Center, New York City, 2009.

to Queens. The Sculpture Center is an artist-originated exhibiting insti-
tution, founded in the 1920s. They had relocated from Manhattan to
Queens, not many blocks from the huge P.S.1 contemporary art center,
which had recently been acquired by the Museum of Modern Art.

While Norman designed the installation, Cataldi ran the pro-
ject, and described it on the website: "The University of Trash is ...
modeled after radical utopian architectural projects and pedagogical
experiments from the late 1960s and late 1980s. Adventure play-
grounds, historic urban spaces such as Tompkins Square Park, and
vernacular architecture came together to form a series of intercon-
nected pavilions and walkways within the exhibition space. Built from
readymade, recycled, and found materials, the installation functioned
as a temporary, makeshift free school. Throughout the three-month
exhibition, The University of Trash hosted over 50 courses, lectures,
presentations, and workshops, taught and attended by members of
the public on a wide range of topics. An essential part of the work was
the involvement of local students, community organizations, artists,
activists, and academics, all of whom led small classes or talks within
the space of the exhibition. These topics included grassroots organiz-
ing, DIY architecture, the evolving aesthetics and politics of public
space, screen-printing, boat building, and composting."

The "University of Trash" project joined in a stream of less public artist-run free school projects, of which a well-known early example is the Copenhagen Free University (2001-07).[1] These include The Public School project, which began in Los Angeles with a well-designed internet interface, and a participatory model of self-organization which has seeded itself in a number of cities, including Philadelphia, Berlin, and Mexico City. These self-organized initiatives were emulated in 2007 by the e-flux group in their well-funded "unitednationsplaza" free school in Berlin. The phenomenon of the artists' free school responds to the discontent in universities pursuant to the implementation of the Bologna Process of standardization in Europe, and the simultaneous cutbacks and tuition fee increases imposed by governments around the world. The website Edu-factory has been a voice for the global student movement for years, coming out of the Italian Onda, or the Wave. Like occupation, the free school model has been a key political tactic of the present era.

The free school was also serving as a way for artists to continuously educate themselves about the political and economic conditions of the rapidly expanding global crisis. In March 2009, the 16 Beaver Group hosted an evening with Anna Curcio and others from the Edu-factory project who spoke about self-education initiatives. Anna was also involved in the ESC social center in Rome, along with a graduate student I met at Queen Mary University in London. Anna told us that ESC – for Eccedi, Sottrai, Crea; "exceed, subtract, create" – is part of the second wave of social centers that arose after the Genoa G8 protests were so brutally repressed. This social center was set up across the street from a large university, and its members engaged the students directly, providing study space, counseling and other services in an autonomist atmosphere. Now, she said, the task of the Edu-factory group was to "stay within and against" the educational system.

"The University of Trash" was rather like a pop-up social center running in a sanitary environment. Most of the projects taking place, or scheduled to take place there were the same as would be found in a social center. The convergence of forms is circumstantial: artists need to share skills and build social solidarity, the same as unemployed

1 The Copenhagen Free University was a project in which Jakob Jakobsen played a central role. He has continued as a student of Scandinavian Situationism and free universities past and present. He recently developed a project on the 1968 Antiuniversity of London for the Mayday Rooms archival project, which includes a tabloid publication (at: HTTP://MAYDAYROOMS.ORG/COLLECTIONS/ANTI-U/).

Opposite: Dancer at the "University of Trash" at the Sculpture Center, New York City, 2009.

workers, students, and others. The organizational form, however, is different. Occupied social centers are initiated by activist collectives and run by democratic assemblies. There are small group dynamics of power, but there are usually no designated leaders, administrative bodies, or representative councils. Established schools, on the other hand, are vertical organizations, and artists' schools, although they are self-organized, tend to emulate that verticality.

For this reason, artists' free schools, like artists' emulation of many movement strategies, may be criticized as watered down versions of the more politicized models. Still, what artists do with models like free schools, social centers, etc., is formalize them, publicize them, subject them to public scrutiny, and present them for public enjoyment. In short, artists make movement forms into research objects – things to look at, be in, and think about. Once these forms become more widely known, they become more available for re-use and transformation in both artistic and political contexts.

As a sculptor, Nils Norman has long been concerned with utopian visions and radical pasts. In New York galleries, he was known for his miniature diorama reconstructions of key moments in actual and imaginary anarchist histories. One of these, a fantasy, imagined tree sits in Tompkins Square Park. This was a crossbreeding of two contemporaneous moments of activism, the Tompkins Square Park homeless encampment and the neighborhood's squatter resistance, and the near-simultaneous English anti-roads movement, which saw activist occupations in the branches of ancient trees. These were marked for destruction along with small hamlets in the path of planned new highways. As the Sculpture Center show opened, Nils also had a long-term installation on Governor's Island: a cluster of tents that simulated a protest encampment was part of the Creative Time exhibition, "This World and Nearer Ones."

For the "University of Trash," Nils returned to the Tompkins Square Park theme as he and Michael worked with a group of high school students – among them my son Taylor – to build a large wooden framework for planned events, using recycled building materials from a center called Build It Green. The centerpiece of the installation was a

third-scale reproduction of the Tompkins Square Park bandshell, torn down during the mayoralty of Rudolph Giuliani. The bandshell was painted with designs by members of the JustSeeds graphics collective.[2]

I was delighted to see this. The destruction of the bandshell, built during the 1960s, was a direct blow at the cultural underpinnings of the radical movements in the East Village, most especially the squatters. (The "Squatter Mayday" festival had been held at the bandshell for years.) It also erased a historical site. In 1969, the Young Lords Party launched their political campaign with a rally at the bandshell. Many famous musical groups played free concerts there during the '60s. Its demolition was a pure act of vengeance by a mayor notorious for his usually more cunning attacks on cultural symbols.[3]

During the course of the show, a group of Nils' students came over from Copenhagen. Steven Englander and I spoke to them during a visit to ABC No Rio. At the University of Trash, two of these artists sat on the bandshell and talked about their work squatting vacant land near the famous free city of Christiania. (See *House Magic* #1.) Their project had been imitated, very shortly after its eviction, by a group of architects working for a real estate development company. They produced a festival modeled on the public space themes of the occupation.[4]

2 JustSeeds is a national cooperative of political graphic artists that occasionally shows together. Josh MacPhee is the founder. The project emerged from Josh's work with infoshops and anarchist bookstores, touring shows of political graphic art in the U.S. and abroad. The network grew, and was collectivized with a distribution center for low-priced prints (HTTP://JUSTSEEDS.ORG/). The group has also worked together to make large collaborative installations. JustSeeds showed in the 2011 Pittsburgh Biennial and the 29th Graphics Biennial in Ljubljana, Slovenia, where they made a collaborative installation at the Alkatraz Gallery of the Metalkova Mesto occupied social center.

3 I urged Clayton Patterson to show his famous videotape of the 1988 Tompkins Square Park riot on screen at the recreated bandshell. Clayton videotaped the riot for three-and-a-half hours. His tape was subpoenaed and he refused to hand it over, serving time in jail in an early case of the rights of citizen journalists. [Patterson, 2007] He had not been included in the "House Magic" show at ABC No Rio, and was unhappy about it. It seemed like a good opportunity to point decisively to the significance of the structure Nils Norman and Michael Cataldi had built by showing the riot tapes there. Clayton declined. Finally, Paper Tiger TV programs of the period were screened.

4 This is what the students told us in 2009. They showed a slide of the architectural project intriguingly titled "Get Lost." Ask Katzeff wrote to me later that this project was "disguised as an activist art project, however it was really sponsored by a

The wallpaper and other décor from the "House Magic" show was mounted in one small room in the University of Trash, a promontory of the open framework stuffed with colorful propaganda. I worked several days a week in an adjacent room fitted out as a library and video viewing room. Nils left the country, and Michael was exhausted by the job of organizing the show. The interesting truck he had borrowed with its pirate radio capabilities sat in the courtyard, and was only used to broadcast concerts. (Pirate radio has long been a feature of squats, especially in the days before computer-based hacklabs.)[5] I had the time to give to the project, and could have done more, but Michael maintained control over all decisions, so any other possible organization of events was stifled. Probably the institution insisted that he control everything closely. Any open situation tends to inspire "assembly anxiety" in cultural managers. Finally, the Sculpture Center is on a dead-end street in an industrial neighborhood, and no foot traffic passes by. No one comes in off the street with ideas or energy. Its possibilities as a public space are limited both by its location and by organizational constraints.

Still, I was happy. It had always been my dream to organize academic research on under-examined sub- and countercultural topics. When Michael told me, "You are running a research bureau in the University of Trash," I played my assigned role in the academic simulation contentedly. During the summer that the University of Trash ran, the Sculpture Center became a kind of hub for Brooklyn- and Queens-based artists to present and socialize. Numerous music bands played there. Many people browsed the "House Magic" installation, watched the videos and looked at the books. The informational display flew the great flag of the pirate Queen Elizabeth, copied by Julie

big mortgage provider gone altruist." In another example of squatter chic, a real estate company sought to rent office space under the slogans, "The inner city is dead," and "Squat now!" (Ask Katzeff, email May 26, 2012).

5 March 2009 saw the "Broadcast" exhibition travel from the Baltimore Contemporary Museum (2007) to the Pratt Manhattan gallery, the NYC venue for the show, The gallery held Gregory Green's mobile radio station, *Radio Caroline, The Voice of the New Free State of Caroline.* The latter political entity is Gregory's own politico-artistic creation. Radio Caroline was a famous pirate radio station broadcasting off the coast of England in the '60s and '70s. The artist duo neuroTransmitter also memorialized this broadcast adventure in their sculpture *12 Miles Out* in the show. For squat-related radio activity in Italy, see Franco "Bifo" Berardi, "Radio Alice," interview by Rosetta Brooks, July 10, 2010, at: HTTP:// WWW.ZGPRESS.COM/?P=36; and HTTPS://LIBCOM.ORG/HISTORY/RADIO-ALICE

Hair from an English book on political squats, *What's This Place?* [Social Centres Network, 2007] I spent my time researching squats and processing the material generated during the show at ABC.

When the "University of Trash" exhibition finished, I produced a catalogue of the project, *House Magic* #1. It was conceived as a zine. Wikipedia defines "zine" as "an abbreviation of fanzine, or magazine … most commonly a small circulation publication of original or appropriated texts and images. More broadly, the term encompasses any self-published work of minority interest usually reproduced via photocopier." "Small circulation…minority interest" – yes. Before photocopiers became common in the 1970s, little magazines were the staple means of communication among literary and artistic circles. I participated in that pre-photocopy circuit, working with small magazines and underground newspapers, many of which I have seen in museum vitrines. [Allen, 2011] So I understand this differently. "Subculture" today is what modernists called the "avant-garde." Because I couldn't get all the important findings of the research into that first catalogue, it seemed necessary to consider making another.

James Andrews of the Nsumi collective onstage at the "University of Trash" at the Sculpture Center, New York City, 2009. (Photo by the author)

Sledge hammer in a guitar case, exhibited by Andrew
Castrucci, 2009. (Photo courtesy Andrew Castrucci)

UNREAL ESTATE AND A TENT CITY IN HARLEM

Even as the "House Magic" show was installed at ABC No Rio, I journeyed to Chicago to present a "suitcase" version of it there. Ed Marszewski had involved me. He is an energetic promoter of new art in Chicago, and the owner of a large storefront in the Bridgeport neighborhood. Edmar, as he is known, produced the annual exposition called Version Fest, a title alluding to software updates. (This one was titled Version>09, or Versi9n.) For a number of years, this multi-venue artist-organized festival had been an important annual event for artists' collectives. This year's theme was "Immodest Proposals."

Edmar was in the middle of things when I appeared. As the producer of the Version Fest, parties and related events in his cultural center, and editor/publisher of two magazines, *Lumpen* and *Proximity*, he is supernaturally busy. In my only photo of him he is blurred, in motion. He seemed surprised I actually showed up. There was no room for me where artists had set up their booths, a large open hall where the exposition – the "NFO XPO" – was being held, so I posted the House Magic clipboard dossiers in the lobby and the "wallpaper" in the basement, where a "Free University" was advertised.

I talked with Emily of St. Louis. She told me of a group of squatters who had started a community garden and greatly improved their building in a derelict neighborhood in St. Louis. The city evicted them, so they moved to Kentucky. Many U.S. cities are tearing down vacant buildings as quickly

as they can. They fear they will become drug dens, crack houses, pockets of vice. City managers who cannot distinguish between criminals and socially productive squatters will simply drive motivated young people out of their failing cities. It was precisely this mentality that I hoped to change through the "House Magic" project, to demonstrate through multiple European cases, the dramatic creative social effects that could be achieved through self-organized extra-legal initiatives. Squatting can be direct action civic improvement.

Edmar put me up in the loft of his storefront, called the Co-Prosperity Sphere. As part of the Versi9n, the large window of the CPS contained two installations. One was a ghostly office, with huge electronic consoles, and two enclosed bunk beds. It looked like a spaceship. In the morning there was a crumpled pair of jeans, shiny shoes and a beer bottle on the floor in the window, because someone was sleeping in one of the beds. The bunkbed sleepers turned out to be two visiting artists from Rotterdam who told me they too were squatters, having taken over warehouse buildings on the waterfront there many years before. These were now legalized as artists' studios, and that was where they worked. The corner window held a model for the community of Bridgeport after Chicago Olympics redevelopment is done with it – a totalizing wipeout, the "Bridgeport Supersphere Olympic Village megacomplex." Was it for real? Chicago was a candidate city for the 2016 Summer Olympics, and that would have meant massive redevelopment and displacement. (Their bid failed, Rio de Janeiro was the winner.)

Another show in the window took up the squatting theme. The offices of the fictitious Reuben Kincaid Realty Corp were created, complete with desk, computers, and brochures advertising recently foreclosed homes as "for squat." The logo of this company was the international squatters' symbol of an encircled arrow. Leaning up against the side of the desk was a large sledgehammer, the "key" to the properties on offer.

The Reuben Kincaid Realty Corp project wasn't real in the way, say, of the London-based Advisory Service for Squatters. The "realty company" was a kind of ironic propaganda for squatting. Since it was an art project, viewers of this window installation could take it as a joke. But the joke went further. The website of the RKR included a page analyzing the subprime mortgage crisis of 2008 which dislodged many people and led a surge in vacant residential property in the U.S. The collaborators had done research into local foreclosed homes which were re-presented as squatting opportunities in conventionally

styled posters in the window and on the website. RKR was a project with elements of tactical media (the website), and conventional installation and sculptural components. In addition to the window "office," the team of RKR collaborators also prepared a "Rehousing Starter Kit" of "tools needed to reclaim a foreclosed home," basically a bunch of supplies convenient for squatting packed into a large tool trailer.[1]

Edmar's magazine *Lumpen* that month reprinted an interview with Max Rameau, the leader of the Miami group Take Back the Land. Rameau is a charismatic African-American grassroots housing justice activist. His group founded the Umoja Village shantytown, taking over city-owned land that had been intended for sale to a private developer in the mostly African-American Liberty City neighborhood of Miami. Unsurprisingly, in view of the riotous past of the district, the city kept hands off for quite some time, although the encampment was eventually evicted. [Rameau, 2013] When I saw Max Rameau speak in New York in May of '09, Take Back the Land had just occupied another vacant tract to grow fresh food in a community garden, much like the Participation Park project in Baltimore.

During that same event at the CUNY Graduate Center, Neil Smith spoke of the "global social crisis" which had ended the last and greatest wave of gentrification. Now, he said, there is the political possibility of changing the rules of the game, to forward tenant and neighborhood control of city housing resources. He warned that state repression is likely, and cited the example of activist movements of the 1930s that led to public housing in New York. Peter Marcuse asked what could happen after a squat? What ought to happen, and what needs to happen, so that what ought to happen can? He recalled the policies of NYC's last progressive mayor, John Lindsay, who set up the Division of Alternative Management in the city housing department which oversaw the homesteading of abandoned buildings. In the absence of such policies, the cycle will continue as it has after this interruption of the capitalist business cycle. "The next generation of gentrifiers are buying up houses now," Marcuse said.

1 The Reuben Kincaid Realty Agency project in Chicago (reubenkincaidrealty.org) made a "Prototype Reuben Kincaid Rehousing Starter Kit: Tools Needed to Reclaim a Foreclosed Home." This is an assemblage collage, a collaboration of Chris Roberson, Emily Clayton, Dr. James Harry Ewert Jr, Rod Hunting, Adrianne Goodrich, Peter Skvara, Michael Pajon, Ryan Duggan, Chad Kouri, Matt Nicolas, Jim Kozar, Ed Marszewski, Ben Speckmann, Sarah Jeziorski, Richard Smith and more. The project took a jury prize at the architecture part of the 2012 Biennale di Venezia.

Frank Morales, an Episcopal priest working at St. Marks Church, was also at that meeting, A forceful speaker, Frank is active in Picture the Homeless, a highly inventive decade-old activist group. He is a key convener of Organizing for Occupation (O4O). For him, squatting is "putting flesh on the bones of an abstract right" to housing. O4O undertook a brief squat of a building in East or Spanish Harlem, in March. The action was supported by the activist art group Not an Alternative from Brooklyn.

The artists dressed like city workers and put up official-looking signs with optimistic slogans while the homeless activists took over the building. A second occupation in July was a "tent city" in a long-vacant lot owned by a bank that had been recently bailed out by the federal government. It was across the street from public housing, where families were doubled and tripled up from the pressure of rising rent.

The action was meticulously planned. A meeting was called in Union Square Park, and a crowd of people headed uptown on the subway for an undisclosed location. We were trailed by police, and more met us at the subway stop. Organizers directed us to split up in groups and head off in different directions. Our group, including me and the Japanese writer Sabu, were followed by five cops. We went around in circles and finally hailed a taxi to reach the site.

Meanwhile, Not An Alternative had built a set, festive and homey, complete with bandstand, a dozen or so tents, and cardboard shovels and pick-axes signifying community initiative. The artists pretended they were using the lot for a fashion photo shoot as they cut the fence and put up the props. By the time the cops showed up en masse, 100 people were on the scene, enjoying a lunch of grilled corn, beans, bread and fruit, and music by a band called the Welfare Poets.

Frank Morales was in full priestly gear, wearing his clerical collar. Experienced activists chatted with the cops – among them Ben Shepard, a CUNY professor of social work, and Chris Flash of the Lower East Side *Shadow* newspaper. Legal observers wearing their trademark green hats, familiar from the 2004 protests against the Republican National Convention, were there alongside us. The cops were massing to make arrests. Although the occupation lasted only a few hours, it inspired the activist group and its allies, and made the *New York Times*. [Not An Alternative, 2009]

When the "House Magic" project began, I educated myself in housing and economic matters by frequent attendance at lectures. I turned from bewildered outsider to the left academic urbanist community

of graduate students, professors and organizers, to a journalist's familiarity with some faces and issues. In the fall, An Architektur, the Berlin group of architects and urbanists, came to New York. (Their name means "On architecture," with a sly inference of "anarchist architecture," or "anarchitecture," a coinage popularized by Gordon Matta-Clark.) They produced a ten-day event discussing "post-capitalist space" as part of their program of "oppositional architecture." I was invited to put the "House Magic" show library in their space.

The sessions were rich in ideas. The presentations included talks on decommodification of housing, the prospects of planning, and the commons: taking versus granting rights. At the wrap up, Damon Rich spoke. He works as a planner in Newark, New Jersey, and is a founder of CUP (Center for Urban Pedagogy), a group committed to education, and to "making policy public." CUP had recently prepared a graphic poster, "Predatory Equity: The Survival Guide," which describes the cycle of speculation in property that destroys low and middle-income housing in the USA. This is the cycle, Peter Marcuse said, that must end. "Why is land a commodity?" he asked. It's a natural resource. Housing tends to be a monopoly, with a largely fixed supply. A rise in rents does not lead to an increased number of units, just more profits for the owners. What these academics and activists were calling for was a nationwide land and housing direct action initiative, to reclaim TARP properties (that is the U.S. "Troubled Asset Relief Program," under which defaulted home mortgages were bought by the government.) These houses and many other abandoned properties in the nation's cities are being demolished so that the value of the remaining housing stock will rise.

Thanks to this meeting I also began to form a better historical sense of how older academics like Peter Marcuse and David Harvey had formed their ideas. An Architektur had published a set of three journals on the "community design" movement for participatory planning in the U.S. [*An Architektur,* 2008] The journals list a host of efforts, some with militant names like Architects Resistance, nearly all of them formed by young urbanists during the 1960s and '70s to stand with communities against the tide of "urban renewal" in the U.S. Some of these groups persist, although neutered by long-term institutional engagements. Marcuse, Neil Smith and David Harvey were trying to jump start the same kind of professional resistance among urban planners and architects in order to slow the rampant depredations of neoliberal city managers.

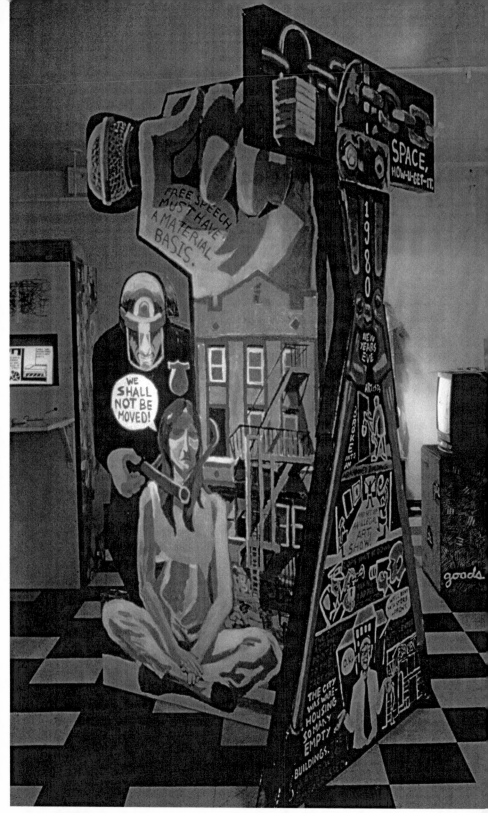

TEN

DISTANCES

Late in 2009, the Lower East Side squat art gallery Bullet Space produced a 25-year survey exhibition called "The Perfect Crime." Bullet is Andrew Castrucci's project. He is as at once curator of the gallery, artist and squatter. He showed photographs, drawings, paintings, sculpture, and objects of utility, posters and texts. In the handout, exhibition curator Carlo McCormick wrote that it was "an aesthetic rendering of the criminality that lurks in all our imaginations, the trophies of what we got away with and the relics of what we do to get by. It is an imperfect crime.... The artifacts from the settling of this squat speak to the forbidden crafts of crime."

If so, it was crime as work, and that work as art. The poet Michael Carter wrote of the objects in the show that, while "these works point back to a personalized legacy of involvement with Bullet Space, they are often also a somewhat coy attempt to see that legacy as an already aestheticized experience, brim with art-historical tropes or in-jokes." To be sure, Castrucci's presentation of these tools was highly aestheticized. They were often made by hand, for example, to

take water from the city. Tools of the building trade were turned not
to trade, but to the requirements of living, made and used by people
who know how to make and fix buildings but use that knowledge to
make provision for themselves and their community.

In the same publication, the poet John Farris recalled "a flight of
small birds [he] recently witnessed training for what I realized was
migration and the avoidance of predators whose imperative was speed
and precision of flight." He compared this to "how the anarchist re-
jects the dictates of the indifferent state and other authority in favor of
groups formed of voluntary cooperation among individuals, the act of
evasion expressed in these unions from which an art is produced from
alienation and close community, managing to maneuver for survival."

These nuanced considerations of the relation of art and squatting
found no resonance in New York's wider art world. Art writers, cura-
tors and cultural managers in New York have long looked away from
squats and squat culture.[1] Castrucci told me before he opened the
"Perfect Crime" that he pulled everything out to show the director
of an important university archive of downtown New York culture.
The director never showed up; nor did he come to the show Castrucci
decided to mount.[2]

1 The New York City artworld's aversion to politics is deep-rooted and long-lasting.
 U.S. institutions rely on private donors, and only more recently on state funds
 highly sensitive to political manipulation. The institutional and market struggles
 to forward modernist forms of art-making in the early 20th century succeeded at
 the cost of neutering their significance. The most recent clear example of this is
 the historic compromise achieved in the 1950s between institutional advocates
 of modernism (especially in the Museum of Modern Art) and liberal political
 forces (e.g., the U.S. CIA) that allowed what Irving Sandler called the "triumph of
 American art" to be achieved globally. Even as European artists and intellectuals
 took positions in support of liberation movements during the 1960s and '70s,
 prominent U.S. artists in the main stood back out of a sense of self-preserva-
 tion. This situation has really never changed. Lucy Lippard was disparaged in the
 1980s as overly shrill for writing about art in support of movements protesting
 U.S.-supported rightwing repressions in Latin America. (See Lippard, "Too Po-
 litical? Forget It," in *Art Matters: How the Culture Wars Changed America*, Brian
 Wallis et al., eds., New York University Press, 1999.) Given this common historic
 allergy in the center of global capital, it is unsurprising that art related to direct
 action movements remains unexhibited, unstudied and largely unsupported.

2 New York University's Bobst Library has two public access collections, the Fales
 and the Tamiment. The Fales collection has recently concentrated on the postwar
 cultural history of lower Manhattan, while the Tamiment collection is dedicated
 to labor history. Both are indispensable research resources for understanding sub-
 cultural and political history in New York City.

Bullet Space had two moments in the sun of broader regard, first as a contributor of substantial aesthetic content to Martha Rosler's 1987-89 show project around the issues of housing and homelessness, "If You Lived Here," [Wallis, 1991] and again in a basement show of artists' collectives at the New Museum curated by Gregory Sholette in 1998.[3] In 2009, the e-flux group was circulating Martha Rosler's archive of that important show of 20 years before, called "If You Lived Here Still." This included many boxes of yellowed newspaper clippings, her preparatory materials, but next to nothing of Bullet Space or the many groups she had recruited to fill the large exhibition. "If You Lived Here" was a veritable exposition of activist artists and political projects, but on-going projects like Bullet Space, the Mad Housers group of guerrilla architects, and Picture the Homeless, among many others that participated have not seen any re-emergence within the circuits of the art world.[4]

During that same eventful year, Martha Rosler was also regularly publishing extended articles on the role artists play in the creative city. The conception of a creative city was and remains a key metaphor guiding the neoliberal redevelopment of cities in the 21st century. As the archive traveled around Europe, Rosler spoke on the blighted promise of the creative city discourse for artists and the harsh realities of neoliberal city-making which the discourse conceals. Her ruminations in the e-flux journal were finally gathered into a small book [Rosler, 2013]. Okay. All very well, and normative practice. This work of criticism – ceaselessly valorized as "critical thinking" – has been a principal project of radical cultural thought for most of the 20th century. Yet to my mind, it is circular. Always we return to the seminar room for a long discussion. The radical direct action strategies and organizing which the "If You Lived Here" show began to reveal in 1989, and which during the intervening years had burgeoned into a wide array of movements, were not part of the 20-year comeback tour. The curator's memorial to her own significant historical project had been subordinated to the ends of a critical argument.

David Hammons is a senior African-American artist and artworld star who quietly supports Bullet Space, and the Lower East Side

3 Gregory Sholette's show in the basement of the New Museum was called "Urban Encounters" (1998). He asked artists' collectives of the day to comment on collectives of the past.

4 The curator's memorial to her own significant historical project had been subordinated to the ends of a critical argument.

space Tribes, the music, poetry and art apartment of Steve Cannon (this place closed in early 2014). It is traditional in art communities that the successful support the rest who struggle.[5] This hidden pattern underlies all aspects of the art system. Art institutions regularly rely on sales of editioned artworks by well-known artist friends as a key component of their operating budgets, in a kind of bureaucratization of traditional behavior. Hammons' ideas have played key roles in Castrucci's installation work, and Hammons exhibits his art in group shows at the squatter art gallery. The occasional spectral presence of a work by this global art star makes Bullet Space impossible to ignore completely.[6]

As I began to prepare the second issue of the *House Magic* zine, Scott Rigby invited me to Basekamp in Philadelphia to present the "House Magic" archive as part of their Plausible Art Worlds project. He had set up the Library of Radiant Optimism, a project of Brett

"Team Players for Plausible Artworlds" by Basekamp and friends, a series of nine weekly exploratory events for the Plausible Artworlds project, in the "Locally Localized Gravity" exhibition of artists' collectives at the ICA Philadelphia in 2007. (Photo courtesy of Basekamp)

Bloom and Bonnie Fortune, in a little alcove for their "book of the month club." Another artists' self-education project, the Philadelphia branch of The Public School franchise, had launched.

Basekamp was a large loft in the central downtown district, located only a few blocks from the historic city center. A major tourist magnet, Benjamin Franklin's house is nearby, and his visage and silhouette is everywhere. But it seemed as if a quarter of the stores and buildings were empty. Lovely 19th century constructions, some very fancy, were shuttered. Many had been disfigured with "modern" style storefronts, blank, cheap attempts to clean them up at the street level. The impression of dereliction, misuse and abandonment was strong. Coffeeshop proprietors look glum, their shops empty at midmorning. Somewhere rich people were hustling and bustling and spending their money, building new prosperity and electing politicians who promised to keep their money out of public hands. But in downtown Philadelphia, there was depression, many ragged poor and beggars. Maybe that's why space was cheap, and Philly was getting a reputation as a good place for artists to live. (Five years later, Basekamp moved out; the rent was raised.)

Since 1998, Basekamp had been producing exhibitions and work sessions there, and maintained a substantial online presence. The place opened with a series of performance installations designed to explore collective interactions. In the "Hegemonic Bar," for example, people who showed up were each given a certain amount of (play) money that they could use to buy drinks. But each person was given a different amount of money, which meant that when they visited the bars, they found themselves sorted into impromptu social classes for the evening.

Basekamp moved from artists acting as curators, managers of behavior, and "drifters" (they organized international *dérives* on the Situationist model), to hosting an international gathering of artists' collectives, a day-long retreat, to discuss their work and the collective process itself. Collective work in art and online networking became a focus of Basekamp's work. They were included in the "Locally Localized" show at the Philadelphia ICA, and they invited me to talk then. In 2010 Basekamp began a long series of regular online interviews with artists' collectives worldwide which they recently transcribed. The House Magic project is among them. [Basekamp, 2013]

While working there, I visited the Wooden Shoe, a longtime anarchist bookstore. Albo Jeavons, the manager of the place, had attended

Thomas Hirschorn working on *The Bridge*, Whitechapel Gallery, London, 2000. (Courtesy Whitechapel Gallery, Whitechapel Gallery Archive)

my talk, and spoke a little about the squatting movement in Philadelphia past. One of the leaders, Albo told us, was elected mayor! Then he sold out the movement. His brother was recently imprisoned for fraud. There are numerous squats in this city, Albo said, but since this was not a research trip I did not investigate. LAVA – the Lancaster Avenue Autonomous Zone – is an activist-owned place that runs many programs similar to those in social centers. It is described as a media center, and its occupants publish the Philadelphia anarchist newspaper *The Defenestrator*. The Wooden Shoe bookstore is an easy walk from Basekamp, but people there didn't know it. This disjunction between political spaces with their cultural programs and cultural spaces with their political programs is perfectly normal in the U.S. In Philadelphia, it seems, the crossover audience is minimal.

This separation between art and political systems was addressed by the Swiss artist Thomas Hirschhorn in his *Bridge* (2000) sculpture. Hirschhorn designed an impromptu ramshackle cardboard structure linking the café of the Whitechapel Gallery, a non-profit institutional exhibit space in London with the famous anarchist bookshop called Freedom Press. The Freedom bookshop, mentioned above, is within spitting distance of the gallery. It was part of a show called "Protest & Survive." [Whitechapel, 2000] Hirschhorn produced an artist's book about the *Bridge* project; it is an envelope stuffed with the correspondence between the gallery and the artist, a steady stream of objections

to the project. [Martin, et al., 2001] When the piece was mounted, the meaning was crystal clear. Julian Stallabrass wrote at the time that the work evidenced a lack of hope for the future. "How has it come about that the bridge [between art and politics], so robust as recently as the 1970s, is now so frail?" he asked. "The most salient reason is the decline in the belief in a universal alternative to liberal democracy and capitalism." [Stallabrass, 2000]

As in New York at ABC No Rio, I still had not shed the idea that everyone in Philadelphia was ready to jump in on the House Magic project. I blogged that the ideal "suitcase show" setup "would include a workstation with an online computer and a printer so that visitor/participants could download and print out their own researches and add them to the dossiers or start new ones. Each 'suitcase' show should build the whole, accreting the record of the many experiences of doing bottom-up, grassroots, disobedient, radiantly optimistic urban development using creativity and labor rather than capital. These stories are all remarkable and we need them badly." When I came to retrieve it, the "House Magic" archive was only dusty.

I drove down to Basekamp from New York with Matt Metzger, Carla Cubitt and Alan Smart to give a talk at the Wooden Shoe. Matt and his partner organized the Squatter Rights Archive collection at the Tamiment Library archive of labor history at New York University, the only repository of information about the New York City squatter movement of the 1980s and '90s in a public collection. Carla Cubitt is an artist, a maker of brilliant assemblage works, who lived in the Lower East Side squats in the 1990s. (She was featured in the 1994 "Inside/Outside" show at 13th Street.) Alan Smart was an architect then researching Provo in Amsterdam. We all stayed the night at Basekamp, courtesy of Scott Rigby. Still, no one from Basekamp came to our talk at the Wooden Shoe. Instead, the audience was almost entirely local political people with a polite interest in things remote from their city. In the front row sat a small group of "crusty punks," two pretty, dirty young women who stared at us fixedly and mutely, and one older man with dreadlocks who asked pointed questions about the tactics of squatting. At one point, a speaker said he thought there were thousands of squatters in Philadelphia, but there was no network, no organization at all. Traditional housing activist groups do not support them. (The Kensington Welfare Rights Union squatted a number of buildings for the poor in the 1980s; they achieved some

of their housing objectives, and then backed away from the tactic.)[7] There was, in effect, no movement – but in a city full of abandoned houses there was a lot of action! When the talk finished, I stepped outside while Matt smoked a cigarette. It was then I realized some dozen crusty punks were sitting with their dogs on the sidewalk outside. It looked to me like these were the shock troops of the new Philadelphia squatting movement, with the leaders inside gathering pointers.

7 The Kensington Welfare Rights Union was founded in Philadelphia in 1991 by Cheri Honkala. David Zucchino wrote about the movement in *Myth of the Welfare Queen* (1997). Honkala was the Green Party vice presidential candidate in the 2012 national elections.

Jim Costanzo making whiskey in an undisclosed location in upstate New York for the Aaron Burr Society, 2009. (Photo courtesy of Jim Costanzo)

ELEVEN
WHISKEY, PAPER AND POLICE

By the spring of 2010 I had finished the second issue of the *House Magic* catalogue zine, and I took some opportunities to display it. The first was where the project was born, at the one-time squatted cultural center ABC No Rio on New York's Lower East Side. The next was at the fourth New York Anarchist Book Fair at Judson Memorial Church in Washington Square.

At the ABC No Rio gallery for their building-wide "Ides of March" show, *House Magic* number two was mounted in a display rack in the zine library, along with photos and other zines about the squatting and

social center movement offered for sale. (The zine library at ABC No Rio does not sell anything, unlike 56A in London and others.) What I realized at ABC and later at the Anarchist Book Fair was that many people don't see online publications. Important texts about political squatting like the Canadian *Affinities* journal issue on social centers in Italy, the "Monster Institutions" issue of the online zine *Transversal*, and the UK compendium of social centres called *What's This Place* were not as well known as I felt they needed to be. So I made it my job to do a little distro. I downloaded these texts from the internet, photocopied and peddled them for sale at cost. But it got a little weird. The opening of the show was crowded with young artists and their friends. I sat with Jim Costanzo, a media and performance artist, dressed in 18th century costume. Jim had been involved in the RepoHistory sign collective in the 1990s. A longtime political artist, he had recently launched the "2nd Whiskey Rebellion" as a project of his Aaron Burr Society. He brought his still, and offered his home-brewed whiskey for sale – which act is technically a federal crime. Jim had done this brewing as an act of civil disobedience in commemoration of the original Whiskey Rebellion of 1791-94. His "Distillation of the American Spirit of Economic and Social Justice" was intended as a history lesson in the genesis of Wall Street power. Alexander Hamilton, a lifelong opponent of democracy whom Aaron Burr killed in a famous duel, set up the Federal Reserve system. Jim Costanzo's project was to valorize Hamilton's enemy, and thereby to question the system of financialized capitalism exemplified by Wall Street.

A year later, Jim Costanzo's Aaron Burr Society joined with Noah Fischer to produce "The Summer of Change, numismatic rituals for Wall Street," a series of distributions of coinage in the Wall Street area intended to "unlock reason & light in the fourth year of the Dire Global Recession." This sacrificial shower of coins of various denominations, identified by their political symbols, was an obliquely sarcastic reference to Obama's "change" slogan, and a direct rebuke to the masters of the epicenter of the global financial crisis. It also made classic avant-gardist references to the potlatch beloved by the Situationists, derived from Georges Bataille's notions of free expenditure of excess as fundamental to economic health. By the time of the final distribution – of 10,000 Lincoln pennies on September 22nd, 2011, with Noah wearing a Lincoln penny mask – Zucotti Park in the Wall Street area would be encamped by hundreds of Occupy Wall Street

demonstrators. Both Costanzo and Fischer would be closely involved in the Occupy movement, Fischer most prominently in the actions of the Occupy Museums group.

In the spring of 2010, however, the "2nd Whiskey Rebellion" enchanted me with its clever disobedience and its substantial historical antecedents. It wasn't speaking directly to the economy, but was, Jim wrote, about "local autonomy and the environment." I also dressed up, in remnants of the costume I had worn as an also-ran member of the Greene Dragon, a street theater group protesting the Republican convention in 2004. This group, convened in bars in the "colonial Williamsburg" neighborhood, adapted the name of a notorious patriots' drinking spot in Boston for a series of public actions styled in late 18th century dress and revolutionary rhetoric. During those days we drank in Fraunces Tavern after crossing on the ferry from Staten Island, crying "Down with King George and his ministers!" The ferry was accompanied by two U.S. Coast Guard launches sporting manned heavy caliber machine guns, and USCG comandoes wearing mirrored sunglasses and toting machine guns stalked the boat. For Jim's whiskey project, I made little cardboard coins using early colonial-era models. Visitors to the "Ides of March" show could buy these coins and use them to pay for shots of his watery "moonshine," thus circumventing at least one law against unlicensed sales of liquor. Agents of the Alcohol, Tobacco and Firearms agency of the U.S. government did not show up.

The ABC show was followed close on by the fourth annual New York Anarchist Book Fair at Judson Church, where the *House Magic* zines were cast upon a sea of radical publications, from tables full of published books to photo-copied zines sold literally in the stairway of the church. The Anarchist Book Fair is organized by old-time radical geeks, and draws anarchist travelers from across the northeast. They were crouched on the sidewalks outside the famous liberal church on Washington Square Park, dressed in their colorful shades of black. "House Magic" wallpaper, the same I had used in Chicago, went up in the hallways of the book fair. Afterwards it was rolled up and taken away to the offices of Picture the Homeless in Harlem.

Shortly before the Anarchist Book Fair began, on the eve of a film festival organized by the Independent Anarchist Media collective, the Brooklyn home of these radical media workers was raided. Police walked into the rented Thames Street residence – sometimes called

Opposite: The late squatter activist Brad Will, from the *Peops* series of portraits by Fly, 2001. As the artist draws, she also writes down some of the sitter's words. (Courtesy of Fly Orr)

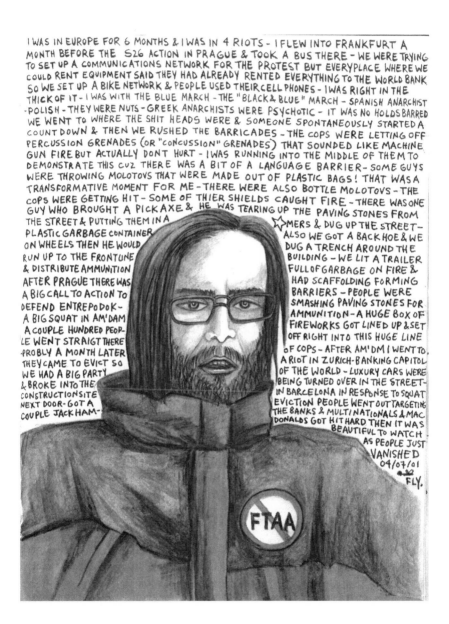

I WAS IN EUROPE FOR 6 MONTHS & I WAS IN 4 RIOTS - I FLEW INTO FRANKFURT A
MONTH BEFORE THE S26 ACTION IN PRAGUE & TOOK A BUS THERE - WE WERE TRYING
TO SET UP A COMMUNICATIONS NETWORK FOR THE PROTEST BUT EVERYPLACE WHERE WE
COULD RENT EQUIPMENT SAID THEY HAD ALREADY RENTED EVERYTHING TO THE WORLD BANK
SO WE SET UP A BIKE NETWORK & PEOPLE USED THEIR CELL PHONES - I WAS RIGHT IN THE
THICK OF IT - I WAS WITH THE BLUE MARCH - THE "BLACK & BLUE" MARCH - SPANISH ANARCHIST
- POLISH - THEY WERE NUTS - GREEK ANARCHISTS WERE PSYCHOTIC - IT WAS NO HOLDS BARRED
WE WENT TO WHERE THE SHIT HEADS WERE & SOMEONE SPONTANEOUSLY STARTED A
COUNT DOWN & THEN WE RUSHED THE BARRICADES - THE COPS WERE LETTING OFF
PERCUSSION GRENADES (OR "CONCUSSION" GRENADES) THAT SOUNDED LIKE MACHINE
GUN FIRE BUT ACTUALLY DONT HURT - I WAS RUNNING INTO THE MIDDLE OF THEM TO
DEMONSTRATE THIS CUZ THERE WAS A BIT OF A LANGUAGE BARRIER - SOME GUYS
WERE THROWING MOLOTOVS THAT WERE MADE OUT OF PLASTIC BAGS! THAT WAS A
TRANSFORMATIVE MOMENT FOR ME - THERE WERE ALSO BOTTLE MOLOTOVS - THE
COPS WERE GETTING HIT - SOME OF THIER SHIELDS CAUGHT FIRE - THERE WAS ONE
GUY WHO BROUGHT A PICK AXE & HE WAS TEARING UP THE PAVING STONES FROM
THE STREET & PUTTING THEM IN A

PLASTIC GARBAGE CONTAINER
ON WHEELS THEN HE WOULD
RUN UP TO THE FRONT LINE
& DISTRIBUTE AMMUNITION
AFTER PRAGUE THERE WAS
A BIG CALL TO ACTION TO
DEFEND ENTREPODOK -
A BIG SQUAT IN AM'DAM
A COUPLE HUNDRED PEOP-
LE WENT STRAIGHT THERE
PROBLY A MONTH LATER
THEY CAME TO EVICT SO
WE HAD A BIG PARTY
& BROKE INTO THE
CONSTRUCTION SITE
NEXT DOOR - GOT A
COUPLE JACK HAM-

☆MERS & DUG UP THE STREET -
ALSO WE GOT A BACK HOE & WE
DUG A TRENCH AROUND THE
BUILDING - WE LIT A TRAILER
FULL OF GARBAGE ON FIRE &
HAD SCAFFOLDING FORMING
BARRIERS - PEOPLE WERE
SMASHING PAVING STONES FOR
AMMUNITION - A HUGE BOX OF
FIREWORKS GOT LINED UP & SET
OFF RIGHT INTO THIS HUGE LINE
OF COPS - AFTER AM'DM I WENT TO
A RIOT IN ZURICH - BANKING CAPITOL
OF THE WORLD - LUXURY CARS WERE
BEING TURNED OVER IN THE STREET -
IN BARCELONA IN RESPONSE TO SQUAT
EVICTION PEOPLE WENT OUT TARGETING
THE BANKS & MULTINATIONALS & MAC
DONALDS GOT HIT HARD THEN IT WAS
BEAUTIFUL TO WATCH
AS PEOPLE JUST
VANISHED
04/07/01
FLY.

FTAA

Surreal Estate – without a warrant, their probable cause being that
the door of the place was open, and they thought it was a squat. IDs
were checked, and a couple of people were arrested; the next morning
judges dismissed all charges. The two arrested reported that they had
been questioned about the film festival.

At the time I thought this was ridiculous, and an instance of Key-
stone Kops bumbling. A fashion blog, *Animal New York*, agreed,
headlining "Anarchist Film Fest Gets Free Promo from NYPD."
[Galperina, 2010] But it's not. This kind of harassment is a fact of life
for radical left movements. The U.S. anarchist movement, in all its
immaturity and inexperience, is a plum target for organized bureau-
cratic sadism that goes by the name of counter-intelligence.

While I don't usually address it in my reports, it is important to
note how the shadow of police surveillance has been and contin-
ues to be cast over resistant movements of all kinds with deep and
long-lasting affective consequences. Undercover police also regularly
intervene in demonstrations and movement events as provocateurs,
often to legitimize attacks and applications of force by line officers
in the eyes of conveniently present television cameras. Informants,
who are often key participants in the movements they betray, are
a constant presence both real and suspected. How do activists ne-
gotiate the climate of fear and suspicion that undercover police ac-
tivities generate? This constant problem for activists is all too often
managed through paranoia, accusation, calumny and internal strife
–perfect outcomes for the police.

Provocation by police and controversial anarchist groups them-
selves have played a role in violence related to Anarchist Book Fairs in
New York in recent years. Pressure by New York police, both through
surveillance, infiltration, and provocation, has clearly grown since an
ex-CIA officer took over the intelligence division, and earlier restric-
tions on covert action were lifted. [Dwyer, 2005; Apuzzo and Gold-
man, 2013]

The activist Warcry (Priya Reddy), who started the Anarchist Film
Festival in 2007, is well known for her work organizing demonstra-
tions in different cities against international corporate-state meetings
in the anti-globalization or global justice movement. She began resist-
ant activism in the late '90s doing forest defense in Oregon with Earth
First! Her comrades doing tree sits were Brad Will and Jeff Luers.
Will, a bold Lower East Side squatter in the '90s, [Democracy Now,

2006] was shot dead in 2006 by Mexican government irregulars while video reporting on a teachers' strike in Oaxaca. Luers was jailed in 2000 for his role in radical environmental arson attacks. Reddy started the film festival in commemoration of Brad Will. ["Warcry," 2013] It featured videotape of demonstrations and confrontations with police from around the world, a lot of what some call "demo porn." In a workshop, Brandon Jourdan presented footage from the California student movement occupations. Jourdan has since gone on to make short, pungent on-the-ground documentaries about major demonstrations in the Eurozone.

At the time police roughed up the occupants of the Thames Street collective house in Brooklyn, the rumor was that federal officers were involved. This is far from unlikely. The radical environmental movement had already been penetrated and many of its activists indicted. [Potter, 2013] The idea that military forces are not involved in domestic policing is a popular myth. Since 2003, federal forces have been able to be involved in response to "domestic terrorist incidents" and "unexpected civil disturbances." All this activity is coordinated by the U.S. Attorney General and the Department of Homeland Security. [Brinkerhoff, 2009] This power would soon be brought to bear against the Occupy Wall Street movement, which was suppressed in a national campaign coordinated by the FBI together with national banks in early 2012. [Wolf, 2012]

Contemporary anarchism is a highly literate self-educating culture. Book fairs are but one of the ways this culture is expressed, and they are key nodes in the international anarchist movement. They take place annually in cities around the world. The one in New York is relatively new, and has regularly included an art show, usually a performance festival, and a film screening series. Unlike social centers, which may be primarily oriented to cultural activities, anarchist book fairs concentrate on political information and education. The book fairs are rendezvous for writers, publishers and activists who travel the circuit. They regularly feature meeting sessions and workshops, discussions of pressing questions and sharing of skills. These sessions, like much of the material on publishers' tables, often make links with, anarchist movements of the past. I heard an aged veteran of the international brigades of the Spanish Civil War speak in New York at one of these. He had been recruited in Paris as a teen, and was full of energy and unbowed idealism as he told of his experiences.

One of the older anarchist book fairs, held in London, began in 1983. By the first decade of the 2000s anarchist book fairs had spread around the world. How did this form of sharing information develop? What relation does it have to the infoshop, a common feature of anarchist communities in the 1990s? These centers for meeting and sharing informational material were once numerous in the U.S., although now they are more rare. Many anarchist collectives concluded by the turn of the century that the infoshop was an excessive expenditure of movement labor and cash (for rent). [San Filippo, 2003] Infoshops, as well as libraries and archives, are frequently maintained in European social centers that don't pay rent. Some key examples include the Archiv der Sozialen Bewegungen (archive of social movements) in the Rote Flora of Hamburg; the Archivo Primo Moroni in Cox 18, Milan; and more recently, the Archivo 15M in ESLA Eko, Madrid.

Anarchist publishing is intertwined with zine-making culture, the self-published personal projects that predate the internet. This is a subculture, and there are fairs for these as well, called zine fests. U.S. zine production crested in the 1970s punk music scene, with another surge during the "Riot Grrrl" movement of the early 1990s. While numerous professional writers have emerged from the zine-making scene, zines "celebrate the everyperson in a world of celebrity." [Duncombe, 1997] In recent years librarians have been attracted to zines, and many institutions have started collections of this radically heterodox material. This interest, especially strong among younger librarians, stems from an institutional interest in attracting young adult users and the "traditionally underserved," an audience of working class, homeless, "shoestring travelers," and gender minorities. Also, zine-making itself provides an interesting participatory activity for libraries. Some librarians also recognize that the existence of infoshops is a response to the ignorance or deliberate exclusion of radical materials from public libraries. Their presence indicates "some degree of failure on the part of urban libraries." Library science students have teamed up with infoshops to catalogue and preserve their material, which can be at risk of loss. [Cure and Pagowsky, 2009]

Infoshop organizers and librarians – and of course these may be the same people – share the conservational impulse for printed information. Self-organized collections of radical material can often reflect an archeology of collections. The zine library at ABC No Rio, for example, is comprised of a number of collections. The core of it is from

a zine library in a squatted house in the Bronx that was evicted. The library of zines, books and journals at the Seomra Sprai social center in Dublin consists of a number of libraries which have been consolidated. This was evident from the different stamps on the books. The collection was in some disarray, and I was told when I visited in early 2013 that library students were planning to work on it.

Anarchist book fairs in the U.S. can be occasions when direct action is catalyzed, as happened in Asheville, North Carolina in 2011, when a building was briefly occupied as a social center, [Crimethinc, 2011] or more trivially, when a handful of riotous anarchists organized a Black Bloc-style attack on a Starbucks, as occurred in New York in 2012. More usually, the fairs are mass occasions for self-education and conviviality among idealistic misfits. At the Anarchist Book Fair of 2013 a group called Practical Anarchy did a workshop of militant research, asking participants to draw and talk about what attracted them to anarchy. The lead quote on their website: "I generally look at things differently. When I look at an abandoned building, I see a home, I see a squat. When I look at – take any object, anything, take a car – I imagine welding it into a stove; take a street and I imagine it being torn up into a garden. I'm a much more optimistic person as a result." [Practical Anarchy, 2013]

The Squatting Europe Kollective meeting at the London Action
Resource Center, 2009. (Photo by Elisabeth Lorenzi)

TWELVE
A CONSPIRACY IN
LONDON

Working on tactics of resistance – squatting and
occupation – during a revolutionary era is like surfing
a historical wave. Being part of it is more than being
part of an art movement. There was a sense of rush-
ing towards some unknown destination, a feeling that
many people I knew were all working on the same
kinds of things, and moving in the same direction.
This was the sense I had in New York, in Chicago and
Baltimore, in the U.S.A. during the years leading up
to the start of the House Magic project. Gradually,
the old parameters of artistic practice seemed to fall
away. The way to make art was enlarging in new ways.
It was a movement of artists and thinkers who were
working on political and social questions using ideas
and techniques from political theory, activism, com-
munity art, theater and performance art – altogether
an emerging set of usages which was coming to be
called social practice. It was also the (re)emergence of
a serious engaged political art, a strengthening of ex-
isting currents, with groups of people working collec-
tively to spotlight issues, embarrass the powerful, and

inspirit the oppressed. Artists weren't doing this by themselves. They were expressing popular feeling, if only among a minority, and working with pre-existing and emergent forms of activist organization. What institutions would not allow, what they would not or could not permit inside their walls, artists were doing outside them, generating thereby a constant homeostatic pressure back onto the institutions. It felt like a slow motion revolution, a necessary social evolution that artists were contributing to designing and modeling.

I was going regularly to Madrid and seeing well-functioning social centers up close. But I had no real idea how they worked, their internal conflicts, their triumphs and losses. It was like a postcard view, exciting but distanced. Squatting is a deeply rooted long-lived popular movement in Spain. Miguel Martínez is one of the principal students of this movement. He is a sociology professor who was working then with a group at a social center called Malaya. The group, *Okupa tu tambien* (squat it yourself), was researching the history of squatting in Madrid. Miguel had published a book on the history of squatting in Spain. [Martínez, 2002] My first meeting with him was brief. I told him of my project, and he immediately agreed to give me materials for the "House Magic" show in New York, and to share his trove of photographs of demonstrations and the assemblies that run Spanish social centers for publication in *House Magic* #1. As well, Miguel had recently convened a group of academics studying squatting called SqEK for Squatting Europe Kollective. They had already held two meetings, the first in Madrid, and the next in Milan. I was invited to attend the London meeting in the summer of 2010. The time coincided with the U.S. Social Forum in Detroit. I had to make a choice.

Many of my friends were going to Detroit. That city is grand, magnificent in its ravishment, a city of powerful nightmares and fragile dreams. I had interviewed for a job there some years before, and marveled at its art museum and public library. I visited Tyree Guyton's extraordinary Heidelberg Project of painted abandoned houses and yards. I saw a show about the IWW at the Walter Reuther Library at Wayne State University which seemed like a harbinger. (That's the International Workers of the World, or Wobblies, an anarchist union; Reuther ran the United Automobile Workers, the UAW.)

Detroit is the largest, most extreme example of the bankrupt rustbelt post-industrial shrinking city. Its democracy is over; governance is in the hands of managers. But its radical communist culture

is by no means extinct. The projects that have emerged in the ruins of its housing districts and public institutions by artists and activists have a global resonance.[1] Although I did not go to the USSF then, I think what happened in Detroit in 2010 was important, at the very least for politicized cultural practice in the U.S. Among the many who were there: Brian Holmes, Claire Pentecost and others from the Midwest Radical Cultural Corridor project; artists of the *World War 3 Illustrated* graphic magazine; the Justseeds political graphics cooperative; radical historian Chris Carlsson; analyst Cindy Milstein; as well as Ayreen Anastas and Rene Gabri from 16 Beaver Group. Rebel Diaz collective and many musicians showed up. The anarchist contingent from Baltimore came, the same who had organized the City from Below conference, and Dan Tucker of Area Chicago blogged the event. An open exhibition, "Another Detroit's Been Happening!," on the radical history of the city was mounted at the Trumbullplex social center.

Did this presage the sudden, remarkable U.S. resistance movement of 2011, the Occupy Wall Street campaign? I can't say. Neither the Madrid encampment of the 15th of May (15M) nor the New York OWS surprised me. It seemed natural, normal, a continuation of what everyone I knew was already doing. If you assume that what activist people are doing will have a larger effect, will be amplified, even within the generation of those who are the principal proponents, then the big waves are not surprises.

The London meeting of SqEK was held in a tiny building called LARC, the London Action Resource Center. A wealthy benefactor had purchased this former church for use by left wing groups, and the SqEK contingent had it for a few days to hold their conference. Most of the researchers were sleeping there as well as holding sessions. I greeted these numerous folks from different European countries, introduced myself, and settled in with my computer to take notes. The researchers had not yet made the clear decision to open their meetings to the public, nor had they sought to include squatters themselves as presenters or direct collaborators on the academic work they were doing. Even so, Edward – a squatter, zine-maker and analyst who would play an important role in SqEK – came up from Brighton, a few of my comrades from previous visits showed up to the conference – Kirsten

1 In her *Culture Class* (Sternberg Press, 2013), Martha Rosler notes the continuous presence of international artists, particularly Dutch, learning from the situations they encountered in the deindustrialized, crumbling city of Detroit.

Forkert and Peter Conlin, Stevphen Shukaitis – but mostly SqEK's London conference seemed to take place in a bubble.

The LARC building is, in the words of their website, "collectively owned for the use of direct action groups working on projects for radical social change." The project was conceived by a group active in the direct action struggles of the late '90s, the anti-roads activism which contested plans to expand the highway system through old growth forests and ancient towns, and the spectacular actions of Reclaim the Streets and the Carnival against Capitalism. They wanted a safe meeting place – squatting was becoming increasingly difficult (now it is illegal) – and a central location that could bring together a movement dispersed throughout greater London. [LARC, 2002]

I stayed with Peter and Kirsten in Deptford – rents in the center are high – and so experienced that dispersion firsthand, with a long daily commute to the conference. Somehow the papers presented, either formally or informally, at the London SqEK didn't seem so important. What mattered most was the tenor of the interaction, the easy exchange between practicing academics, students and activists. Rancor was absent – although Miguel regularly insisted on critique, and camaraderie was the order of the day. While organizational meetings asserted a modicum of discipline, planning for the anthology books and such, the baggage of academic conferences was refreshingly absent.

The internal meeting of the group was like a faculty meeting in a dreamy insurrectionary university, and also an introduction to the European academic landscape. The SQEKers discussed funding for research – which is available in Europe. Hans Pruijt took on the administrative burden of writing proposals. Hans teaches in Rotterdam, and has written one of the best general articles on European squatting. [Pruijt, 2004] He was involved in the Dutch squatting movement from 1977 to 1984, difficult years of struggle both with the police and within the movement. He told me he had almost lost his eye to a beating by police. Now he has fully embraced his role as an engaged academic, speaking to the press, lobbying the legislature, even advising the police. (On which, more below.) As an expert on databases, Hans tried to sharpen definitions throughout the first day's discussions.

A fair amount of time was given over to the subject of research grants. Eliseo Fucolti advocated for self-funded research, which he said is the norm in Rome. A series of events or a big concert, for

example by Jello Biafra, can raise hundreds or thousands of euros. To me this talk of official support was quaint. Research funding for this topic in the U.S. I imagined to be non-existent. (I may be wrong, as I learned later, or the situation has changed. Some attention by urbanists has recently been focussed on the "informal settlements" or encampments of homeless people in the U.S. and migrants in Europe, although not on squatting per se, and not on anything like a squatting movement, which is what SqEK formed to investigate and support.)

As social scientists, the SQEKers were very concerned with data in its aggregated, systematically collated and presented form. This isn't my thing, to be sure, but the discussion of how to configure data-bases of squatting activity over time quickly turned very interesting. For instance, there are very different experiences of political squatting within one country. This is obvious, but complicates the question of a database that tends to blend different experiences into one set of num-bers and a homogenized cartography. For example, Elisabeth Lorenzi pointed out that squats in the Basque country have a better success rate than in other parts of Spain, and they have set up many youth houses. (We would later meet Basque squatters in Berlin, living in the house we stayed in when we had our meeting there.) Those in Barcelo-na and Madrid are more regularly evicted and hence more ephemeral. Even within Spain, then, there is great variation.

Eliseo described Rome as a lively scene, unique in Italy, with more than 25 collectives running social centers. [Mudu, 2013] He was working with CSOA – (for Centro Sociale Occupato Autogestito) – Forte Prenestino, a huge center in a former military base, and planned on starting a "geography laboratory" there. Eliseo showed his plan for a database of Roman squats and pointed out some of the great com-plexity of the project. Squatted houses in that city change seasonally as to whether they are used for housing or as a social center. So to call it a social center is about the time frame. If it is less than three months, it is not a social center. "This is my arbitrary choice," he said. "I am more interested in permanence – PAZs not TAZs." (The reference was to the well-known book by Hakim Bey, *TAZ,* for "temporary auton-omous zone." [Bey, 1991]) Hans suggested, "We also must record the outcomes. Were the squats abandoned?, evicted?, legalized?" "If you do all the squats," Eliseo replied, "you have thousands of records. It's out of control. I wanted to do 100%, but really I can only do 15%, and only in Rome."

"A database is not a neutral construction," he continued. The anarchists in Rome will never give information for a database. Many people believe that the more invisible they are the more powerful they are. For example, the social centers in the Leninist network – nobody who is not a Leninist knows that these exist. We can't write something that will make trouble for social centers. For example, a map of houses squatted by immigrants was used by the police to evict them. "You must specify your role. There is a need of self-reflection. Many who do this study still think they are neutral observers."

Miguel put up the SqEK manifesto on the screen, and asked who wanted to work in which areas? Of course I signed up for culture – "Squatters as producers of knowledge and cultural innovators (alternative media, etc.)." Then, as with any group, we talked about the next meeting, planned for the fall of 2010 in Berlin or Hamburg. This was also when I first heard of the "house projects" going on in Germany. We would stay in one of them during our Berlin meeting, organized by Baptiste Colin, a French historian then living in Berlin.

I will not give an account of this or any other entire meeting of SqEK. (My rough minutes of several meetings, edited by Miguel, are posted on the SqEK website). It is enough to say that the London meeting was a flood of new information for me, and a rushing tumble of new comrades For the first time, I began to see this as an integrated European movement with a dynamic and flow all its own. Researchers came from all over Europe. Many would come to subsequent SqEK meetings and become familiar faces. Lynn Owens came from Vermont; I had met him in Baltimore the year before when he joined me for a talk at the City from Below conference. In London, Lynn gave a subtle description of factors which built the squatting movement, particularly the mobility of participants, including the "revolutionary tourism" of U.S. participants in the European squatting movement. Gianni Piazza came from Sicily; he was working on the factors of success in squatted social centers and reoccupations. Ask Katzeff came from Copenhagen where he was teaching alongside Nils Norman, the artist who had welcomed "House Magic" into his show in Queens. Other researchers we did not see again, although they have continued in their work to engage the subject of squatting.

The importance of this meeting for me was in the sudden growth of a community of engaged and activist scholars, and the warm feeling of solidarity that animated this and every subsequent meeting of

SqEK. One afternoon, we picknicked like students on the grass of a nearby park. The streets of London were deserted as England lost in the World Cup soccer finals. Later we visited the recently squatted Foundry, a bicycle messengers' bar I had visited years before with Stevphen. Pub time then had seen a crowd of dozens of road warrior bicyclists gabbling on the concrete apron out front. Banksy had painted a design in the alley behind the bar. Now the place had been vacated for redevelopment. We walked amongst the disheveled squatters sprawled on the decaying furniture. Our solidarity visit had come across the last party at the Foundry. Afterwards we posed for a group photo out front.

Later, at Kirsten and Peter's house, as I sipped a beer called "Fursty Ferret" made in Dorset, I enthused in an email that this small group seemed to be cutting new ground in thinking seriously about squatting and the social movement of political squatting. "Nothing like what they are doing has been done before," I guessed. Already SqEK was planning to convene in New York in 2012, and I was looking forward to helping organize that meeting.

THIRTEEN
THE OLD TOBACCO FACTORY

At the foot of Embajadores street where it runs into the roundabout a massive block-wide building stands. It was begun in the late 1600s to make playing cards and snuff for the Spanish royal court, and continued to grow over centuries as the central processing plant for the state's monopoly of tobacco. The building was closed in 2000 after the tobacco trade was privatized. Today, it is a well-preserved example of an 18th century factory building in central Madrid, with heavy stone walls, broad passages and cavernous cellars. The building retains a special place in the history and imagination of the Lavapiés

workers' district. A large female workforce labored in the factory, which included a nursery for childcare and a big cafeteria. *Las cigarreras* were a well-organized and often rebellious workforce, well-known for their feisty image.

The empty building was turned over to the Ministry of Culture. Plans were noised for a museum of decorative arts, or of cinema – but when the financial crisis hit, Spain's manic campaign of museum building came to a halt. Already in 2004, local activists had begun to push the question of public use of the Tabacalera building as a social center, with a public discussion convened at the Círculo de Bellas Artes, the venerable arts club.[1] The discussion was largely instigated by squatters from the feminist squat La Karakola, and the thrice-evicted Laboratorio project.[2] In crisis-wracked Spain, in the waning months of the socialist federal government, they pulled it off. A persistent and dedicated group of activists inked a temporary contract to use part of the building as a social center. [Ibáñez, 2014]

I heard about Tabacalera when I arrived back in Madrid in July of 2010, and visited as soon as I could. I wandered through the immense decrepit halls of this new project in disbelief. It seemed like an emerging cultural utopia, teeming with people and humming with activities. Dozens of projects, ateliers, theaters, and studios had been launched. Tabacalera is only a few blocks from La Casa Encendida, a large cultural center funded by a bank. Casa Encendida has a fine exhibition series, film screenings, and workshops for young people, etc., but of course it is run hierarchically. Tabacalera was different. It was to be a "CSA," a self-organized social center – but not a CSOA, not an "okupa," since they had a government contract for short-term use. The administrative functions were to be discharged in assembly, a regular open meeting, just as in a social center, a form of horizontal rather than vertical administration. Symbolically, the assembly met in the former office of the factory boss. All activities would fall under "copyleft"

1 "Fábrica de Tabacos (Madrid)," Wikipedia (es.wikipedia.org); and the reference, "La Tabacalera a debate," at: http://latabacalera.net/web2004/ (accessed October, 2013).

2 The last of these, Laboratorio 3, is celebrated in a 2007 video, *Laboratorio 3: ocupando el vacío* (64 min.; Kinowo producciones, 2007), and recalled in the photo book with text inserts edited by Julien Charlon [Charlon, 2003]. The video is at https://vimeo.com/37888018; a DVD with English subtitles is distributed by the Traficantes de Sueños bookstore, which is near by Tabacalera.

common license; they would be collaborative and cooperative, and ecologically sustainable.

The Tabacalera project was the outcome of determined community organizing, yes, but it was also the product of a substantial institutional and intellectual effort by a loosely linked set of groups, including a cabal of Spanish academics called Universidad Nómada, the city-study project Observatorio Metropolitano, a multi-disciplinary group which published a fat book on Madrid as a global city, and, improbably, the Museo Nacional Centro de Arte Reina Sofía, the principal modern and contemporary museum in Spain. Finally, it was this institutional support that swung the hammer. It was part of museum director Manuel Borja-Villel and his allies' project of "new institutionality." [*Carta*, 2011; Ribalta, 2010] But there is a worm in the apple: Tabacalera also has a built-in expiration date with each successive contract they sign with the state. And, ultimately, as SqEK researcher Thomas Aguilera discovered, the state plans for it to wind down and disappear. [Aguilera, 2012]

I had no idea about this background in 2010. During those first visits I savored the bustling creative atmosphere, teeming with interaction, with a continually changing scenography of painted walls and materials in motion. The building sported a banner with a strange device – two dogs, a flute and the motto "*quien la propone se la come*" ("the one who proposes eats"). The dogs and flute refer to the epithet *perroflauta*, denoting the multivarious urban tribe of punks, hippies, anarchists, and squatters with low hygienic standards. [Frikipedia "Perroflauta"] Even then the banner was already scrawled with the graffito "*vendidas*" (sell outs), indicating that some did not accept this line of action.

This question often makes for a split in squatter movements. Many fear that a legitimated space means the other "bad" *okupas*, those who refuse to negotiate an agreement with the state, will more easily become targets for eviction. The question of negotiation for legitimation was extensively discussed at the SqEK conference in London after Miguel Martínez' presentation. [Martínez, 2013b]

After this first visit, I returned for a dance that concluded the third annual festival of resistance, "Crítica Urbana," produced by the *okupa* CSOA Patio Maravillas. Artists working there gave me a tour of Tabacalera. We met up with Eli Lorenzi, a SqEK member I had first met in London, at the brightly-painted hut which is the bicycle workshop in

the patio behind the building. Access to the patio then was through a wooden spiral staircase, really a hole in the floor behind a cabinet, in a room that housed historical relics of the old tobacco factory. A sign read: "*No tocar las cosas historicas*" (don't touch the historical things). Down the rabbit hole, and we were in the patio. Eli told us that a number of people who had been active in the CSOA Laboratorio – 1, 2 and 3 – were central to the assembly at Tabacalera. They had long wanted this neighborhood center in Lavapies, the multi-cultural district where many of them lived.

We met a Czech actress who talked with us about her "job of doing theater for free." Tabacalera is dedicated to free culture as a foundational principle. The actress was a curious person, smiling, very sweet. I noticed she was standing with one foot in a large green plastic tub.

After a drink at the crowded bar, we descended into the basement, where years ago tobacco leaves were stored. There I was introduced to Ciril, who was central to the Taller Urbana, a group of street artists. The studio had a big table with many people around it, talking, drawing, drinking – and in the first bay of the basement warehouse a sort of ad hoc exhibition area for the products emerging from their work. Ciril said he'd worked at the famous Berlin squat and art center Tacheles, in the '90s, during the glory days after *die Wende* (the turn) of '89, when the Wall came down. Many vacant properties near it in the former city center of the east were up for grabs, and the Berlin squatter movement seized the day. Ciril thought the scene in Spain was sluggish, so he went to Berlin and stayed for four years. Now, he said, after the Barcelona squat scene has been more or less crushed, he thought Madrid is where it's at.

In the big main hall where the concert was underway, a couple of boys from the Patio Maravillas crew were beside the stage, bouncing to the music. Of course it was too loud to talk. Later in the hallway I met Luis, who has good English, and I asked him about the antagonism represented by the "vendidas!" graffiti on the banner outside. Luis said that despite the criticism, many of the other *okupas* were already seeing how useful Tabacalera could be for the movement. The fact that the Patio Maravillas party was drawing a crowd of many hundreds shelling out three euros each could mean a lot for that place. I recalled the confidence Eliseo Fucolti expressed in London about raising money for a publication through a concert at the massive Roman CSOA Forte Pretestino. "Once with Manu Chao, and we have

it." Although free culture and "copyleft" are ideals in practice, there was already disagreement about what role money should play in the new CSA.

Luis was optimistic. The movement in Madrid, he said, is more open and less fractionated than it is in Barcelona. It was this cooperation among many people of many ages and points of view that had made something like the Tabacalera possible. Of course, when money appears, many open hands appear also. Another artist told me that the state has begun making noises about the group in Tabacalera paying rent. Of course, were they to budget their project, with all the in-kind work, the sweat equity that all the volunteers provide cleaning, repairing and administering the space, the calculation should end up with the state owing them for providing such extraordinary services on such a large scale! Just as Leoncavallo in Milan began in 1979 to provide volunteer social service, so the Tabacalera CSA then stood ready to become the primary artist-run cultural center for a city that has never had one.

In the summer of 2010, in the heyday of its beginnings the place was, as one artist said, "boiling." Even then, it was an open question how long would it run, and how it would be managed, with many already expressing doubts and worries. There were already many disagreements to be worked out in the assembly, frictions between the political activists and artists. I was enchanted with the place. When Hans Haacke came to work on his MNCARS exhibition, "Castillos en el aire" ("Castles in the air"), I was happy to bring him and Gregory Sholette for a visit. I was looking forward to working with Tabacalera, arranging exchanges with my political artist friends in the United States. The institutionalization of a horizontally managed politicized cultural space in the city I was living in seemed like a dream to me. It was a central part of the goals of my House Magic project, to naturalize and broaden the influence of the squatter movement to provide a genuine populist cultural provision in the city. Here it was, happening at last. At the time, Tabacalera seemed to me a real anarchist urban development, a clear instance of "the city from below."

That was three years ago now, an age in *okupa* time. The national government has changed from socialist to conservative. While I have not made a follow-up investigation, the rumor is that the Tabacalera project at this writing is in trouble, with strong internal critiques mounted from various sides. In late 2011, leaders in the Templo Afro,

a basement workshop that serves primarily African immigrants, delivered a caustic bill of particulars charging a cabal of leaders in the assembly with favoritism, and an unfair suspension of the Templo's activities.[3] Then, before the Rodea el Congreso ("Surround the congress") demonstrations in September of 2012 (29S), organizers of 29S were arrested during a meeting in the Retiro Park. Their fallback meeting place, the anarchist center CSOA Casablanca, was evicted by special judicial order, and throughout these weeks Tabacalera was inexplicably closed. The withdrawal of the center during a period of strong political conflict made clear its limited utility for radical political movements in Madrid.

My initial hopes of working with the place proved groundless. I went to one assembly, which was intensely conflictive. Shortly thereafter, Tabacalera closed for "reorganization" for weeks on end. Thereafter, whenever I passed by it always seemed to be closed. Its website was inaccurate. After I began to work with another center, I gradually lost touch with Tabacalera.

Although Tabacalera continues to host diverse and interesting activities, the center is much less active than before. The contrast with the bustle of the earlier years is clear and painful. Many of the Tabacalera project blogs have not been updated in years. Many I speak with at other centers express irritation with the place and its managers, although these critiques are voiced vaguely, and never spelled out. The CSA's government 'twin,' the north part of the building, which was always the larger space, is gradually taking on definition as an exhibition space. Even as the self-organized part of Tabacalera opened its doors for the first time, this area was being used for a show of photographs. They were hung from steel wires above the rubble-strewn floor. Today, shows of photographs and installations by well-known artists are mounted there. With each successive exhibition, the space has been cleaned up a little more and made more like a normal museum. Naturally it is nearly always empty of visitors, peopled mainly by guards. In mainstream media, the name "Tabacalera" means only this part, not the social center. Soon, it seems, the whole of Tabacalera may be just another boring cultural mausoleum.

3 The issue is the relation between social centers and immigrants. Tabacalera cannot perform like a political social center; Seco is, and continues to do so. On the other hand, the walls of Seco are bare, clear evidence of their disinterest in art.

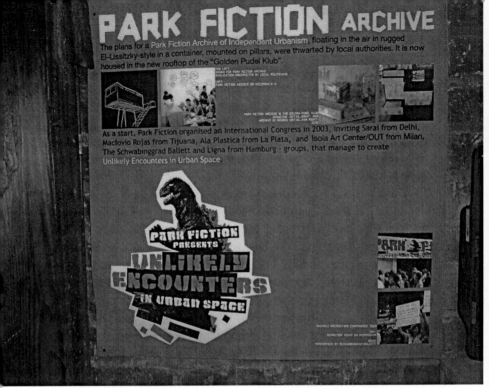

The Park Fiction display panel in the Creative Time "Living as Form" exhibition in New York City, 2011. (Photo by the author)

FOURTEEN
HAMBURG

Hamburg was famous in the 1980s for its crusty,[1] resistant squatting scene. It was war from the first. After the violent eviction of a squatted collective house on Ekhofstraße in 1973, some of the

1 This time, "crusty" doesn't mean an unwashed traveler punk. "Crusty" and "fluffy" denote differing positions in demonstrations in movement lingo. "Keeping it fluffy" means no one is looking to be arrested. Crusty demonstrators are willing to battle with police, and do audacious things like "unarrest" demonstrators taken by cops (and, in the citation below, jumping onto a policeman's horse). The usage may derive from the UK. (See "Protest without arrest," at HTTP://ACTIONAWE.ORG/ PROTEST-WITHOUT-ARREST/. Both terms are used in this text of reminiscence, "Anti Criminal Justice Marches, London 1994," at: HTTP://WWW.URBAN75.ORG/PHOTOS/PROTEST/CJB.HTML.)

residents went to jail; others took up the gun and joined the RAF. The squatting movement was born out of this initial repression. Now 40 years on, the pitched street battles have come to an end, and the wildly painted houses have been legalized and fixed up. [*Wir wollen,* 2013] But the popular resistance to the urban manipulations of wealthy rulers is a proud Hamburg tradition that has taken on new forms in the 21st century.

I met a group of Hamburg artists in New York, and they invited me to stay at the Künstlerhaus Frise in the summer of 2010. That's a former school of hairdressing converted into artists' studios. We had links already, since the Frise hosted ABC No Rio artists in the past – in 1990, with the traveling "10 Years," and more recently with a fancy wig show. Michel Chevalier, our guest at the "House Magic" show, had told us about Hamburg's rich self-organized art scene with its many artists' collectives and exhibition spaces called "off." He invited me to talk about my book at the space he ran, Unlimited Liability. And so, after experiencing the intensity of Tabacalera's beginnings in Madrid, I bounced through Berlin to Hamburg, and rested that night on the floor of a quiet studio of a vacationing artist from the Frise. The next day, my host Sabine Mohr showed me more of the city, including the new Gängeviertel occupation in the center.

That first day we had a drink on a terrace of the former school of nautical studies, the Seefahrt Schule, a historic Bauhaus building overlooking the Elbe River. The school had been vacant for 10 years, and some artists had been allowed to open a small café hosting exhibitions there. Upon walking into this modernist classic what struck me was the extraordinary flow of air through the building. It came from the terrace above the river, and rolled through the rooms, freshening the interior on a very hot day. The school was slated to be torn down to make way for a high-rise luxury apartment building, and there was talk of occupying it to forestall its destruction.

We walked along the Elbe riverfront facing the ceaselessly busy, fully containerized port that occupies the opposite bank. Sabine pointed out a trendy bar that had been a squat only a year or so before. Many giant luxury buildings have been built along the waterfront, as if in a wall. (Some call it the "pearl necklace.") Despite these monsters, the walkway along the water remains technically accessible to the public. We walked purposively amongst close-set tables filled with diners at one point.

Then, in the middle of this expensive density, Park Fiction came into view. This oddball park is designed with multiple gently curved raised lawns to resemble flying carpets, and tall metal palm trees, and it is full of people, chatting, drinking, and strumming guitars. This was supposed to be another luxury high-rise. The park in St. Pauli neighborhood is the outcome of a 15-year struggle to reclaim public space from the top-down development plans of the Hamburg city government.[2] Park Fiction was a participatory planning exercise led by artists. They organized the process as a game, and collected an "archive of desires" from amongst the squatters and working class inhabitants of the Haffenstraße who were being pushed out as a result of gentrification. Once the group was invited to present at the prestigious art fair Documenta XI in 2002, the city started to deal with them more seriously. The final outcome was the city's withdrawal of plans for another giant high-rise, and today the popular development called Park Fiction is there instead.[3] Next to the park is the Golden Pudel Klub, the original squatter's bar with a lively art and music scene, a club doing a booming business. When I visited, the Park Fictioneers were very active with a new anti-gentrification campaign called "Es Regnet Kaviar" ("It's raining caviar").

We met Michel at a bar on Hafenstraße, the harbor street where Autonomen squatters battled with police to defend their squats in the '80s and '90s. I drank a beer with a man who told me he could never enter the U.S. because of his political activities then. We walked on to the Rote Flora (red flower), which since 1989 remains a resistant occupied social center in a prolonged and complex standoff with the city. It is housed in an antique theater, spectacularly grimy and festooned with banners, the focus point of an area thronged with young folks, restaurants and nightlife. The crumbling building houses an improbably clean and well-maintained archive, the Archiv der Sozialen Bewegungen (the archive of social movements). When we arrived at

2 Peter Birke says that in developing the St. Pauli/Hafenstraße district, Hamburg followed the model of the Docklands development in London (1981-1998). [Birke, 2010] The Docklands mega-development of today was contested in the 1980s by politicized artists in a billboard campaign that became an early model of artists' resistance to gentrification. The project in turn inspired the PAD/D group in New York in their "Not For Sale" campaign on the Lower East Side. [Sholette, 2011]

3 Christoph Schäfer showed me around during this visit. Two parts of the Park Fiction project were never completed: the fountain monument to the Pirate Queen, and the on-site archive of documents showing the struggle it had taken to get the park built. [Czenki, 1999; Kester, 2004]

the Rote Flora, a big bass disco was in progress, but we were shown inside to the ink-smeared silkscreen atelier in the back where the clever monthly schedules of the Rote Flora are produced to be posted on the street. (Some of these were in the "House Magic" exhibition at ABC No Rio.) During the winter, the silkscreen workshop is the warmest room in the place, so the bands sit there between shows.

The next day, Sabine took me by the vast abandoned department store that was slated to become an Ikea store, an outlet of the Swedish furniture giant. Artists occupied this remarkable building, located in the Frise's neighborhood of Altona, but they were evicted after a little more than a year. The project – called Frappant – is fondly remembered and regularly recalled by Hamburg artists as an exemplary episode in their self-organization.

We ended up in the Gängeviertel, squatted in 2009. It is a Viertel, or quarter, a cluster of late 19th century buildings crouching amidst the giant skyscrapers of the city center. It is a survivor of wartime bombing, and a remnant of the swath of working class housing that used to stretch from the harbor deep into the city. A large group of artists turned it into a thriving warren of studios, ateliers, and apartments. Then they announced they were squatting it. The very beginning of this squat was exciting. Some of the artists who maintained studios in the decaying buildings put up an exhibition in which every work was anonymous. They invited the whole of Hamburg to the opening, then came back themselves into the space as visitors in the midst of the big party, and squatted it. It was a neat trope expressing collective intention within a distanced anonymity. The city, which normally sends police to evict squatters within 48 hours, negotiated with the artists. To the surprise of many, the artists ended up with a long-term contract and paid renovations.

Michel took me to a lunch with his friends at a storefront called the Druckerei (printing plant). This was the more politicized group within the Gängeviertel complex. A man named Til told me of the process of developing and managing Gängeviertel. The organizers of the squat, who were meeting for months beforehand, were well-connected to people in government and higher circles in the arts. They involved others through an open network. Til got a phone call asking if he wanted to participate. He became one of the troops, which then became the management. There had already been conflicts. Not all the buildings in the Gängeviertel complex belonged to the same package sold to the Dutch investors, and later bought back by the city.

Some people wanted to squat a building outside that group. Organizers did not want that to happen, so they barricaded the building and sat inside it to resist the intended internal squat. As the project has developed, Til said, there has arisen the age-old problem of who gives and who takes, advantages reaped by some in the Gängeviertel at the expense of others. Til pointed to the table at which we were sitting. It may look like a Volksküchen (a people's kitchen, open food event), he said, "but if you look at people's plates, you can see what they want to put in and what they take out."

The institutionalization of the Gängeviertel squat was a change of course for Hamburg's rulers. The gentrification processes in Hamburg have not been subtle. After lunch, Michel and I walked through an adjacent neighborhood, the Karolinenviertel: neat, quiet, expensive. This had been a thriving countercultural quarter, he said, with a strong left organising. To persuade people to leave the area, the city began moving many rough people and drug addicts into public apartments there, and an epidemic of crime ensued. The backbone of the left organizations, older people with children, left, and the area was cleared for an upgrade. Michel pointed out the prophylactic paintings on the walls, commissioned works of simpering skateboarders etc., intended to suppress tags. The idea is that people will not tag over another's murals. I saw the same kind of banal paintings in gentrified districts of Berlin.

We ended up at the Vorwerk Stiftung, a former squat, and a charming old building. NYC squatter, musician and artist Peter Missing of the Missing Foundation punk band used to live there – we saw his tag on the walls. Now it is an international artists' residence house. There is a communal kitchen in the place, and it still retains much of the ethos of a collective house. We talked with the artists leading a rent strike there, after the new governors shifted terms on them, interfering with their affairs more and more. Next door is a playground that at one time was the Bamboola, a Bauwagenplatz, or parking place for house trailers, in fact, a mobile living community. The mayor had evicted it.

An article by academic urbanists comparing recent protests against gentrification and unilateral cultural management in Berlin and Hamburg sketches the history of German urban social movements [Novy and Colomb, 2013]. The authors call these "USMs," the unit of their analysis; it is also the analytic frame that informs the work of most SqEK participants. Much of the program of the activists of the '70s and '80s they say was absorbed into the shifting German political

landscape, especially with the emergence of the Green Party. The artist Joseph Beuys was among its founders in the 1980s, at the conference where its four principles were spelled out: social justice, "ecological wisdom," grassroots democracy, and nonviolence. [Wikipedia, "Alliance '90/The Greens"] The new movement contesting the city elites in Hamburg and Berlin includes many of the so-called "creative class," identified by the popular urban consultant Richard Florida as the motor of urban growth in the information age.

Novy and Colomb cite David Harvey's contention that in addition to political activists, politicized segments of the community of cultural producers might offer a new resistance to the pressure, coming from capital and the state, to displace poorer residents of large cities. [Harvey, 2012] Florida's ideas and recommendations to encourage creative people to remain in the city played an important part in the development of urban policy in Hamburg. But that part of the development was done on the cheap. The big money went to trophy projects like an opera house, an urban "lighthouse" project budgeted at a half a billion euros, and politically controversial ones like a military museum. Further, the city's cultural institutions and funding agencies have exerted continuous pressure to manage Hamburg's artists who were doing fine by themselves.

The urbanists express reservations about the new heterogeneous movement they describe. While their squatting action and subsequent legalization of the Gängeviertel occupation was news all over Germany, Novy and Colomb note that the artists were criticized by "observers from the radical left and 'autonomous' scene." Were they only a self-interested group, looking for cheap studio and living space? Noting that many in the new movement come from privileged classes and groups, the authors claim that what protest movements "need to be judged upon is their commitment to build and expand solidarities and collective actions with other social groups and actors." Evidence that this may be happening is the formation of a Right to the City alliance in Hamburg, which has been driving anti-gentrification protest and education events. As I write this, Park Fiction has been renamed Gezi Park Fiction in solidarity with recent protests in Istanbul, Turkey. A group of African political refugees – named the Lampedusa group after the Italian boat tragedy – are being housed in the nearby church as a campaign is waged to prevent their deportation. The kind of solidarities that political analysts are calling for are clearly developing.

The contest waged by Hamburg's artists against the cultural ma-
nipulations by the government of this wealthy city is complex, with
many layers of activity by many groups and people, some of whom
at one point or another may be working for the government or some
institution. State funding of culture plays an important role in ac-
tion on every level, even supporting events at the very resistant Rote
Flora occupied social center. A 2010 article in *Der Spiegel* cited by
Novy and Colomb, spells out the recent reshuffling of traditional
political positions. Times have changed, writes the pop music histo-
rian Philipp Oehmke: "Nowadays, squatters look like management
consultants, and vice-versa. Conservative newspapers print manifes-
tos from the leftist subculture, while a guru from Toronto [Richard
Florida] quotes Marx to deflect suspicions that he is providing rec-
ipes for gentrification. The city's negotiator talks about artists as if
they were his children, while the city unofficially aligns itself with
the squatters. Its former ally, a financial investor of the kind that
cities would previously never have turned away, has now become the
enemy." [Oehmke, 2010]

The high profile Hamburg residents who penned an anti-Florida
manifesto, organized the conferences for Right to the City and the
successful negotiations for the Gängeviertel are only the top layer,
if you will, of the critical artistic community in Hamburg. The city
is full of initiatives by lesser-known players. I had a taste of some of
these when I was there and Michel was in the thick of many of them.

During the 2000s, anger rose among Hamburg's artists as state
funds previously available for independent cultural projects in the city
were redirected to serve master plans for urban development. Ham-
burg artists developed an extensive and pointed critique of these plans,
in projects like *Journal for Northeast Issues* (2002). This magazine put
"the dominant developments of living spaces – of cities, neighbor-
hoods, streets, and buildings – up for debate in the arts." [Puffert, et
al., 2006] Following on, The Thing Hamburg was run for a few years
(2006-2009) as a critical platform for artists and writers.[4] The state
funded fees for texts, but in 2009 they pulled the plug.

4 The Thing was an online platform for networking and internet art started in New
 York City in 1991 by the Stuttgart-born media artist Wolfgang Staehle. Wolfgang
 was also a collaborator with the New York artists' group Colab, producing public
 access cable TV and exhibiting at ABC No Rio. The Thing sprouted branches
 globally, including in Hamburg. When I told him I had met some people with
 Thing Hamburg, Wolfgang, with his characteristic sarcasm, said they were rogue.

During those years, things were getting worse for artists in Hamburg. Many decamped for Berlin. Starting in 2008, the city funded an international exhibition of socially engaged artists and collectives called "Subvision." It sounded good, except that the elaborate show sucked up all the funding previously used by the local project of artists' initiatives called Wir Sind Wo Anders ("We are somewhere else"). Moreover, it was to take place in the newly developed, luxury Hafencity district. The three-year Wir Sind Wo Anders initiative involved 22 Hamburg artist-run groups and spaces, including a number of politically engaged groups, and culminated in a 2007 festival of the artistic projects which in Hamburg are called "off."

"The issue is recuperation," said Christoph Schäfer. (He was speaking at a discussion with invited Subvision artist Dimitry Vilensky[5] from St. Petersburg that took place in 2010 at the Gängeviertel.) Funding now is channeled, Schäfer said, as "art is instrumentalized to support urban development in Hamburg. Other funding has been starved."[6] As the Subvision show was being put together, a blistering critique appeared on the website of Wir Sind Wo Anders. The extensively footnoted text documented the charge that Subvision was generously funded while independent initiatives were being starved. The text attacked the Subvision curator for the changes he had made while directing the Hamburg Art School (HfbK, or Hochschule fur

5 Dmitri Vilensky, a philosopher, is a member of the Russian group Chto Delat. For the Subvision festival they published a broadside entitled "Another Commons." The group was then working on a project called *Activist Club*, which referenced Rodchenko's 1925 workers' club. It has a clear relation to occupied social centers, which Vilensky referenced in another text of 2009, "Activist Club or On the Concept of Cultural Houses, Social Centers & Museums." [Vilensky, 2009] It was shown in Madrid in the 2014 "Playgrounds" exhibition, with several documents of artists working in solidarity with squatters.

6 These conversations appear in edited form on YouTube as "1-Gaengeviertel versus Subvision Part 1 of 3." The quote is from Christoph Schäfer's introduction. All the visiting international artists of Subvision were invited to the talk, but few came. They were all very busy, of course, but, as Vladan Jeremic from Belgrade observed, "maybe they don't have this [same kind of] fight at home, nothing to change." In Belgrade, Jeremic said, "I am also involved in struggle with the city government. This is why this fight is touching us so much." The Hamburg politicized artists' network is evident in the credits on the video. They note that the idea for the meeting was Christine Ebeling's. She is a central organizer at Gängeviertel. The video was shot by Margrit Czenki and friend; Czenki also made the film, *Park Fiction: Desires will leave the house and take to the streets* (1999). The talk was produced in 2009 by Feuerloscher TV, an online video platform that has consistently documented the political art and squat scene with well-produced short videos.

bildende Kunst). "Under his tenure the once 'experimental' school has steadily drifted back to traditional media and commodity-production, in a no-black-sheep atmosphere that fosters individual scurrying for posts, prizes, awards, stipends, funding and favors." The text scored other principals in Hamburg art institutions for their commitments to "sensuousness" and "beauty now" over what was disparaged as "prim concept-art." In contrast, the authors insist, artist-run exhibition and work spaces "take a position in urban discourse, and present art as a non-instrumentalized field of experimentation in the spirit of social innovation." These self-organized ventures provide a "third pillar" of artistic production in an integrated system, and work parallel to galleries and museums that establish market values and determine representative works. [Wir Sind Wo Anders, 2009]

I was deeply impressed by the sheer bulk of the vacated Frappant building, which was covered on all sides with posters and painted murals. This gargantuan old department store was exciting in its form, but now it was empty. Artists had occupied it, turning it into a warren inside of galleries, shops, theaters and meeting rooms, with many public projects at street level. To me that short-lived occupation represented the contrast between an artistic culture of production and a capitalist culture of consumption. In a blog post, I compared the Frappant to the Grand Bazaar in Istanbul, a dense commercial structure built up over centuries with a special kind of organization: The bazaar itself, the labyrinth of small shops, is surrounded by a network of workshops where artisans make many of the things that are sold there. [Khansari, 1993] This was how Frappant was organized, with shops, ateliers, and living quarters. It is fundamentally different from – and in Frappant, articulated in opposition to – the dominant forms of capitalist consumer culture of large shopping centers with multinational chain stores that erase small stores and street level artisans in a given district.

The building was still plastered with inventive posters poking fun at Ikea, the corporate overlord who was slated to build on the Frappant site. One project there had been a café bar developed in the vein of social practice art. The Blinzelbar was described by its organizers as an "art space in the redevelopment area of Altona-Altstadt with projects against social and cultural displacement, against waiting without prospects – for investors and creative managers." They presented "tangible utopia projects," concerts, films, installations and performances

and "incident-related communications." The interior of Blinzelbar was designed by a collective. It had modern-looking furniture built from chunks of walls inside the squatted building, and a densely patterned optical floor intended to invite people in, and blur the distinction between inside and outside. [Blinzelbar, 2009]

I gave a talk about my book in Michel's tiny packed-out Autonopop space. Michel had been talking to Thomas Beck, a musician working at Rote Flora about doing a show there. The Rote Flora was trying to firm up their art world connections to improve their bargaining position with the city in upcoming negotiations. I told Michel I would help him cook something up. I was determined to return. Hamburg was just too interesting.

Students in a window of the occupied Wheeler Hall, University of California, Berkeley, 2009. (From the publication *After the Fall: Communiqués from Occupied California*, 2010)]

FIFTEEN
BAD STUDENTS

It is hard work to squat a building, wheth-er for living or to organize a social center. It is laborious to open, secure, and clean it up, rig it with power and water, organize a crew to run the programs, and organize defense for when repressions take place. All this is normally undertaken by energized young people who revel in the technologies of resistance: attitudes, camaraderie, and the many tasks that maintaining a free space require.

During the first decade of the 21st century, mass movements of young people – students in universities and secondary schools – sprang up around the world. These were localized responses to government initiatives cutting school budgets, regularizing curricula, imposing more stringent testing, and raising fees. These student movements, while they were often short-lived, were regularly marked by intense confrontations with authorities. They were also jumping-off points for further activism, connecting to other movements, particularly during the global financial crisis starting in 2008.

Radical students have a proud history of occupations. The tactic has been used continuously in student revolts. The year 2008 saw the 40th anniversary of the global wave of student protest of 1968, and many conferences and publications reflected on that past. Student movements then were closely linked to other protests, especially against the brutal war in Vietnam. In January of that watershed year, the North began the Tet Offensive in Vietnam, at one point occupying the U.S. embassy. In response, U.S. forces destroyed the historic capital city of Hue. The U.S. mission took over from the French in Indochina; their forces only left in 1962. French students had no difficulty understanding this direct succession of empires. The student demonstrations from the universities and high schools which began in Paris in February to protest overcrowding and poor conditions were flavored by solidarity with the anti-imperialist struggles of the Vietnamese. By March the suburban mega-campus of Nanterre University had been occupied, and the radio station taken over. Professors were involved in the actions there, including a number who became famous in years to come. The influential Situationist pamphlet "De la misère en milieu étudiant" ("On the poverty of student life: a consideration of its economic, political, sexual, psychological and notably intellectual aspects and of a few ways to cure it") was published by the Strasbourg University student union in 1966. Situationists and Surrealists both played roles in the subsequent events of May in Paris, in particular the radical student Comité d'Occupation de la Sorbonne.

As the French situation developed, students in New York took over Columbia University in April, an occupation brought on by plans to construct a gymnasium that would displace poor tenants in the neighborhood. While in France the tactic of occupation came from industrial unions, it had also been used extensively during the 1960s U.S. Civil Rights movement as a protest against *de jure* racism. It would continue in U.S. colleges as students of color organized during the 1970s to demand ethnic studies programs in their schools. At Columbia, different groups controlled different buildings while, for a brief moment, the venerable university was reconfigured as a different set of faculties.

By the summer of 1968, a series of student assemblies in Mexico City had demanded reform of the huge Universidad Nacional Autónoma de México, UNAM. The protests expanded,[1] challenging

1 Elena Poniatowska's *Massacre in Mexico* (University of Missouri, 1975) was compiled soon after from contemporary interviews. Álvaro Vázquez Mantecón writes that the 1968 student movement in Mexico was the forerunner of many of the

"a one-party state, a muzzled media and judiciary, and an oppressive security apparatus." In October, on the verge of hosting the prestigious Olympic Games in the capital city, government forces attacked a mass demonstration in the plaza of Tlatelolco in the capital city. It is likely that hundreds were killed, although the matter was never investigated. [*Economist,* 2008]

Such radical manifestations of student movements during the revolutionary year of 1968 affected the lives of thousands, and had a lasting impact on social movements, political thought, and culture in general. Student-led protests and occupations continued strong after 1968. Artists were a little slower to jump on the bandwagon, but fully determined when they did so. The occupation of the Hornsey School of Art in north London was long and well-publicized, and inspired similar actions around the country.[2] In early 1969, the Art Workers Coalition convened in New York City. [Moore, 2011] Both New York and London saw the near simultaneous founding of free alternative universities. The revolutionary surge of 1968 led to a decade of radical social experiment that included prominent squatting occupations in many European cities. Whole neighborhoods, true urban autonomous zones, were squatted in the high tides of the movement.

As the left was celebrating the 40th anniversary of the onset of radical social creativity, a new campaign of educational restructuring was

artists' groups that emerged between 1977 and 1982 (Mantecón, "Los Grupos: A Reconsideration," in Olivier Debroise, ed., *La Era de la Discrepancia /The Age of Discrepancies: Art and Visual Culture in Mexico: 1968-1997,* Universidad Nacional Autónoma de México/Turner, 2006). As this book goes to design, Mexico is undergoing another great wave of protest, over the state-sponsored murder of dozens of rural student teachers, the "normalistas."

2 The Hornsey College occupations grew out of a one-day "teach-in." The occupation spread to other art and design colleges in England. The authorities at Hornsey fled, and the school was run by students and staff around the clock. The action led to a nationwide discussion on educational reform and a first-ever government study on creative labor. When the self-organization ended, its traces were erased by local officials. "There's no vandal like an official vandal." Faculty participants were fired. Years later, one student recalled his surprise that such a disparate group could discuss and act together. Still, these were "art and design students, doers and makers rather than talkers.... That this phenomenon is extraordinary and deeply threatening to institutional establishments," wrote David Poston, "is a profound comment on our social organisation and the way in which it continues." (From Margaret Drabble, et al., "Journeys into the past," in *Tate Etc.,* issue 18, Spring 2010. The Hornsey files were given to the Tate museum in 2008.) At: HTTP://WWW.TATE.ORG.UK/CONTEXT-COMMENT/ARTICLES/JOURNEYS-PAST.

underway. The Bologna Process, intended to regulate and streamline university instruction and testing in the European Union, was being implemented. On top of this, the crisis era austerity programs of most governments included strong cuts to education. Political leaders were often openly hostile to those who opposed them. One writer quotes President Nicolas Sarkozy, who came to power in France saying in 2008, "My victory shows the death of May '68 and that legacy in France, and I will destroy it forever." [Meerding, n.d.]

The thinking that influenced the development of the student movement of the new century was produced in a very different intellectual environment. For one thing, it was void of the certainties promulgated by the state socialist bloc. Although these parties had impeded rather than aided the risings of '68, communist unions and party cadres struggled hard to co-opt the student movements, resulting in much alienation. Many of the philosophical sources informing 21st century activism were unrepentant French '68ers. The workerist theories of the Italian Autonomists, suppressed by their government in the later 1970s, also played a leading role.

The Edu-factory collective has been important for the student movements of the 21st century. They agitated and organized against the Bologna Process reforms through their online platforms, and as their name implies advanced an integrated analysis of the new and emerging conditions of knowledge production and capitalist accumulation around immaterial and precarious labor. [Edu-Factory collective, 2009] Autonomist thought was key in formulating a clear description of the emerging conditions of a super-fluid, digitally powered global marketplace for labor and a retrenched public sector that offered a bleak future to university graduates. Moreover, rising fees had driven many into debt, threatening a lifetime of unwilling servitude in precarious jobs far below their trained capacities.

Meanwhile in the U.S., the nomadic anonymous anarchists of the Crimethinc collective staked out a new revolutionary position. Committed to continous direct action against a total social enemy, they brought the tales of dumpster diving, boxcar jumping, squatting and joyful rioting told in scores of humble photo-copied zines to a broader audience. Crimethinc popularized a new kind of deterritorialized anarchist bohemianism for the '00s, which was not bound to any city or region.

In France, resistant theoretical work was carried out by the journal *Multitudes*, which revived the tradition of an unremittingly critical

left. An intransigent group around the journal *Tiqqun* carried on in the tradition of the Situationists. That work culminated in 2007 with the release of a long pamphlet *L'Insurrection qui vient* ("The coming insurrection"), by the evasively named, and rurally based Invisible Committee. This text, citing the 2005 revolt in the banlieues of Paris (and its international echoes) as evidence of the impasse of the present, and a future with no future, announced the end of the era of political representation. The Committee analyzed the decomposition of all social forms through a thorough critique of the affect of alienation, the "maintenance of the self" in a period of new forms of work when a growing majority "has become superfluous."

The Committee observes that the metropolis is a terrain of constant low-intensity conflict, where police and army now evolve "in parallel and in lock-step." In a sophisticated analysis, which moves beyond most anarchist writing, they observe the interests of "capital's reform program," the degrowth movement, in revalorizing the non-economic aspects of life. Capital, they claim, "hired our parents to destroy this world, now they'd like to put us to work rebuilding it... at a profit." Insurrection is a necessity, they write, urging the like-minded first to find each other, and attach themselves to what they feel to be true. Expect nothing from organizations, and beware of social milieus. "Form communes. Get organized in order to no longer have to work. Plunder, cultivate, fabricate. Create territories. Multiply zones of opacity. Travel. Open our own lines of communication." [Invisible, 2009] It is easy to see in this pamphlet a guiding text for a theory of permanent occupations.

In fact, it immediately influenced the students of the University of California confronted, with unprecedented fee hikes, whose protests became one of the largest student movements in the U.S. The Invisible Committee were themselves emulated in their theoretical ambitions by a Californian group which launched a website in 2009 with the slogan "Occupy everything, demand nothing." This online platform for "militant research, critical pedagogy, feminism, media interventions, dissent and prefigurative action" published "Communiqué from an Absent Future," a bleak assessment of the University of California. "No one knows what the university is for anymore.... Gone is the old project of creating a cultured and educated citizenry; gone, too, the special advantage the degree-holder once held on the job market. These are now fantasies, spectral residues that cling to

the poorly maintained halls." Their aims were the same as the Situationists in Nanterre: "We seek to push the university struggle to
its limits." [Communiqué, 2009] Occupation was declared a form in
and of itself.[3]

As these theoretical currents show, it makes sense to locate the
source of many of the ideas informing the student movements of the
new century in the radical reconfiguration of labor and government
in the digital era, and the concomitant response – often uncertain
and blundering – in the ambit of educational institutions. With disciplinary parameters and social requirements changing rapidly, and
the configuration of educational work itself (often styled as "content
delivery") in transition, universities have frequently become sites of
contestation between administrators and faculty. It has also become
clear to this generation of students that the burden of maintaining an
overgrown educational machine has been shifted to their backs in the
form of intolerable debt.

Stefano Harney and Fred Moten observe that the conflict between
university and state is embedded in the formation of the latter, as an
"onto- and auto-encyclopedic" project. The ambition of the university
to include all knowledge in development mirrors that of the state's
ambition to impose its worldview, constantly exceeding and localizing
the state. "It follows that to be either for the University or against it
presents problems." [Harney & Moten, 2013]

As these trends roll forward, student movements will continue to
take and hold both active and disused institutional spaces to resist,
organize, and press their demands. At the same time, cadres of young
intellectuals, forestalled by the prolonged economic crisis from the
opportunity to work sustainably in their trade of teaching and research, will need to somehow adapt to the drought of jobs.

Although no longer young when I undertook the trek, I also
marched through this desert. As I pursued a PhD degree in the '90s,
I taught art history as an adjunct in the New York City area, trying
for several years to adapt to the straitened conditions of teaching in
my discipline. As the years rolled by, I began to see that the opportunities were slight. I could not foreswear my research interests, and the
universities in which I was working offered scant support and scope

3 In 2012 at the Transmediale new media festival in Berlin, the keynote lecture
was Jodi Dean's, "Occupation as Political Form" – "a political form of the incompatibility between capitalism and the people." Posted with discussion at: HTTP://
OCCUPYEVERYTHING.ORG/2012/OCCUPATION-AS-POLITICAL-FORM/

to pursue them. Adjuncts are the workhorses of the U.S. academy. By some estimates, 70% of core subject teaching duties are performed by adjunct staff. Revisionism in this area is not appreciated; in fact, the trend is to automate "content delivery." In 1997, with the publication of the startlingly titled book *Will Teach for Food: Academic Labor in Crisis,* the corrupted nature of this situation was already made clear. [Nelson, ed., 1997] In New York, this model is sustainable only thanks to the constant parade of graduate students pouring out of multiple schools which can be ceaselessly milled for adjunct teachers (it starts as "experience"). In art programs nationwide, impecunious artists and writers in local communities fill these slots.

The conservatism of the academies and the imperative to learn together about rapidly changing conditions drove artists and other intellectuals in New York to begin in earnest to organize their own extra-mural learning assemblages. Having reached the limit of student culture in my degree program fairly fast, I joined enthusiastically in these ventures, participating in the programs of the 16 Beaver Group and The Public School.[4]

Following these projects led me to become aware of similar initiatives in northern Europe which took off in the middle 2000s, such as the Manoa Free University, the Free Floating Faculty, University of Openness, Informelle Universität in Gründung (informal university in foundation). One of the earliest was the Copenhagen Free University (2001-07). A number of these groups came together in Vienna for a month in 2005 in an exhibition called "W... WirWissen" ("We know") to explore "strategies and positions in collaborative knowledge production and emancipatory self-organization."[5] One of the found-

4 I wrote of this experience, and the emerging phenomenon of artists' self-education, in 2007 ("Academic Entrepreneurialism: Eggheads Outside the Crate"). The text was posted on two web-based publishing platforms that have since disappeared, which underscores a problem with both self-organized extra-institutional academic initiatives and nomadic "pirate" educational projects.

5 The show included the groups *Greenpepper Magazine* (Amsterdam), La Loko (Kopenhagen), Mana Mana (Budapest), Sefik Seki Tatlic (Sarajewo), Universite Pirate (Paris), Working on Fire (Bangkok), TvTv (Kopenhagen), die üblichen Chih Chie (Berlin), Meine Akademie (Berlin); Angefragt: VertreterInnen von Freiraum – Kritische Nicht Universität (Wien), K.u.u.g.e.l. (Innsbruck), Ladyspace (Wien), and Université Tangente (Paris). "W...WirWissen" Ausstellung archive page at WUK (Werkstätten und Kulturhaus) Vienna, 2005. At: HTTP:// WWW.WUK.AT/WUK/KUNST/KUNSTHALLE_EXNERGASSE/ARCHIV/SEARCHFOR/ WIR%20WISSEN.

ers of the Copenhagen Free University, Jakob Jakobsen, has gone on to explore autonomous learning initiatives of earlier times, like the short-lived London commune called the Antiuniversity.

Playing with pedagogy, its routines, its performances, and the whole theater of knowledge construction and reproduction has become an artistic genre. While most of this activity folds back into the art institutions, a good amount of extra-institutional self-education is carried out in squatted social centers. This tradition does not spring from art education, but is primarily directed at self-education among workers. In the Spanish radical tradition, *ateneos*, or atheneums for education and circulation of texts, were set up in the factories of the republic; many self-education programs in occupied social centers today take the name *ateneo*.

One of the things that attracted me to the social centers as a research object was the possibility of refuge that they seemed to offer, of a real place to escape to, where serious politically engaged intellectual and cultural work could be carried out. It seemed that dissatisfied intellectual cadres had moved into the squatted social centers, swelling the depth and quality of activities offered there. I wanted to join them.

The agitation and organizing against similar cuts and changes to the universities in England have led to sustained autonomous organizing. Italian autonomists have been popular there, and gave numerous lectures in London at museums and art schools. During the height of the anti-cuts activism in the schools a group called Really Free University was organizing a series of short-lived squats in London with a specifically educational focus. Professors and well-known intellectuals gave talks and held classes in these places. The tactic of moving into public space to hold classes was also used in Spain during protests against cuts to schools. All of this organizing of, and in, squatted and public spaces for educational purposes is a clear instance of moving outside the institutional confines which are intolerable, increasingly sclerotic and constrictive when they need to be ample and nimble.

The animator of a pirate university initiative in Barcelona appears in Dara Greenwald's videotape "Tactical Tourist" (2007) while he was working in the social center Miles de Viviendas ("Thousands of homes"). Traces of interesting-looking popular education programs appear on the websites of many Spanish squats. In Spanish *okupas*, intellectual leaders may have a strong influence. In Italy, the home of

the Edu-factory collective, autonomous squat-based complementary education projects have taken root.

In spring of 2008, the Berlusconi government enacted a series of stringent "reforms" – like a return to single teachers in primary grades (breaking up the teaching of separate subjects), compulsory uniforms, marks for behavior, and an overall reduction in funding and number of teachers. The cuts impacted precarious teachers and researchers at the universities most strongly. By October students were in the streets chanting the slogan, "We won't pay for your crisis." Professors joined student assemblies to discuss the global financial crisis. La Sapienza University in Rome was occupied, becoming a center of coordination and mass planning for students, parents, teachers, and school work-ers.[6] This surge of protests came to be called La Onda ("The wave"). "The Sapienza debates were clear and united," declares a text on the movement published in London. "The students and researchers are not defending the University as it is. They want *autoriforma*: self-re-form of the universities as written by themselves. The crucial theme of the debates was that any reform must come from below, from the students themselves." ["Anomalous Wave," 2008]

Prime Minister Silvio Berlusconi called the occupations violence, and threatened to use riot police to evict them. The activists of La Onda circulated pictures online of the exceptionally violent raid by Italian police on a school in 2001 where protestors were staying dur-ing the protests in Genoa against the Group of Eight (G8) meetings of international government leaders. This infamous incident was only then beginning to be investigated in Italy. "I am not scared" became their new slogan. La Onda used various tactics, including open-air classrooms with prominent lecturers, and blockades of public streets. The movement did not accept support from politicians, nor did it ally with unions. It was in this sense a true political avant-garde.

The most recent turns of the screw of austerity have led to some

6 This kind of combination of protestors is called transversal, after concepts first enunciated by Gilles Deleuze and Félix Guattari. Gerald Raunig, of the European Institute of Progressive Cultural Policy (EIPCP) in Vienna, uses the concept of transversality extensively in his book *Art and Revolution*. [Raunig, 2007] It is of-ten entwined with the question of class composition, i.e., how the post-industrial working class is constituted. How to understand the composition of a new revo-lutionary class has been a burning question in left theory. It can no longer be the factory-working proletariat of the industrial era, the epoch of the factories called Fordist. Class struggle must be understood on a new basis. The Italian answer was the precarious workers, *aka* the precariat.

lasting results as the precarious Italian 'immaterial laborers' put their energies to work building autonomous centers. Claudia Bernardi, who first became active during the G8 protests in Genoa in 2001, recently described the evolution of her collective in Rome. They decided early on to move beyond their political work within the university to stake a position outside it. Their analysis connected the ivory tower to the town around it. "The university is a productive space for students who are already workers inside it – they produce knowledge and cooperation that is not recognized." At the same time, students work outside the university. "So, there is a strict connection between these two spaces of production." This analysis reflects that of her Edu-factory group, which understands the school and the city as new factories with new kinds and intensities of labor. These are the sites where organizing must take place. [Bernardi, 2012]

Bernardi's collective started a project in an occupied warehouse close to the large Sapienza University [Counter-Cartography Collective, 2007] in a student district undergoing an aggressive gentrification process. The area was also home to immigrants and artists. They called the center ESC, for Eccedi Sottrai Crea (exceed, subtract, create). The idea behind the work of the ESC Atelier in Rome was to leverage resources of the institutions to which the teachers had access, and use them to serve autonomously determined needs. But at the same time they did not let go. People in ESC work with autonomous assemblies in the colleges of the university. "It was basically aimed to cross the border of the university, to share knowledge in an independent way, and at the same time, to contaminate the academy and their form of knowledge production."

The 7th Berlin Biennale of Art in 2012 produced an off-site project at ESC. It was transformed into a white, empty space, where people could draw or write on the walls. "We did a lesson of the Italian language school on the wall of ESC, using the images and drawings as a process of knowledge production," Bernardi said. The students, mostly migrant laborers, shared the project with their teachers who are students of the university, so that the "language itself became less of a border."

The project continued activities and discussions about immigration laws and migrants' work at ESC and in the university. These included free legal help at the ESC and a course of self-education about the post-colonial condition and borders where migrants themselves

are the researchers at the university. In 2010 they organized a "lesson of alien illegality" in front of the Parliament to protest against proposed new laws. Refugees from Afghanistan and illegal aliens did a public lesson about their condition in Italy.

Radical organizing in ESC was led mainly by PhD and undergraduate students, Bernardi said. The aim of ESC, to cross the border of the academy, is continually renewed by different people with various skills coming and going, debating and organizing. With university fees much higher than before, students must graduate quickly. So ESC is actually more stable from the point of view of circulation of people. ESC participates in "UniCommon. The revolt of living knowledge," a ten-city network that does annual self-education seminars around Italy. This work is necessary, because in the last two years, the changes to the education system have erased many issues and points of view. "Self-education and autonomous spaces are much more important now, to fight against the destruction of education and culture." In the last years several theaters and cinemas have been occupied across Italy.

Bernardi reflects on La Onda, the response to the restructuring of 2008. "The last movements in Italy, in particular in 2005 and 2008, were basically student movements claiming free education, autonomous spaces, welfare against precarity and a common self-reform of the university. The government attacked us heavily: we were called children, we were being told we were not capable of building up our own lives, not to be researchers, so, we had to migrate or, as the Minister of Welfare told us, 'you need to do manual work.' It's just the evidence of their intention to close the university as a space of knowledge production, to discipline and control students, as paradigmatic figure of the contemporary workforce, by building up new borders within the university, they aim to establish which are the preferable figures of labor: precarious, removable, passive and exploited."

SIXTEEN
BERLIN!

Only my second SqEK meeting and this was the bigtime. We were going to the city of squat legends. Anything-goes nightspots stuck into liberated territory – whole squatted streets of non-stop party people and crusty anarchists living free. Every apartment a commune, a grassroots socialist paradise grafted onto a welfare state. And no compromise. The original Black Bloc Autonomen – iron-fisted building defense, serious head-busting by riot police, car burning, and bank window smashing "retributive violence" for evictions. Ossie guards opening hidden doors in the Wall so the punks could slip into the east when the "bulls" got too close. [Ryan, 2006] Doors in the squats open for RAF members on the lam.

I knew that was all over. Squashed between two super powers, modern history provided the conditions to build the movement that entranced generations of libertarian socialists and anarchists by its strenuous resistance. The image of a post-Cold War open city, a beacon for bohemians and artists worldwide is likewise fading away. Now it's the capital city of Germany, and very busy putting on its stiff monkey suit and starched collar. Still, I was psyched. A bunch of us were going to stay as the guests of the Rote Insel squat in the Schöneberg neighborhood. We would live there together as a temporary scholarly commune. SqEK's meetings would take place at the New Yorck in Bethanien squatted social center in the Kreuzberg district. We would have house tours and neighborhood tours, hear many interesting papers, and meet Berlin squatters in a public speak-out.

The Rote Insel was a little tough to find. I came into Tegel airport late, and had to bunk in a hostel. In the morning I set out for Schöneberg, making every wrong turn possible. Out of the U-Bahn, I passed a new "bio-café" and co-working space with a sprinkling of nerds gulping coffee. Wrong turn. I walked back beneath the railway overpass with its discolored and rusty trestles torn into here and there with slugs from the war. Above me was a defiant graffiti, big letters done in housepaint – "We don't want a cake, we want the whole bakery!" Beneath the train tracks commercial billboards showed happy hipsters enjoying branded beers in Prenzlauer Berg, once a heavy squat scene.

In the end, the Rote Insel is hard to miss with its five-story high screaming murals. Martin, our host was waiting on the street, and let me into the big double apartment building. The walls inside were covered with graffiti, murals and radical posters. He explained that the door was an issue; they still feared unwelcome intruders like the police. Inside it's a real warren of units, tidy but rundown in a very German *deshabille*. The guest room is big, with mattresses for a dozen people in a loft above a room full of couches. With a poster high on the wall of masked street fighters defending the 1970s-era Milan social center Leoncavallo, the place feels like an anti-capitalist safe house. The walls bear the marks and messages, both militant and drunken, of many who have passed through. There's lots of Basque stuff at the top of the stairs, posters of dozens of prisoners from the nationalist movement that spawned the armed clandestine group ETA, and throughout are "antifa" (anti-nazi, anti-fascist) slogans and decor. The house logo is an AK-47 between two palm trees! Although they still go

to demonstrations, this kind of militance is in the past. All the really hardcore posters are yellowed and peeling. Martin, as he showed me around the house even seemed a little embarrassed by the house logo. I just wanted the t-shirt.

Over coffee, Martin lamented the decline of Berlin's squatting movement. Yorckstraße in the past had some 90 squats, and now almost none remain. With anemic squat defense, they have been picked off one by one. Today, Kreuzberg squatters grumble about the tourists with big sunglasses who photograph the remnants of oppo-culture. Their attention is denaturing the culture, turning it into spectacle.

I had arrived early, and after seeing the house, I joined the few guests already there, a guy from Istanbul and two from the Basque country. Gunejt, a resident from Istanbul, cooked a splendid meal on this first night, working from what seemed almost nothing. A trained photographer who worked archeological sites in Turkey, Gunejt is a sharp cookie and a sweetheart. Now he was cooking to get by in Berlin. He told me his brother lived in a community of *gecekondu* – "overnight houses" – in Turkey. These towns, he said, have the "craziest architecture you ever saw!" The overnight houses are traditional, and technically legal – if you build a house on unused land during one day's time, you can stay. In practice, the government often sends soldiers to evict them. "They do what they want," Gunejt said. The next day, the rest of the SqEK crew rolled in. Lynn Owens from Vermont, Edward from the Cowley Club in Brighton, Miguel Martinez and Elisabeth Lorenzi from Madrid, and Thomas Aguilera and Margot Verdier from Paris. Baptiste Colin, *aka* Tisba, a French historian who organized much of the conference, showed up and jawed with Martin. They had never met; all had been arranged through someone else. Good connections in the culture of resistance are fast and firm.

A few nights later Rote Insel held its regular VoKü (for Volks Küche or people's kitchen). Gunejt was making pizza. The café bar in the house is not open for business because of legal restrictions. It operates occasionally, as a private club, and holds benefits for different projects. The VoKüs, like most events at Berlin's squats, social centers and left venues are announced in the regular publication *Stressfaktor*, which is available online and in print as a monthly. Every left bookstore and many cafés and restaurants we visited had copies available.

On VoKü night several members of the Rote Insel told SqEK members the story of their house. First, Martin outlined for us events

in the recent movement of squatting in Berlin. The first wave of squatting in Berlin was during the '80s, in Kreuzberg. The second wave was in the '90s, after die Wende (the turn, or end of the communist eastern government) from 1989-92. This took place in the former eastern zone, in Prenzlauer Berg and Mitte. 1992 saw the riotous eviction of 13 squats on Mainzer Straße [Dawson, 2011; *Berlin – Mainzer Straße*, 1992; Feffer, 2013]. At that time, sexism was the issue dividing the movement, especially when a leading political man was accused of rape. Now the divide is over the Israel-Palestine issue, which emerged in the mid-1990s in the antifa (anti-fascist) movement as the "anti-Deutsch" position. This anti-nationalism has been called by some "ethno-masochist," and involves unconditional support for Israel. Now, the only consensus is to stand against evictions and repression. The current struggle is over the social center called the Köpi, currently under threat of eviction. The large centre is housed in a building at Köpenicker Straße 137, amid a rapidly gentrifying former industrial and warehouse area.

The campaign for all squats, called "Wir bleiben alle" ("We all stay") was strong for a couple of years, then it was dropped. I had seen the Umsonst Laden, the free store on Brunnenstraße during my earlier visit, bedecked with a four-story mural as part of this campaign. During this visit, I saw that the building had been gutted. Across the street, remnants of squat murals were still visible on a building under renovation, next to a new boutique hotel.

Movements in Berlin, Martin told us, are inclined to depend on personalities. The most lively movement in 2010, Martin said, was probably Media Spree, and there again a personality is up front. This campaign contested gentrification in Kreuzberg and Friedrichshain, as the land along the banks of the Spree River has been sold off, and a large media-related development project is in the works. That movement has itself split, with one side going with the Green party and the negotiating left, and the other holding to an Autonomist position and disturbing the process. Although classic divisions in the German left have weakened the movement, there remains consensus against evictions and gentrification and the expulsion of immigrant workers.

Martin, Mufflon, Kathia and Iratxe together continued the story of their house. The twin buildings of the Rote Insel were squatted in 1981. At that time, in West Berlin, there were 180 squats, mostly in Kreuzberg. Today the Rote Insel is one of the oldest "house projects"

in Berlin, a squat founded by activists with the specific intention of living together comunally. Kreuzberg and Friedrichshain, where most of the house projects were concentrated, are the most diverse districts in Berlin. In recent years their multicultural image and animated street life have attracted many new residents, driving the familiar urban pattern of gentrification and property speculation. This relentless economic pressure has shortened the lifespan of many house projects. In some of these former squats, individuals eventually acquired ownership, and have forgotten their previous relations with fellow activists who are now only neighbors.

In the past, the entire district of Schöneberg itself was called the "Rote Insel" for the radical workers living there, hence the name of the house. The house had many different people in what were really two separate buildings. The government had a program in the '80s to support squats with money. In 1984, the Insel was the last squatted house to make contact. The city became the owner, and gave them nine months to get a construction contract to make the improvements. "We were 20 young people with lots of problems, so it took a long time," and they went for a few years on one-year contracts. To get the permanent contract they had to have an official association, so they joined with a youth center nearby which had also begun as an occupation. (They still retain a project of car repair from those days.) Construction work has been continuous. For some time, they all lived in half of the building, 25 people sharing one small kitchen.

At the time, Berlin was a city-state inside the DDR (communist East Germany), and had lots of money to distribute. "With this money they could bring down the movement," calming it through legalization. In recent years, the Berlin city government began to sell the buildings to private owners to avoid the administrative costs of these earlier programs. This means a legalized former squat now may have a private owner who can reclaim the building when the contract expires.

The movement did not just accept the new municipal trend of privatization, but evolved legal strategies to deal with these processes. During the '80s a Besetzenrat (squatters' council) existed, but with the era of contracts the organization was broken. Now, we were told, there is a syndikat, or association, to help houses get legal help, and avoid moving into private ownership. A GmbH (limited liability company) buys 49% of the shares in a house. (Martin showed us a chart of how this works.) It is a decentralized structure of money that cannot be

broken if one house goes down. So there will never be an owner who can sell it.

The Rote Insel is self-managed, with an assembly that meets every two weeks (it's called a plenum). The rules of the house are: no violence, and you must do something for the house. That is not fixed: everyone determines what he or she is going to do. Some do more, some less, some nothing. Problems are resolved by talking and "social pressure. We have people here who have no working papers and can't pay rent. But they must stay in contact, and open up their problems to the house." They have in the past evicted people. The playground next door was a hotspot for drug dealing at the end of the 1980s, and they had some problems with heroin addiction. "We made a policy that addicts had to go out. No opiates. Anyone we see with small beady eyes – out."

In addition to the bar, there is a bicycle workshop where neighborhood kids can come and do their own repairs. The publicity on this is informal, since the collective can't support the workshop as an open public project. Their silkscreen workshop is "a little bit sleepy" because people don't work on it. It depends on private interest: who is here, and what they offer to do. The bar collective can be approached to do parties or concerts, and a musical tour circuit works through private contacts. They regularly do benefits for different causes. There is also a rehearsal room where bands can play for the cost of electricity.

In the following days we visited another '80s squat that was started in Kreuzberg at almost the same time, but with a very different orientation. The Regenbogen Fabrik ("Rainbow factory") is a 19th century factory complex squatted in 1981 as a collective working project. The building behind was squatted by the same group as living space. We met Andy, a smiling older man bedecked in a red Sandinista neckerchief. He was seated on a bench in the tranquil courtyard of the Regenbogen Fabrik. They host a *Kita* (a Kindertagesstätte, or day care center), and all around us children were playing, mothers and fathers coming and going.

Historian Carla MacDougall translated Andy's German. He was born in Kreuzberg, and he gave us a brief history of the squatting scene there. In the 1960s and '70s, Kreuzberg was an urban renewal area. There was a housing shortage in Berlin, and many of the beaten down buildings were standing empty. Andy showed photographs of U.S. soldiers stationed in Berlin using the district for urban warfare

training exercises. There were plans for a highway, and a "clear cut urban renewal" to tear down existing housing. Speculators were hovering around, and they wanted Kreuzberg to be torn down. Many of the remaining tenants were organizing, and there were a number of rent strikes. The municipal government was widely perceived as corrupt.

First, the area around the Kottbusser Tor metro station was torn down and redeveloped. This modernist development was uninspiring, and, beginning in the late 1970s, people began to renovate houses in protest against the government policy of abandonment. There was a squat here and there, but it wasn't really a squatting movement. When on December 12th, 1980, police prevented a building from being squatted, there was a three-day riot, and it marked the start of a movement. Eventually the police said they would stop evicting people. By May of the following year, more than 160 houses had been squatted. People in the growing movement had mixed motives. They were against the housing policies of the city, for collective living and working, for doing politics like the anti-war and peace movement, and so on. For some it was just about getting an apartment.

The original idea at the Regenbogen Fabrik was to have a neighborhood center. The first thing they did when they squatted the place was to hold a neighborhood party. Just recently, the party celebrated its 30th anniversary. The first squatters were single mothers – since it was difficult to find an apartment with just one child – as well as people involved in labor unions and the radical left scene. Most were drawing social welfare money. Those who were studying in Berlin stopped their studies for ten years to work on the project. Some wanted to raise their children collectively. Some wanted to work collectively. That was how they envisioned their living situation.

The Regenbogen Fabrik set up workshops so that people could work collectively. Andy showed us pictures of the rundown and ruined group of shacks they took over in 1981. The factory was built in 1878 on a common in Kreuzberg. It was close to the canal, and housed a steam-powered sawmill. The chimney remains, preserved by the squatters as a monument to that period. They saw themselves as contributing to the preservation of historic buildings, a part of working class heritage. The last use was as a chemical factory that made paint. It closed in 1978. The ground was totally contaminated, so the whole yard had to be dug out and the soil removed.

Those who squatted here were open to negotiation, and they worked with the neighborhood center and politicians – a divisive issue in the early 80s squatting scene. (As we saw, the Rote Insel held out for a number of years.) The bicycle workshop was a successful negotiating point, since people could help each other to build and repair their bicycles. This was a popular idea in Kreuzberg. A lot of the bicycle workshops of squatted houses became commercial businesses, but the one at Regenbogen Fabrik is still as it was, collectively organized. (They also rent bikes.) Now people think of Berlin as a bicycle city, Andy said. But in the 1980s it was so only in Kreuzberg, because the Berlin Wall interrupted car traffic in this district. The hostel and the café (formerly a VoKü) on the street are the two income generating projects of the Regenbogen Fabrik.

Our tour moved from the courtyard to the cinema (Kino) – a large, long clean room painted dark, with a bar. The seats were raised banks of big, overstuffed sofas. Originally a space for parties, the Kino was rebuilt after an arson fire. (Neo-Nazis were suspected.) Now they can show 16mm and 35mm film, and they have a beamer for digital content. The Kino group are all volunteers. They welcome initiatives, particularly political, from the outside. The principle of the squats, Andy told us, was to do what people wanted to do, what was fun for them. So here people organized to show films that they wanted to see. Many of the Berlin squats had cinemas in the past.

Both Carla MacDougall and Armin Kuhn led the tour[1] through the Kreuzberg neighborhood where we saw and heard about the district that had been the heart of the Berlin squatting movement. It was a fascinating story of intertwined governance and business, realist political activism and hardheaded utopian aspiration. Architects had been in the thick of it.

We began in Oranienplatz. Carla and Armin explained that 19th century Kreuzberg had been a factory district. The housing was basically barracks for workers, with little factories nearby, like the kind we'd seen at Regenbogen Fabrik. In 1961, the Berlin Wall was built through the district. Isolated within Communist East Germany, the economy enjoyed much state support. West Germany had labor agreements with eastern countries, especially Turkey. The migrants of

1 I took notes as best I could in the cold, walking along. They are disjunctive and telegraphic. I have reordered them, merging both Armin and Carla's discourses together. In general, Carla talked more about the IBA and Armin more about the squatting movement.

the early 1960s found homes in Kreuzberg, since in other parts of Berlin they faced discrimination. Even so, the owners did not expect them to stay. An older man passed our tour group wheeling a bicycle. "This was a Turkish ghetto," he said. "Still half the people are Muslim, although the English try to get us out!"

Plans devised in the mid-1950s deemed Kreuzberg an urban renewal area, awaiting a wave of drastic demolitions, so the owners allowed the buildings to fall apart. In 1973-74 the Kottbusser Tor development was built, and the city's plans for development became clear. A storeowner whose business was cut off by the new buildings became active in politics. He would become an important figure in the government, and supported the squatting movement in the political seesaw between tolerance and repression.

Slowly, the residents began to push back on the city's plans. The squatting movement was part of the strategy, together with neighborhood assemblies. During this time until the late 1970s, there are some 12 to 18 squats. A group of community activists began to do token squatting in the late 1970s to force the government to sign leases with area residents.

Squatting was part of an integrated strategy by a strong neighborhood movement to force a participatory process, a less aggressive rehabilitation, fewer expulsions of the working class population and the recovery of many industrial courtyards as the gardens and playgrounds we see today. (A neighborhood to the north, Prenzlauer Berg, has one of the few remaining adventure playgrounds, where children spend the summer building structures by themselves, supervised by teenagers.)[2]

As an example of this strategy, in 1977 planners and architects joined with community tenant organizers to hold an idea competition, "Strategies for Kreuzberg," to promote citizen participation in urban renewal. In 1979, the International Building Exposition (IBA; Internationale Bauaustellung) began as a process intended to renew Berlin in time for the city's 750th anniversary in 1987. Architects critiqued the "clear cut renewal" idea, and promoted careful modernization instead. This accorded with an evolving acceptance throughout

2 The adventure playground arose after World War I from children's own activation of vacant, bombed-out space. [Norman, 2003] Artist Nils Norman has made projects reflecting on this as a kind of archetype of a self-organized indeterminate urban space. The Reina Sofia museum in Madrid mounted a large exhibition on the theme as a kind of metaphor for post-1968 art, activism, and design: "Playgrounds: Reinventar la plaza." [Borja-Villel, et al., 2014]

Europe of the need for historic preservation. The 1987 IBA show in Kreuzberg took the form of "IBA old" and "IBA new," with the theme of living in the inner city.

We were able to enter a back courtyard to see one of the buildings created in those days. A dramatic intervention in glass and steel from IBA '87 opened up the back of a multi-story building to a common staircase. Other buildings nearby had been gutted and rebuilt with more spacious interiors.

Carla reminded us that before 1990 the Berlin housing market was heavily subsidized by the government, so the public demand for social housing and participatory planning had a strong position. The slogan of the neighborhood became renovation without displacement. Still, the "IBA old" demonstration projects of '87 did not change the government's fixation on new construction. Rents went up with renovations and many existing residents had to leave. Out of this disillusion, a number of architects joined the community activists in the newer squatting movements. IBA-connected architects helped out a punk house of young squatters.

The Berlin squatting movement had different factions, but two main camps. The Instandbesetzen, which started in 1978, were occupations of buildings to renovate them. The other main camp was the alternative movement, born of the new communism of 1968. They had decided that intervening in society would not get them anywhere, so they decided to make their own projects of living and working collectively. They set up communes and worker-owned businesses. By the end of the 1980s, 100,000 people were making up the movement. The third group was the Spontis, in revolt against the emerging precarious life of young workers and students. This kicked off in Zurich, with the slogan "Zuri brennt" (Zurich burns). [Videoladen, 1980]

Throughout these years, the squatting movement was resistant, and the police regularly repressive. Starting on December 12th, 1980, there were two days of riots in Berlin. The police pulled back from a large area of the city, and people squatted 160 buildings. The Heinrichplatz in Kreuzberg was called the squatters' village. The Berlin Senate was in crisis because of tenant resistance to its housing policy and a corruption scandal. In 1981 the Senate "fell" – and was crippled until elections could be held in May.

In May 1981, a conservative Senate came in, and every new squat was immediately evicted. The "psycho-winter" of repressions began.

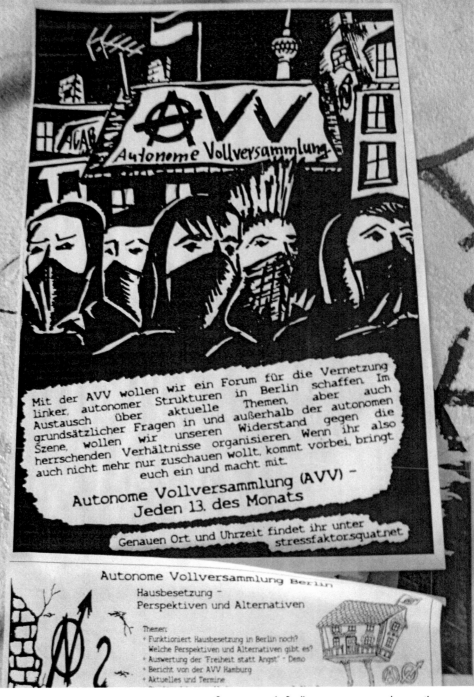

Street poster in Berlin announces a regular meeting of Autonomen, 2010. (Photo by the author)

Wall paintings on the New York in Bethanien
squat in Berlin, 2010. (Photo by the author)

One squatter died, chased by police in front of a bus. People hunkered down, and worked on living together. From 1981-82 conflicts emerged within the movement over negotiating or not negotiating. People in the tenant movement saw squatting as a basis for realizing demands for a new housing policy. The Autonomen wanted to keep squatting as a conflictive action. Some people were forced to leave their homes if they did not agree with the ideology. Hans Pruijt asked whether some people could not afford to be legalized? They may not have been able or ready to take on more responsibility. Yes, Armin, replied, and that also had class implications.

The conflict that emerged in the movement in the '90s was between the punky, party squatters, the family home-making squatters, and the political squatters who sought "to raise a conflict line, to break the poverty logic." In recent years, Armin said, the guiding philosophy of the government of Kreuzberg has been one of "the social city." They have used pre-existing organizational infrastructure for "activation strategies" to build up attractive areas for the creative class. This is an example of residents' self-organization that is co-opted for neoliberal government objectives. One example, Hans commented, is that at the Regenbogen Fabrik "social welfare cases are sent for forced labor in the alternative movement."

We passed the Milchbar, a squatters' bar where Nan Goldin photographed during the 1980s. Most of the stores in squats during the 1980s were bars, cafés, eco-stores, and bookstores. The women's house had a women's health clinic. In the courtyard of the Milchbar building had been the Bauhof, where squatters could drop off and pick up construction materials and find expert advice.

Carla pointed out a ten-year occupation by lesbians on Naunyn Strasse. These women were challenging domesticity – "We don't want to live like our parents." By the end of the 1990s there were five women-only squats. The one we saw began with one communal kitchen for the whole house, Carla said. Now there is a communal kitchen on each floor, but the house is more broken up, with two to four persons in a flat. They had a holistic medical clinic on the ground floor when they began. Another legalized squat is nearby, in the shadow of the aging Kotbusser Tor development.[3] The storefront had been a common

3 The building of the huge "Plattenbau"-like glass and steel structure beside the U-bahn station at Kottbusser Tor was a galvanizing moment of controversy. Today the structure is deteriorating and crowded with ugly shops, although I was told there are many hip late-night bars on the upper floors, as people dig that

space, now it was cleared out and available for rent to short term tenants. A photocopy shop next door had a smear of posters and graffiti extending over their facade from the former squat.

The main action for SqEK in Berlin took place in a room in the New Yorck in Bethanien, a squat with a rich history. There we heard members' papers and discussed them.[4] We also ate lunch together in a lunchroom in the building run by a theater company. The Bethanien is a former hospital complex. Already by 1971 a part had been squatted as the Georg von Rauch house, named for the radical (1947-1971) killed in a shootout with police. The building was taken after a concert by Ton Steine Scherben at the Technischen Universität and became one of the first self-organized house projects in Berlin. (Rauch himself had lived in a commune.) Today it is a self-help living place for homeless youth: "Our door is always open, and our rooms offer retreat from life on the street." The first squat in the Bethanien complex, then, evolved from its birth in an angry student movement to fulfill an ongoing important social mission, serving troubled youth.[5]

The project at 59 Yorckstraße began differently, as a factory building rented with a commercial lease, later converted into collective living and work areas for numerous initiatives. These included projects against racism, for African women, information on Latin America, and a radio station. The Yorckstraße collective engaged the Kreuzberg community with annual parties. After the 1991 death of a refugee in an attack on a detention camp, they launched the Gelber Punkt (yellow dot) program enlisting local businesses as safe spaces in the event of a racist attack on the street. The house members also worked

Plattenbau modernist scene. A Turkish immigrant group, Koti & Co, have been fighting gentrification from an encampment in the plaza. (In our 2013 visit, we could not find their Koti Haus.)

4 As mentioned in the introduction, this book does not include discussion of most of the many useful papers and discussions presented at SqEK meetings. I concentrate instead on the local experience in each city we visited. The minutes of many of our conferences are on the SqEK website for those who wish to consult them, and a number of the papers presented have been published by the authors in journals, and in SqEK compilation books presently released and forthcoming. [SqEK, 2013, 2014]

5 Information from the Georg-von-Rauch-Haus website, HTTP://WWW.RAUCH-HAUS1971.DE/JUGEND_KULTURZENTRUM/VEREIN.HTM; and the Umbruch Bildarchiv (radical change picture archive), and "Georg von Rauchhaus in Berlin: 1971-2007," at HTTP://WWW.UMBRUCH-BILDARCHIV.DE/BILDARCHIV/FOTO1/BILDGALERIE_RAUCHHAUS/INDEX_3.HTM

continuously against what they called the "complex sleep" of gentrification. In 1994 their house was sold, and the new owner quadrupled the rent. They resisted the increase. In 2003 the owner went bankrupt, and the residents and users tried to buy the building with the help of the Freiburger Mietshäuser Syndikats, a group supporting left initiatives and collective houses. Meanwhile, the new overseer of the property prohibited the annual festivals in the courtyard, and charged the tenants for removing their political posters from the entranceway. City-supported negotiations to buy the building failed in the end, and in 2005 Yorck 59 was cleared by 500 police.

Only five days after the eviction, former residents and supporters took over two floors recently vacated by the offices of welfare and unemployment in the Bethanien. Demonstrations continued after the eviction with a day of protests by sympathizers, actions by the group Reclaim the Streets and massed bicyclists. Street signs throughout the inner city of Berlin were changed to "Yorckstraße" with the slogan, "Yorckstraße is everywhere!" (The same strategy would be used in fighting the eviction of Ungdomshuset, the Youth House in Copenhagen two years later.) The political leader of Kreuzberg was on the left. His party and the Greens supported negotiations with the newly occupied New Yorck in Bethanien, while the right parties called for immediate eviction. Meanwhile, a court declared the eviction of Yorckstraße illegal; even so, work began to convert the building to luxury lofts. ["Yorck 59," 2013]

Since 2002, the city had been planning to sell the Bethanien complex to a private investor, and was searching for one with cultural interests who would convert it into an "international cultural incubator." The costs of maintaining the property for public use were too high. One result of the New Yorck occupation was to open a discussion around this plan. Citizens finally rejected the privatization plan in a referendum, and a round table began to meet to consider the future of the complex. The director of the neighboring Künstlerhaus Bethanien (established 1975), meanwhile, was angry that the Yorckstraße group had squatted the space he wanted for his institution. Director Christoph Tannert launched a campaign to get them out, circulating a petition that was signed by many cultural figures. The pushback – and my Hamburg friend Michel Chevalier was involved in the defense against this move (see Chapter 7) – pointed out the corporate constituency of the Künstlerhaus, and the gallery connections

of nearly all the artists. (As artist residents must be recommended by a range of state cultural agencies, the responsibility is certainly shared!) Tannert complained that the unsightly squat was damaging the image of the Künstlerhaus (Imageschäden), and his corporate sponsors were pulling out. In the end, shortly before our visit the Künstlerhaus lost the fight with New Yorck, and expanded elsewhere with the support of a real estate baron. Kreuzbergers, it would seem, preferred that the politically-oriented New Yorck project should continue, rather than that public space be turned into more artists' studios.[6]

After days of hearing SqEKers' papers in a room at New Yorck, Berlin squatters had a chance to query us directly in a roundtable in which we presented the situation of squatting in our respective countries. The Berliners listened and queried attentively. Later that year, Berlin squatters organized an exposition reflecting on their history – "Geschichte wird gemacht" ("History was made"), a 30-year commemoration of the movement. For many young Berliners this must have been fascinating. Autonomous movement archives are bulging with material – zines and flyers, posters and videos, but few books tell the story of this decades-long resistance to top-down urban redevelopment.

For the last days of my stay, I booked out of the Rote Insel to stay with Andreas, a graphic designer who was working at New Yorck. He designed the dramatic "You Gentrify, We Occupy" graphic, which was blown up to an enormous size and hung from the tall towers of the Bethanien complex during their battles with the Künstlerhaus. (It's the cover of *House Magic* #3.) On the way to Andreas' house, we cycled along the Spree River, passing a quaint old Bauwagenplatz, a trailer encampment. They host a beer garden and stage during the summer months, and I would return in a later visit. Andreas was then

6 After 2009, cultural uses of the building have continued under new, more socially conscious management. These include exhibition and production space, and recently a high-end restaurant, all under the name of "Kunstquartier Bethanien." I view the "defeat" of the Künstlerhaus as unfortunate: an art institution with a willful leader single-mindedly pursued an alliance with corporations and art marketers to the extent of doing battle with a center of left political activism and culture. Perhaps the director thought he was being realistic; but rather than "image damage" to the Künstlerhaus, I feel Tannert damaged the image of the art community in Berlin. His campaign offers a clear example of why political people distrust artists and art institutions. Künstlerhaus works hand in glove with corporations and real estate developers, fine. But to fight with the people running beleaguered political programs puts parochial interest ahead of any social mission, even public service good, that art may be said to have or to provide.

working on graphics for the Mediaspree campaign, an attempt to hold back the tide of privatization that was taking over the riverbank lands. The anchor development was to be a monstrous media complex. He was not optimistic about the future of the Bauwagenplatz.

I visited the Kreuzberg and Friedrichshain neighborhood museum near Kottbusser Tor, and bought a beautiful book about these encampments called *Wagenburg: Leben in Berlin*. It is a portfolio of prints celebrating the free-living style of these voluntary urban gypsies, made in the museum's spacious book art workshop in a variety of artisanal media, including fabric patches. Everywhere I travel, I collect materials, intending to use them in the ongoing "House Magic" exhibition project. I visited a spot we had passed in our tour, the Oh 21 bookshop. This normal-looking bookstore continues the project of a squat's infoshop. I picked up a back copy of *Interim*, a cheaply printed radical zine. (This one had an article on the New Yorck in Bethanien.) I asked if this was the same magazine the police had confiscated at the Schwarze Risse ("Black crack") bookstore in the Mehringhof? The people at the Risse told our tour group the story of the police coming into the bookshop, and I could scarcely believe it. In these days of e-info, why bother to bull into a bookstore? Yes, the clerk at Oh 21 said. They had been five times to that bookstore to do the same thing.

Oh 21 had a poster in the window of a moose kissing a camel, advertising a forthcoming event for queer and transgender people. This community has played an important role in squatting history, and not just in Berlin. At the close of the speakout, we met with Dido, a senior gay activist, who told us about the Queeruption there in 2003. Queeruption events were held in numerous cities from the late '90s. The intention was to create a safe autonomous space for an international queer culture festival where participants lived together. In Barcelona in 2004-5, it was held in a purpose-squatted place, the "Okupa Queer," and lasted several months.[7] The 2003 Berlin Queeruption "action week" was perhaps more explicitly political than other iterations, in which "radikal/anarko" queer people would meet "against the constructed boundaries of sexuality, gender, nation, class, etc.," and live together for a week. [Indymedia.de, 2003; Brown,

7 Jack Waters and Peter Cramer of ABC No Rio had attended the event in Barcelona. They spoke about it during the "House Magic" exhibition in 2009. A partial transcript of the conversation is in *House Magic* #2. The Queeruption concept recalls their own "Seven Days of Creation" show in 1983 at No Rio, with which their involvement with the space began. [Moore & Miller, 1985; Dingle, 1998]

2007; Vanelslander, 2007] The Berlin group later analyzed the event explaining, "Queer spaces are about Freiraum[8] – spaces where we have the freedom to dismantle restricting, acquired codes of sexual and bodily behaviour." They critiqued the "excessively sexual atmosphere" of the event, calling for sensitivity. "Queer is not 'hip' and 'cool'. We need continual discussion." [Queeruption Berlin, 2003]

On my last day in Berlin, Dido offered to give me a tour of the graves of some of Berlin's important gay activists, a melancholy proposal I regret I could not accept. I was off to Hamburg, to talk at the show Michel and the gang had put up in the Rote Flora social center. We hoped it would later travel to New Yorck in Bethanien.

[KoepiEntrance.jpg: Entrance to the Berlin squatted social center Köpi (Köpenicker Str. 137), 2010. (Photo by Lynn Owens)]

"Rebel New York" exhibition in Hamburg. (Photo by the author)

SEVENTEEN

"REBEL NEW YORK" AT THE RED FLOWER

After the Berlin SqEK meeting, I took a train to Hamburg. The show Michel Chevalier and the Siebdruckwerkstatt group had prepared was up in the Rote Flora social center. The show was timed to support the squat during their negotiation for renewal of permission to use.[1] It was a solidarity show

1 Another major push along the same lines was made later that year, with a "Flora-Bleibt-Festspielwoche," a week of artistic activities to support the place. A website mounted by the Right to the City network of Hamburg argued that the Rote Flora should remain that "big, dirty, unsaleable monster that cannot be captured as a 'catalyst' or 'incubator' for a 'creative milieu'." (Google translation from: "Ich würd's so lassen! [I would leave it alone] Die Flora-Bleibt-Festspielwoche," 2010. At: HTTP://WWW.BUBACK.DE/IWSL/INDEX.PHP; a project of rechtaufstadt.net, the Right to the City network.) This bunch did not come to see the show we put up. It was just another

with this center for independent political culture. Michel entitled it "'Nicht das Neue, nicht das Alte, sondern das Notwendige,' a No Wave Squatter Punk (Anti)Art Ausstellung." The tag line – "Not the new, not the old, but the necessary" – came from the Russian Constructivist Vladimir Tatlin, 1920. The show was a collaboration between me, Michel, and the Rote Flora Silkscreen Workshop. "Nicht das neue" reframed New York independent art, music and film culture of the '60s-'80s through a strongly political lens as a continuous history of radical culture. It was ambitious in scope, and had been exciting to organize, of course with almost no money. The center ponied up 300€ to print a selection of the digital files I was sending them, but that was it.

The show was – as this chapter is – about New York. I was going to Hamburg, but in my mind I was going to New York, a mythical city of the past, a vision I shared with Michel. I had numerous artist friends involved in various phases and incarnations of the NYC squatters' movement. The scene as it evolved in the neighborhood was fascinating, and worlds away from the scrubbed-up galleries on the same streets. It was dirty and could be rough. [Little, 1999] There were alcoholics and drug addicts and petty criminals involved, as well as numerous unsavory personalities. Nevertheless, people participating could, within the material and social limits, do more or less what they wanted. This freedom of action is invaluable for artists. Many artists have it as the result of the money they have or make. Squat freedom, the freedom that one takes and makes for oneself, has to be renewed and defended almost daily.

As I looked at the cultural relations within European squats, I had a New York model firmly embedded in my mind. The squatter artists of NYC were part of a political movement, but they were also clearly an art movement. The artists – working in visual and moving image media, music, literature, and performance – dealt with the same set of issues in all their works during a certain period of time. Many of them lived together. Subsequently, their careers have diverged, but a political commitment remains common to most of them. A number of them were represented in the show in Hamburg. Still, this was not the focus of that show. Rather, it centered on the geneaology of collective groups (particularly Colab, Group Material, and PADD) outlined in

instance of no love lost between radical groups, ostensibly on the same side in Hamburg. Dmitri Vilensky noted in his talk there the year before that the left scene in Hamburg is famous for this conflictive in fighting.

my book *Art Gangs,* which was then at press. We tried to shoehorn a bunch of different artists, many of whom did know each other, into the same boat, the radical cultural and political environment of NYC in the 1970s and '80s. Michel and I both wrote texts about the show.[2]

"Not the New" tried to knit together 30-odd years of politically engaged art centered in Lower Manhattan to present it as an integrated culture of resistance. For decades institutional representations of NYC '70s and '80s art have been about desolation, ruined and abandoned city streets, formal innovation, a "return to content," or a transgressive sexual culture. All of these aspects were surely present. But the salient political dimensions of these years, the resistance to the impinging tide of hogwash that engulfed the U.S. cultural scene during the Reagan years, the many dispiriting controversies provoked by the right that debilitated art institutions, are rarely recalled. U.S. institutions are allergic to political content, and Europeans follow suit. It was this politics that we sought to bring back in Hamburg, in both its critical and liberatory dimensions – as artists' self-organization and resistant squatting. To present NYC art of this period as revolving around resistance to gentrification and squatting was a stretch, but the dynamic was present then, and it remains relevant.

Produced on a fraying shoestring, "Not the New" was more like a blown-up zine than an art show. But I think the premise of it was sound, and if a resourced institution were to undertake a version of the project, it would be a revelation. Artists fight money-centric culture, corporate control and repressive politics every step of the way. They struggle continuously for equality, diversity, and free expression. That may sound trite, but very few exhibitions have tried to show the urban struggles of creative people in historical depth. Institutions have no incentive to show that.

Putting together PADD, Not for Sale, [Sholette, 2001] and Bullet Space made sense. The "No Art/No Wave" section was more odd, putting together the Boris Lurie-organized group of the early 1960s [Lurie, 1988] with the later 1970s music movement of intellectual punks.[3] Michel pointed out that the two are linked across time by

2 The texts that Michel and I wrote are posted at the House Magic Google website, "Rote Flora solidarity show Spring 2011," together with artists' links, at: HTTPS://SITES.GOOGLE.COM/SITE/HOUSEMAGICBFC/ROTE-FLORA-SOLIDARITY-SHOW-SPRING-2011.

3 Second-guessing these selections today, I'd say the more nearly contemporary UK Scratch Orchestra and Henry Cow were also more consonant with the No Art!

their common rejection of pop art and pop music. The most coher-
ent panel in the show was the group's selection of Marlis Momber's
photos. The rich life of the Puerto Rican people of Loisaida was
shown in the center in color, and ringing that the devastated land-
scape of urban neglect, political demonstrations, and literary fig-
ures like Bimbo Rivas and Jorge Brandon. Colab's group work was
represented mostly by street posters for events, including the Real
Estate Show (the occupation of the Delancey Street building), and
the Times Square Show held in a rented abandoned building near
42nd Street, to which artists from ABC No Rio in the Lower East
Side (LES) and Fashion Moda artists in the South Bronx contrib-
uted work, bringing expressions from the marginalized peripheries
of New York into the city center. Lisa Kahane sent blow-ups of her
photographs of these important art spaces.[4]

The most remarkable work in the show, however, was the large
billboard on the front of the theater, two by three meters, carefully
lettered and imaged by hand to look as if it were printed. The slogan
was "Flora bleibt unverträglich" ("Flora remains intolerable"). It was
quite nice looking, with its quaintly provocative slogan, as if to say,
"Come and get us!" (If you dare).

As noted in an earlier chapter, ABC No Rio was given to artists af-
ter an occupation action. At one point in its history, for some years in
the early '90s, when negotiations with the city broke down, the build-
ing was also squatted. I had hoped artists working there now would
join in this exhibition, and I invited them to do so. Finally, most did
not, possibly because their engagement with the place had come later,
and they felt no kinship with the squatting movement. The artists in
the ABC circle who contributed work to the show were those who had
participated during the years of the squatting movement.

group. That was participatory and improvisatory music making that had ideolog-
ical roots and support among communist groups, which was more in the spirit of
No Art! than No Wave. No Wave artists had some romantic interest in European
terrorist groups, but were, on the whole, more interested in heroin than politics.

4 Lisa Kahane then was putting together a show of Colab artists in a Los Angeles
gallery, to go along with the large "Art in the Streets" show at the Museum of
Contemporary Art. Jeffrey Deitch, a longtime friend of Colab, curated that. To
date, only two institutional exhibitions have been mounted about aspects of the
group's work, "Times Square Show Revisited" in the Hunter College CUNY art
gallery in 2012, and "XFR STN" at the New Museum in 2013. (It hardly seems
to count that "Real Estate Revisited" in 2014 had a demi-institutional show at
ABC No Rio, an exhibition space that is historically a Colab creation.)

The artist named Fly (Fly Orr), together with ABC No Rio director Steven Englander, produced a show in 2000 called "Dangerous Remains," [Moore and Cornwell, 2002] the first I had seen to explicitly address the squatting experience. Fly's work was featured in the Hamburg show. Her collages of photos of different buildings squatted during the high tide of the movement (many were evicted) are humanized portraits of these sweat equity locations. Like Seth Tobocman, Fly also works in narrative graphic media. She produced a number of short graphic books about the squatting experience. And, like Peter Missing, Fly toured European squats in the '90s while performing in a punk rock band called God Is My Co-Pilot. In her long-term project "Peops" (as in my peeps, my people), Fly publishes a series of zines of her bust portraits of artists, thinkers, and activists. As she draws the portraits from life, she talks with her subjects. The conversations, in the form of words and fragments of sentences, then become part of the finished work.

I was glad to include the work of Marlis Momber, a German émigré photographer who photographed her adopted community during the '70s and '80s. Marlis worked for *The Quality of Life in Loisaida*, a little magazine produced at the occupied social center El Bohio run by the nationalist group Charas.[5] For Hamburg, Marlis let us show many of her images of the Puerto Rican community during those years when the buildings were falling apart and burning down from landlord neglect and arson. I had seen her slide show a year or so earlier at a conference organized by the Center for Puerto Rican Studies. She showed old work she had recently re-discovered, images of marches for housing, militant gatherings associated with first wave squatting in the district in the 1970s. The marchers, waving their banners and flags, passed before large painted murals depicting idealized marches of the past. These photographs blended two related images, one painted and one actual, in one place and one frame, for a striking presentation of the public dynamic of political activism.

Marlis told me after her talk that her bunch never liked our group back in the early '80s. We were running ABC No Rio during the invasion of East Village art galleries, so we were perceived as gentrifiers

5 Mary McCarthy was the editor and publisher of the *Quality of Life in Loisaida* journal, which continued for over 10 years (bimonthly, 1978-ca. 1991; copies are at New York Public Library, along with McCarthy correspondence). Their office was in the El Bohio building which was managed by the Charas group, and nominally under the control of a community coalition called Seven Loaves.

– the enemy.[6] At the time, Puerto Rican activists enjoyed strong po-
litical support. But as the neighborhood changed, so did the political
balance of power. By the mid-'80s, an old line Jewish socialist had
lost her council seat, and a young gay Puerto Rican neoliberal had
been elected. He pushed the public-private swap so that a number of
Puerto Rican families were housed in newly built apartments, while
the bulk of the city-owned properties were turned over to private de-
velopers. The old ethnic politics of divide and rule were alive and
well. This politician also loudly backed the right wing mayor's war on
squatters, and many buildings were violently evicted. In the most fa-
mous of these evictions, at a complex of buildings on East 13th Street,
the police used tanks. In another case, eviction was by demolition.
All this repression cemented solidarity among the remaining squat-
ters, forging a tight-knit community that years later would sacrifice
ever-pressing personal interests (New York is expensive) to support a
project honoring those days. (See Chapter 33)

Key artists among this group were Fly, Andrew Castrucci of Bullet
Space, Seth Tobocman and Peter Missing. The Hamburg show in-
cluded Seth's graphic novel *War in the Neighborhood* (2000), still the
most sensitive, militant and nuanced story of the squatting movement
of those days. Although it is ostensibly fictional, Seth did extensive
research for the book, and the characters are based on real people. In
1979 Seth was a founder of *World War 3 Illustrated*, a radical political
graphic magazine, with Peter Kuper. The group, which has included
many artists over the years, had a retrospective called "Graphic Radi-
cals" at Exit Art at the end of 2010.

As I was gathering the show materials for the Rote Flora collective,
I again visited Andrew Castrucci at Bullet Space, the ground floor
gallery he runs in his home, the squat on East 2nd Street. He had
recently closed the retrospective show of the gallery, called "25 Years:
The Perfect Crime." [Castrucci, 2010] A city room reporter, not an art
critic, reviewed the show. It was Colin Moynihan, a longtime reporter
for the *New York Times* on the LES squat movement. [Moynihan,
January 29th, 2010] As discussed before, Bullet Space is the 20-year
aesthetic project that coincided with, reflected upon and amplified

6 Marlis Momber observes that she was a homesteader, and started in her building
 in 1977. "The squatters in the Lower East side were viewed as competing for the
 same spaces, sometimes squatting already homesteaded buildings. That's where
 the conflicts arose! Plus the fact that very few Puerto Ricans were involved with
 the squatters" (email, July 2014).

the ethos of a radical social movement. Andrew is an artist who has made the squat gallery his métier. [Moore, 2010] Many other artists have shown there, but Andrew's attitude brands the enterprise: "Art is for liberation, for life, or it is for nothing," he wrote in 1986. "Like the building we struggle to reclaim & rebuild." [Schonewolf, 2011]

The reading room in Hamburg included the 1988 Bullet Space tabloid publication "Your House Is Mine." The title was a slogan of the Missing Foundation band, a project of the artist Peter Missing. Missing lived in Berlin at the time of the show, in a trailer behind the giant art squat Tacheles. While he was not interested in participating in anything I was organizing when I met him – he suggested I buy his music albums instead – Missing was an important radical voice in the resistant squatting movement. Clayton Patterson produced an exhibition of his work in New York in 2002 featuring numerous paintings based on his most famous image of the '80s, an upside down martini glass accompanied by the slogan, "The Party's Over." Both Andrew Castrucci and Seth Tobocman commented on the image at the time. "I believe art can be used as a weapon," Andrew told Colin Moynihan. "And Pete's symbol was successful in that it helped scare away developers and slow them down." Seth said, "The martini glass became a symbol of causing trouble. To a lot of people it said, 'Start something.'" [Moynihan, 2002]

While I was in New York preparing for the Rote Flora show, I at-tended a meeting at ABC No Rio called by Time's Up environmental action group leader Bill Di Paolo and his friend Laurie Mittelman. They wanted to discuss plans for a new museum, an institution that would collect past relics of recent Lower East Side occupations of buildings as squats and vacant land as gardens and display them as exemplary instances of reclaiming urban space. At the time, I felt that their plans seemed half-baked, and unlikely to get off the ground. Happily I was wrong. I had underestimated the collective desire be-hind the project, and the resources this movement could still com-mand. By the time the SqEK group met in New York, the MoRUS – Museum of Reclaimed Urban Spaces – was almost ready to open.

Working with social centers is not an untroubled process, as I would find out, though I have never ceased to try. This first outing was fraught with difficulties for the organizers. They had encountered numerous obstacles imposed by the plenum, the assembly that man-ages the Rote Flora. First up was censorship. Michel wrote to me that

at the Rote Flora "anything with nudity is not possible due to 'political' watchdogs, so we will pre-screen everything." No animals in pain, of course, or images of them being eaten. Compared to the freewheeling open-access squatter culture in New York City that we were intending to show, this was a dampener. In addition to the conditions imposed upon content, the show could only be open during certain times on certain days, and then needed to be taken down completely and stowed away every weekend. No photographs of the interior were allowed, i.e., the show in situ, nor any photos of any person. These Germans were clearly more avid to make rules than to break them. There was more bad news to come. We had planned to take the show to Berlin and Paris, but the group at New Yorck in Bethanien decided that they could not support the project. We were welcome to do it, but we would have to come to Berlin and sit in the show every day it was open. Soon after, Michel encountered a series of personal disasters that required his full attention. The show never made it to Berlin or Paris, and sits to this day in a closet in the Rote Flora.

At the time, I didn't know that the show would go nowhere. I was very pleased with the Rote Flora show, and charmed by my second visit to Gängeviertel. Besides, even if I had wanted to be properly gloomy, I was going on to Paris, where Michel had arranged for me to spend a couple of weeks at La Générale en Manufacture, an artists' squat in Sèvres.

After the show, I wandered down to the Gängeviertel, a block of 19th century workers' housing in Hamburg Mitte occupied by artists. I'd been there before in the summer. (See Chapter 14) This time it was the weekend, lunchtime, and everything was closed. There's almost nowhere to eat in the business district when the workers in the giant buildings which ring the Gängeviertel are gone. But in the yard behind the artists' complex I found a compost toilet, mounted high on a platform as they need to be. It was unisex, a feminist project. Later on, I found a perky woman named Regina opening her shop full of artists' works – low-priced postcards, tiny paintings, all arty souvenirs of the place – at the Gängeviertel. Regina told me she was an old-time San Francisco squatter who had been in Hamburg for 15 years. She said the Rote Flora once had an "art club" upstairs 10 years ago. If so, it had certainly been forgotten by the present users. (Later someone else told me it was more like a bar, with drinks and sketching, and soon moved out.) Regina also told me about an "art circus"

that passed through Hamburg from Lisbon on its way to Paris – "Arte Ocupa." [Henrich, 2010] Things could really get rolling, I thought, if I could hook up with those guys. I never did, although I later saw a poster for the Paris leg of their tour at 59 Rivoli.

As we chatted, along came C., a sharp dressing, urgently charming guy I had met last time I was there. C. loves to talk about his adventurous life as a "permanent beginner." We went around the corner in the complex to have a coffee, and he told me stories of sailing on the Mediterranean, eating crab with ganja pancakes, and all about his beloved jazz festival in Morocco. A gruff hippie served us. The café smelled of hashish. It was the kind of place where you could while away the whole day…

Drawing hanging in Le Bourdon-L'Arsenal so-
cial center, Paris, 2011. (Photo by the author)

PARIS ADVENTURE SQUATTING

After Hamburg, Michel set me up with his pals in Paris for my first trip there to investigate the squatting scene. (The SqEK group held a conference in Paris two years later. See Chapter 35) I would do an artist's residency at La Générale en Manufacture. This place is in Sèvres, across the river from the end of the metro line. It's a rather harrowing walk along a tiny sidewalk beside a metropolitan highway, heading towards forbidding looking corporate towers. Suddenly there is an opening in the high gray walls. Inside, there is a courtyard and two rundown buildings, the former school of the government porcelain factory. I was there to give a public talk about my book, and to learn about art squats in Paris.

Michel's friend Jerôme Guigue welcomed me. His worktable was littered with deconstructed Chinese toys. Éric Lombard, who was coordinating the artist residencies for La Générale, gave up his room overlooking a public greenhouse and nursery for my stay. Eric is an ex-punk rocker who drums sometimes in

the group Sister Iodine with the "other Eric," Erik Minkkinen, who produced an annual sound art event called the Headphone Festival. We toured their hangout, a former TV studio in the listed 1932 building, with heavy glass-walled control room still intact. On that first day, I was recruited straightaway to advise Alexandre of La Biennale de Paris on his upcoming trip to NYC. Afterwards, Beatrice took me in hand, and we set out to visit some of her friends.

We made a nighttime visit to Montreuil, an easterly district of Paris with Anne who was running a feminist seminar. It turned out to be a melancholy march past shuttered and bricked-up former squats. Anne told us of the Bastille squat, violently evicted at night with tear gas during a memorial party held for a dead friend. Perhaps it was fear of the growing network of squats that led to the repression. The administration of Montreuil changed from Communist to Green Party, and the new mayor, Anne said, was considered "some kind of a witch" for the violence of the evictions she ordered. Her intention to gentrify the mostly working class district had led to a kind of war with the police. As a result of the repression, Montreuil became "a desert" for public occupation activity. (This would change, as we saw on our next visit.)

We passed Titaken (Titanic) on Rue Carnot, a former squat, now empty and bricked up tight. It had been active with many events, and full of mostly queer and transgender teenagers and young people. A local hater told neighborhood youths that Titaken was a fascist squat. The neighborhood is largely Moroccan, from the Maghreb. Encouraged by the police, these youths attacked Titaken, beating up squatters as they went in and out. One was hospitalized in a coma for three days. Finally, they abandoned the squat.

Two years ago the son of a local theater director lost an eye in a fight with police at the shopping mall near the train station. A semi-abstract wall mural in the square alludes to the event – at its center is a staring eye. In another incident, a group of kids at a school were attacked by police, who shot one of the youths in the eye with a flash bomb. They were aiming for the head, which is forbidden with these weapons. La Clinique squat was evicted by a special tactical unit of the police. They used helicopters to drop men onto the roof of the squat. La Demi-Lune ("Half moon") was also violently evicted, even though two pregnant women were living there at the time. The building was destroyed at 6 a.m. Why, I asked, do people continue to squat with all this repression? "C'est choutte," Anne replied – it's fun.

Of course squatting in Paris has a serious, political side to it as well. At the end of our tour, we visited a large apartment building on Rue Bara near the metro stop Robespierre. It was full of African immigrants from Mali. By then it was late – 9 p.m., and all the women had retired. The men were sitting talking and playing games, milling about the courtyard, eating sandwiches and drinking coffee, buying cigarettes and miscellanies from small stands. Anne told us the place had been opened around 1997 by autonomists of the *sans papiers* movement (that is, migrants without papers, or the undocumented migrants). For a while activists and immigrants lived together, but now Bambara elders ran the place. The Montreuil district has many Malians; if it were in Mali, it would be its second biggest city.

In the morning we visited some of Beatrice's activist friends. They open houses for the *sans papiers*. We arrived at the metro stop Place de la Nation where a group of African women were dancing in a circle, insulting the cops. They were preparing for a demonstration that would begin soon. We walked along to a housing block and rang up to the new apartment of Beatrice's friends. We entered a North African household with a demi-circular red couch on which two women reclined. There were dates on their stems sitting on the table, and curious, eager children climbed around. I talked a little with them in English, which they found exotic. Mama served us tea, pouring it from high in the air down into the cups. Soon she brought couscous, and a honey nut desert and coffee. We chatted with the two gals on the couch – or rather, Beatrice did since I didn't speak enough French to participate. One of the women declared that she was part Basque, and proudly related how her grandfather fought with the Resistance during the war and later escaped from a prison camp.

She herself had led an action against an architectural exhibition in Paris in the 1990s. The city had commissioned a show of temporary shelters for the homeless, a project called "Toolkits for Survival." She went with a friend from the journal *Liberatión,* and took a press pack with a map of all the projects, so her group could go around and fuck up these symbolic, superficial responses to a real crisis. The other woman, in pain from an attack of periodic migraine, was chipper at times. She described how she had been invited to a recent Social Forum gathering, but decided not to go. She did not want to be co-opted by the NGOs, which that dominate the social forums. Her group is autonomous, and happy to stay that way.

On my next visit to Paris, the SqEK group would meet in a bilingual encounter with a large group from DAL (the Droit au Logement – the Right to Housing group) – one of the most prominent activist collectives that squat houses for marginalized groups in France. But during this first trip, I hadn't really much idea what was going on. I could just be impressed by the variety, the seriousness of purpose and depth of commitment of the squatting movements I encountered.

I was tipped off about a meeting of a group planning a new squat. It was the Coordination des Intermittents et Précaires d'Ille-de-France (CIP-IDF; Coordination of Temporary and Precarious Employees of the Ille-de-France), a prominent radical labor rights group whose actions had inspired Brian Holmes' viral essay of 2001, "The Flexible Personality." [Holmes, 2002] The CIP-IDF[1] had a large, dilapidated office building beside a canal. It was to be demolished. They hadn't been given another, and so they were planning an occupation. About

1 The Coordination des Intermittents et Précaires d'Ille-de-France (CIP-IDF) stems from the struggles of entertainment industry workers in France in 2003 against proposed changes in their unemployment compensation system. Continuous restructuring of film, television and theater work over decades which unions had been unable to cope with had radicalized many of these workers. They evolved new influential conceptions of their work and its relation to economic domination by capital. Italian autonomist analysts theorized them and their social position as immaterial and precarious laborers. Canadian scholar Christopher Bodnar identified an anti-war group of artists, called Canal déchaîné, as the source of this thought, which was influential in broadening a new kind of anti-capitalist organizing around the emerging realities of precarity – what capital prefers to call flexibility. This thinking centers around cultural work and the labor of artists like those in the CIP-IDF. In 1997, Bodnar writes, Canal déchaîné described the work of mental laborers. Communication workers who "create cultural products that help define and materialize identities, tastes, ways of life, imaginations, and sensibilities for the sole purpose of consumption. As such, 'mass intellectualism does not only produce the cultural product or merchandise, but also and simultaneously the public or consumer'." (Christopher Bodnar, "Taking It to the Streets: French Cultural Worker Resistance and the Creation of a Precariat Movement," *Canadian Journal of Communication*, vol 31, no 3, 2006; at: HTTP://WWW.CJC-ONLINE.CA/INDEX.PHP/JOURNAL/ARTICLE/VIEW/1768/1887.) As the struggle was renewed in 2012 under the regime of austerity, the *Guardian* quoted arts economist Françoise Benhamou on the French unemployment system: "It was invented at a moment when this sector was unique in its precariousness. Now lots of sectors are going the same way, it's difficult to say culture can be different. To make an exception for artists during a period of growth and low unemployment is fine. When other industries have problems too, it becomes far more complex" (Angelique Chrisafis, "European arts cuts: France threatens to pull plug on creatives' special benefits," Monday 30 July 2012, at: HTTP://WWW.THEGUARDIAN.COM/WORLD/2012/JUL/30/REVIEW-THREATENS-FRENCH-CREATIVES-BENEFITS).

20 people of all ages and degrees of unkemptness were gathered around a big table smoking and drinking Cokes and beers. I was introduced and passed the *House Magic* zines around the room. Several people contributed to the talk – a tightly poised sharp-featured man of about 40, smoking continuously; a heavily bearded man who spoke only briefly. A disagreement flared. Cigarettes waved, hands flailed. At one point everyone arose and put their mobile phones into a large cooking pot, and the lid was closed. A whiteboard easel with a diagram of a building was set up. The spring occupation season was beginning in Paris.

Later, Beatrice told me that the CIP-IDF had been given another building, so they did not after all have to carry out any occupation. There was no reason to be uneasy at that meeting, she said. It was an open meeting that any police spy could attend. Was the strategy conference then a kind of bluff? It was clear I had no idea how these games were played.

That was fun. But the most exciting anarcho-tourist outing I made was to Fontenay, again with Beatrice. Again the perilous and fearful walk out of La Générale along the road filled with murderous motorists. It's anxious walking with other people, or if you meet someone coming the other way. This time we went to Fontenay, on the opposite end of the metro line that goes to Montreuil. From the train station I spotted the squat straightaway by the red and black flags flying from its upper story. It had been opened just two weeks before by a group from the Brussels student movement. Ephraim, a tall handsome black-haired young man with a serious mien told us the group had met at an earlier project, a group of squatted flats in an apartment building near the Odeon. That was a noisy, dirty squat, he said. It wasn't designed to soothe the feelings of the neighbors, and they were evicted pretty fast.

Ephraim said there is a strong division between the political and artistic squats. (This was to be practically the leitmotif of the 2013 SqEK meeting in Paris.) The art squats are given more space and time by the state, while the political ones are evicted more quickly. The kind of squat they had opened in Fontenay, he said, is "an open space to experiment with another form of life." He felt that a combination of artistic form and political practices was very important to develop in the squats, but the government allows only a disconnected artistic practice to take place.

The squat can be a critique of the political system. If it's only a cheap studio, a stop on the road of art world success, it's not interesting. There is a conflict between the forms of life available under capitalism and the possibilities of forms of living in open space. A "maison de liberté" should not only be for poor artists. (The term has already been appropriated by the real estate industry, just as in Berlin I saw a rental agency called "Freiraum," free space.) Ephraim told us he aimed to open three new squats in Paris, and to create a little village. This would begin a struggle with a standard form of politics. The anti-capitalist struggle must include the form of living. The question, he said, is how can we invent this form of living?

The recently opened squat in Fontenay already contained a library, a hacklab, and a free music rehearsal space. It was a former Catholic school. The owner wanted to sell it to the city, but the council hadn't raised the money yet. I asked what kind of activities were already going on. Different young people gave answers. Now they were reading Marx's *Capital* and also giving German lessons. A photography workshop was planned; and a recording studio, a place for sculpture, a bicycle workshop, welding. They told us they wanted to "develop metropolitan skills like gardening and beekeeping." Two beehives were already in place on the roof.

"We are everywhere," Ephraim said, not only here. This was not a heterogeneous group. "It can be a trap to see the squat as a unity." They often disagreed, but were united in the practice of squatting. "Conflicts show potential."

I spent some time there with Natasha, a young Russian who spoke English. I visited her room, photographed the graffitied walls – she had the first great "Köpi bleibt" poster I had seen – and queried her about the scene in the east. Russia is very repressive, she said, although there were some squats outside the big cities. I urged her to write something about the little-known movement for *House Magic*, although as usual I did not expect that she would. She was planning to return to school in sociology. Now, it seemed, she was sowing wild oats. (A tape-lettered sign over her bed read "Too Drunk to Fuck.") But Natasha was a serious traveler who had been in many squats, in Barcelona and Zurich. Such travelers with their varied experience are the heart of the international squatting movement in Europe. They are also a kind of dark mirror of international capital. Unlike the localized punks one can find in the U.S., a bright young woman

speaking several languages and traveling between squats has much in common with any number of aspiring servants of capital. Only her investment is on the other side of the social ledger!

I phoned Stephen Wright, a translator and theorist who works with Basekamp, from the – surprisingly working – telephone in the library of the Fontenay squat. A guy wandered in and placed a cage on the floor with baby chicks in it. The cat is prowling around, he said.

"Last night they almost died because of the cold." It's always cold in squats. Now they have been set down near an electric heater. "We are raising them for the eggs," Natasha told me. "It's amazing how fast they grow."

We had lunch with the Fontenay squatters, a thin soup of vegetables they'd gleaned from a supermarket dumpster. A mountain of tiny cups and plates lay in the sink, previously used by the school for children's meals. I washed some of these in return for the meal. One of the group, Maxim, asked if I wanted to go along with him to have dinner at another squat at metro Bastille. They have a court judgment against them, and they are waiting to be evicted. Maybe this will be the last meal. With such a dramatic agenda, how could I resist? We went along with a group. At the metro station in Fontenay, the group of black-clad young men formed and reformed. None of them paid the fare. I don't travel that way. Instead, I became stuck in the turnstile, and a station attendant helped me. I needed to buy a two-zone ticket at the machine. The anarchists were jumping all around us, but the worker paid them no attention. It was as if they were invisible.

We arrived at metro Bastille and walked toward the squat. Maxim explained, "We don't fetishize the building. We squat and squat. We don't negotiate." I remarked that the Fontenay building looked like a good prospect for long-term institutionalization, to get in ahead of the game and have a say in what the building is ultimately going to be used for. Silence. We arrived. Le Bourdon-l'Arsenal was also festooned with red and black flags and defiant graffiti. The squat had been a ground floor of a factory, closed off by double steel doors. Inside was a party space with a bar, which had clearly seen a deal of good times. Their logo was a deer in the street, fist raised beside a pile of burning debris. Behind the deer-person, what looks like a line of police with riot shields stand in front of a line of barbed wire. I photographed some cool graffiti and wall murals.

Main room in the squatted social center Le Bourdon-L'Arsenal, Paris, 2011. (Photo by the author)

Upstairs was the private space, a floor of rooms all joined to a central common space. This was a well-lit circular room, with rich plasterwork on the ceiling and inset paintings of fauns and nymphs. It looked like a classic bordello. Several squatters were sitting around on low-slung couches and rococo banquettes. There was some sadness, I was told, for the group had recently lost a friend to a drug overdose. A woman with dyed red hair hobbled around the room on a bandaged foot. She was a real *actrice*, and amused the boys. She seemed no stranger to drugs herself.

I had a long discussion with a serious young woman named Sophia about political art, Surrealists and Situationists. I explained ABC No Rio and the House Magic project. She confused the New York space with ABC – Anarchist Black Cross, the venerable prisoner support group. Their house had recently held a benefit for a squat in São Paulo, Brazil, which had been occupied by ABC.

The squatters at Bastille were waiting for the cops. Eviction was certain. Every so often, someone would look out the window, and

make a remark like, "Here come the flics." "They are joking," Sophia said. Still, I was growing nervous. I was hungry after the thin soup lunch in Fontenay. Deciding that I'd rather not be deported on an empty stomach, I made my excuses.

The scene at the Bastille squat was eerily like a play. With squatters pacing and mugging in a faux 18th century salon room, watching for the cops and smoking like Belmondo, it resonated with a hazy memory of dozens of films about doomed crooks and anti-heroes. On the metro back to Sèvres a man got on at the Beaubourg stop. He was reading an art magazine. The back cover had an ad for a Superflex show, and inside was an article entitled "Destroy the Museums!"

We were playing a game, *un jeu de guerre* – a low level conflict as a way of life. Maxim told me that the bail for arrest for having no ticket in the metro is less than the fine. (It's 40 Euros as against 200.) He'll risk arrest rather than give his name and take a ticket. Like graffiti writing, squatting is a sport, and an adventurous way to live. One art strategy could be to identify the parts of the game, and make playing equipment – like the "marihu" game of Jasper Groetveld in '60s Amsterdam. I started thinking about solidarity art, "soli-art," like soli-parties. To some activists that sounded silly. I think not. Art humanizes, naturalizes, softens and reduces the gravity of political situations to something that is somehow comprehensible, even humorous, and different than the hard polarizing facts of confrontation.

I considered that a symbolic barrier might be constructed as an art piece, to be completed by the evicting police. Each component of a multi-modular barrier could have the name of the squat on it, becoming an *objet d'art* only when completed by the police. How to retrieve them once the barrier has been broken? Ah, that's the rarity! I proposed this bustable barricade to Eric. Perhaps his Fashion Garage group would want to take it on? Eric replied he had long thought of making a barricade museum of old artworks to use in squat defense. This was like his Zonméee squat project in the '90s – making a museum of things.

The thread of what could be called adventure squatting runs also to solidarity with *sans papiers*, immigrants and the homeless. This amounts to a tradition in Paris. In SqEK meetings we had heard from Baptiste Colin, *aka* Tisba, about the campaigns of Abbé Pierre's group in the 1950s. Tisba told us of the tin pan parades that would be held on eviction day in Paris as activists led evicted families to new squatted

homes. Back then, the movement was aggressive, at times even armed against landlord thugs. The famed priest, a member of the wartime French resistance, became actively involved in homeless issues early on. As late as 1994 he himself was squatting, declaring that "families which occupy an empty home owned by a firm of rogues cannot be thrown out." [Getty, 1994] At the same meeting, Thomas Aguilera spoke about the complex position of governance towards squatting, based on the paradox of the French constitution that affirms both the right to housing and the sanctity of private property. [Aguilera, 2013]

On another solo outing, I went to see 59 Rue de Rivoli, the legalized occupation on the Parisian luxury shopping street. It seemed like a fun-filled scene for the participant artists. But it surely was apolitical and inoffensive, and full of the artists' screaming desire to be seen, and naturally, to sell artworks. (The municipal overseers require that all the studios be open to the public.) I walked through it quickly, like any other tourist, not talking to anyone except to nod and approve, as I would at any open studio event. After years of working as an art critic in New York, it is never easy for me, grazing along like a metropolitan beast, looking for something interesting which I will not end up buying. The banality of most work and the stability of the shopping routine make for a kind of hell, a poor way to interact with a creative milieu. "200 meters from the Louvre" boast the flyers – yes, 59 Rue de Rivoli gives the young tourist a sense that they might matter in the world of culture, that there is some life and reality to art, and that being an artist can be positioned outside of a museum-tomb. The "after-squat" both glamorizes and deflates the idea of art and the artist. I thought the best thing in there was the Musée Igor Balut, a massive junk assemblage by a possibly fictional artist who was thankfully not sitting in it, and nothing in it was for sale. After what I'd seen in Paris, the legalized art squat was no longer very intriguing for me.

I saw a poster in the hallway for the show that a Portuguese art entrepreneur had put on in the Gängeviertel. Mobile hedonistic creative youth, *tres bien*! Go where the sun shines and the cities welcome you; bring fun and interest to a place for free. You will have to leave eventually, but hey, who wants to stay anyway? Life is short and there's a lot to see and do. The artists move on.

Stickers on the door of the radical radio station we visited in Paris, 2011. (Photo by the author)

NINETEEN
SLAMMIN' AT JOE'S GARAGE

My understanding of European squatting movements expanded enormously through the work of SqEK. The Anarchist Book Fair in New York in the spring of 2011 featured a panel on "Squats, Social Centers and Autonomous Zones,"[1] and myself and the artists of La Générale video-called in from Paris. The talk was held at a satellite venue of the fair, the

1 Sebastian Gutierrez, "Squats, Social Centers and Autonomous Spaces – I," the first of his five part documentation of the April 2011 discussion at HTTP://WWW.YOUTUBE.COM/WATCH?V=XMPIM55S3P4. Participants were: me, Howard Brandstein, homesteading organizer and director of the Sixth Street Community Center, Frank Morales, Episcopal priest, squatter and housing organizer, Marta Rosario, resident at Umbrella House Squat, and Ryan Acuff of Take Back the Land.

Tamiment Library of labor history.[2] The discussion was organized by the Colombian filmmaker Sebastian Gutierrez working with O4O – Organizing for Occupation, a group directed by Frank Morales. Frank is an Episcopal priest and a longtime squatter activist.[3] Sebastian had made documentary portraits of the previously obscure Spanish-speaking squatters in Loisaida. None of them assumed leadership roles in the movement because many were illegal immigrants. The discussion reflected the growing linkages between New York activists and the newer U.S. occupation movements.

In the spring, Hans Pruijt called for a "mini-SqEK" meeting in Amsterdam during the summer. Nazima Kadir, working on a PhD in anthropology at Yale, was moving away and Hans felt we should hear about her work *in situ*. (I had met Nazima briefly two years before.) The SqEK meeting happily coincided with an invitation I had received from the Amsterdam art space W139 to give a talk on the cultural history of the Lower East Side.

The Dutch movement is one of the oldest and best known postwar squatting movements in Europe. It began in the 1960s, when the prankster activists of Provo [Kempton, 2007] published their "White House" manifesto. Rather than wait for years on social housing waiting lists, young Amsterdammers started taking the matter of housing problems into their own hands. Soon they had squatted hundreds of houses in the city center. Thanks to the initial clumsy repression by the police, the squatters gained much public sympathy. As time went on, the movement acquired broader political objectives. The Provos dissolved, and some of them went on to have political careers. Bizarrely, the powers that were had decided the city needed an underground

2 The library had acquired the "Squatters' Rights Collection: Jane Churchman Papers." (Its full name is the Tamiment Library and Robert F. Wagner Labor Archives, at Bobst Library, New York University. Access is free to the public upon request.) Old-line radical historian Michael Nash was the director when this material, 1.5 feet, was acquired. Other material relevant to the relation between art, squatting and occupation in downtown Manhattan is to be found in the same library, in the "Downtown Collection" of the Fales Library & Special Collections. (These include the Lester Afflick Papers, *Between C & D Archive*, Stefan Brecht Papers, Collective Unconscious Archive, Sylvère Lotringer Papers and Semiotext(e) Archive, and others. Access to Fales is also free upon request.)

3 O4O, or Organizing for Occupation, is a group supporting direct action squatting and eviction defense in New York City and environs. It is closely related to the organization Picture the Homeless, and includes Robby Robinson and Frank Morales.

metro. This would require massive demolition and squatters carried out strategic occupations of historic canal houses in districts targeted for urban renewal. (This campaign was Hans Pruijt's case study for the concept of "conservational squatting." [Pruijt, 2004]) By the time of our visit, the squatting scene in Amsterdam had undergone many changes. Squatting had been criminalized. Still, as we were to learn soon, the practice was by no means historical.

I had visited Joe's Garage, a storefront social center, some years earlier for their weekly Voku kitchen event. (See Chapter 4) It's not a big place, and the attitude towards visitors is not overly friendly. It's thick with evidence of classic Dutch squatter attitude – dry, humorous, with barely concealed aggression. But this visit was different. We were guests. We were not invited to stay anywhere, but we were made to feel comfortable in the nicely decorated room during the conference, and the political workings of Joe's were fully explained. The "garage" is set amidst a web of streets named after the Dutch founders of

SqEK members and their hosts in Amsterdam on the roof terrace of a self-managed office building full of artists, galleries, and offices. (Photo by the author)

South Africa (Afrikaaners), and at least one hero of the anti-apartheid movement. For many years this district was the home of immigrants living in social housing. Now the relentless pressure of the city's housing market has led to a cycle of privatization, speculation, evictions, and redevelopment. Amsterdam's "squatting group east" – since the city has long been divided into sectors of a united movement – has conducted a campaign of occupations and tenant organizing against these processes of gentrification.

Momo, an activist in in Amsterdam's squatting group east, explained that Joe's Garage was named after Joe McCarthy – not the notorious rightwing U.S. senator from Wisconsin, but another, Joe Cyrus McCarthy, an Iranian who backed the Shah and fled to Amsterdam after the Ayatollah Khomeini came to power. Joe bought a house with black money, Momo told us, and intimidated the rental tenants into moving out. (Amsterdam real estate is a good place to launder money gained from illegal activity, according to Momo.) As soon as the authorities found out, Joe fled the country to avoid prosecution, and the squatters took over his house. This was the first Joe's Garage, which they held for seven years. Relatives of the owner took them to court, but could not prove they owned the building. Because of the irony in the name, the squatters used Charlie Chaplin as a symbol for the squat. The English-born Chaplin was expelled from the U.S. as a communist during the more famous McCarthy's crusade. In 2008 police, with water cannons appeared at the door of Joe's Garage at 6:30 in the morning. It was time to move... across the street!

Nazima Kadir had been studying the Amsterdam squatter scene for several years, immersing herself in their anti-gentrification campaigns and living in a squat. She was the lead presenter of the "mini-SqEK." Her work concerned the internal dynamics of the Amsterdam squatter movement itself and traced the trajectory of activists' "careers in the movement as a scripted path to self-realization and autonomy," including an extensive analysis of conflicts taking place.

Nazima explored what she calls "squatter capital" – who is a "real" squatter, and how they demonstrate their skills through "activist performance," both within the public sphere of the squatting movement, and the private sphere of a squatted communal house. The kinds of questions she asked within the world of Amsterdam squatting group east were: Who is listened to? Whose suggestions are followed? What makes someone a figure of authority? How do these processes play out

in private life? "People who are gossiped about the most, particularly their sexuality, have the highest authority."

Nazima's talk touched on many issues key to a sophisticated understanding of the culture of squatting, within the public sphere of the social center, movement meetings, and the private world of the communal house. She spoke of involvement in the movement as "an extended adolescence." People are usually in the movement temporarily. Those who are "unable to leave are seen as marginal. They dissuade people from long-term identification, because they don't want that as their future." She spoke of the "taste culture" of squatting: dressing, eating, and walking. "Every point of taste speaks of your convictions... every moment of consumption is a moment of conviction." Many movement leaders, she said, get the kind of skills a social movement requires, then move on to be middle class professionals.

Nazima's work points to uncomfortable realizations, especially for those involved politically. I muttered darkly that this was precisely what the CIA men I met at Yale would like to believe about the squatting movement, as well as laying the groundwork for evolving strategies to disrupt it. Alan Smart remarked that the German movement, which we had recently examined, seemed to have had "higher stakes." Cesar, a young scholar who would later present on Milan, suggested that the dysfunctions Nazima described arose from the adjustment between radical ideology and the values dominant within society.

Miguel Martinez noted that social movements have their contradictions, but these must be seen in relation to their achievements. If the contradictions are so strong that it seems people are only "doing social life," partying and so on, then this is a serious matter. But if activists can live with some contradictions, then they can develop their work in the city, as opposed to living a pure life in the mountains. "If you refuse that utopian model, once you are involved in society you are experiencing contradictions. Building community resources, sharing things, building networks, opening islands in society – this is the political point of view." The movement Miguel knows in Spain is open to new people "only if they join the philosophy of self-management and opposing capitalism."

Nazima responded that behaviors in houses and social centers are quite different. "There is a difference when you share your whole life with people and when you share only your activism.... I am looking at how internal dynamics work." She had presented her work to

the people she wrote about, and they asked her what is the relation between the good things we do and hierarchy and authority? She responded: "I still don't know. I don't think this is a dysfunction, I think this is how groups work. Groups define themselves according to rhetoric, but they can't work that way. I did four presentations in squats. In one, a guy was drinking (which is not allowed), and saying abusive things. I yelled at him and threw him out. Others said you are being authoritarian. People who worked in social centers said you are doing the right thing. People who don't work in the movement said you are being exclusionary. People in the movement said yes, you have to set limits." Momo chimed in to say that at a meeting he attended the day before, "a group was overwhelmed by hash-smoking couch potatoes who won't do any work, and no one had the guts to throw them out."

Later on, Momo led us on a tour of the immediate neighborhood of Joe's Garage. He outlined the housing crisis in Amsterdam that puts both co-ops and rental housing out of reach for most people. Rent is regulated, and "the waiting list for social housing is 14 years. In reality you cannot get in. You can get a job right away for six euros an hour, so there is a giant gap" between what is available and the low wage earners and renters. There is little or no profit in renting residential property, so the push is on to convert it all to co-ops. Renters are being "mobbed out" of their apartments – most of them built as social housing – and their units are being converted for sale. Squatting group east does an occupation publicly, with 50 people. "In one hour we open it and we close it" – that is, they barricade the house against eviction. "They wanted to sell the apartments, so we squatted." Activists joined some of the remaining tenants, like the ex-taxi driver from the building where Nazima squatted, a woman with "an ass of stone" who refused to move out. I had seen that in bank-owned buildings in Madrid, squatters and aging rental tenants are joining forces in a similar way

The Dutch squatting movement has been fractured by the emergence of the "anti-squatters," short-term tenants acting as guards for private security companies in return for cheap rent. Often low-wage workers and students who used to be squatters themselves are now anti-squatters. The developers use them to "protect their speculative emptiness." In the late 1980s, buildings were seized, collectivized then legalized. To prevent this now the buildings have been filled with these "scabs." Tito Buchholz interviewed the CEO of the Hamlet Europe anti-squatting company. He was told that employing anti-squatters

was "cheaper than security" for empty buildings. The company managing the buildings near Joe's Garage is called Alvast. Momo pointed to one of the building with their banners on its façade.

On the Kruger Plein, there was an anti-squat with an art gallery in it. A signboard read "Open." Momo led us into this public space hung with anemic abstract paintings. He asked the attendant to explain what he was doing there. The man said they got the place because it was in development. The developers wanted people there to make the place more lively, he went on. Previously, it was a house full of Moroccans ridden by poverty and crime. Momo told him: "You are here to keep us squatters of squatting group east out." He cursed him, and our group marched out. On the way out, I told the chagrined young man, "C'est la vie – c'est la critique." Walking on, we passed elegant modernist houses designed by a famous architect, social housing of the progressive era. Some of these were once squatted, now they were filled with anti-squatters. There was another storefront – "Ah, you see? They are all artists!" Momo cried. "These properties are temporarily administrated by artists."

Walking on, we came to a large high-rise office building and rode the elevator to the rooftop cafè. From there we looked out over two similar office buildings with the names of Dutch newspapers emblazoned on them. The same company, Momo told us, owns all of these newspaper office buildings, even though the newspapers represent different ideologies and political positions. All these are now empty, and filled with anti-squatters as they await redevelopment. There is a huge excess of office space in Amsterdam, Momo maintained, and there is more being built still. These assets are hyper-valorized on corporate books, but in the real market they are not so valuable. The Netherlands is sitting on a giant commercial and high-end residential real estate bubble. The building we were in had been organized by squatters. To engage in the legalization process takes commitment, Nazima said, unlike squatting itself. Now the building was full of artists' studios – among these, Alan Smart told us, is the Urban Resort group, with Jaap Draaisma as its principal. He was a squatter in the '80s, and connected to the Adilkno group of squat-based media activists.[4]

4 ADIILKNO, *Media Archive: Adilkno: Foundation for the Advancement of Illegal Knowledge* (Autonomedia, 1998). ADILKNO / BILWET [Foundation for the Advancement of Illegal Knowledge / Stichting tot Bevordering van Illegale Wetenschap] was a collective of five artists/authors, Geert Lovink, Arjen Mulder, BasJan van Stam, Lex Wouterloot and Patrice Riemens.

Now he advocates and organizes temporary use strategies for cultural groups in municipalities. (We would see him two years later, speaking at a conference at Ruigoord.) This building, Momo said, is a "competitively hip place." It is not a giant squat. A collective of the tenants deals with the owners.

Momo told us of squatted streets in the neighborhood, today was dotted with chic cafès with open windows, plants and chalked signboards. We popped into the storefront of a charming old apartment building where we met Andre, a white-bearded grinning squatter. Nazima praised him for his fearlessness during police assaults. The tiny space, called Blijvertje has, since 2007, mounted food service, concerts, poetry readings and political assemblies. It was a social center. Momo pointed to a swiftly executed ink drawing on large white paper in the window. He praised the late squatter artist: "Hank documented our struggles, with an aesthetics which served the content." As if to validate some broader role for artists than sketching, Alan Smart spoke about the work produced by the Event Structure Research Group, inflatables to support the Nieuwmarkt district occupations carried out in the 1970s by ex-Provos and Kabouters to oppose construction of the Metro line.

Back at Joe's, Cesar Guzman-Concha presented his work on the Italian social center movement in Milan in the mid-70s, the high tide of the radical left. In the two years between 1975 and '77, 35 illegal social centers opened in Milan, including Leoncavallo and Cox 18, which continue to this day. The city became a point of diffusion of the movement to other cities in Italy and abroad, especially Spain. Tino Buchholz had just finished a film about Amsterdam called *Creativity and the Capitalist City.* [Buchholz, 2011] He reported on the big Hamburg meeting of the anti-gentrification network Right to the City, which had been nearly simultaneous with our conclave.

Miguel told us about the 15M encampment in the Puerta del Sol of Madrid, the strongest European echo of the Arab Spring. I would soon have my own up-close view of the great 15M experiment. Hans Pruijt had lobbied, unsuccessfully in the Dutch parliament against the squatting ban in the Netherlands. In his talk at Joe's Garage, he engaged what he called an emerging argument among intellectuals that squatting is a precursor of neoliberalism. He outlined the reasons – among them, that squatters and social centers are plugging holes left by the retreating state with their giveaway shops, language classes, free

food, etc. This led to a lively discussion, particularly about the ways in which the squatting movement across Europe has become a sort of a training ground for future managers and politicians.

There was an awkward moment when Nazima accused Miguel of bad faith for recording the meeting without permission. I regretted that Lynn Owens, our U.S. expert on the Amsterdam squatting movement, was not on hand to calm the waters with his shy politesse and keen analysis. Miguel took the accusations with aplomb. Throughout these days, Nazima's peppery positions opened up a lively and productive dialogue. The questions she raises are ones many activists don't want to confront, so there is the danger that a researcher in solidarity with activists may tend to avoid them. On the other hand, I am convinced that unlimited critique prizes out the mortar from every block of new world construction. I prefer to let things be, to help them grow, instead of nipping them in the bud, and to concentrate on aspirations and their adventures rather than contradictions and failures they can lead to.

Hans took us on another *dérive*, on bicycle into central Amsterdam to visit several of the sites of resistance and historic squatter occupations he and Nazima selected. We passed a windmill building that contained a brew pub and brewery, the commercial incarnation of a company that had begun by brewing beer for squatters. Some of the younger participants in our tour introduced us to some Spanish women living in an abandoned boathouse along the canal.

While the "mini-SqEK" was fascinating as ever, I had other fish to fry in Amsterdam. (The herring that were running then in Holland, however, are eaten raw with chopped onions and pickles at stands parked on the canal bridges.) I had been invited to give a talk at the W139 art space. W139 is in the center of Amsterdam, very close to the central station. It is surrounded now by "coffee shops" selling marijuana and other intoxicants, and a stone's throw from the red light district where pop-eyed young men ogle the ladies in their glass-fronted cages on the street. While today it is sleek, W139 is also an example of old-school DIY. It was first squatted in 1979.

During my visit, W139 was hosting a show by Glasgow-trained British artist Jonathan Monk. It was backward looking, an installation as a kind of gloss on a 1989 exhibition of East Village artists called "Horn of Plenty" at the Stedelijk Museum in Amsterdam that had influenced Monk as a student. He had W139 drop the ceiling

on their spectacular interior space to exactly his own height when wearing high heels. The drop concealed about 10 meters of light-filled gallery, creating a bizarrely institutional environment in which to look at installation photographs of the 1990 exhibition.

I had been recommended[5] to Tim Voss, the lanky director of W139, to talk about the East Village district, *aka* the Lower East Side, back in the day of the "Horn" artists, the '80s of the East Village gallery movement. I started in the 1960s. Monk seemed a little bewildered as I talked about Ben Morea, Valerie Solanas, and Tuli Kupferberg, then carried on into the '80s and '90s with Bullet Space, Fly and Seth Tobocman, ABC No Rio and the Rivington School – the near-forgotten roster of crusty heroes and heroines of the rebel LES, all remote from the artists of the 1989 "Horn" show. At the time, the squatter gang called those artists the "neo-geos," and held them in contempt as appropriators not only of other art and popular images (the name of the movement has come to be "appropriation"), but also of the bohemian Lower East Side itself. At W139, we all agreed that when there are few opportunities, artists have to make them for themselves. Jonathan did it in Glasgow, with his schoolmates.

At the opening party for Monk's show, I met Ad de Jong, an artist, graphic designer, and one of those who first cracked the W139 building as a squat years ago. Amidst the noise of the crowd Ad told how a fellow had wandered in then, a "financial guy," who said his group could secure the building for a long time if they did something for the community. So Ad hung in there after the other artists drifted away, and W139 became a real art space. Now they own the building, which has been beautifully renovated as one of the biggest contemporary art spaces in the center. W139 has a huge downstairs – which the artists' collective Jochen Schmith had asphalted (!), a bizarre floor treatment that made the opening party edgy with the tinkle of beer bottles just aching to be smashed. Later that night, a friend of the gallery crew drove his custom made open road motorcycle right through the front door and all around the large asphalted gallery space, making a hell

5 I was recommended to Tim Voss by Stefan Dillemuth. This Munich-based artist and his partner Josef Strau produced a show on the East Village art movement at the Pat Hearn gallery in New York in the 1990s. Years later, Stefan invited me to the Munich Kunstverein to talk on NYC artists' collectives. My presentation, much revised, was published as "Crosstown Traffic: Soho, East Village and Downtown New York," in Stefan Kalmár & Daniel Pies, eds., *Be Nice Share Everything Have Fun* (Munich Kunstverein, 2010).

of a noise and a leaving a nice tire mark on the wall. This impromptu "intervention," as they say, seemed superbly elegant and appropriate to the installation.

What with the mini-SqEK and the talk for W139, I didn't have much chance to check out other squat scenes. Despite the recently passed anti-squatting law in Holland, Amsterdam abounds in them, past and present. I did visit a squatted school building taken by the Schijnheilig group (Shine-High-lig), and made into a cultural center that was hosting a music and concrete poetry night. ("It was in Dutch," artist Renée Ridgway told me, to console me since I missed the performance.) Vincent Boschma, my host at W139, told me this place was due to be evicted in a wave of police actions against squatters next week. And so they were, very soon after, despite a resistance more colorful than militant. A group of clowns from Rebelact dressed in white bridal gowns ended up being clubbed by the police, along with many others, in a show of force that shocked the movement.

I had met Vincent some years before, when he was working for Anton Van Dalen in New York. Anton is a Dutch artist who has lived on the Lower East Side since the 1960s, and was active with the political artists' group PAD/D and ABC No Rio. Vincent wrote an article on autonomous spaces for *House Magic*, treating projects in both Amsterdam and New York, including W139 where he was working. On this trip, Vincent was busy with his installation in a deserted shopping center, where artists had been given permission to mount a large show.

Renée has a studio in the Kinkestraat, a famous old squat gone legal. We went up to her place to carefully examine the collection of Provo and Kabouter documents Alan Smart had gathered from antiquarian book shops. The vitality, creativity, and pure Dutch cheek of these movements are still palpable in these beautifully-made (albeit cheaply produced) old pamphlets and books. Alan studied architecture, then attended the Jan Van Eyck Institute in nearby Ghent. He has interviewed many past members of the Dutch squatting movements, and plans a book on the topic.

On my last day, I biked around to look at Binnenpret and OCCI, two spaces squatted relatively recently. These were out along the Overtoom, a busy street that runs near one side of the Vondel Park. Binnenpret is a complex of low buildings. It is an important venue for new music and punk bands in the city, and the bizarre – to my eye – traditional buildings have been renovated, tarted up with bright

colors on bare wood. It looks like a postcard picture of a Swiss chalet. In the courtyard, it's hippie-land. A half-dressed Dutch couple darted out of the collective sauna to check the weather in the courtyard: "Oh, it's raining!" and went back in. The cafè is lovely, a glass-fronted jewel-box with a charming garden outside.

Another place, Ot301, is a giant dark building from 1955, a former film academy, with a courtyard, a downstairs café, and a finely tricked-out recording space. The building houses numerous projects, including the design group Experimental Jetset, which had recently produced a show at W139 about the Provo movement. [Experimental Jetset, 2011] Some of them were working on development for Ot301, and visiting other art spaces to get ideas. Their last pit stop was ABC No Rio in New York where I had just missed them.

All in all, my time in Amsterdam had been tremendously productive. Although she was there at the beginning of SqEK in Milan, I have not seen Nazima since Amsterdam. Yet strangely enough, I saw some of her work a year later at the annual ARCO art fair in Madrid. She had been working on a situation comedy about her research as part of the ambitious multi-year Utrecht-based Casco research and exhibition project called "The Grand Domestic Revolution."[6]

6 While Nazima Kadir did not attend any of the subsequent SqEK meetings after her turn in Amsterdam, she made a surprising appearance by proxy as a collaborator on an art project at ARCO, the commercial art fair in Madrid, in February of 2012 as part of the "Dutch Assembly" national component. Artist Maria Pask and a team of artists produced a TV soap opera about squatters based upon her research called "Our Autonomous Life." (See her blog at: NAZIMAKADIR.WORD-PRESS.COM/BLOG/.) This was part of a larger program, "The Grand Domestic Revolution," an ambitious multi-year research and exhibition project, at the Casco Office for Art, Design and Theory in Utrecht.

15M encampment in the plaza of Valencia, Spain, 2011. (Photo by the author)

TWENTY

THE CAMP AT THE GATE OF THE SUN

The year 2011 was the revolutionary year of the early 21st century, a 1968 for the new generation. The tide of rebellion started in Africa, in Tunisia, rolling into Egypt, ricocheting into Europe and through austerity-wracked Greece. Finally, in September, it hit the U.S. with Occupy Wall Street (OWS). The big news where I was living was 15M, the short name for the Spanish movement that kicked off on May 15th with an encampment in the Puerta del Sol – the Gate of the Sun, the immense central plaza of Madrid.

The rising in Tunisia, called the Jasmine Revolution, was the subject of intense interest within the European student movement. The visit arranged to talk

to organizers there was promoted on the Edu-factory list-serve. The dramatic events in Egypt were followed more closely in the western press, since Egypt is a large economy and a key U.S. military ally in that region. These events led to a great surge of hope among resistants and militants in the west, and bafflement among the talking heads of the U.S. mainstream media. Only BBC journalist Paul Mason seemed to have it right in early February, with his now-famous blog post "Twenty reasons why it's kicking off everywhere." [Mason, 2011, 2013] In the fall, worried U.S. elites for the first time ever (and since) turned to the likes of David Graeber and David Harvey, who are normally *personae non grata* on corporate airwaves, for an explanation. By December, even *Time* magazine had taken the cue, naming "The Protestor" its person of the year.

This bafflement was the result of the programmatic historical amnesia of the corporate-sponsored television media, always surprised by any popular movement of resistance to globalized capitalism. Many features of the Arab Spring and Occupy movements – mediated connectivity, horizontality, diversity of tactics – were already present in the turn of the century movements against the global summits of government and corporate leaders, or the global justice movement. [Yuen, et al., 2001] What was new in 2011 was the large-scale adaptation of the tactic of encampment. Even this tactic, however, has decades-long antecedents in the long-term "peace camps" around nuclear installations in Europe. [Feigenbaum, et al., 2013]

Like so many others, I followed the action on the internet: I watched news programs, live video streams, and news websites with Twitter streams. I watched in horrified amazement as Mubarak's hired goons mounted on camels attacked the Tahrir Square occupiers. Many analysts were calling this extraordinary new connectivity the very cause of all the risings. Without doubt, new media facilitated the organizing. But it was equally clear that mass demonstrations, and more particularly large-scale prolonged occupations of physical spaces played the key role. Bodies, not signals made these revolutions.

As soon as I returned to Madrid, I hastened to the encampment in Puerta del Sol in the center of the city. By then, the 15M movement was two weeks old, and fully articulated. It was a kind of huge civic festival, and tremendously exciting. Activity of all kinds swirled around us in the many different zones and impromptu "offices" that the campers had set up. My partner Malena cancelled her meetings

and we wandered around in awe. She quickly became engaged in conversation. For me, with minimal Spanish, it was mostly a spectacle. Still, it all seemed quite familiar: marvelous, but unsurprising. It was an open-air social center, the biggest I had ever seen.

The police station fronts on the square, and it was surrounded by blue barricades. Cops stood behind them, glowering at the encampment. Cameras were everywhere. One hipster had set up a backdrop and was taking photos of passersby who wanted to dress in a costume. In a tented area set up by the "activities and scenic arts committee" people were playing guitar, singing, and conversing in the shade. White haired leftists wandered around grinning. Painted and drawn signs of every kind were everywhere – taped, pinned, hanging from strings.

Every corner of the square was filled with individual campers and their tented common areas, each with a colorful name. A tall building with construction scaffoldings facing the square had been covered with signs, completely effacing the advertising billboards. The ever-present dressed-up cartoon characters of the Puerta del Sol plaza had been pushed out of the square. Their king, Mickey Mouse, hovered around the outskirts of the camp waving balloons. The bronze statue of the bear of Madrid had a flower in its mouth. Children played on a scaffold hung with a banner reading: "We are the [child's drawing of a smiling sun]." The glass-domed subway station was plastered with signs as far up as could be reached, signs upon signs upon signs, a thick crust of expression.

One information booth – the "Committee of internal coordination" – had a graphed hour-by-hour calendar of the day's assemblies and meetings. Other tents dealt with other functions of the 15M with volunteers and the ever-present signs: "Make your proposal" – "Participate in your neighborhood" – "Look for the assembly in your barrio," scrawled atop a massive list of all the neighborhoods in Madrid.

A kitchen had been set up, with food delivered and cooked there. Behind the existing iron fences of the plaza lurked concentrations of media equipment that streamed video and communicated the 15M presence to the world. Media swarmed, and press conferences were being held, but mostly dozens of conversations with very different people were going on all around us.

There was even a crude mural with cutouts for your face. Malena photographed me in it holding a sign reading "Spanish revolution"

(in English), and a T-shirt, "I want another world, and it is possible" in Spanish. ("Another world is possible" is a well-known slogan of the global justice movement.) Behind me in the photo was a painted panorama of the 15M encampment.

We returned on July 23rd for the arrival march of all the *indignadxs*, as the protestors were called. (The "x" makes the word gender neutral.) They were walking to Madrid from cities all over Spain, talking all the way. (Puerta del Sol holds the "kilometer zero" of the country, from which all distances in Spain are measured.) The contingents made their entrances from different streets leading into the plaza, flags waving and drums beating. The square was packed with people cheering the arrival of protesters from several provinces and cities of Spain. The evening saw a national assembly of *indignadxs* from all over Spain, hundreds of people in orderly discussion.

In the summer "mini-SqEK" meeting in Amsterdam, Miguel told us he had been there at the start. On the 15th of May, he went to the plaza with several hundred people in the autonomist and libertarian bloc. There they found themselves in a crowd of 15,000, and the objections they normally had to most other political initiatives melted away. The group which had called the demonstration decided to occupy the plaza, and Miguel's bloc joined them under conditions that previously they would not have agreed to – i.e., no violence, reformist claims on the democratic system, talking to the mass media, etc.

"We liked that this demonstration was forbidden, management was absolutely horizontal, and no flags – even the anarchist flags were forbidden. Finally, taking the public space – we wanted always to mobilize people in the street.... It was a very autonomous movement, even for people who never listened to the word 'autonomy' – it was absolutely new." There were many problems, with homeless people, sexist attitudes by men, excessive drinking (endemic to this tourist destination at any time), and a lack of political memory. "But the truth is that something changed. Now even squatted social centers which didn't work together in the past are working together in this occupation."

This was clear from the social center I was visiting regularly. Tabacalera was vast and impersonal, and showing the first signs of an internal strain that would soon cramp its activities. (It was very often closed.) Miguel worked with CSOA Casablanca, which was just up the hill from the Reina Sofía museum. In one outing I could visit both

the museum and the squat, so I started to go there regularly. When the 15M activists came to town from around Spain, many of them stayed at Casablanca. The backyard and courtyard were full of sleeping bags. A great mural appeared in the courtyard, a trompe l'oeil of a white-clad painter "painting" the 15M assembly in Puerta del Sol which appeared under his roller. Casablanca also offered temporary shelter to evicted tenants referred by the PAH (Plataforma de Afectados por la Hipoteca; the movement or platform of mortgage victims). After the dispersion of the Madrid encampment, the center came to house the archive of the 15M encampment at Puerta del Sol (Archivo 15M), and the library of books that had been assembled there (Biblioteca Acampada Sol, or Bibliosol).

The 15M was especially fraught for Spain since it took place only a week before national general elections. Demonstrations are forbidden during election periods, but this one continued. The 15M movement was not supporting any political party ("Make no demands"),

The assembly at Puerta del Sol, Madrid, after the delegations from the rest of the country arrived, 2011. (Photo by the author)

although the Izquierda Unida (United Left, including Communists) provided support. Only days after the movement broke, former Spanish prime minister and Socialist party graybeard Felipe González, in comparing the protests to those going on in southern countries, pointed out that "in the Arab world they are demanding the right to vote while here they are saying that voting is pointless." [Wikipedia, "2011–12 Spanish protests"] Posters appeared on the street pointing graphically to the complicity of both political parties in the austerity measures, and the conditions of the European Union financial bailout that were wracking the country.

The 15M movement was certain to be evicted from their encampment in Puerta del Sol. In anticipation, they had already planned their decentralization, just as the Spanish *okupa* collectives plan their next squat when eviction looms. Assemblies were created in every barrio or neighborhood of Madrid (which is larger than the city itself; a small province). Not all of them survived, but many did and thrived. The assemblies allied with existing neighborhood organizations, tenant unions and the like. In the city center and outlying neighborhoods, some of these assemblies began to meet in occupied buildings – social centers.

The impact of the 15M movement on political life in Spain has been considerable, and is built on the larger history of the left. The movement is made up of educated, under- and unemployed young people, a problem throughout the crisis-ridden Mediterranean countries. As time went on, I would conceive it to be my task to somehow link these two movements, OWS and 15M, through the medium of their graphic production, their images. I am not sure how successful this strategy, derived from the practices of '80s politicized art, can be. Still, I traffic in images, in representations, magazines and books. I make them, I present them, and I move them around. What effect that activity might have, finally, I cannot say. At least I was moving around and talking to 15M people.

I was working on *House Magic* #4 when 15M broke. It was already too late to figure out what to write about it, so that number has a color *back* cover, with an image of the Puerta del Sol encampment. At the same time, I was trying to figure out the puzzle of "New Institutionality," a tentative program of the Reina Sofia museum that followed along the thread of engagement between Spanish cultural institutions and the political squatting movement. [*Carta*, 2011] When I checked in with Jesus Carrillo, the museum's education director about it, he

explained that they were as yet unclear how to relate to the 15M movement.[1] 15M people had besieged their recent invitational meeting in Málaga. There had been a revolution, but perhaps it wasn't yet clear just whose it was. Finally, the museum seemed to back away from the New Institutionality initiative (Although by 2014 they would return to it). This seemed wise, for the sake of their own jobs, since the socialists would soon lose power to the right wing in a sweep that gave the Partido Popular (popular party) an absolute majority.

Throughout all the momentous events of the new Spanish movement I was bustling about the States promoting my new book *Art Gangs*. I was also preparing for my appearance at the Creative Time Summit in New York in the fall. Its curator, Nato Thompson, had been a respondent on a conference panel in Chicago in February where I presented my work, and he invited me then. Just as OWS was about to break in New York City, my plane fare and hotel there were paid so I could talk about squats to an audience of hundreds. The Temporary Services collective gave the "House Magic" project a booth at the opening of their "Market" in the "Living as Form" exhibition that accompanied the summit. [Thompson, 2012] (The show would later travel around the world in suitcase form as a synoptic survey of the slippery mode of art called social practice.) The "Market" idea was to include a rotating selection of local projects presented in a distinctly designed area of the broader exhibition. My son Taylor sat in the booth, next to Gregory Sholette's Dark Matter archive and ABC No Rio. In the last session of the summit, curator Nato Thompson led the audience from the Abrons Art Center on the Lower East Side down to the newly formed Occupy Wall Street encampment in Zucotti Park.

1 This turns out to have been unfair. As this book goes to design, the Reina Sofía Museum opened the exhibition "Aún no/Not Yet: On the Reinvention of Documentary and the Critique of Modernism" (catalogue forthcoming). It included a room installation given over to the "If You Lived Here" exhibition, which curator Jorge Ribalta conceived of as an extension into social practice of the post-1968 tradition of engaged documentary photography. In her talk at the museum, Martha Rosler said she had at last the opportunity to quickly reassemble some of the artists who had work in that show for the "Aún no" installation.

SqEK members tour the bicycle shop at Candy
Factory #2, Copenhagen. (Photo by the author)

TWENTY-ONE

COPENHAGEN: THE YOUTH HOUSE, CANDY FACTORIES, AND THE FREE TOWN

Copenhagen is a city where my fish-eating northern European roots stand out clearly. People are always talking to me in Danish. It's cold and clammy in early December, and a steady wind was blowing most days we were there for the SqEK conference. It cut through our clothing and impeded the forward motion of our bicycles. But the organizers had planned everything well. They had seen to it that we were all snugly ensconced in the guest rooms of collective houses owned by students, mostly in the Nørrebro neighborhood. I stayed with another attendee from Leipzig in a student house called Molevitten, a name which seemed to translate as "Shebang." Our hosts were accustomed to having guests. They easefully carried on their studies and collective life around us. Some showed a polite interest in our business, but the students were all seriously taken up with holiday

cookie making, their last group activity before leaving the city to be with their families.

We had our first SqEK internal meeting at another warm and cozy collective house where Tina Steiger, a German researcher and one of the organizers who would later lead our tour, lived. There we planned for the forthcoming book of essays, and the February meeting in New York City that would be my job to organize. The public SqEK meeting was held in the tiny cinema of the Bolsjefabrikken – the Candy Factory #2. It was a kind of DIY auditorium artfully constructed from found lumber. In the bitter December weather, we found that the video projector that put our presentations on the screen did not agree with the wooden stove heating the place. Our computers grew cold in our laps.

The compound of the Bolsjefabrikken itself was a graffiti speckled complex of small buildings splayed out over a paved courtyard. We had been briefed on the history of the multiple Candy Factory self-management projects. [Steiger, 2011] They came after the hard-fought eviction, destruction and resurrection of the Youth House – the Ungdomshuset in the middle '00s. That left a void in the Nørrebro neighborhood for radical, alternative, and underground culture. A collective of politically minded artists, craftsmen and students took over a former candy factory with the permission of the owner. There they hosted workshops, concerts, exhibits and early meetings of the Pirate Party political movement, dedicated to an ideology of free information.[1] Soon the artists had to move, and in 2009 they went to a former plumbing factory along the railway tracks in the same neighborhood. The complex, called Candy Factory #2, is owned by the city and the artists pay a nominal rent. This was the Bolsjefabrikken where our meeting was held.

The three buildings house various workshops, a cinema, kitchen, gallery, and a café bar. We tramped through these various parts, including attic studios for musicians and painters, and another building with collectively run spaces for silkscreen printing and sewing. There is a gallery where they sell T-shirts, bags, calendars and such at cost. It was closed during our visit, so we bought some "merch" that was lying around the ateliers.[2] The Candy Factory also had a new record-

1 The Pirate Party is an electoral initiative that began in 2006 in Sweden (Piratpartiet), coming out of an organization opposed to restrictions on intellectual property. They gained seats in the European Parliament in 2009 ("Pirate Party," Wikipedia, accessed December 2013).

2 As I noted in the introduction, I collected squat and social center ephemera continuously during these years. The items from the Bolsjefabrikken store among

ing studio, and a video studio was under construction. They planned to build a computer workshop they called a hacklab. The attic held a painters' studio for easel work, and work desk stations for drawing and small scale painting. Living there is not allowed, although two people are there to guard and maintain the place. We rummaged through the piles of clothing in the chilly free shop. I dug up a two-sided fabric banner that had been hung in the streets during a recent campaign of support for the free city of Christiania, and split it with Femke Kaulingfreks from Amsterdam.

Every squat is cold in the winter. Although the collectives were allowed to use these buildings, they couldn't afford to heat them. Throughout this tour my notes are partial, because I didn't want to take my hands out of my pockets to write. Our tour of Bolsjefabrikken #2 ended up in the bicycle workshop, one of the few heated areas. An old bearded bohemian sat by feeding sticks into the handmade double oil drum stove. The workshop is large, with garage doors opening directly onto the courtyard. All over the grounds of the Bolsjefabrikken lie products of the workshop, bikes of all kinds, eccentric metal sculptures, cargo bikes, fantastic multi-level bicycle "experiments," along with metal scrap awaiting transformation. In other corners of the grounds massive piles of fire wood lay covered with tarps, in preparation for the long winter.

A burly young man in the metal shop explained that the original Candy Factory was a complex of ateliers occupied by different creative people. There are now two more of them. The Candy Factories also support political activism. They organized places for the thousands of activists who flooded into town for the Climate Summit called COP 15 in 2009, as did Christiania. The city asked the ateliers to house the activists, although the police later raided them and seized and destroyed belongings they claimed would be used for violent demonstrations. Edward explained that the Laboratory of Insurrectionary Imagination had collected abandoned British bikes on the docks of Bristol and shipped them to Denmark for the COP 15 activists to use. The police took all of these, and a video of the confiscation was posted online. (See Chapter 31)

Our host in the bicycle workshop told us all the ateliers make individual decisions about how they are to be run. Money is collected from each group for electricity and such. Access is important, a part of

many others are now in the Interference Archive in Brooklyn.

the ideology of the atelier. They do some small jobs for the state, and also fix bikes for kids. The police collect abandoned bikes from the street, and the Candy Factory recycles them. One day a week the bike workshop is open to the public, but they can't always be open. Our host carefully explained that if everyone can use your workshop, you are only always cleaning up, and can't do any of your own work. That's why the bike workshop at Christiania, which does a high volume of commercial work, is now closed. "We do every Wednesday open" at the Candy Factory. Other workshops also have open days, Tina said. (We saw the same at the Regenbogen Fabrik in Berlin.) Of course, said our host, "you just have to know the right people and you have access all the time."

While the Candy Factories are not squats, Tina said, they see themselves as being a part of the squatter movement because they pay no rent and are dedicated to the production of independent culture. Now they are trying to raise the money to buy the place from the city. The grounds of the Candy Factory #2 are contaminated, and something must be done about that. (The Regenbogen Fabrik in Berlin, a former paint factory, has the same problem.) "If we own this space," our bicycle shop host said, "we can do improvements at our own pace. We don't want to have rules over our heads."

Once we had warmed up, we hopped on our bikes and moved on, rolling down a dirt lane that cut through a vacant lot with a garden, an oddly built wooden shed and a house trailer. Tina said a group makes street furniture there during the summer. We stopped outside the gated-up site of the first Candy Factory. It was a thoroughly derelict ruin, painted all over with graffiti from its days of occupation. There were strange lumps of concrete studded with glass and ceramic shards protruding from the walls here and there, an odd form of sculptural graffiti. We could not get inside the courtyard, where a man eyed us with suspicion as he climbed into his car.

We journeyed on to Candy Factory #3, another complex of disused factory buildings, but really big, with too many buildings to see all from one vantage point. This was the place where the bulk of COP 15 activists had been housed. After the summit, Copenhagen artists decided to try to build it up and make it another Candy Factory. The principles are the same. In the large ground floor salon, a bearded fellow standing behind a bar gave us a talk. The place we were turned out to be a concert venue. "We can't use the upper floor," he said, "because the

improvements we made are not approved." But that had not stopped them. Climbing the stairs, we saw people everywhere busy building walls and installing fixtures. One room held drafting tables with what looked like pages of a literary magazine laid out upon them.

How many collectives are working here?, we asked. "Many." Another building held a concert venue called Mayhem, a place for experimental music. There are youth service places, like a Thai boxing club that works with at-risk youth. The artists and artisans using the place had made many improvements, he said, so now the city wants to raise the rent. The place was for sale for $20 million. They have filed a lawsuit seeking recompense for all the volunteer hours they put in. Parts of it were being built up, with a kita (kindergarten), for example. But, he said, "It could all be demolished. Whoever shows the money decides."

SqEKers asked what he knew about squatters in Copenhagen. Our host told us, "You go into a house and then you shut up. You sleep. Slumstorming we call it. There are a lot of these places. And they don't make any noise." They are not organized or declaring themselves. The

Courtyard of the Candy Factory #2, Copenhagen. (Photo by the author)

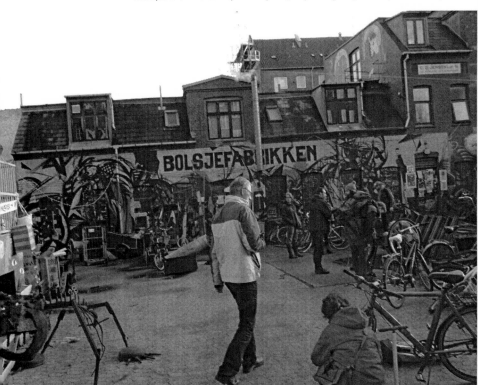

sprawling complex at Candy Factory #3 had a lot of squatters as well. "All the garages are squatted." For living? "No one really knows," the bartender replied. "I am going to a neighborhood meeting today, but some of the squatter groups won't come. They keep to themselves. We only see them when they use the toilets."

We climbed back on our bikes. Joost De Moor rode sitting in the square front box of a bike made in Christiania, the cargo tricycle that made their workshop famous. We wound through the city streets to a district outside the center to visit the new Ungdomshuset, the Youth House #2. The first Ungdomshuset, evicted after a bitter struggle, had been a leftist union hall, where both Lenin and Rosa Luxemburg spoke. The building had been let to young people by the city in 1982, and became an important music venue and political center. In 2006, the city government turned right wing, and reclaimed it. Despite a foundation's efforts to buy it for the youth, the city sold the building to a religious group, the Faderhuset Christian group (which weirdly means "father's house"). The call went out, and Autonomen came from all over Europe to tear the city apart in rage. Street signs all over were changed to "Jagtvej 69," the address of the evicted house. Residents of that street told one researcher there had been tear gas inside their apartment for a week.

We were shown around the Ungdomshuset #2 by a member of the collective. We got this house in July of 2008, she said. The place runs on money from concerts, T-shirt and beer sales. Touring bands get gas money, meals and a place to sleep. The activists also get meals. No living is allowed, but since they were robbed, there is now always someone there. We sat in a large cafèteria with a big kitchen on an upper floor. It adjoins a spacious library. Political groups also meet there. There are 100+ activists volunteering here, she said. They are keyholders. A private foundation is behind the project, the same one that tried to buy Ungdomshuset #1 unsuccessfully during early negotiations. Now they help us with #2. They are our link with the state.

Most of the riots took place in March 2007. There were weekly demonstrations of 300 to 1,000 people, and massive arrests almost every day. Some big demonstrations became riots. The police finally insisted that the city government do something, because their resources were strained. Criminals were taking advantage of the situation. The politicians had said, "No negotiations with the youth because they use violence." We always said yes, we would negotiate. We want a new house. This began in March of 2007, and by October they said

yes. Concerts continued at various venues. All the trials and arrests are now over. Only the legal bills remain. Some politicians continue to hassle the house, but really the state won't start expensive trouble with us. The activists who fought for this house have now mostly dropped out when we got it. The old punks now come with their kids, and read anarchist books in the library.

Ask Katzeff: The Youth House had a translocal effect. The city of Hamburg now is afraid of evicting the Rote Flora, because they know that people will travel to riots.

Amantine: What do you think of Mark Kennedy, the British police spy who said he told police about the inside security of Ungdomshuset #1?

Host: We don't care.

Ask: He didn't show up for the film screening of the BBC documentary here. We would love to see him but he didn't come.

Host: We think a lot about security, so he didn't know anything important. The really secret stuff only a few people knew. Those who knew him feel bad about it, but...

Tina: Is this house more radical than Ungdomshuset #1?

Host: Ungdomshuset #1 concerts were mobbed all the time. It was very popular.

Six months before the eviction, she continued, a demonstration drew 3,000 people. After the evictions, one demonstration had 10,000. Commercial T-shirts with Ungdomshuset skulls on them appeared for sale. The G13 actions – (a large-scale squat of a disused public waterworks) – involved many of the same people, but it was a peaceful protest to show that we could do something differently. So then the politicians could talk to us. In April of 2008 at the city council meeting, we threatened to lock them in with a big action until they agreed to give us this house. We wanted a house before the summer holiday. Now real estate development is beginning to come out to this

part of the city, but this was the best we could get at the time. The building had to be city-owned. They weren't going to buy anything for us. We meet every Monday. Nobody here signed anything with the city. Only the foundation did. And they could dissolve overnight, so no one would be responsible.[3]

Our group made a visit to the site of the first Ungdomshuset, amidst the increasingly gentrified streets of the Nørrebro neighborhood. It turned out to be a sad vacant lot, completely cleared of rubble but strewn with trash. The U.S. street artist Shepard Fairey, in town to do municipal commissions, painted a mural on the wall of the adjoining building in the summer of 2011, months before our visit. The work became the focus of controversy and a target for attacks. Fairey painted a white dove floating in a patterned background above the logo "peace." This mural by a visiting artist was resented and attacked by paint bombs. The artist himself was assaulted on the street. These attacks expressed outrage that the city of Copenhagen would pay a famous artist to make a mural urging peace when there was no peace. Fairey addressed the missteps in public statements and he modified the mural. He invited a local group of aerosol artists, RaxArt, to paint a historical section on the bottom imaging the violent police attacks on the Ungdomshuset. Amidst fire and smoke, helicopters drop members of the police tactical squadrons onto the roof of the Youth House, which happened in reality. By the time of our visit at the end of that year, the RaxArt section had been almost totally obliterated by further paint bombs and personal tags. These defacements, we were told, had been encouraged by police.

While it was brave, it also seems to have been an act of hubris for a U.S. artist to step into this cathexis of struggle with a conciliatory statement, and Fairey paid for it. In his written reflections on the experience, Fairey refers to the ethos of street art and draws inspiration from Los Angeles punk rock.[4] Both aerosol painting and punk rock music overlap

3 That's "G13" for the address of the squatted municipal building, Grøndalsvænge Allé 13. Details of our host's account of the Ungdomshuset events have been supplemented by information from Wikipedia, "Ungdomshuset" entry (accessed January 2014). That account differs from our host's, particularly in relation to the role played by the police.

4 In his own text on the incident, Fairey wrote: "I tried to work out a positive solution for the wall and I can only control my own actions, not the actions of others. I have always understood that street art is nothing to be precious about. The fate of the mural is out of my hands now, but I'm sad that such a great piece by the RaxArt guys was attacked. It was clearly a piece about social justice and I find the attack senselessly barbaric.... I'd say... [it was] demoralizing... [but] listening to

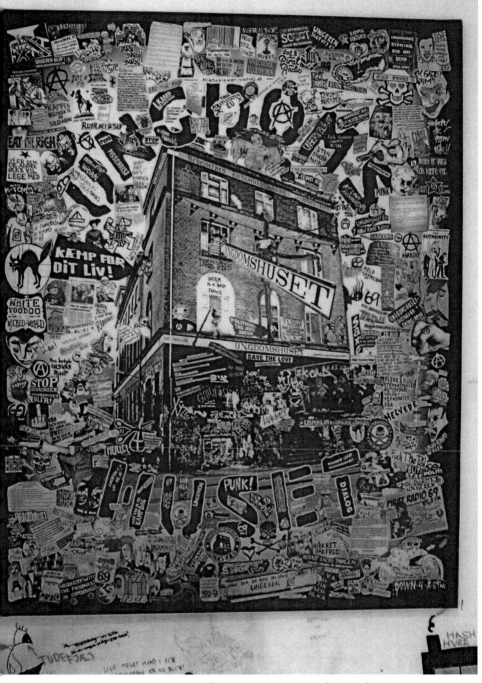

Collage hanging in the cafeteria of the Youth House #2 recalls Youth House #1 and the bands that played there. (Photo by the author)

with squatting and European punk music – Ungdomshuset was a major European venue for punk bands. But these practices don't read the same in different political contexts. In the U.S. cities in which he worked, Fairey was never part of a politicized squatting movement. He was a skate punk as a youth, and his work came out of skater punk sticker culture. As a street artist, Fairey was arrested many times, and continued to put up his work illegally even after achieving success. Skater punks, like graffiti and street artists, are nomadic users of public space. Skating in public space is often prohibited, and, like street artists, skaters are oppressed by police. So their issues are similar. But they are not squatters, and they are not usually politicized. Fairey is also now a successful artist who is given museum exhibitions and municipal commissions. He did a number of other city-funded murals in Copenhagen that summer, and many thought this mural too was funded by the city, although it wasn't. Fairey's official standing compromised, even voided his subcultural position. What is more, his practice of appropriating imagery from revolutionary movements of the past (e.g. Cuban posters) had already drawn criticism from artists on the left. [Vallen, 2007] Fairey's troubles throw into relief the disjunction between an international art culture that valorizes episodic transgression [McCormick, et al., 2010] and the politicized culture of the European squats.

At one point in our tour, as we walked along the streets, we were warmed by a glass of tea and some cake shared with us by Danish Shia Muslims who were celebrating the Day of Ashura. We had seen them marching along the streets of Nørrebro in small contingents, carrying ceremonial poles. The day marks the death in battle of Hussein, the prophet Muhammad's grandson. A child handed me the tea.

The last part of our all-day tour was dinner at the free city of Christiania. I missed it. Instead, I went to greet Gene Ray, who was speaking at a bookstore. Gene had introduced me to the New Yorck Bethanien occupation in Berlin when it was new. He had been invited to Copenhagen as part of a series produced by Brett Bloom, a member of the politicized U.S. group Temporary Services, which produced the "Market" show in New York for Creative Time in September. Brett was teaching

Black Flag ...it is imperative to RISE ABOVE, so that's what I'll continue to do" (Shepard Fairey, "Street Art and Politics in Copenhagen," 2011, at HTTP://www. HUFFINGTONPOST.COM/SHEPARD-FAIREY/STREET-ART-AND-POLITICS-I_B_926802. HTML); see also ObeyGiant.com, Fairey's website. Comments on the Huffington Post website point to ambiguities about the government subsidies the artist received.

in Denmark, and it turned out he was living around the corner from the house where I was staying in the Nørrebro district. I visited him and his partner Bonnie Fortune, and he loaned me a bike. Gene Ray's talk was packed, as people turned up to hear this critical theorist of art. Gene talked some about the recent U.S. Occupy Wall Street movement, and their refusal to make demands. "It's probably very smart to articulate only a big 'no' to what is going on," he said. Brett Bloom commented that, with endless war and militarized neoliberal capitalism, new forms of collectivity are being forced upon us whether we like it or not.[5] "People are aching for new forms of collectivity, new languages."

As an example, Brett said he was deeply inspired by the Trampolin-huset ("Trampoline House") project in Copenhagen. The project, which we did not visit, is a "culture house" run by a volunteer group of artists, activists, lawyers and others. It is designed to help immigrants – specifically seekers of political asylum, to enable them to share time and experiences with Danes. Denmark has both a generous policy of political asylum and a strong anti-immigrant political movement.[6] Trampolinhuset is not a squatted social center; it is rented with foundation support. It is a political project with a cultural emphasis, "a user-driven culture house for refugees and other residents of Denmark working together for a just and humane refugee and asylum policy." These attempts to help immigrants and asylum seekers have marked the political squatting movement throughout Europe for decades.

During the SqEK conference[7] Femke told us of a project that directly engaged this issue, the squatted mosque in Amsterdam – the

5 Brett Bloom was referring to the vogue among contemporary city managers to style their building campaigns as participatory, and to produce rituals that enforce a kind of bogus democracy. This tendency has been trenchantly analyzed by Markus Miessen in *The Nightmare of Participation: Crossbench Praxis as a Mode of Criticality* (Sternberg Press, Berlin, 2010).

6 The 2005 imbroglio that erupted when a Danish magazine published satirical cartoons of the Muslim prophet Mohammed is a measure of the depth of misunderstanding compounded by prejudice, suspicion and war that surround Danish-Muslim relations. (See "*Jyllands-Posten* Muhammad cartoons controversy," Wikipedia, accessed January 2014.)

7 Generally I have privileged information about the disobedient cultural scene in the different cities in which SqEK met. I wrote of Femke's talk about another city – entitled "Cracking the participation creed: The squat-mosque as an inspiration for intercultural self-organization" – because it related directly to an issue that is of general concern throughout Europe and the alternative scene. A SqEK publication on squatting and migrants is in preparation.

Kraakmoskee. Femke worked with the Schijnheilig squatter group; I had visited their school project shortly before its eviction. In the west of the city, just outside the center, many immigrants live with poverty and crime. The area also has many vacant office buildings. A group of squatters took one of them, called the Bridge Building, an empty structure that had been built over the A10 highway. But, she said, they didn't really know what to do with it. In the first week they set up a bar with coffee and tea, and opened the building to the neighborhood. Lots of kids from immigrant families came to play and had a good time. At length, the director of the local mosque foundation came, and asked if he could use the space for his group. It was close to the holiday of Ramadan, and there was no space for them to pray. (Although it shifts on the Gregorian calendar, Ramadan falls during the summer.) So they made an agreement with the squatters, and after the Ramadan they stayed. For four years between 100 and 200 people came daily to pray. They had a meeting place with tea. Thereafter, squatter collectives from all over the city came to the Kraakmoskee for a big dinner around Ramadan.

In late 2007 the Planet Art collective produced a three-day show called "Bridge," with Moroccan food and music, video shows, audio installations, sculpture, and visual art. [Planet Art, 2007] In 2010, once the Dutch government passed an ordinance outlawing squatting, the Kraakmoskee was one of the first buildings to be evicted. The mosque foundation did not have time to file a court appeal. In the intervening years the squatting groups had faded back from the project, and the foundation lacked the support they needed to resist the eviction. Besides, Femke told us, squatting group west was busy protecting its own squats. The foundation could not get funding for their mosque "because they were not supporting integration of their community into Dutch society." Squatting had provided them with a place and with visibility. The Kraakmoskee project also gave the squatters the opportunity to step out of their own neighborhoods and explore the outer ring area of the city.

Image from the "Strategies for Public Occupation" exhibition at the Storefront for Art & Architecture, NYC, 2011.

TWENTY-TWO
OCCUPY ART

In his recent book on the Occupy Wall Street movement, Nathan Schneider has a totalizing vision. He writes, "The realization was creeping upon me, or in some cases creeping me out, that this political movement I'd been mixed up in for months was really, truly, and above all best understood as a gigantic art project, which unwittingly I had been helping to carry out." [Schneider, 2013] This comes to him after a "visioning" meeting at the artists' center 16 Beaver Street early in 2012, months after the eviction of the encampment.

This seems like a confession of naïvete about what it takes to foreground a social movement in a

wag-the-dog world where consensus, or the comfortable general un-
derstandings that pass for it, is freshly manufactured every day. But let
me take up Schneider's paranoid aesthetic vision, and look at OWS as
a kind of *Gesamtkunstwerk*, a total work of art, an extended spectacle
including all the different creative forms.

Cruising only one of the websites connected with the New York
movement, one enters a swarming sea of Occupy-related initiatives by
creative people. The suavely designed #OccupyArtists site links to nu-
merous solidarity websites and projects.[1] It reflects a movement-time
network the site calls a "stack of artists, musicians, writers, thespians,
chanteurs, crafters, filmmakers, designers, composers, photographers,
thinkers, illustrators, dramaturgists, tinkerers, raconteurs, bricoleurs."
This lineup of varied personae from the creative community may al-
ready be familiar to the reader, since artists of all kinds are among the
most active patrons, initiators and sustainers of the political occupa-
tions called social centers.

The role of creative producers in the OWS movement and the im-
pact of the movement on their respective communities would – and
I hope will – make another fascinating book. Only to begin a typol-
ogy of kinds of artists within OWS, we may say that the occupation
was initiated by media artists, sustained by performers, and promoted
by graphic artists and filmmakers. Repression was met by politicized
street artists ("artivists," or "creactivists" in earlier coinages), who
also worked on the aftermath of OWS, like Occupy Sandy. Along its
course, the movement was made flexible by various theorists, and had
a substantial impact on the complex structures of the global institu-
tional artworld.

Occupy Wall Street began in response to a call by the *Adbusters*
magazine, a glossy publication created by a group of Canadian doc-
umentary filmmakers. *Adbusters* as the name suggests, aims to break
the corporate monopoly on media messaging by working inside that
process. It's a prominent organ in a broad front which takes take on
the forms and methods of mass media to promote progressive and
radical content – to deliver information and to glamorize the message.
They call it "anti-advertising."

1 #OccupyArtists is at www.occupyartists.org. It includes "Occupy Music //
 Occupy Design // Occupy Writers // Occupy George // @OccupyArtWorld //
 Occupy Art (Facebook) // Occupy Together // The Occupennial // Occupy Bos-
 ton Art // Occupy Love // [Occupy] Hyperallergic." Hyperallegic is a web-based
 art journal that supported OWS.

As a national media hub, New York City has a long tradition of media activism. Underground newspapers and early video documentary collectives like the Videofreex in the '60s and '70s were succeeded by Indymedia (Independent Media Centers or IMCs, beginning 1999). "Culture jamming" activism was exemplified by the pranking of Abbie Hoffman and the Yippies, which was assiduously followed by mainstream mass media in the '60s and '70s. The city has also been a center for digital art production, with the Rhizome.org networking project (now part of the New Museum), and the Eyebeam atelier. A good part of this emergent digital creativity has been activist political action. [Greene, 2004] This was formulated in the late 1990s as "tactical media." [Garcia & Lovink, 1997; Tactical Media Files]

The theoretical roots of this political aesthetic lie in a kind of satiric collage that first emerged in the Dada movement, and was reformulated by the Situationists in 1956 as an artistic method called "détournement," in which any and all elements of culture are used to make new combinations. [Debord and Wolman, 1957] The method was theoretically refined as a "style of negation," "the flexible language of anti-ideology" in Debord's *Society of the Spectacle*. [Debord, 1967]

Billboard alteration – or "liberation" – has been the clearest example of this, with the "subvertising" of Ron English among others in the 1980s and '90s well known in NYC. By the autumn of 2011, the practice of culture jamming had become doxa among many political artists and activists. Stephen Duncombe published his influential book *Dream: Re-Imagining Progressive Politics in an Age of Fantasy* in 2007. He soon began working with artist Steve Lambert to found their Center for Artistic Activism, a teaching project based in "art, activism, advertising, and social marketing." (They use Boyd, et al., 2012 as a textbook.) The Yes Men – a duo of radical artists who specialized in corporate and government impersonations – achieved some of the most spectacular successes of an advanced form of this mode of practice. (The Yes Men made two feature films, in 2003 and 2009; a 2009 exhibition was titled "Keep It Slick: Infiltrating Capitalism.") By late 2010 they had form the Yes Labs to recruit collaborators.

By September 2011, many groups of politicized creative media activists in New York were standing ready to pick up the ball of a 21st century activism the moment a new movement put it into play.

I experienced OWS primarily from a distance. I passed by the impressive police preparations hours before the demonstrations began

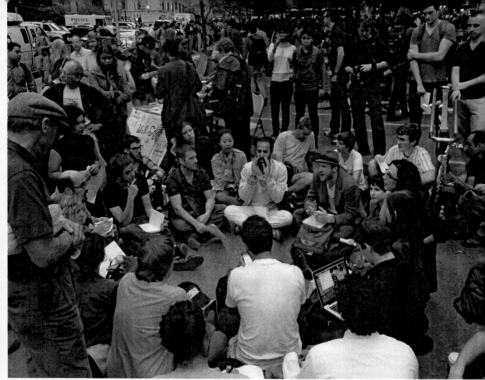

An Occupy Wall Street assembly in Zucotti Park in the Wall Street district, NYC, 2011. Creative Time curator Nato Thompson is seated in shirt-sleeves to the right of the central man in white. (Photo by the author)

on my bicycle, then left town. I was back soon after, for an event that probably represented the first coordinated artistic response to Occupy Wall Street, by people in and around the annual Creative Time Summit. This global event drew in international speakers on varieties of socially effective creative practice and creative political work, all of whom were surely intensely curious about the newly-fledged OWS. The theme of the 2011 suummit was "Living as Form," also the title of an exhibition [Thompson, 2012] in a vacant stretch of the Essex Street Market on the Lower East Side.[2] As the Zucotti Park encampment of the OWS emerged downtown, an ad hoc part of the exhibition was added – a little painting bench near the exit where visitors could make signs to take down to the camp.

After the last event of the summit program, held at the Abrons Art

2 The summit was expanded to include "not only curators, scholars, and visual artists, but also those working in theater, architecture, and dance, as well as in social justice" ("About the 2011 Creative Time Summit," at: HTTP://CREATIVETIME. ORG/SUMMIT/OVERVIEW/OVERVIEW-2011/).

Center on Grand Street, Creative Time curator Nato Thompson led
his audience down to the encampment in Zucotti Park. I went along
downtown, and later saw Nato sitting in the general assembly (GA)
circle. Gerald Raunig also went along to see the encampment. Back in
Vienna, he immediately came out with the "#occupy and assemble"
issue of the *transversal* web journal of his European Institute of Pro-
gressive Cultural Policy. This included essays on the recent Madison,
Wisconsin, state capitol occupation by Dan S. Wang, a text from Ath-
ens, a reflection on OWS by Nato Thompson, feminist theorist Judith
Butler's influential essay "Bodies in Alliance and the Politics of the
Street," and a long article on squats in Vienna. These were among the
first publications, the opening salvos in a critical industry that would
spring up around the Occupy movement.

Two years later, the institutional theme of the Creative Time Sum-
mit of 2013 was something called "place-making." The event was a
survey of ways in which creative people could regenerate public uses
of contemporary urban environments, and a report on the institu-
tional funds that might pay them to do it.[3]

In my few days around Occupy Wall Street, I saw the incredible
profusion of cardboard signs. These were statements to the public,
to the passers-by, many of whom were Wall Street workers. I saw the
encampment spring up and take form. There were very few older ac-
tivists present. (One of these, Seth Tobocman, was conspicuous in
the early days and made some of those signs.) This was entirely new,
I realized, since demonstrations in decades past were nearly all full of
familiar faces. I had a couple of meetings in the stone paved plaza that
would come to be called Liberty Park, with Matt Peterson of the Red
Channels screening group, and Maria Byck of Paper Tiger, a political
public access cable TV show that started in the 1980s.[4] These were
committed young cultural activists. Matt had toured Europe with Ben

3 The summit theme for 2013 was "Art, Place and Dislocation in the 21st Century
 City." This has been an issue for political squatters for a long while, as it is for
 anti-gentrification activists like those in the Right to the City Alliance. Christoph
 Schäfer of Hamburg's Park Fiction spoke of this in his presentation.

4 Paper Tiger (at papertiger.org) is a community television production and distri-
 bution group started in 1981. They have been closely involved in issues of public
 access TV, and the evolution of radical media. The group formed at the same
 time as many other artists were working in public access TV, including the Colab
 group I worked with to produce a series called Potato Wolf artists' television. Pa-
 per Tiger TV offices are in the War Resisters League building, the so-called "Peace
 Pentagon" building on Lafayette Street.

Morea earlier that year, and Maria would later accept the invitation to Occupy and 15M activists extended by the Berlin Biennale.

Matt was among a small group of OWS artists who launched a wildcat occupation in late October. Their target was the alternative art space Artists Space in Soho. Once again, the *New York Times'* squat beat reporter Colin Moynihan reported the event: "On Saturday, during a talk about conceptual art at the gallery, Georgia Sagri, a Greek [performance] artist, suddenly rose and shouted out, 'This is an occupation,' witnesses said. About a dozen other people joined Ms. Sagri in declaring the gallery, Artists Space, an autonomous zone." [Moynihan, October 24th, 2011] Many occupiers – at one point, some 200 of them – spent the night. Gallery staff were sympathetic. Still, there were confrontations, some vandalism and thefts. Finally the occupiers left, under the watchful eye of a group of security guards summoned at the behest of the board of directors. Moynihan quotes Stefan Kalmár, the executive director and curator: "'It was not a bad idea as a project,' Mr. Kalmár said … [but] he was disturbed by the behavior of some protesters and the confrontational tone adopted by some.... 'This was a dictatorship.'" Stefan pointed to the political objectives of his curating: The most recent show had been about an artist identified as anarchist. The next show would "address the ways major museums have come to resemble corporations." The art press, while careful, was not kind to this initiative. A blogger for the Blouin media group, Karen Archey, wrote that she expressed support for the group's mission to the occupiers, and would "consider aiding future, better-planned occupation efforts in some way" given the deplorable working conditions in the field. But the group called Occupy 38 (for the address of Artists Space on Wooster Street) was not interested in her offer. [Archey, 2011]

I followed this from afar, monitoring online chat on a list-serve called "The Work of Art in the Age of Occupation." While opinion on the action was overwhelmingly negative, the conversation around it was long and thoughtful. There was a general recognition that the issues facing the art community were a part of those protested by Occupy Wall Street. I found the Occupy 38 action intriguing and on point. Artists Space was not a self-organized space, like many other "alternative spaces." It was established by the state, and moved from a mid-'70s moment when the Artists Meeting for Cultural Change met in its galleries, through numerous stages to an organizational model

wherein a director/curator held total control. [Moore, 2011; Gould & Smith, 1998]

This is not to say that Artists Space is not a respectable and venerable institution, an oasis of serious and thoughtful work in a commercial sinkhole. But the Occupy movement was challenging all hierarchical structures in the art world, just as the Art Workers Coalition had done some 40-odd years before. The AWC's target then was the Museum of Modern Art. Coincidentally a Greek artist, Takis (Vassilakis Takis) led the charge. Sagri came from a Greece wracked by austerity where the resistance movement had been severely repressed. Her brother was an active anarchist in Greece. She was part of a contingent of internationals involved in OWS with a far greater commitment to radical anti-capitalist activism than the liberals who mostly make up and govern the U.S. and international art world.

Occupy 38 was passionately defended by Andrea Liu on a list-serve called "The-work-of-art-in-the-age-of-occupation." In a retrospective analysis for the *Social Text* blog, she pointed to the "'centrism' that OWS produces" through its consensus process – the general assembly, or GA. The Occupy 38 action was a critique of consensus, and what she saw as the professionalism and proto-institutionalization inherent in the OWS working groups. Liu rooted her critique in Chantal Mouffe's theories of agonism, the dissensus or conflict that is "the constitutive element of democracy itself.... Take Artists Space sought to shatter the ritualized 'unity' propounded by mainstream OWS. Take Artists Space believed in a re-radicalization of everyday life outside the hyper-specialized division of labor into an endless series of committees." [Liu, 2012]

Liu continued her investigation of assembly processes through a residency at the free community of Christiania in Copenhagen. She reported her findings on her Facebook page in December of 2013. Noah Fischer, whose group Occupy Museums had staged similarly controversial interventions in New York museums during the course of the OWS encampment, responded, referencing a recent project of his own: "Consensus process is magical, only because it's rare and even shocking compared with how things normally happen. Occupy Museums and friends recently used it as a tool to challenge an intensely vertical power structure at the CCA in Warsaw [Centre for Contemporary Art, Ujazdowski Castle] in a project called Winter Holiday Camp. OWS style meetings were opportunities to perform

and explore alternative division of power. Over time I think it changes you. There are many traps to reifying anything and of course there was all kinds of realpolitik behind the scenes. Consensus process was still a jewel of the movement as far as I'm concerned." [Fischer/Liu, 2014]

Occupy Wall Street and the global movement that climaxed in 2011 was the subject of many initiatives by cultural organizations and later museum exhibitions. *House Magic* #5 reported on the Berlin Biennale 7 in the spring of 2012 which included a faux encampment of OWS and 15M activists, and the Steirischer Herbst gathering in Graz, Austria, in September 2012, called "Truth Is Concrete." As I write this, the Zentrum für Kunst und Medientechnologie Karlsruhe (ZKM) has opened a show called "global aCtIVISm." The institutional art world, if not the commercial, will be processing this experience for some time.

Occupy Wall Street also managed to include people whose struggles in New York usually take place off stage. An important connection with New York City's communities of color came through music, when members of the South Bronx based rap crew Rebel Diaz visited the Liberty Park encampment in its early days. They came after many Occupiers had joined the march in solidarity with Troy Davis, protesting his execution in Georgia on September 21st.[5] Rebel Diaz is a seriously political rap crew. In a September 28th post on their website, the rappers noted that the encampment was full of white people, and that they were not warmly received. Even so, they argued that the protest was globally significant and should be supported. "Perhaps the topless nude activists, or the drum circle may not be for you," they wrote, but the issues raised mattered. In comments, OWSers apologized for the cold shoulder, and urged the rappers to return. [Rebel Diaz, 2011] They did, and became active in advocating for Occupy. The Rebel Diaz group, some of whom were children of Chilean immigrants, had turned a vacant warehouse into an art space and community center in the impoverished New York City district. This was only the most recent initiative in decades of radical community

5 Convicted of the 1991 murder of a popular policeman, Troy Davis was many times refused a chance on procedural grounds to enter exculpatory evidence. Despite a sustained national and international appeal of this questionable conviction, including a message from the Pope in Rome, Troy Davis was executed in Georgia on September 21, 2011. OWS campers joined on a large march and protest that day. This show of solidarity marked a turning point in OWS relations with communities of color.

organizing in the Bronx, connections to which the rappers drew attention. (Their Richie Perez Library was named for a Puerto Rican Young Lords leader, long active against police brutality.)[6] Venezuelan president Hugo Chavez had greeted the Rebel Diaz collective during his 2005 visit to the borough, which led to a multi-million dollar effort to support community building there by that country's Citgo oil company. In March 2013, the Rebel Diaz center was evicted by armed police after landlords refused to renew their lease on political grounds. ["MrDavidD," 2013]

The Occupy Wall Street camp remained in the heart of New York City's financial district for nearly two months. It inspired dozens of other encampments in cities throughout the U.S. and in other countries. It "moved the political conversation," as news media everywhere started to talk about the occupations, as well as the issues the movement raised. The event continues to reverberate in the public imagination. The activist currents that went into, and came out of it changed the political landscape by reinvigorating the U.S. left. The event bathed the young people who took part in the atmosphere of a highly mediatized revolutionary mass movement, a baptism from which many emerged committed. For the elders, Occupy was a confirmation. Even as the Copenhagen SqEK conference was underway in December of 2011, bulletins from around the world, articles and analysis, continued to flood into my email. While it was still far from mainstream, squatting seemed to be shedding its rags. The basic political nature of the action was beginning to be recognized before it was reflexively condemned as theft of the use of a property.

6 In 1983, Richie Perez led an important campaign against a Hollywood film that was seen as racist. He spoke about this work on the political cable TV show Paper Tiger; "Richie Perez Watches *Fort Apache: The Bronx* (Bronx Stories Cut)" at: HTTP://VIMEO.COM/23736674. For a text on his importance, see: Boricua Tributes, "Richie Perez (1944-2000)" at WWW.VIRTUALBORICUA.ORG/DOCS/PEREZ.HTM.

HOTEL MADRID

Sitting in my office in Madrid, immersed in
the blizzard of discourse from Occupy Wall Street,
the startling videos, and the clamor of live streams
gave me the impression that I too was part of it. But
I wasn't. I wasn't there in the meetings, and, as an
Anglophone in Spain, I wasn't really here in Madrid
either. I was not only sitting in my armchair, but also
wearing pajamas, since I rarely left the house. I felt
like a true *otaku* revolutionary in the most heavily
mediatized event of the entire 2011 movement.

Since I could not participate directly in the face-
to-face discussions in NYC, nor make much head-
way without fluent Spanish in the 15M, I tried to
concentrate on what I could do instead. Maybe I
could organize an art show? I proposed an exchange
of images and words between Madrid and New York,
and struggled to get it adapted as a project by the

Oliver Ressler (holding microphone boom) and his crew taping 15M assembly partic-
ipants in Madrid, 2012 for his installation "Take the Square." (Photo by the author)

Arts & Culture working group of OWS, and the Comisión de Arte y
Cultura of 15M here. I pitched the project to Casablanca, the social
center where Miguel Martinez worked, as a "night of solidarity and
exchange" ("solidaridad y intercambio"), with poster images on paper,
videos, and a live-streamed online discussion. Although I secured a
date, in later November, I didn't find any collaborators. The idea ex-
cited mainly me, and it turned out to be a bigger bite than I could
chew. At last, I was able to put up a set of posters from Occupy Wall
Street in the hallway of Casablanca. Most of these were from the mul-
ti-colored newsprint poster edition of the *Occupied Wall Street Journal,*
created by the JustSeeds graphic arts collaborative.[1] They looked good,

1 The *Occupied Wall Street Journal* sprang up soon after the Zucotti/Liberty Park
 encampment, containing news and reports from the occupiers. The format of
 the tabloid plays on the established *Wall Street Journal*, and seems inspired by the
 November, 2008 Yes Men's *New York Times* (Steve Lambert has posted about this
 project with a full crew list at HTTP://VISITSTEVE.COM/MADE/THE-NY-TIMES-SPE-
 CIAL-EDITION/). People from the "Occupy Wall Street Screen Printing Guild, an

pasted up above the wide oak plank staircase of the ancient building. Users of the center on their way to meetings on the upper floor passed these images every day. While it was modest, the show lasted more than one night.

During my lengthy meetings with groups in different places I caught glimpses of the disarticulated structure of the 15M as it began to spread into the *okupas*, the social centers of the city. I saw more when Oliver Ressler came to town from Austria to make his film on the assembly processes of the emergent movements in Athens, New York and Madrid. [Ressler, 2012] One meeting of 15M's Comision de Arte y Cultura[2] took place in a room at Hotel Madrid. This squat of a vacant commercial hotel was perhaps the first *okupa* to come directly out of the 15M encampment. It was organized by a local assembly that met in a plaza half a block from the hotel, which was in turn half a block from the Puerta del Sol.

I first visited in October 2011, just after my return from New York. I mounted the long stairway to the lobby, and naturally inquired of the man at the desk: "What's going on?" I presented my hand-carried copy of the *Occupied Wall Street Journal*. He threw it on the rack with the others! He told me that the hotel might serve the many evicted former homeowners who could not maintain their mortgages and found themselves suddenly on the street. Evictions have been a key issue of the neighborhood assembly of Lavapiés, the district that has seen many okupas and now holds the immense Tabacalera CSA. The assembly had conducted a number of eviction defenses, citizens' blockades of evicting police and court officers. But it wasn't certain yet, said the man at the desk. The matter was even then under discussion around the corner by an assembly in Plaza Jacinto Benavente, which was laying plans for the new hotel occupation.

I wandered through the teeming halls. Most already had signs indicating their functions. A small boy with dirty blonde hair controlled the heavy glass door of one large empty room. He threw out his arms

official working group within the New York City General Assembly," produced the print edition of the OWSJ. Another group, Occuprint, emerged to coordinate graphic resources for the OWS movement. It included volunteers from the Just-Seeds graphic art cooperative (from a text reproduced at HTTP://HEMISPHERICIN-STITUTE.ORG/HEMI/EN/OCCUPRINT). Some in the JustSeeds group also worked on mobile silkscreening stations in the Liberty Plaza encampment and elsewhere.

2 My engagements with 15M have been sporadic. The group Comisión de Arte y Cultura seems to have dissolved.

and cried, "This is a studio!" Inside, a broad open window overlooks the busy street below. It's choked with people, masses traipsing past the glitzy store windows into the Puerta del Sol plaza. This street is busy in a way that activists and artists are very rarely able to access. The hotel occupiers had already set up an information table on the street to distribute leaflets, collect signatures on a petition of support, and discuss what they were doing with passers by.

Back in the lobby animated conversations were brewing among people of all ages. I met a man named AJ, a stocky, 40-something sculptor who'd spent years working in the U.S., at a studio near Washington, D.C. He complained about an article in the *Occupied WSJ* which implied that the 15M movement had rioted. "We never did that!" he insisted. It was always the police who attacked. AJ said when they took the hotel the week before the owner sent around some thugs to get them out. But a few heavies were not enough to do that job, and now the case was before a judge. The owner was bankrupt. AJ said the place was a mess they had to work hard to clean up. Big holes in the ceilings upstairs marked where thieves stripped out copper from plumbing and electrical systems. I asked, why was there no graffiti? There was some from before, he said, but the occupiers repainted the walls. There is a theater in a conjoined building, a historic site that AJ thought should be used, "open for the people, even if it doesn't make money."[3]

I went to the communications office to check out AJ's story. Everything seems more organized when it's indoors, and this office looked quite realistic. A couple guys were sitting around dozing, like the old-time copy room in the movie *The Front Page*. One young man with long blonde hair strode by, but told me he couldn't fact check AJ's story. He'd only arrived in Madrid a few hours before, and was working on computer security. "That's my contribution here." AJ too had plans to move on, to "walk north," although cold weather was coming on. He told me he saw the whole thing – the 15M movement, Occupy Wall Street – as the beginning of a necessary, real transition. He was excited about something called the Venus Project, a "feasible plan of action" for a "peaceful and sustainable global civilization" based on resource economies. "I might not live to see it, that kid

3 This theater, owned by the same company, is a historic structure. According to hearsay, it was occupied by a breakaway group against the consensus of the assembly; this new occupation precipitated the eviction. It was not the first time this theater had been occupied.

might not live to see it," AJ said, as the door-boy ran by, "but that's what's gotta happen."

On my way out, a heavyset man in the concierge's position just inside the doorway nodded at me. Bring on the thugs! While the "desk clerk" seemed unsure of the fate of the Hotel Madrid, a painted sign over the door announced that it was a CSO, an occupied social center.

On my next visit a few weeks later, I roamed around the bustling hotel – much busier than on my last visit soon after it had been cracked. Many more floors were open for business. I parked myself in the hall where the meeting I had come for was scheduled to be held. People began to gather, awaiting the arrival of members of the comisión of 15M. One group was discussing their project in French, and the elder among them explained it to me in English. They were making a documentary on new movements in the Mediterranean area, starting with Spain, then on to Tunis, Egypt and Greece. Conversations continued in the hall, until people who seemed to be in charge finally showed up. The room was dark. We followed them from room to room, as they tried to find an appropriate meeting space. The room of relocation was locked. None of the rooms seemed to have power. Finally one man was able to light a bulb and the meeting began. The film crew asked about actions planned for the near future that they might film. An action was mentioned; they thanked the group and departed. My project pitch did not catch fire with this group. They directed me to another room where a photographer was shooting studio portraits of indignados. Here I learned that the archive of the Puerta del Sol encampment was housed in the Casablanca social center. A tall young man volunteered to walk me over there to see it. We wandered through the streets, my companion excitedly picking up likely art material from trash piles we passed. At Casablanca, the room he thought held the archive was locked. (Subsequently, I was never able to visit it, and came to doubt that it even existed.) I ended up at my guide's studio, surrounded by daubs and piles of art debris. He and others were apparently also living there. A roommate emerged briefly from a room thick with reefer smoke…

Hotel Madrid was a warren, and the emerging and dissolving 15M bureaucracy was baffling. Still at least it was clear from all this that the 15M movement had changed squatting in Madrid. The encampment of spring 2011 had brought together those the press called indignados or indignadxs – indignant ones, a name inspired by Stéphane Hessel's

polemical 2010 pamphlet *Indignez-vous!* While the activists keeping things going were mostly young people, the indignadxs included people of all ages, including those who had been active against the Franco dictatorship in the 1970s.

By the time of my next visit, Hotel Madrid had been evicted. A police car was parked out front. Banners from the occupation were still visible in the windows.

The hotel was taken after an international day of action on October 15, 2011. This action, called on the five-month anniversary of the Puerta del Sol camp, turned out hundreds of thousands in Spanish cities. The immense Puerta del Sol in Madrid was literally packed. Demonstrations in answer to the call from Spain took place in nearly a thousand other cities, endorsed by local peoples' assemblies. Camps were attempted in Berlin and Frankfurt, and the Occupy London encampment beside St Paul's Cathedral began with this day's protests.

The protests continued the momentum of 15M and Occupy Wall Street, crying out against economic inequality, undue corporate influence in government, and lack of real democracy. The Hotel Madrid, targeted for occupation by a combined group of indignadxs and activists from the Madrid squatting movement, was owned by the bankrupt Monteverde Group of investors. A report posted by the assembly of the occupied social center Casablanca detailed the winding financial and political trail that this company twined between the hyper-developed coastal city of Málaga and the capital Madrid. [CSO CasaBlanca, 2011]

The occupation did not last long. The Hotel Madrid was evicted on December 5th. But for 50 days, it served the surging movement as a school and a laboratory for subsequent squats throughout the city and the Madrid region, as well as politicizing many families evicted due to Spain's harsh mortgage laws. [Abellán, et al, 2012] As I saw it, the place was humming with meetings and conversations. It was a key part of the 15M movement. Hotel Madrid maintained a transitional center city presence for the movement after the decision taken at Puerta del Sol to concentrate on building peoples' assemblies in the neighborhoods of the city and region had kicked off a new cycle of mobilizations.

The Hotel Madrid was the first building occupation undertaken directly by a 15M assembly. As Abellán, et al. explain, in order to build bridges to the larger society, the hotel was called "liberated and

My local social center: Salamanquesa in the Madrid barrio of Salamanca, 2012. (Photo by the author)

recovered space," not a squat.[4] As the hotel opened up to evicted families, mainstream news coverage was positive. An office for housing and occupation was opened, consulting on how to take over vacant properties owned by banks (many of which had been bailed out by the government) and public institutions. Their intention was to change the social meaning of occupation. The indignadxs' decision to engage with the plight of the evicted joined them with the PAH (Plataforma Afectados por La Hipoteca, or organization of those affected by mortgages). Loud, energetic PAH demonstrations and eviction defense actions were regularly covered by television news, and continuously put online via dedicated documentary groups like Toma la Tele (take the TV). A steady stream of violent, poignant evictions of impoverished and elderly people, as well as a number of suicides, gave new meaning to the actions of Spanish squatters. Although the conservative

4 Abellán, et al., explain: "Spanish activists use the term 'okupación' for the politically motivated squatting of buildings, while aspects related to the 'occupation' of space are usually addressed as 'taking' (i.e. take the square). During the occupation of the Hotel Madrid the term 'okupación' was avoided (Abellán, et al., p. 4, 7).

government sought to dampen the outrage by introducing some cosmetic reforms, the activism of the PAH continues strong.

Amongst the wave of squatting actions in Madrid that accompanied the 15M movement's crest was the social center La Salamanquesa ("The salamander"), located not far from where I lived in the barrio Salamanca. [Centro Social La Salamanquesa, n.d.] The activists, loosely tied to the 15M assembly meeting every Saturday in the Plaza Dali, took over a large vacant warehouse on a dead-end alley (called a *callejón*), in September of 2011. It is owned by the department store giant Corte Ingles. The organizers told me the company had an obligation to sponsor cultural and social programs in return for permission to build high-rise stores in the city center, but had done nothing of the sort.

The warehouse is a starkly bare multi-story concrete building with a central atrium lit by a skylight. When I visited, artists were already moving in. Water had been rigged up with a hose, and an urban gardening project was starting in the atrium. Murals were appearing: one in the main space downstairs extended Picasso's 1922 image of two women running on a beach; another showed a giant deep sea fish; and another was the half-finished, intricate tag of a Polish crew passing through Madrid. Classes in circus techniques were forming. A human-sized golden yellow salamander puppet would soon become their symbol. The young organizers invited me back for the English classes.

Neighborhood teenagers came in quickly, claiming a room upstairs to smoke and drink beer. In the circle of overstuffed couches downstairs, I chatted with a couple of men my age. One was an actor wearing a beret (called a boina in Spanish), the sign of a left-winger in the city. They could have been yayoflautas – the over-60 protest group named for a combination of the Spanish term of affection for grandfathers and a derogatory term for dirty hippies. [Reuters, 2012] (That's "perroflautas," or dog-flutes, after the habit of some to repose with their dogs on public streets and play flutes; the coat of arms and insignia of the Tabacalera center shows a dog playing a flute.) The group, usually seen wearing signature bright yellow vests, are involved in many creative actions, and are handled less roughly by police.

By May 2012, Salamanquesa was evicted. The building was bricked up, and all murals on the exterior and nearby walls were painted over. (The painters, however, did not cover up the non-political graffiti

nearby.) The impression was that on this deserted warehouse street, nothing had ever existed. Only a couple of altered plastic bottles with dead plants in them hung from the grating outside a bricked-up window – a pathetic remnant of the gardening project that took place in the space.

The collective opened another *okupa*, this time far away from me, in a vacant public school in the neighborhood of Moratalaz. Spanish squatter collectives try to answer each eviction with an occupation – sometimes within days. The new Salamanquesa lasted less than a year, and was evicted in September 2013. [Wiki.15m, "Lista de centros sociales de Madrid"] Where will the gecko pop up again?

Opposite: SqEK reception at Interference Archive, Brooklyn, where an exhibition of squat-related materials was mounted, 2012. Center in baseball cap is Josh MacPhee; in foreground, Amy Staracheski. (Photo by the author)

MISSION ACCOMPLISHED – SQEK MEETS IN NEW YORK

SqEK met in New York City in February of 2012. It was probably the first time a group of activist researchers from the European squatting movement had gathered in the U.S. to speak publicly about the decades-old movement of squatting and building occupations in their respective countries. It was a culmination for me, the logical end to the four-year House Magic information project. Now U.S. audiences would hear about the squatting movement from people with first hand knowledge. The timing was also propitious. The Occupy movement was still in full swing. Despite the recent evictions of camps across

the U.S., activist solidarities remained strong, and new configurations were forming. I was full of this contagious collective optimism and bubbling with new plans.

The week began with a reception at the Lower East Side art space ABC No Rio, a cultural center closely tied to Lower East Side squatter history. (See Chapter 1) Through the network of ABC and the squats, many of our conferees found places to stay. Among the crowd at the party were veteran LES squatters like Steven Englander, the director of ABC, Matt Metzgar and Bill Di Paola. There were also a number of artists from my group Colab which started the place in the '80s with the occupation of a city building.[1] On Saturday morning, SqEKers returned to ABC No Rio for a tour of the building, followed by visits to private apartments in some of the original Lower East Side squats. Matt, Bill and Frank Morales led us around. Frank works today with O4O and Picture the Homeless. Matt co-organized materials for the squatter archives in the Tamiment Library of labor history at New York University.[2] Bill is the key organizer in the Time's Up environmental group which coordinates the Critical Mass, among other bike rides, and runs bike repair clinics. [Time's Up, 2013] The group held one of its workshops in the dank basement of ABC No Rio, a grotto that was once the venue for Saturday afternoon all-ages punk rock matinees. Together with Laurie Mittelmann, Bill was launching a new project. They were setting up something called the Museum of Reclaimed Urban Spaces (MoRUS), which would soon open in the storefront of C Squat.

Soon after the meeting, Miguel Martinez blogged about the tour SqEKers were given. He wrote that the image of the '80s and '90s time of the New York squatter movement seemed quite close to Seth Tobocman's graphic novel, *War in the Neighborhood*: rows of heroin dealers, gangs controlling territories in the Lower East Side, constant

1 Several of those who greeted us – Becky Howland, Ann Messner, Peter Fend and Tom Otterness – were my comrades in the original occupation. They coordinated a follow-up exhibition in April of 2014 called "Real Estate Show Revisted," together with Robert Goldman (aka Bobby G), Christy Rupp, Jane Dickson and others. I edited a supplement to *House Magic* for that show, including a long essay on the 1980s action, "Excavating Real Estate." [Moore, 2014]

2 See Peter Filardo, "Research Guide to Housing Related Collections at the Tamiment Library: Squatters, Tenants' Rights / Other," 2012, at HTTP://WWW.NYU. EDU/LIBRARY/BOBST/RESEARCH/TAM/HOUSING_GUIDE.HTML#SQUATTERS. The collection includes materials from the graphic artist Fly, Italian emigre artist Roland Politi, photographer John Penley, and poet Peter Spagnuolo, among others.

arson fires in dilapidated tenement buildings, vacant lots strewn with debris, police on every corner (or no police at all!) continually harassing squatters in their buildings and community gardens. [Martinez, 2012] Amy Starecheski, who co-organized the New York meeting, came along on some of the visits. She is an anthropologist and oral historian studying at the CUNY (City University of New York) Graduate Center, and writing on the legalization of the NYC squats.[3]

The next day was spent at the occasion for our get-together, the annual meeting of the Association of American Geographers in the giant 6th Avenue Hilton hotel uptown. Unlike many academic organizations, the AAG makes a lot of room for its radicals. Eliseo Fucolti had arranged a day-long special session, "Squatting and Social Centers: Resistance and Production of Critical Spaces" in one of the ballrooms. That evening we were received at the independent self-organized Interference Archive in Brooklyn [Bader, 2012] where organizers had mounted a show of their own materials about squatting in Europe. Bright colorful posters and long shelves of books and zines on squatting lined the walls of the archive's public space. The IA had put their own materials together with the "House Magic" research collection and SqEK members' contributions for permanent consultation by people in the States. (The SqEK Library continues as a special collection at the Interference Archive.)

SqEK researchers gave a well-attended public talk about squatting in their various countries. This happened at the Living Theatre around the corner from ABC No Rio.[4] I was especially pleased that we could talk there, since Judith Malina is a much-esteemed elder in the world of anarchist culture and American theatre. The Living had been a presence in New York since the late 1940s. Judith and her partner Julian Beck were prominent in the occupation of the Théâtre de l'Odéon during the May 1968 uprising in Paris. The basement Living Theatre was very busy that night. Still, they sandwiched in the SqEK talk

3 Amy Starecheski studied the legalization process among New York City squatters, when many acquired an insupportable debt burden. Her dissertation is a study in the social practices of homeownership, working from an anthropological perspective, in which property relations are "inherently unstable and contingent." (From her prospectus, "What Was Squatting, and What Comes Next?: Property and Politics in New York City, 1984-2014.")

4 Sebastian Gutierrez posted video records of the talks on YouTube shortly thereafter, as "SQEK I [II, III, IV, & V] – Squatting Europe Collective." (See also "SqEK public talk at Living Theatre, NYC (February 2012); partial transcript," at: HTTPS://N-I.CC/FILE/GROUP/91603/ALL.)

between a play about nurses in Vietnam, and the final performance of Judith's own anti-war epic, *History of the World*. We passed the red jar, and raised some money for the perpetually under-funded Living. It's never enough. Although they only had a basement, the Living Theatre closed just a year later, "rentrified" out of the Lower East Side.[5]

Sunday saw a leisurely lunchtime meeting at the 16 Beaver space, the announcement for which recalled their 2009 panel at the annual Left Forum gathering called "How Occupation Works." That event brought together LES squatters and student occupiers at the New School and NYU in an effort to "understand what from these experiences could be put into play" at the time. 16 Beaver became a kind of think tank for reflection during the Occupy Wall Street encampment of the nearby Zucotti, *aka* Liberty Park in 2011. Their announcement quoted my own press release: "The tradition of political squatting is moving from the shadows into the light. With the world-wide rise of the Occupy movement, the deep reservoir of experience within the movements of political squatting have become suddenly significant."

An Occupy London media group presentation on the anti-austerity struggles in Greece took place that evening at 16 Beaver, but SqEK members joined the O4O group (Organizing for Occupation) and Picture the Homeless in the conference room of an office suite in a nearby high-rise. The meeting was organized by Frank Morales and Rob Robinson, a longtime activist for the homeless. [Robinson, 2011] There we heard about their housing-based occupations and civil rights campaigns. The group had just released their report, "Banking on Vacancy: Homelessness & Real Estate Speculation," a count of vacant buildings in the NYC metro area organized with Hunter College CUNY. [Picture the Homeless, 2012] The report put the spotlight on the longtime city government policy of subsidizing private hotel owners to house homeless families at exorbitant rates rather than developing social housing. Monday we met students at the CUNY Graduate Center in a student lounge room to discuss researching squatting.

Once the conference ended, a bunch of us dug into the history of the counterculture, attending a conference at New York University about the *East Village Other*, the famous underground newspaper of

5 Even after losing her last theater and moving to a New Jersey retirement home, Living Theatre founder Judith Malina rolled on. In late 2013, she visited the Teatro Valle in Rome, occupied by its workers.

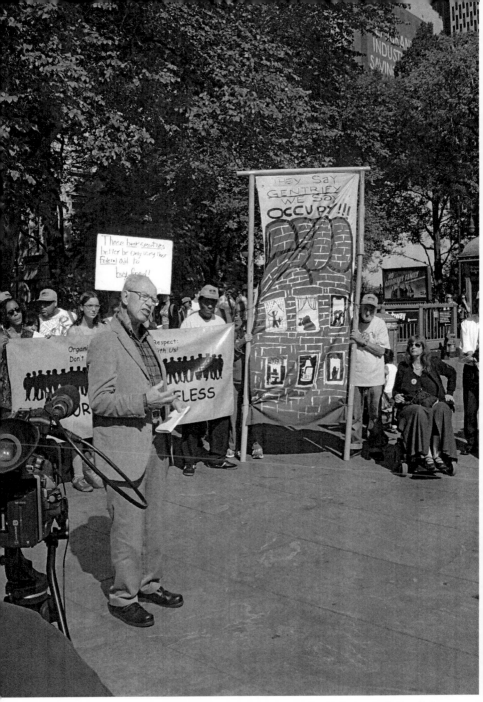

Urbanist Peter Marcuse speaking at City Hall, New York City, during a Picture the Homeless demonstration, 2011. (Photo by the author)

the 1960s.[6] In question time I asked the panel of venerable journalists whether they had any recollections of political squatting, big building occupations, and communes in the East Village during the 1960s. The question drew blank looks from the many former outsiders who had became professionals on the panel. We scarfed up NYU's sandwiches and wine, then went on to a local bar to watch Matt Metzgar's band perform. Bill Di Paola gave us all hats for the newly launched Museum of Reclaimed Urban Spaces, and we kissed goodbye.

The panel at NYU turns out to have been another step in the process of turning the past of the Lower East Side and East Village into a kind of research project for that private university. As more and more traces of the old radical, creative, multicultural, impoverished ghetto and barrio that the place was disappear, the students and young people replacing the old timers seem fascinated with the history of the place. The leaders of NYU's archives at Fales and Tamiment have carefully fed this development through their acquisitions, and many

Tour of Lower East Side squats organized by MoRUS museum stops at ABC No Rio, 2012. Speaker is Matt Metzgar; to his left is ABC director Steven Englander. (Photo by the author)

departments of the university are picking up on it. In April 2014, we produced a show on the history of the Real Estate Show occupation. The initial commercial gallery show expanded into a public project involving three other venues, all producing displays and events concerned with gentrification and redevelopment. The "Real Estate Show Revisited" exhibition [Kurchanova, 2014] overlapped with the first annual Lower East Side History Month in May 2014, which in turn involved a network of local institutions.

For me, the New York SqEK brought a kind of closure. My work with the "House Magic" project was to make the social center and squatting movement legible to a U.S. public — to render its political objectives intelligible, and its constituency of activists and participants visible. Through this, I reasoned, it should become possible to legalize successful occupations, to make them into demotic institutions (not only "monsters" as the Universidad Nómada authors argued in 2006). I'm not sure what I expected to happen at the New York SqEK meeting. Everyone seemed pretty well satisfied, and the meeting surely set in motion scores of individual and collective projects. Little by little, right? But, probably like everyone else who is heavily involved in organizing what they feel are subversive discourse events, I was hoping for extensive mainstream media coverage (all the events were ignored, of course), followed by an immediate revolution.

TWENTY-FIVE
ENTER THE CURATORS

After the encampment went up in Zucotti
Park in late 2011, "occupy" became a meme. The
word in its every possible signification blew around
in texts of all kinds for nearly a year. As the verb
"occupy" spawned countless lame jokes and puns in
commercial messages and social media, the tactic, the
practice, the idea, and the networked social fact of
occupying public space and vacant buildings brought
on a renewed interest among operators in the cultur-
al sphere. Multiple processes of reflection and recu-
peration were going on in other sites of the global
reactivation of political activism, including Spain's
15M. Throughout 2012, Occupy thinkers and their
international allies organized meetings and symposia,

planned actions, published journals and anthologies. The institutional art world of colleges and universities and exhibition organizers were quick to attempt various reflections – or enclosures – of the movement, producing exhibitions, special sections of biennials, and more novel kinds of events.

It is an easy reflex, and a likely symptom of the many disappointments of 2011, to point to the flaws in all of these efforts. But this is habitual behavior. Artists make and show art, whether or not they are working in, with or for social movements. While it is disappointing – and boring – to see the reassertion of normal procedures and conventional hierarchies in exhibitions, conferences and publications, it was and continues to be regularly wonderful and frequently inspiring to watch the large-scale shifts in perspective, and the many new inclusions and emphases that have come with the institutional art world's adaptations to, and of, the 21st century social movements.

In New York City, efforts began almost immediately to build exhibitions with the Occupy vibe.[1] These shows were both big and small, and thrown together quickly with an open door populist curatorial policy. They prominently included demotic expressions like the river of cardboard signs articulating grievances which flowed around the rim of the Liberty Park encampment. These shows were the modest forerunners of the big European art festivals to come which would also and engage the themes and actors of the movements of 2011. OWS affiliated artists around the New York camp began with shows such as "No Comment" in the JP Morgan building on Wall Street, a rented space of the Loft in the Red Zone group, in October and November 2011 That show included work by longtime political artists, like Rainer Ganahl's installation of decorated fruit and vegetables *Credit Crunch Meal*. The OWS Arts & Culture Working Group coordinated a window show at the Printed Matter artists' bookstore in Chelsea. These and other shows were covered in the *Hyperallergic* e-zine, which for two months in 2012 gave up a chunk of their offices to the OWS Arts & Culture Working Group. Educational institutions scrambled to get on board with the movement which so many of their students had been involved in creating, with fast shows like "This is What Democracy Looks Like" at NYU's Gallatin School.

1 A distinction is made between the many groups and individuals promoting activities in the name of Occupy Wall Street. Some proceed directly from committees of the General Assembly of OWS. Most of those I discuss fall in that category, but I leave it to others to sort out the bureaucratic history of the Occupy movement.

The Occupy movement was national, of course, and spurred artists to show around its themes out of town. "Wall Street to Main Street" in the town of Catskill, along the Hudson River in upstate New York, was a festival of work by local artists and Occupy veterans. Curators and organizers from Occupy with Art put it together alongside a local group committed to artist-activated economic development. Numerous vacant storefronts were enlisted for the months-long project in the spring of 2012. The smorgasbord of cultural activities temporarily contained in stores along the streets of Catskill was a veritable inventory of progressive currents that ran into and out of the Occupy movement.

Maria Byck and Antonio Serna, who would soon develop the Making Worlds commonsing project, hosted a "People's Collection," an exhibition space set up for late-arriving art and artifacts. The two hosted a workshop on the idea of a cultural commons: how resources, including art, culture, and ideas, can be shared and managed by a local community. Using historical examples, they promised to contrast modes of public participation with a profit-driven culture market.

Veteran political artists participated, like the curator Geno Rodriguez, who had recently moved to the town. In the '80s and '90s Geno ran the Tribeca-based Alternative Museum that mounted many a landmark political show. The performing poet and humorist Sparrow held a session called "Speaking to the Gods" in the Occupy Books storefront. He read texts from literary masters, and invited people to speak to the group about their political struggles, spiritual life, and personal difficulties. Occupy Books was also the site of radio broadcasts during the festival.

Members of the Bread and Puppet Theater came down from Vermont, to demonstrate their "Upriser Calisthenics." The Illuminator van showed up, a "mobile activist tool" built by Mark Read, and famous for projecting the OWS "bat signal" on high-rise buildings during the occupation. In Catskill, Read's van converted into "an Occupy Wall Street library and cinema with hot cocoa and popcorn" which viewers could consume while watching short videos and cartoons about the movement.

The Hudson Valley region is populated with many ex-New Yorkers and is traditionally strong on environmental projects, which were well represented in "Wall Street to Main Street." These included workshops by the Woodstock Transition Team, from that nearby town, and

Sustainable Hudson Valley. WS2MS also saw a teach-in run by the Brooklyn-based Buckminster Fuller Institute, a legacy of the visionary architect who moved east from California in 2004. Their workshop expressed the groundswell of architectural thinking that lay behind the OWS camp and has moved forward with a remarkable proliferation of subsequent public space and occupation-related projects in that discipline. The "Practice Where You Occupy" workshop explained the methods and means used by designers and activists to supply the Liberty Park campers with water, energy and food during the occupation. The energy bikes used to run the OWS media center computers came from the Time's Up environmental group, organizers of the NYC Critical Mass bike ride. [Greene County Council on the Arts, 2012] These same bikes, installed outside the MoRUS museum in C Squat on the Lower East Side, would later provide that community with some power to charge mobile phones during the prolonged blackout of the district after Hurricane Sandy.

The WS2MS festival was organized by artists and groups directly connected to the movement in collaboration with a local arts council. More traditional art museums also responded to Occupy. The Yerba Buena Art Center for the Arts in San Francisco produced the "Occupy Bay Area" exhibition over the summer of 2012, which made important historical connections. The show framed the Occupy and the linked wave of global protests within a few key themes — "encampment and collective living, the direct democracy of the General Assembly, and the refusal to draft a manifesto with specific demands." It combined recent work with images from earlier protests in the Bay Area, celebrating the region's leadership in progressive causes.

Director Betti-Sue Hertz wrote, "This exhibition is a visual dialogue about the effect of Occupy on local understandings of political action within a long and valiant history of protest and resistance." ["Occupy Bay Area," 2012] The show sought to be "a testament to the power of images to evoke the emotional expression of popular and widespread sentiments," including iconic images that had emerged in designs intended to symbolize community, call to action, or simply announce events.[2] "Occupy Bay Area" included posters and photographs from

2 A fourth objective has disappeared from the website; I printed it earlier when preparing *House Magic* #5: "4) The self-organizing social structure of the Occupy movement, as a curious amalgam of the Paris Commune of 1871, where people of diverse classes came together to create a council sensitive to the needs of workers and the power of the public sphere as a form of political agency; and

Occupy SF and Oakland, as well as creative work done for earlier political struggles. These included the Black Panther Party, the International Hotel resistance in Manilatown (1968–77); the ARC/AIDS Vigil at City Hall (1985–95); the Occupation of Alcatraz, the abandoned federal prison (1969–71); the Free Speech Movement at UC Berkeley (1964–65); and the San Francisco State University protests to gain programs in ethnic studies (1968–69). All of these movements used occupation tactics.

The European response to developments in political culture was as usual broader, deeper, and faster. First out of the gate was the Cabaret Voltaire Dada museum in Zurich. At the end of 2011 they put up "Dada New York: The Revolution to Smash Global Capitalism." The Berlin Biennale 7, which opened in late April of 2012, one-upped the Dadas by featuring an actual camp. The show was curated by the Polish artist and filmmaker, Artur Żmijewski, in consultation with Joanna Warsza – who went on to curate the "Performative Democracy" show in Leipzig in 2013 – and Voina collective from St. Petersburg, Russia. (Voina is often in trouble with the law for their actions; some members of the group formed Pussy Riot.) The exhibition was full of provocative political works. The most spectacular and controversial turned out to be the permitted occupation of the ground floor of the main exhibition venue. Activists from 15M, Occupy Wall Street, Germany, and the Arab Spring took part. The space of the Kunst Werke gallery was divided into a sleeping area with tents, a kitchen and canteen, a banner-painting area, a zone for projecting websites and videos, a "99%" radio station, and an open forum area for presentation and discussion. In the quieter backyard of the KW, participants in the assembly conducted sessions of an Autonomous University. [Kopenkina, 2012]

The "Occupy Biennale" at first unnerved its New York participants, who felt themselves to be in a fishbowl. They wrote: "Żmijewski, an internationally renowned artist in his own right, has a track record of using people as marionettes and creating ethically and politically

as a manifestation of aspects of the hippie communes of the 1960s, where there is a partial dissolution of private property and a concerted effort to share food, lodging, and other resources in a specific localized geographic space, oftentimes in a natural setting" (from the curator's statement in *House Magic*, #5, 2013). This history had recently been explored in a series of conferences in the Bay Area; a book came out of it: *West of Eden: Communes and Utopia in Northern California*, edited by Iain Boal, Janferie Stone, Michael Watts and Cal Winslow (PM Press, 2012). The curator Betti-Sue Hertz worked with the New York City group RepoHistory during the 1980s.

ambiguous scenarios. We were afraid we unwittingly agreed to play a role in his latest piece, an Occupy time-capsule and tomb that historicizes and deactivates the movement." But the assembly was able to organize political actions outside the BB7. They also launched a campaign of meetings with the staff at the host institutions to air grievances and try to move towards a more horizontal way of working.[3] [Occupy Museums, 2012]

In her critique, Olga Kopenkina tends towards a Badiouian reading of the BB7 as driven by a curatorial (and artistic) imperative towards "eventfulness." That is, the desire to make a show full of political events that are unreal, and because they are not connected to any political party, are vacuous acts of resistance fully enclosed by the neoliberal state. The assembly of activists in Berlin seems to have been able to achieve something anyhow. As for the larger BB7, in addition to the many daring political projects in the German capital city, the curatorial team also arranged for numerous "solidarity actions" at other German, Polish and Italian centers. Their question was: "What can art do for real?" [Berlin Biennale, 2012]

One of these actions saw the rare conjunction of a prestigious national institution and an occupied social center in Rome. Paweł Althamer's "Draftsmen's Congress" project, launched in a deconsecrated church in Berlin, was extended to two simultaneous venues in Rome. Participants were invited to use pencils, paint and ink to draw on walls about topical issues of politics, religion and the economic crisis. Many artists showed up to draw on the whitewashed walls and plastic-covered floors of the commodious exhibition spaces of the Swiss Institute of Rome, overseen by an onsite artist. The walls of the institute were filled with crisis-era commentary, as well as a mélange of handprints, Vikings, rock stars, flying elephants, and children's art. A steady stream of visitors fueled the continual graphic metamorphosis, bringing to life Althamer's ideas of democratic painting, and pluralism through the mingling of active bodies in space. Reporter Andy Devane quotes a U.S. artist based in Rome: "It was inspiring to walk into a giant community drawing; this show is a perfect example of free art. I love to participate with tons of other people, it is so creative and uplifting to see how talented everybody can be when provided with an open forum."

3 Much of the discussion around, and documents proceeding from the Occupy camp at BB7 are online. Many of these, particularly concerning the horizontal initiatives, are redacted in *House Magic* #5, Spring 2013.

Simultaneously the "Draftsmen's Congress" took place at another venue, the ESC. Some of the artists who drew in the Swiss Institute also visited the place Devane describes as an artist-run collective occupied since 2004, near the also occupied Cinema Palazzo. ESC organizes regular events to promote social justice and has "a freer, more underground feel to it." ESC – for Eccedi Sottrai Crea (Exceed, Subtract, Create) – is closely connected to the LUM (Libera Università Metropolitana, the free metropolitan university of Rome). This project of a group of academics, including Paolo Virno, works to leverage the resources of a nearby university for autonomous education.

Devane notes that the BB7 curators' project was driven by austerity-era cuts in state support for the arts in European countries including Britain, the Netherlands and Italy. The curators also called for a "new social contract" to be drafted between artists and Berlin cultural institutions. The alliance with an academically affiliated occupied social center in Rome was part of the curatorial team's program to use the Berlin Bienniale as a political platform. After decades of degradation of the cultural sector in Italy, [Hamelijnck and Terpsma, 2012] the idea of the occupied social center was coming back, seeming like a possible way forward.

The most ambitious of the attempts to engage the spirit of 2011 was part of the Steirischer Herbst annual art festival in Graz, Austria in September 2012 called "Truth Is Concrete." [Steirischer Herbst, 2014] It was produced as a "24/7 marathon camp" for one week with around 200 artists, activists, and theorists invited to "lecture, perform, play, produce, discuss, and collect artistic strategies in politics and political strategies in art. All day long, all night long. It is a platform, a toolbox, as well as a performative statement—an extreme effort at a time that needs some extreme efforts." The furniture for the Graz event was specially constructed by the architectural group Raumlabor.

What made the BB7 exhibition of Occupy interesting was the clash of cultures between the art world and the democratic social movements, and the concomitant efforts at grassroots internal reform of an art world system entrained to global capital. The conference in Graz was very different. It was deliberately structured to be what it was. It was not an exhibitionary art festival straining at its limits. While of course it was a cultural construct and not an organic political event, it was, in a sense, a more normal, happy baby than the monster of BB7. Graz was an expanded conference imitating a protest camp or squatter

convergence.[4] The panel descriptions and the archived videos are fascinating. The historian of radical art Gavin Grindon reported that this cultural festival, with its mix of invited and subsidized participants, was different from "groups willfully collaborating for their own strategic reasons." Grindon discusses the network diagram of collaborators, which privileged some names, and showed less a movement of shared strategies than a "map of cultural capital in action." He confessed to frustration born of days of lecture presentations with inadequate time to discuss them. [Grindon, 2012]

Leftist academic conferences have reasserted normal procedures in the wake of Occupy, with big wigs sharing stage with presenters and everyone else in the audience. It was a mark of Occupy's influence that, at least in the short run, few of these events were allowed to take place without some gesture toward assembly, some efforts made to break the hierarchies inherent in that infrastructure. The horizontality of the 2011 movements, however, runs against the grain of the necessities of the education trade. It crimps the minting of academic currency – institutional validation, the symbolic capital accrued by public appearances, where only some speak and are recognized as authorities. The very architecture of institutions is built to do that work. The kind of open listening that was such an important feature of the North American assemblies must devolve into a deadened Q&A so that the normal, monetizable flow of knowledge may be preserved.

"Truth Is Concrete" was certainly different, with a team of artists and curators focused on the processes of radical democracy. Careful efforts were made to form participatory arenas of listening. I watched the live stream enviously, and learned of many new people and perspectives during this week-long gathering of fascinating theorists and adventurous practitioners – the knights of creative activism – sharing ideas and strategies. Part of what made the event so interesting was that everyone was good. It was an exclusive event. Complaints were heard about the privileging of activist art stars, about the feel-good love fest nature of the camp, and the failure to fully include

4 The Graz "Truth Is Concrete" meetings seemed to borrow from, and expand upon, the format of the Creative Time organization's summit series, an annual large-audience event with international presenters giving brief talks. (Oliver Ressler, an organizer, was included in the 2010 Creative Time Summit, "Revolutions in Public Practice.") The records of both of these events offer a great resource for understanding the strong current of social and political work by artists today. [Steirischer Herbst, 2014]

important excluded groups, especially immigrants. But the habitual sad envy of artists for one another had to be tempered by the knowledge that "Truth" was in no way a traditional art exhibition. It was not a concluding event, or even a moment that defines a style of art, a movement or a mode, from which if you are excluded you will always remain a walk-on figure in the history of your time. The Graz conference was a stop on the way to something bigger than the artworld, a deliberate attempt to make a kind of grand central station for people who the central European organizers believed were able to contribute to the general assembly they had curated at that moment. It was a pure political art event.

Street stencil in Berlin against atomic energy,
2010. (Photo by the author)

ARTIST FOR A DAY: INSTITUTIONAL REGULATION OF VACANT SPACE IN NEW YORK CITY

During SqEK's meeting in New York City, it was hard to ignore the fact that there were no active public squats for us to visit. Even rented spaces with facilities used by artists for political purposes like social centers have been attacked and evicted.[1] And once gone, they were fast forgotten. None of the white bearded journalists from the '60s era underground newspaper *East Village Other* whom I queried during the panel discussion we attended seemed to recall anything about squatting back then. In fact, the Lower East Side during

1 The 13 Thames Street building in Brooklyn [Gwynne, 2011] and the Rebel Diaz center in the South Bronx (discussed in Chapter 11 and 22respectively) are the recent examples alluded to here. Police attacked 13 Thames, and the Rebel Diaz center was evicted. The Lower East Side squatters' attempt to establish a social center called ABC in the '90s was repelled. (This was *not* ABC No Rio.) The Charas-controlled building El Bohio on East 9th Street was evicted in 1999, but not forgotten; the private developer's plans have been continuously blocked. Overall, there are very few places for extra-governmental political organizing to take place in a city that once had dozens. In large measure this is a direct result of the demise of left political parties, which NYC once had in profusion. [Fiks, 2008]

the '60s was full of squats and communes, and a number of large buildings were taken over as social centers.[2]

Today, almost no one who wanders into the shabby little store-front of the East 4th Street Food Coop, a few blocks from the massive Whole Foods megastore, not even the volunteers themselves, has any idea that this project began in a squatted high-rise building that today is a luxury condominium. As the city sells itself, it eats itself, digesting its working class and artists and shitting them out further and further away from its center. To maintain high rents and the rate of profit, vast swathes of properties must be kept vacant. No squats or occupations opposing this system are allowed to exist for long. When they do spring up, most artists have looked upon them – if they do look at all – as mere pustules of delusion.

Rent is a major source of profits in New York City, and the biggest local industry. Meanwhile, NYC's redoubtable social housing programs have been gutted. Rent regulations have been rolled back almost entirely. The baseline cost of living is incredibly high. Hope?[3] Well, for artists, there is some. What New York City does have is a set of regulated programs whereby the city government and private landlords, acting through cultural agencies, make a small sliver of the city's vast reservoir of vacant spaces available to artists and other cultural workers on a short-term basis. Agreements for artists to use vacant city-owned properties in areas deemed ripe for urban renewal began during the 1960s. Some buildings along the Bowery, and in the South Street seaport and Brooklyn waterfront, for example, were handed over to artists at low rents.[4]

2 The LES social centers have all been lost, and their histories forgotten. I have written scraps about this in different texts, but there exists no single account of the East Village communes, both squatted and rented, the big building occupations led by Puero Rican groups like Cuando and Charas, and by Black Panthers, like Christadora House [see *House Magic* #6]. Nor were these occupations happening only in NYC; they took place throughout the country during the 1970s. Were these occupations networked internationally?

3 The 2014 election of Bill Deblasio as New York City's mayor is leading to some changes in development and housing policy. Many initiatives that could not get off the ground during Mike Bloomberg's eight years as mayor are now getting a hearing.

4 Caveat: The statement in the text and nearly all that follows in this note is based on hearsay. I visited a large warehouse property reportedly run by the sculptor Mark di Suvero in South Street during the late 1970s; he also had (and has) extensive studio facilities on the Brooklyn waterfront. (It is now also a public park with

During the 1970s, cultural agencies arose to mediate these uses, to regulate artist occupations of vacant New York City owned properties. The best known of these is the Institute of Art & Urban Resources, the agency created by Alanna Heiss in 1970. (In an interview she admitted being inspired by the 1960's London art center movement, which in turn was inspired by Alexander Trocchi's Sigma proposals.) Heiss arranged with city officials for short-term use of buildings and lots all over the city, uses which enabled many important early artists' projects and shows. Her first big coup was the attic story of a run-down underused city office building on Broadway at Leonard Street. Heiss moved her offices there in 1973. The very top of the beaux-arts building housed a defunct clock surrounded by a rooftop plaza. The Clocktower hosted a series of well-remembered artists' installations and performances, then settled down to 30-plus years of exhibitions, media work, and artists' project offices.

Alanna was close to the artists of the post-minimal school, especially Gordon Matta-Clark. Gordon wandered throughout the city, exploring its vacant spaces. He became famous for his dramatic sculptural interventions in empty buildings slated for demolition. Many if not most of these were unauthorized – squat art, in short. In the middle 1970s Matta-Clark was planning to start an ecology education center on occupied city-owned land on the Lower East Side, working with a local Puerto Rican development group of ex-gang members called Charas. The project was inspired by Gordon's visit to an abandoned occupied factory in Milan, one of the early social centers in Italy. He died before it could begin. The Charas group, continued, developing city-owned vacant lot on East 9th Street as a park called La Plaza Cultural, and taking over a vacant school building a few years later took which they called El Bohio – The Hut. [Guerra, 2014]

Alanna Heiss' biggest coup made the Clocktower seem like small change. The Institute of Art & Urban Resources was given control over a beautiful old empty school building in Queens. This massive complex had been the crowning achievement of a 19th century

a residency and commission program for sculptors.) Coincidentally, di Suvero has a large sculpture in Zucotti Park, site of the Occupy Wall Street encampment. The artist, who is married to a prominent city official, remained mute throughout those days and after. Other artists who had long-term sweetheart deals on the Bowery included Kate Millet and Hans Haacke. I met a jazz musician there in 1975 who was renting to a friend. I was told he lived in France. All of these artists made their deals in the 1960s. How? I have no idea. This is the anecdotal tip of an historical iceberg of coziness between some artists and city property managers.

political boss. P.S. 1 (for "public school") opened as an art space in 1976. Dozens of artists were invited to make site-specific work using the schoolrooms with their peeling paint and abandoned furniture. This strong start, together with smart management, transformed the entire building into a new locus for art in New York City. [Foote, 1976] P.S. 1 became a center for local artists' projects, international studio residencies, inventive, even daring exhibitions, and great parties. The place was vast, and administration was loose. As the building was gradually renovated, with a dramatic architectural redirection of its main entrance in 1997, P.S. 1 gained many new layers of professional staff. Exhibitions became increasingly ambitious, the artists more famous. In 2000 it affiliated with the Museum of Modern Art. In 2010, MoMA gobbled it up completely, and Alanna Heiss was retired. She retreated to her first base of operations, the Clocktower, and continued to produce peculiar and interesting shows there. The Filmmakers Coop, a circulating archive of classic avant-garde film and video, moved there shortly before its co-founder Stan Brakhage died. In 2013, the Clocktower was sold to become a multi-million dollar residential condominium. Alanna Heiss hit the streets. The Institute for Art & Urban Resources had been "rentrified."

Alanna's success was inspiring, and other cultural organizations soon got into the game of mediating artists' use of vacant commercial and institutional space in New York City. The Lower Manhattan Cultural Council (established 1973) worked mainly in the Wall Street area, arranging numerous shows in corporate lobbies, and labored to network lower Manhattan cultural institutions through their newsletter. Their offices were destroyed in the terrorist attacks of 9/11. In the aftermath of the attacks, the downtown business district languished with a huge count of vacancies, and LMCC was richly funded to help in the revival. Suddenly, art fairs began to appear in spacious vacant floors of abandoned offices, and in 2005 LMCC began their Swing Space program of "project-based residencies" in vacant office buildings. With recovery of the real estate market, the program was scaled back in 2014.

The Creative Time public art-commissioning group (also established 1973) achieved prominence through a series of dramatic uses of the huge landfill on the lower western end of Manhattan island that would become Battery Park City. Throughout the early 1980s, Creative Time's "Art on the Beach" series put temporary installations, performances and

land use projects in amongst the wind-swept dunes of the landfill as the material settled over years before building could begin.

In 1995, Anita Durst, the daughter of a major real estate developer in the Times Square area, began Chashama to make space in the area available to artists. The theatrical visionary Reza Abdoh, who often used street wanderings in his work, inspired her. During the preparatory period of the redevelopment of Times Square, Chashama ran projects in a string of low-rise 42nd Street storefronts due to be demolished. These were continuously kept busy during the early '00s. The programming hand was so loose that at one point a days-long anarchist convergence was allowed to be held.

During the prolonged economic crisis of the 21st century, as global cities remake themselves into enclaves of the rich, No Longer Empty has arisen as yet another mediator of interim use in NYC. It represents a new kind of institution, closely linked to urban planning and the emergent academic discipline of curating art. Founded by a real estate professional experienced in the development of luxury hotels, and "keen to study and measure the effects of art as a tool for re-activating corridors and making a local economic impact," members of the group have post-graduate degrees, and have worked in major museums like the Guggenheim. No Longer Empty seems structured to work like a gentrification machine. Operating with professional curators, the group researches a community with available vacancies and develops curatorial themes. They then prepare the given empty store to be "just like a museum," and launch an exhibition that is accompanied by educational programs and discourse events. After a one to six month project is done, "It is difficult to move on."[5] But they do it.

This is temporary use in the age of the art fair and the "pop-up" retail store; a form pioneered by the nomadic vendors of fireworks,

5 All this comes from the website of No Longer Empty, 2014, which describes the background of founder Naomi Hersson-Ringskog and president Manon Slome (at: HTTP://WWW.NOLONGEREMPTY.ORG/HOME/WHO-WE-ARE/TEAM/), and how they operate (at: HTTP://WWW.NOLONGEREMPTY.ORG/HOME/WHO-WE-ARE/ NLE-PROCESS/). Speaking to the Forum for Urban Design, Hersson-Ringskog called for city assistance for her program, including databases that track public and private vacancies and tax incentives to encourage their interim use ("Leverage Our Vacant Spaces," at: HTTP://NEXTNEWYORK.ORG/TRANSFORM-OUR-VA-CANT-SPACES-NAOMI-HERSSON-RINGSKOG/). In 2010, a group of young curators involved in these programs launched a class at The Public School with an instructive syllabus; see "Conversion Strategies: Temporary-use and the Visual Arts" at HTTP://NYC.THEPUBLICSCHOOL.ORG/CLASS/2346.

Halloween costumes and Christmas decorations. Pop-up stores have been used by major retailers to test sites, build brand identification, and amp up excitement around consumer products, like the mysterious, nearly unobtainable trousers described by William Gibson in his novel *Pattern Recognition* (2003).

The highly professionalized management of vacant commercial spaces for cultural purposes in New York City makes the anti-squatting companies of England and the Netherlands – specialists in "vacant property management" – look primitive.[6] What's more, it makes the political squatter collectives look like working class schlubs, completely out of touch with the reality of the neoliberal global city. But, then, that's the point, isn't it? Relax, do your art, and leave all that other stuff to the pros.

6 At least one group of urban consultants, the Urban Resort group run by Jaap Draisma, a former squatter in Amsterdam, undertakes similar projects of administrated short-term use. The "breeding place" program in the Netherlands, launched by the government, sought to replace the cultural provision of the large building squats that had been evicted during the '90s and '00s with managed temporary use programs.

Occupied Real Estate project image for residency at Exit Art, 2012.
(Photo courtesy of Not an Alternative)

TWENTY-SEVEN
EXIT ART AND NOT AN ALTERNATIVE

Consider: What is the relation between politics and art? Straightaway you are lost. What seems discipline-specific drops off into a trackless bog. That's because the relation is intimate; it is only within the lived conjugation of the two spheres that some kind of an insight may be gleaned. That is how I'm trying to write this book: as a record of a lived experience, with reflections, distractions, and vistas down paths that invite the reader to explore. Unbeknownst to me, I made a crucial decision one sunny afternoon

when, as a callow 20-year-old, I saw two paths open before me. I was a public school student visiting the sumptuous campus of an expensive private California university. In one afternoon I saw Jean-Luc Godard and Jean-Pierre Gorin of the Dziga Vertov Group present and discuss their rigorous film *Letter to Jane* (1972), a nearly hour-long cinematic essay that deconstructs a single news photograph of Jane Fonda in Vietnam. The war was still in full swing. After leaving the lecture hall profoundly baffled, I saw the Bread & Puppet Theatre perform on the lawn. I fell in love. I would have Toby Tyler'd it right then and there, except the whole cast that year was French, and I couldn't say much more than "bonjour." In my heart I chose praxis, but in the end, I committed myself to reflection.

The "House Magic" exhibition at ABC No Rio was the formal start of the research project of which this book is a record. It was a commencement in ignorance, however, and I never stopped wanting to repeat it, enriched with all the new information I had gathered. Throughout my career, U.S. art institutions have been largely closed to contemporary political work, and curators who would take a chance on political content have been scarce on the ground. It was quixotic, I knew, to propose a show on the cultural production of squatting when so much of the funding for museums and cultural projects came from speculative capitalists and real estate wealth. Anything to do with a squatting movement should have been a non-starter. I didn't stop, however, and at one point I got close. I'd been shopping around a proposal, and at last it looked like there might be a second small "House Magic 2" show at Exit Art in Chelsea when the SqEK conference came into town.

A curatorial advisor to Exit Art, Mary Anne Staniszewski, had pitched my proposal to the director Jeanette Ingbermann, and she wanted to do it. Mary Anne had shepherded the grand political art survey "Signs of Change" through Exit Art, which had so inspired me the year before "House Magic." Jeanette founded Exit Art as a non-profit alternative art space with her husband artist Papo Colo in 1982. (He had recently shown at ABC No Rio, in the "Erotic Psyche" show.) The first exhibition the couple did at their initial small gallery was "Illegal America," based on a thesis Jeanette had written on art and the law. The exhibition celebrated artists who had done transgressive and illegal actions, and it included the Real Estate Show. That was a surprise to we who had made it! Exit Art

was a special place.[1] "Illegal" and "Signs" were not anomalies, but way stations along a road of major curatorial projects by Exit Art that engaged the political in art and popular culture over decades. Exit Art in Soho saw the most important exhibitions of countercultural materials in New York during the 1990s: "Counterculture: Alternative Information from the Underground Press to the Internet, 1965-1995."[2] Their immense Chelsea venue saw the huge "Signs of Change" poster and media exhibition, then a show celebrating 30 years of the radical graphic magazine *World War 3 Illustrated*. Among the last of these grand show, "Alternative Histories," presented self-selected materials from some 130 artists' spaces, groups and projects over some 30 years. [Rosati and Staniszewski, 2012] Exit Art as well was always also a kind of social center, an art gallery with a café bar in the middle of their successive spaces. The funding was mainly public, of course. Associate curator Herb Tam recalled that Jeanette "saw Exit Art as an island, special in the way it expressed marginality without apologies and a cultural jungle populated by strange-looking plants and animals that were hybrid species. It was always an us-against-the-world attitude; we played with an edge." [Tam, 2012]

The "House Magic" show never took place. Jeanette died of leukemia some months before SqEK arrived in New York. Exit Art didn't last much longer. Papo soon retreated to the Puerto Rican island art complex he and Jeanette had been organizing for years. But before the lights went out, Exit Art took a step further towards the Occupy movement than any other NYC cultural institution – they produced

1 The two NYC venues most friendly to political art during the late 20th century, Exit Art and the Alternative Museum, were both run by Puerto Ricans (Papo Colo with Jeanette Ingbermann, and Geno Rodriguez respectively). As colonized subjects, citizen-immigrants to New York City from a mixed-race society with a significant left liberation movement, Puerto Ricans were attuned to a different political reality from the majority of Anglo cultural actors. The same orientation can be seen in El Museo del Barrio.

2 Although the promised catalogue never appeared, the "Counterculture" show in 1995 was one of numerous exhibitions directly spotlighting political content, and probably the most ambitious Exit produced. Curated by Brian Wallis and Melissa Rachleff, this survey of alternative popular culture included samplings of underground newspapers from all over the U.S. as well as punk zines and artisanal media products, video, and internet stations for the emergent medium of the day. I wrote a review for Artnet.com, and Gregory Sholette reviewed it for *Parachute*.

Not an Alternative support for a building occupation by the Picture the Homeless group, 2009. (Photo courtesy of Not an Alternative)

"Occupied Real Estate," a five-day workshop by the Not An Alternative group.

Held just after OWS had pitched hard into their Mayday organizing, the workshop proposed a strong follow-up: "As Occupiers capture imaginations and attention around the world, they enter the battleground in a forceful way, destabilizing ideas about ownership and use of space. This new class of 'real estate agents' comes equipped with the tools of their trade: those of media production and material construction. From foreclosed homes to public/private parks, to warehoused buildings and bank-owned lots, the movement reveals invisible spaces, exposing exclusions and power relations. Through anonymous acts, interventions and appropriations, they activate these spaces, building a new world in the shell of the old. The Occupied Real Estate workshop is an architectural set that puts the production of this world on display. It is both a workshop and a studio set. Agents converge at assembly-line workstations to manufacture tools for the movement and document their practice along

the way. In turning the lens on themselves, they perform a material function with an awareness of its immaterial implications." [Economopolous, 2012]

Not An Alternative is a project driven by another couple, organizer Beka Economopolous and artist Jason Jones. I had met them both in 2004, at a 16 Beaver Group meeting, together with Josh MacPhee and Dara Greenwald. Josh was an artist and historian of political graphic art, and Dara was doing the same for video. Beka and Jason had been involved in a spectacular anti-Bush banner drop from a luxury hotel on Central Park as part of the protests against the World Trade Organization meeting in New York. The arrestees in that action were facing 25 years in prison. Now one of them is a fellow at the Council on Foreign Relations, and has worked for the U.S. Treasury and the U.N. This was a new generation of activist artists, with many highly educated at elite institutions, and well connected to one another through years of international work in the global justice movement.

The creative activism of the 21st century is worlds away from the crowd of scruffy, punky politicized artists I came up with. Most of my friends finally knuckled down and spent their careers fishing for scraps of approval from art world institutions. But these new guys didn't live the betrayal of the promises of the '60s and '70s, the vision that the U.S.A. could be remade with ideals which in the end only became products coated in plastic and sugar. They didn't get whacked by the Reagan reaction, the big bloody bamboozle of the 1980s. Instead they joined the new global revolution, which, as it turned out, had some significant support.

Memorials for Jeanette Ingbermann have called the Exit Art project essentially a love story, between a fearless inventive curator and Papo Colo, the indefatigably transgressive "trickster" artist. [Burt, 2011] The same could be said of Not an Alternative, the Brooklyn space started by Beka Economopolous and Jason Jones. The couple met during the demonstrations of the anti-globalization, or global justice movement. She was an activist, he was a public artist in Canada. They moved to New York City and opened a shop. They called it Not an Alternative, as in "not an alternative space."[3] The

3 The "alternative space" designation has an institutional history that Beka and Jason were at pains to avoid. The pitfalls for politically engaged artists of the alternative space designation was famously pointed out in a manifesto by Group Material, which warned against the bureaucratic tar pit that maintaining such a

place functioned as an exhibition space, discussion center, internet television studio, and a workshop for the manufacture of props for demonstrations. The couple recruited like-minded collaborators, and opened a co-working space in their storefront studio to help pay the rent.

The work of the group was amped up and thoroughly networked internationally through a years-long engagement with Eyebeam, the experimental new media atelier in Chelsea. Eyebeam is funded by the heir to a drug company fortune, himself the son of a famous super-realist sculptor, Seward Johnson. It was run by a politically engaged Australian curator, who invited Jason Jones and crew to present the group's activist projects, and to fabricate the material superstructure of Eyebeam exhibitions on the subject. (For years Eyebeam showcased important hi- and lo-tech tools for all manner of social and political artwork, in between curated shows of prize-winning media art and parties for local academies.) Not an Alternative had already produced props for the uptown building and vacant lot occupations of the Picture the Homeless advocacy group when they moved into direct action. (See Chapter 9) Jason built a stage at the "City from Below" conference in Baltimore in 2009, which dramatized the foreclosure crisis, and shot video interviews with activists and intellectuals inside it. They were invited to the Tate in London during the notorious museum workshop on art and activism that led to the spectacular mediatized protests called "Liberate Tate" against BP (British Petroleum) sponsorship of the museum's exhibition programs. [Clarke, et al., 2011]

The whole crew pitched into Occupy Wall Street wholeheartedly, producing signs and props for use in the encampments and demonstrations. Like most activists, they maintained a feverish pace during those months. In a classic New York workaholic turn, the couple's baby was born in a taxicab as Beka was on her way to or from a meeting. The group continued steady on and whole hog, making signage for the Occupy Sandy relief operation that leapt into action immediately after the titanic hurricane devastated the coastal shores of the New York metropolitan region. (The MoRUS museum played a key role in this as well, since their premises were entirely flooded days before they were scheduled to open.) The show Not an

place could prove to be. (The text of Group Material's 1981 flyer, "CAUTION! ALTERNATIVE SPACE!" is included in Kristine Stiles and Peter Howard Selz, eds., *Theories and Documents of Contemporary Art,* 1996.)

Alternative did at Exit Art just before it closed expressed what had become a much amplified activist project – more of a think tank for creative political work.

Poster depicts "San Papier, protector of the migrants of the earth." Hanging in a Roman social center, 2014. (Photo by the author)

TURTLES, PUPPETS, REBEL CLOWNS AND PUFFY RUMBLERS

The ceaselessly inventive techniques and tactics of networked protest today first came into mass public awareness in the U.S. with the large-scale days-long allied resistance to the third ministerial conference of the World Trade Organization (WTO) in Seattle in 1999. Political artists started working seriously to make protest fun. The actors of the anti-corporate globalization or global justice movement innovated strategies and tactics continuously. Many of these came out of the political squatting movement that played a central role in the organization of the anti-ministerial demonstrations around the world. Key groups emerged in the U.S., England, Italy and Spain. All of them had substantial lineages in creative resistance past.

In one memorable tactic employed in Seattle, hundreds of demonstrators dressed as endangered sea turtles and swarmed in the streets. The costumes were organized over many months of collective sewing sessions, traditionally called "bees." [Steiner, 2008] David Solnit, one of the key organizers of the Seattle demonstrations and brother of the well-known writer Rebecca, said that the core concept of the Art and Revolution groups he was involved with was "to try and bring

together cultural and direct action skills." In an interview for the *Journal of Aesthetics & Protest,* Solnit explained that the A&R collectives began their work at a Chicago anarchist conference that brought together puppeteers, theater people and activists in 1996. They produced "participatory theatrical resistance" at the site of the Democratic Party's political convention that year. The spectacle engaged people differently than ordinary demonstrations, yet, like any other demonstration, the new techniques met with violent police response typical of that city. "The police had their own theatre of dressing like Darth Vaders with projectile weapons, clubs and tear gas canisters and pepper spray," Solnit said.

"Art and Revolution was both a concept and a network of street theater and organizing collectives," he said. "Our goal was to infuse art, theater, and culture into popular movements to create new language and new forms of resistance.... A demonstration is partly a ceremony, and just [like] a ceremony it should make space for peoples' hopes and desires and fears and anger." The U.S. left then had been inspired by the EZLN or Zapatista uprising in Mexico. The sweeping North American Free Trade Agreement (NAFTA) went into effect on January 1, 1994, and the Zapatistas responded by taking over 14 cities in Chiapas. "That is one of the creation stories of the global justice movement" (and from whence comes the term "puppetista"). Later the EZLN concluded a truce, laid down their arms, refused to take power, and relied upon their "amazing sense of spectacle, theater, and poetry." [Angel, ca. 2008]

Key people in the A&R group had worked with Peter Schumann's Bread & Puppet Theatre. Handmade puppets and ragtag music-making have been key parts of the spectacles and marches produced by Bread & Puppet since it began in late 1950s New York in support of the "ban the bomb" anti-nuclear movement. Schumann, a sculptor who delivers "fiddle sermons," was inspired by the rural popular theater traditions of his native Germany. At the end of formal performances, the troupe serves their audiences homemade bread. Working from their collective in Vermont, the Bread & Puppet has been producing work, supporting demonstrations, and training "puppetistas" from around the world for decades.

Solnit said he was following the political lead of social movements in the global south, Latin America, and in Europe, where the threat of corporate globalization was more clearly understood. He praised the

idea of a "laboratory of resistance," in which protests and organizing is conceived of as experimentation. It puts the authorities on unfamiliar terrain. Solnit may be referring to the Laboratory of Insurrectionary Imagination (Labofii), a British art activist initiative fronted by John Jordan. Labofii first began working during the European Social Forum held in London in 2004. Many activists had come to feel that the social forums, which began in 2001 in Porto Alegre, Brazil, as a counterweight to the simultaneous World Economic Forum (WEF) of business and political leaders, were being dominated by large NGOs (non-governmental organizations). Hierarchy, political parties and corporate collusion were gaining the upper hand, while grassroots activists were being shut out, and the social forums no longer had the aims of the "alter-globalization" movements ("another world is possible") in view.

Working from the squatted social center rampART, Labofii invited activists from around Europe to pitch in as they launched a program of creative political actions around London during the Social Forum meeting. These included weird action games in chain restaurants and department stores, urban climbing on banks, mass hexing and praying, and sudden mock battles between creative activist factions. One of these was the Clandestine Insurgent Rebel Clown Army, a project that turned out to have legs. In 2005, the group was invited to participate in an exhibition, "Risk: Creative Action in Political Culture" at the Centre for Contemporary Arts in Glasgow. They built a Clown Army War and Strategic Planning Room, deploying a large map of Gleneagles, the nearby site of an upcoming G8 summit of world leaders that was the target of a global justice movement protest. The Lab also toured the U.K. in a bus, putting on shows, training and recruiting for the Clown Army. In the end, a "platoon" of 200 rebel clowns made it to Gleneagles for the protests.[1]

Jordan's work with Labofii has its antecedents in creative British activism closely linked to the large-scale squatting movements of the 1970s.[2] Protests against the construction of a massive link

1 Most information here is from the website of the Laboratory of Insurrectionary Imagination, "Experiments," n.d., at: HTTP://LABOFII.NET/EXPERIMENTS/ESF/. The Clandestine Insurgent Rebel Clown Army website for this action and others is at HTTP://CLOWNARMY.ORG/. It describes the training, which includes physical and acting exercises, and the mode of organization into "gaggles" which report to a "clown council."

2 The precis that follows in the text comes from Wikipedia, "Reclaim the Streets," and "M11 link road protest," accessed February 2014, which cites some of the

road called the M11 in the early to mid-1990s employed spectacular ragtag tactics of occupation and blockage. [McKay, 1996] Jordan was involved with the start of the Reclaim the Streets group that took up the green struggle after the anti-roads actions. This activism was ecologically based, coming out of Earth First! in Brixton. Their most spectacular action was made for the June 1999 Global Carnival Against Capital, timed to coincide with the 25th G8 summit in Cologne, Germany. Thousands of demonstrators swarmed over the M41, a major motorway near London. To the sound of loud portable sound systems, dancers appeared high up on stilts, dressed in vast wire-supported skirts. Beneath the skirts, guerrilla gardeners drilled holes in the roadway and planted trees, leaving behind an incipient forest. [Blanco, 2014]

This legendary action was matched by another, more widely attended protest. The narrow streets of London's old city, its financial center, are easily overwhelmed by massed crowds. One short documentary of the event ["Carnival," 1999] shows masses of dancing protestors, samba bands, pirate flags waving, masked marchers, stilt walkers, games and clowns which focus attention on the issues behind the protest. Then, police write the script of violence with their attacks. We see cops in riot gear forming lines, squads of horse-mounted police entering crowds, parks being cleared, demonstrators trying to stop arrests, police vans driving over people – provocations and responses, car and shop windows smashed, burning rubbish. A raft of commercial newscasts on the same topic posted to YouTube take up the story of order interrupted, emphasizing violence and chaos, blocked cars "going nowhere," and the evictions of squats which had hosted the anti-G8 organizers. Despite its difficult reception in London, the model of UK's Reclaim The Streets (RTS) actions was quickly taken up globally as a form of protest, leading to a host of "street party" demonstrations against motor vehicle dominance of public space. [Ferrell, 2001]

many books that have appeared on this major wave of green activism. They include two by George McKay, his *Senseless Acts of Beauty: Cultures of Resistance* (Verso, 1996), and the edited collection *DIY Culture* (Verso, 1998). Other important sources on global justice movement activism include Benjamin Shepard, Ronald Hayduk, Eric Rofes, eds., *From ACT UP to the WTO: Urban Protest and Community Building in the Era of Globalization* (2002), Stephen Duncombe, ed., *Cultural Resistance Reader* (2002), and a book Jordan worked on with Notes from Nowhere, eds., *We Are Everywhere: The Irresistible Rise of Global Anticapitalism* (Verso, 2003).

The carnival concept design for protest, with its guiding spirits of rebel clowns, come from deeply elaborated theories of popular culture as resistance. Many rely on the work of Russian literary scholar Mikhail Bakhtin and his conception, expounded in a classic text on Rabelais, of the carnival as an event, which communicates a rich code of subversive messages. In a text opening with a first-person account of the London actions, Gavin Grindon explored this idea. He considers texts by Bakhtin, the Situationist Raoul Vaneigem and the "ontological terrorist" Hakim Bey (*aka* Peter Lamborn Wilson). [Grindon, 2004] A later analysis brings Occupy Wall Street into the picture. [Tancons, 2011] Larry Bogad, a Rebel Clown co-founder, has written on the figure of the clown.[3]

At the same time as carnivals and street reclamations were being plotted and executed in England, a new tactic, directly connected to the struggles of the squatted social centers was evolving in Italy. I first saw the principle used by a New York performance artist, David Leslie, *aka* the "Impact Addict." In a 1987 stunt, David jumped out a second story window in the courtyard of a downtown New York cabaret, covered in plastic bubble wrap and twinkling lights. Later that year, during a benefit for the politicized performance space Franklin Furnace, Leslie plunged onto a stage full of martial artists who kicked him around to the beat of disco music. [C. Carr, 2008]

Plasticized resistance began in Milan in 1994. The Tute Bianche – or white overalls – was an open identity anyone could assume by putting on the clothing and joining the line. The name was inspired by the sarcastic remark the right wing mayor of Milan made when he ordered the eviction of the historic squatted social center Leoncavallo. From now on, he said, squatters will be like ghosts wandering the city. The Tute Bianche organized when Leoncavallo was re-squatted, acting as a security service at demonstrations and defending the social center from attacks. The Tute Bianche evolved a strong practice of self-defense, wearing heavy padding, helmets, gas masks, plastic shields and mobile barricades of inflated tires and plastic panels. These tactics succeeded against riot squads and reduced injuries suffered by

3 A Kolonel Klepto considers the clown with its roots in left theory, Buddhism, and psychology in "Making War with Love: The Clandestine Insurgent Rebel Clown Army," n.d., at HTTP://CLOWNARMY.ORG/ABOUT/WRITINGS.HTML. For a recent text on these activisms and the development of the Rebel Clown Army, see Benjamin Shepard, *Play, Creativity, and Social Movements: If I Can't Dance, It's Not My Revolution* (Routledge, 2012).

demonstrators. The puffy commandos led the invasion of a locked-down immigrant detention center so that journalists could see the conditions inside, and later write exposés that led to the closing of the center. They appeared in demonstrations against the emerging practice of hiring precarious labor, workers who could not be "tute blu," or blue collar unionized workers.

A member of the Wu Ming writing collective described the work of the Tute Bianche in a talk at the "Make-World" festival in Munich in 2001. [Wu Ming 1, 2001] In a lengthy preamble, Roberto Bui ("Wu Ming 1") described the political and mythological components of the thinking that lay behind the tactical movement, inspired by the Zapatistas. Bui/Wu tells that he was a principal in the many-hundred of the Luther Blissett project (1994-99), [Desiriis, 2010] a hard-working firm of "cultural engineers" devoted to "media scams, myth-making, subversive writings, radical performance art and culture jamming," all of whom shared the same identity. As a collective tactic employed by the Italian autonomous movement, the Tute Bianche were an anonymous identity into which anyone could fit simply by wearing white overalls, just as anyone can become part of the Black Bloc by wearing a black mask and a hoodie. The Tute Bianche also changed media perceptions about police violence. "We clashed with the police in such an unprecedented way that the media simply couldn't criminalize us," Bui/Wu wrote. The intention behind this much-valorized tactic of the Italian movement was to "throw ordinary representations into disorder."

It seems fair to conclude that most of these evictions and attacks were not so much a defense of invaded private or public property, but rather attempts to interfere with the international global justice movement. The social centers were vital nodes for organizing these demonstrations in many cities against the rolling ministerial meetings that set up and maintained the current regime of free trade economic flows and financialized economy. The movement circulated in and through the social centers. Knowledges were shared and disseminated through discussions and meetings, preparations and "pep rallys" before demonstrations. The props of the Tute Bianche and "puppetistas" were made there. During those years, police raided a number of social centers, and puppets and props for demonstrations were destroyed. As well as the global justice movement, the social centers have been vital nodes in the organization of movements

against precarity, border control, and others, and the invention of tactics to forward those agendas.

The overlap between creative dissent practices and occupied spaces began in Italy with the Setentasette movement, the '77, named after the year that saw the Autonomist movement stress and fracture over the issue of violence, as well as a large-scale breakdown of the Italian left due to the inherent difference of interests between members of the unionized and precarious working class in the face of a prolonged economic crisis. The '77 saw the appearance of Metropolitan Indians in demonstrations, their faces painted, whooping and marching in single file. Mao-Dadaists and punning transversalists published journals. This ironic praxis quickly gained ground in the "second society" of counter-culture youth, feminists, gays, artists, and "stray dog" left activists. Like punk in Britain and the U.S., '77 led Italians away from the post-'68 utopian consensus among leftists and towards a theater of the streets. [Cuninghame, 2007]

TWENTY-NINE
EARTHQUAKE IN MILAN

In May 2012, I was in Italy with my part-ner, visiting the ancient monuments of Sicily. As we were leaving, a major earthquake with hundreds of aftershocks fractured much of northern Italy's historical patrimony. Our two-week vacation also covered the lifespan of a new eruption of popular disobedience in Milan. A long-abandoned 30-story modernist skyscraper was occupied and dubbed the Macao cultural center. After a season of evictions in Madrid, this squat by the Lavoratori dell'arte group

of artists and cultural workers seemed like an inspiring call of a distant trumpet.

Milan has a venerable tradition of political squatting, and the city was the site of the second meeting of the SqEK research group, in 2009. Yet the Macao project was constituted differently from earlier squattings. Neither anarchist nor communist activists, but a mass of mostly young cultural workers walked into this neglected building. The Macao assembly claimed to represent much of the workforce in the "advanced service sector" and the "creative industries," that is, the budding shoots of labor in the post-industrial networked economy of luxury and leisure upon which Milan, like so many other cities, has staked its future growth.

The squat was also different in that a roster of European artists and academics quickly declared their support. The institutional art world's online mainstay, *e-flux*, promoted it. The fashion industry's staple journal, Italian *Vogue*, covered the squat, sending out photographers to snap elegant pictures of the activists' job-site, including the huge general assembly of Macao. The action was a cool gust of second wind from the global Occupy movement. The recently launched alternative news website, *MilanoX* enthused, "Finally the spirit of the 99% is hovering over Milano," thanks to the mobilization of the impoverished creative precariat who have been made unemployed by the economic crisis. [*MilanoX*, 2012]

On the ground, support poured in as soon as the doors were opened. Lucia Tozzi, writing for the blog of the architecture magazine *Domus,* observed that on the second day of the occupation volunteers arrived: "a whole procession of architects, artists and designers with projects for greenhouses, shells, emergency furniture, cardboard beds and concert platforms." Tozzi quotes activists (by first name) who showed a deep and wide-ranging analysis of the operations of the official artworld and culture industry in their city. The art system is treacherous, said Jacopo, because high-end artworks have "become financial products. Biennial curators simply suck energy from international political movements and appropriate the latest radical thought," while the mass of artists are set aside. Said Angelo, the culture industry generates inequality in its labor relations. The "event economy" of biennales, expos and culture forums leaves nothing behind, "nothing, not for the citizens or the so-called creatives. It commandeers free labor and public space. It

produces gentrification." He cited the huge Porta Nuova business district development located behind the occupied Macao which was built in the historically working class Isola district. The Macao occupiers were more ambitious than simply seeking space, studios for artists and the like. "We raised our game because we are interested in an artistic – and cultural – concept that is far broader in the urban and social fabric," said Maddalena. [Tozzi, 2012]

The occupiers wrote a manifesto: "Macao, the new arts center in Milan, is a great experiment in building with a bottom up approach a space in which to produce art and culture. A place where artists and citizens can gather together in order to invent a new system of rules for a common and participatory management which, in an autonomous way, will redefine time and priorities of their work and allow them to experiment with new common languages." Art workers were rising, claiming space abandoned by capital as their own, to make a new social factory. "We are artists, curators, critics, guards, graphic designers, performers, actors, dancers, musicians, writers, journalists, art teachers, students, and everybody who works in the field of art and culture. We've been mobilizing for one year, meeting in assemblies to discuss our situation as precarious workers in the fields of artistic production, entertainment, media, entertainment industry, festivals, and the so-called economy of the event. A world increasingly hostage of the finance that exploits and absorbs the primary task of culture, which is to be an economy of sharing.

"We represent a large share of the workforce of this city that has always been an outpost of advanced service sector. We are the multitude of workers of the creative industries that too often have to submit to humiliating conditions to access income, with no protection and no coverage in terms of welfare, not even being considered as proper interlocutors for the current labor reform.... We were born precarious, we are the pulse of the future economy, and we will not continue to accommodate exploitation mechanisms, and loss redistribution."[1] [Translados, 2012]

Within two weeks they were evicted, squatted another space, and were evicted in two days. The mayor of Milan expressed sympathy

1 The manifesto text I quoted was taken from the initial website of the Macao project's sponsoring group, accessed May, 2012, at: www.lavoratoridellarte.org. It is gone, although the text remains on the Translados site cited. The Macao website is at: HTTP://WWW.MACAO.MI.IT/ (February, 2014); their Facebook page is at: HTTP://WWW.FACEBOOK.COM/MACAOPAGINA.

with the squatters of Macao, however, and promised space for artists in vacant properties under city control. "We can build this together," he said. The city councilor in charge of culture, fashion and design, told a newspaper: "Legally, it is squatting, sure. But I think that while running a city such as Milan we must acknowledge and never suppress forms of self-management made with constructive energy, creativity and innovation, in other words what the Macao group is offering to the city.... Creativity comes often from places that are not completely regulated, from the walls in the suburbs to the spaces under the stairs." [Marini, 2012]

Although they listened to the politicians of Milan, by the end of that hot May, when the time came for negotiations over the allocation of future space for cultural activities, the squatters of Macao "took a seat outside the door." [ML, 2012] After a month of wandering, they occupied an empty art nouveau style slaughterhouse outside the city center and were allowed to stay. The group joined a network of self-organized spaces throughout Italy, which includes Lavoratori dell'arte, Cinema Palazzo and Teatro Valle Occupato in Rome, Sale Docks in Venice, Teatro Coppola in Catania, L'Asilo della Creatività e della Conoscenza in Naples, and Teatro Garibaldi Aperto in Palermo. A part of the European Occupy movement, the group continues to take part in various conferences and networking initiatives.

The occupation of the office tower had been strategic. "It is necessary to send strong messages of rupture," Emanuele Braga of the Macao organizing group told researchers in an article published in the Toronto-based architectural magazine *Scapegoat*. "When there is no such message then it becomes very difficult to hope to change any paradigm." The act of occupation really disturbs the status quo at both the spatial, territorial level, and in regards to traditional logic. "If you occupy spaces that have a great symbolic and real-estate value, then you disrupt the ganglia of the system." The Macaoistas did not strive to be heroic revolutionaries, nor to build up autonomous zones, islands where "people could think differently." They wanted more. They wanted to build a new mode of production. Their message: "We are the new institutions, we are those who usually work everywhere, and we will remain and work everywhere." [Cultural Workers Organize, 2013] These are the exploited, who yet refuse to be excluded. They don't want to run away from wage slavery to form their own

quilombos. They intend to remain within the system while remaking it from a point of leverage outside. "Give us a place to stand and we will move capitalism."

The most famous of Milan's political squats, the city's signature project from the era of Autonomia, is Leoncavallo. Established in 1975, it is often called the first European social center. Leoncavallo began with the occupation of an abandoned factory on the out-skirts of the city carried out by a coalition of groups. Leoncavallo weathered the years of political crisis, and became an important punk culture venue in the mid-'80s. Altogether, the associations comprising Leoncavallo endured 30 evictions.[2] Here, the famous direct action group Tute Bianche was born in the middle '90s, us-ing a "Michelin man" strategy of non-violent resistance to police attack. (See Chapter 28)

While it has always been diverse, Leoncavallo is a classic social center in the sense that the Macaoistas reject – an autonomous is-land where groups can organize and act independently of state inter-ference. Rather, the Macao initiative is based in the experience and analysis of precarious labor – (also called non-standard, contingent, temporary, casual, part-time, flexible and self-employed work), but it is precarity understood as a general condition of social life. We cannot escape this new mechanism of capitalist exploitation by withdrawing into autonomous zones. The system that thrives on precarity must be reconfigured. The Chainworkers collective devel-oped this analysis in Milan in the early 2000s. That group also met in occupied social centers (such as La Pergola), and developed tacti-cal campaigns to raise awareness of the issue. Among these were the viral activist campaigns of San Precario and Euro Mayday. [Fernán-dez, 2005] San Precario is a sculpture, an actual figure carried in processions of the kind often seen across Catholic Europe. The fig-ure of a young man praying on his knees appeared in many different places where workers are precarious. In 2004, the first procession set out from the Reload social center to a supermarket, accompanied by

2 Andrea Membretti, "Centro Sociale Leoncavallo: Building Citizenship as an In-novative Service," in *European Urban and Regional Studies* July 2007 (locked); see also see A. Membretti, "Centro Sociale Leoncavallo. The Social Construction of a Public Space of Proximity," September 2003, at *Transversal* web journal, at: HTTP://EIPCP.NET/TRANSVERSAL/1203/MEMBRETTI/EN. Membretti's texts are an-alytic; for a history of Leoncavallo, see Leoncavallo (centro sociale), at HTTP://IT.WIKIPEDIA.ORG/WIKI/LEONCAVALLO_(CENTRO_SOCIALE).

activists impersonating religious people, a priest, nuns, and a cardinal. The well-produced videos documenting these actions are pretty wild. They include scenes of consternated supermarket managers, smiling and winking workers, and on-the-spot interviews with customers, some of whom reveal that they don't need to earn a living.[3] The saint San Precario has a prayer card of course (based on the work of the Canadian artist Chris Woods). The campaign was intended as "a rhetorical device to move into the public arena a critical awareness of the changes in conditions and forms of work." [Tari and Vanni, 2005]

San Precario underwent a metamorphosis during Milan Fashion Week in early 2005, turning into a female anagram. Serpica Naro is an invented Anglo-Japanese fashion designer, who slipped into the official program of Fashion Week and staged a spectacular outdoor catwalk that turned into a demonstration against the working conditions of workers within the fashion industry. The Serpica Naro collective continues, working as an open-source brand and running workshops that mix theory and craft to explore the subjectivity of creative workers.

The Macao project artists benefited from close collaboration with artists from the Isola Art Center, a long-term project organized by artists and architects in defense of the historically working class Isola district of Milan, which was being massively redeveloped with new buildings without consultation with the local community. The Isola project itself began in the early '00s in an occupied social center, the Stecca degli Artigiani, in a historic industrial building of the Brown Boveri company. Referencing a well-known term of 1960s sculpture, artists called their long-term effort to engage the dragons of top-down urban development on behalf of their neighborhood "fight-specific," not site-specific. [Isola Art Center, 2013]

The Macao occupation was buoyed by the global Occupy movement and their wave of mobilizations around Mayday 2012. The project reflected a deep analysis of crisis-era economic conditions. Young Italians had been cut out of the labor unions' efforts to save the remnants of their social contract of secure employment. This is a precariat – like, but not exactly a proletariat – of temporarily

3 While the Chainworkers website is moribund, it contains a link to one of these action videos subtitled in English. Most of that site's other links also died around 2008, but the saint's image still rises over the city in the banner for Precaria.org. It has also been adapted as the logo of a football club.

employed workers, fully aware of how badly they are being screwed. The activists of Macao have built upon the multi-layered radical squatting history of Milan in their carefully planned program of demotic institution building.

Aerosol mural on a rolling gate in the doorway of a squat evict-
ed and under renovation, Berlin, 2012. (Photo by the author)

SCHOOLING PROTEST, PLUNDER AND MILITANT RESEARCH

Moving within the terrain of social struggle over time, it is hard to ignore the Sisyphean nature of the work. The "Eros moments" when change seems not only possible but inevitable pass by and dry up like summer rains. The normative discourses of daily life resume their deafening murmur. What we see on the street and the "tele-street," in newpapers and on billboards, in the advertisements and other representations of our daily life – does not speak of struggle. None of it suggests much more than what is, and that what is goes on forever, an eternal pleasant present within a gentle rainforest of consumer delights. Intellectual culture, artistic culture, and movement culture all strive to build pathways out of this desert of mirages, and enclaves within which to escape the powerfully amnesiac landscape of daily public life. This numbing banal affect, which is continuously reconstructed after rare moments of rupture, must be

broken with strong tools to allow any sprout of imaginative rebellion to appear. Those breaks must then be kept open, and their liberatory courses marked and remembered. This is why groups like SqEK exist, to describe and encode disobedient knowledges, and why books like this are written, to circulate them.

The stories and techniques of creative activism spread through special projects of sharing and an education that does not take place in state schools. Waves of strong rebellion leave behind strange creatures along the shores of daily life. In the U.S., the Highlander Folk School was founded in 1932 in the southern mountain state of Tennessee to teach tactics of social change to labor union organizers. Highlander was inspired by the Danish models, a rural school conceived in a tradition of northern European popular education that was also dedicated to conserving and enriching folk culture. Key among these was the practice of choral singing. Songs like "You can't scare me, I'm stickin' to the union," sung together, would later play a key role in the sit-ins of the 1960s Civil Rights movement: "We Shall Overcome." [Martin, 2004]

Creative activists have spread their methods through manuals and courses of instruction, joining in a well-established stream of tutorials on organizing and tactics of non-violent resistance and conflict resolution. Most recently, *Beautiful Trouble: A Toolbox for Revolution* has appeared, a collaborative writing project involving many artist activists. [Boyd and Mitchell, 2012] Lead editor Andrew Boyd devised the political prank group Billionaires for Bush during the U.S. presidential election campaign of 2000, a radically ironic detourning of demonstration strategy that featured play-acting participants dressed up as wealthy right wing supporters. The Billionaires' appearances at demonstrations sometimes confused the police, who tried to help them out. During the 2004 protests of the Republican Convention in New York, I regularly ran into a friend with B4B parading as Robin Eublind. I was trailing along with the 18th century-styled group Greene Dragon group as Seethin' Alan. Andrew Boyd has been at this stuff for a while. He published his first *Activist Cookbook* during the years of the Clinton presidency, [Boyd, 1996] and runs an agency to advise activist groups called Agit-Pop Communications.

Beautiful Trouble is the handbook for another activist education project run by artist Steve Lambert and professor Stephen Duncombe as the School for Creative Activism. It came out of discussions at a

"College of Tactical Culture" seminar led by Duncombe and Lambert at the Eyebeam atelier in 2009. *Beautiful Trouble* is a fully articulated consideration of case studies together with various taxonomic annotations, both practical and philosophical. The book, like the exhibition catalogue for the landmark "Interventionists" show that preceded it by nearly a decade, includes a number of European projects. Nato Thompson and Gregory Sholette's exhibition catalogue is styled – and subtitled – a "users' manual for the creative disruption of everyday life." [Thompson, et al., 2004] Nato Thompson went on to become a curator at the New York City based public art agency Creative Time, inaugurating a series of high-profile public seminar-type events called the Creative Time Summit in 2009.

Both *Beautiful Trouble* and *The Interventionists* feature YoMango, a Spanish anti-consumerist invention that produced choreographed shoplifting ballets in chain clothing retail outlets. (The name of the tactic is a play on the big clothing chain Mango, making it into "I pinch," or steal.) This was during the time when the summit protests of the global justice movement were still going strong, and many artists were devising inventive and fun props for demonstrators. One accessory was a face-obscuring neckerchief with a loopy grin, designed for the "New Kids on the Black Bloc" line of protest wear – *prêt à revolter*. (That's a play on *prêt-à-porter*, or ready to wear, factory made fashion designer clothing.) The line also included snappily designed versions of the Tute Bianche puff pads.

I saw these and other items displayed in videos circulated in the run-up to the 2002 protests of the World Economic Forum in New York. The tape, showcasing different kinds of creative activism, was very different from the usual edited footage of demonstrations, mash-ups which many folks called "demo porn," which may be screened at pre-demonstration pep rallies. A remnant of these videos that is still available on YouTube shows the "New Kids" concept. The video remixes footage from demonstrations old and new (including a Tute Bianche "counting coup," by banging a stick on the shields of lined up riot cops), together with music and images of the New Kids on the Block boy band talking about their excitement at appearing in big concerts. It's so much fun, "I go out on the road with them, and they have so much work to do... there's a lot of hours in this business." The tape concludes with the NKOB's song "Games" playing over both delirious and riotous demonstration footage.

The video was posted by Leónidas Martín Saura, now a professor of new media and political art at Barcelona University and a principal in the cultural collective Enmedio. Martín worked with Las Agencias in the early '00s, a kind of network of creative activists, within which the YoMango project was hatched. Curiously, this activist project began during a workshop at an art museum, MACBA in Barcelona in 2001. [Benevent, 2013] The NKOBB project reflects his idea that collective identification with cultural icons like the popular boy band can open spaces not encoded in ideological terms (left and right). "A shared vision of the joke" creates "post-political" potential that moves beyond media and political labels which define, divide, stigmatize or criminalize. In 2012, the Enmedio group produced "Cómo acabar con el mal" (how to end evil), a five-day conference and workshop on methods of creative activism during which activist artist guests, among them the eco-warrior John Jordan, spoke.[1]

The Tute Bianche tactic originated in the social centers of Milan, and spread through the Ya Basta network in Italy as an open identity, which anyone could assume. (See Chapter 28.) Las Agencias in Spain was a similar underground network, deeply invested in anonymity. Why then, does so much of the discussion around creative activism come to rest around proper names? On one hand, this reflects the realities and current conditions of creative labor. Some people dip into this kind of work, while others commit themselves entirely to a career of creative political activism. Some people succeed, finding perches within institutions from which they can leverage resources to promote this kind of work. Institutions don't usually make contracts with collectives. They prefer to work with individuals, naming and promoting them. Conventional theater and performing arts also overwhelmingly favor the command model of artistic control. Still, in the case of creative activism, there is little doubt that these designs and

1 Leonidas Martin posted "NeW KiDs On ThE BlacK BlocK" (2002; 10:46) to YouTube in 2005. (It's in English subtitled in Spanish at: HTTPS://WWW.YOU-TUBE.COM/WATCH?V=PA75A—OETO.) The artist's website includes descriptions and videos of other projects, like "Yomango," posted June 10, 2011, at: HTTP://LEODECERCA.NET/YOMANGO/; "New Kids on the Black Block," posted June 10, 2011, at: HTTP://LEODECERCA.NET/NEW-KIDS-ON-THE-BLACK-BLOCK/; and "Prêt a Revolter," posted June 5, 2011, at: HTTP://LEODECERCA.NET/PRET-A-REVOLT-ER/. The Yomango strategy, which derived from Italian "auto-reduction" of prices during economic crisis, has spread internationally as a viral activism, to Germany, Argentina, and other countries (see HTTP://YOMANGO.NET). Much of the "Cómo acabar con el mal" conference is online at HTTP://COMOACABARCONELMAL.NET/.

projects serve collective ends, meeting the needs of particular affected groups, as well as supporting mass movements of social change. In order to succeed, creative activism needs groups of people committed to carrying out such plans. These people might be described as soldiers following the orders of generals, spear carriers in the grand opera, or, as in the case of Rebel Clowns, highly autonomous, albeit specially trained individual actors working together under a "big top" concept. Activist ideas that favor autonomous action, whether by individuals or small groups, may have a better chance of going viral, moving into common usage like an app (application) for a mobile device, a piece of real-world code which anyone can execute.

All of this is important to work out, since most of us live under capitalism, and are continuously impinged upon by its protocols. The creative professions, laboring over the centuries under many different social and economic systems, have historically been plagued by the discursive effects of the psychological burdens Catholics describe as sins – cardinal sins, especially envy ("grudging desire for another's advantage or excellence"), pride ("haughty behavior, ostentatious display, excessive elation in your success"), as well as a host of venial sins that transgress commandments against bearing false witness and covetousness. This ancient theological catalogue cuts across the distinction that politically active creative people often make between working for the common good and working for monetary gain – the (usually rather small) rewards of a successful commercial art career, as set against the advancement of social change they believe in.

People working within movements, such as those who manage, organize and sustain occupied social centers day in and day out, accumulate a kind of authority through their efforts, what some analysts call social capital. This is generally based on feelings of trust reposed in someone by the community, and that person's skill at cooperation. Artists, scholars and theorists, on the other hand, while they may work within movements, tend to accumulate symbolic capital, a reputation independent of any social ties, which every motion of the mechanism of the academic institution serves to reinforce. This division of motives can become painful.[2]

2 In a recent Facebook comment, Irish writer Andrew Flood complained about academics "whose research reporting is entirely internal to academia. If they are doing field research on social movements they actual consume quite a lot of those movements' resources and depending on the nature of the research may cause a good bit of disruption (for instance by surfacing conflicts outside of any

The plundering nature of traditional social science research such as anthropology or sociology is a problem that scholars of social movements have recently set out to confront, mainly by discussing and adapting methods of militant research. The Squatting Europe Kollective was conceived as a network of activist researchers. The group's convener, Miguel Martinez, like many European intellectuals, participated in the squatting movement, and in the assemblies that managed occupied social centers. SqEK came out of the needs of scholars many of whom had worked as political activists, and wanted to form a network of mutual support. For their second meeting in Milan, the incipient group formulated a kind of manifesto, or statement of purpose. [SqEK, 2009]

The group marked out and sustained a certain position in relation to its subject organically, through the shared viewpoints and life experiences of those who first comprised it. Most within SqEK understood themselves as students of social movements,[3] participants and supporters. As movements swelled in the second decade of the 21st century crisis, so did the number of scholars who wanted to study them. Already, professors who had grown up participating in the '90s global justice movement were in academic positions, and able to support studies which earlier generations of scholars had disdained.[4] Since

* resolution process)." He went on to note that he had given dozens of interviews, and never been shown any of the finished research. (Posted by Andrew Flood, February 13, 2014.) To return to the argument about sin, the problem we are dealing with here is stealing.

3 Social movement studies comprise an academic sub-discipline with its own journals and institutes. Immediate founding texts are by Manuel Castells, and include the swelling literature on feminism, civil rights and struggle in the developing world. The radical tradition includes work by George Katsiaficas, the Midnight Notes collective, and historical work on grassroots movements like slave resistance and piracy.

4 As an artifact of the divide between the two political philosophies of anarchism and Marxism, a similar divide exists within political academics around which movements constitute significant subjects of study. Marxist academics (a complex question in itself!), by far the majority in the academy, have not usually favored anarchists (the same!). U.S. anarchism revived as a movement after 1968, but since it had little influence in labor unions, refused electoral participation, and did not seek the classic Leninist objective of taking over the state (or its institutions), it was widely seen as insignificant. Ergo, students were not taught it, nor encouraged to research it, nor supported in their careers if they did so. A key 2002 book by John Holloway, inspired by the Zapatista revolution, alludes to this deep political difference in its title – *Change the World Without Taking Power: The*

2011, in the post-Occupy period, the discourse on militant research has ramped up considerably. Early in the century, U.S. academies instituted human subject review panels that looked over and approved all research plans that involved contact – including interviews – with living persons.[5] But notions of militant research go beyond an officially approved format of ethical relations between researcher and subject. It goes directly to the use of the research. Thinking around the question started with dissolving the researcher/subject division. For the scholar to objectify the human object of research becomes a kind of empirical sin, the first step on the road to acting in the service of police or colonial administrators. That was the charge leveled in the 1950s against social scientists by the Situationists.

The earliest form of militant research began with a questionnaire Karl Marx prepared in 1880 to query factory workers about their conditions of labor. It was designed to collect information directly helpful to organizing efforts by querying the workers who it was hoped would form the union movement. The total imbrication of researcher and organizer, activist and worker, and the political instrumentalization of the resulting research, has come to be an ideal at the heart of the practice. Mid-20th century instances of militant research were very much within the organizing projects of communist labor unions included the work of the Johnson-Forest group in the U.S. auto industry, and in Europe, the work of researchers in the factories there. [Haider and Mohandesi, 2013]

These activities went against the grain of classical models of social science. For sociologists, anthropologists, and political scientists the

Meaning of Revolution Today. Since the failure of state socialism around 1989, and the tightening iron grip of global oligarchic neoliberalism, anarchist influence has gained, and anarchist positions and influences have become widespread topics of academic research on the left. The tables of a long struggle within the are turning.

5 The human subjects review panels sprang up in the wake of revelations about historical scandals, particularly in the medical sciences, involving abuse of research subjects. Although it may seem odd, art historians also have had to pass through these panels before pursuing doctoral research. I missed by one year having to justify every interview I would make for the work that ultimately went into *Art Gangs* to a panel of social scientists trained in interview research methods and the handling of "informants." Subsequently, students in humanities have had to bone up on the methods of other disciplines in order to satisfy these panels, codifying relations between historians and artists that had formerly been informal. This has surely dampened research on contemporary topics, since it discourages students from extensive contact with living persons.

question of theory and method is primary, the *sine qua non* of academic training. Theory behind research methods evolves in a way that is both normative (constraints) and critical (innovations). The figure of the militant researcher violates the Weberian doxa of value neutrality, understood as "the duty of sociologists to strive to be impartial and overcome their biases as they conduct their research." [Boundless, 2013] Yet, the ideal of pure scientific objectivity is impossibly rigid when the subject is alive. Numerous older ideologies of research have sought to bring the habits of the academy more into line with the subjects of its research.[6] Initiatives related to militant research in mainstream academic social science practice have included methods of collaborative research. My mother ran a participatory research project with drug addicted Mexican-American gang members imprisoned in California, called "pintos." The extensive multi-year study was run in collaboration with the pintos, who were trained and worked as interviewers to gather data in their own community. This later formed the basis of policy recommendations to government agencies and testimony in court cases. [Moore, 1977]

A recent influential formulation of the project of militant research was advanced by the group Colectivo Situaciones, which emerged from the Argentinian movement of unemployed and precarious workers during the '90s, before the economic crisis and collapse of 2000. For them the process of inquiry involves "identifying shared problems and experiences, needs and desires, [and] working toward the creation of a common space and collective subject" – important, since they have no factory spaces to meet in. Their inquiries in neighborhoods at the urban periphery advanced self-organization there, building popular power bases outside traditional politics and labor unions.[7] [Mason-Deese, 2013]

6 See, for example, "Ethics in community-based particpatory research," at the National Co-ordinating Centre for Public Engagement ("we help universities engage with the public"), which poses questions like, "Who owns this information?," ethical questions about "how people are treated; and who benefits from research." (at: HTTP://WWW.PUBLICENGAGEMENT.AC.UK/ABOUT/ETHICS). This site is designed to facilitate formal partnerships between institutional entities, not between free academic agents and activists working illegally.

7 Knowledge of the work of Colectivo Situaciones in English spread through their text for the *Transversal* e-zine, "On the Researcher-Militant" (2003; Spanish, translated to English and German), at: HTTP://EIPCP.NET/TRANSVERSAL/0406/COLECTIVOSITUACIONES/EN. Other texts were published in Stevphen Shukaitis, David Graeber, Erika Biddle, eds., *Constituent Imagination: Militant*

Their work derived special authority from the extraordinary results achieved by workers' movements in Argentina, including the takeover and self-organized management of many bankrupt factories and businesses.[8] Members of Colectivo Situaciones happened to be in Madrid during the demonstrations of the 15M movement in 2011, doing a residency in the El Ranchito project of the cultural center Matadero. [Colectivo, 2011]

As an extra-mural scholarly project, SqEK has not had to compromise with any significant external requirements imposed by supporting institutions or funding agencies.[9] The constraints on SqEK are internal, arising from the ingrained habits of the academics and activists themselves. What to do, and how to do it, conferences and coordinated research and publication work that is intrinsic to squatting movements is a continual question and subject of discussion in SqEK meetings. Still, normative funded academic research arises from members' initiatives.

In 2012, Miguel Martinez received funding from the Spanish Ministry of Science and Innovation for a multi-year research project on squatting in Spain and other selected European cities. He called it Movokeur,[10] and in February a meeting was convened in Madrid

Investigations, Collective Theorization (AK Press, 2007); workshops conducted by the Team Colors collective in the U.S., and, finally, Colectivo Situaciones (trans. Nate Holdren & Sebastián Touza), *19 & 20: Notes for a New Social Protagonism* (Minor Compositions, 2011 [Spanish original 2002]; PDF online). Another important militant research initiative is Precarias a la Deriva, which began in the feminist social center La Eskalera Karakola in Madrid, and concentrated on the condition of domestic workers. (See "Adrift through the circuits of feminized precarious work," 2004, at: HTTP://EIPCP.NET/TRANSVERSAL/0704/PRECARIAS1/EN.)

8 Marina Sitrin, *Everyday Revolutions: Horizontalism and Autonomy in Argentina* (Zed Books, 2012) is often cited. Sitrin was also active in Occupy Wall Street. See also the films *The Take* (87 min.; 2004) by Avi Lewis and Naomi Klein, and *Five Factories: Worker Control in Venezuela* (81 min.; California Newsreel, 2006) by Dario Azzellini and Oliver Ressler.

9 No requirements, that is, beyond the logistics of occasionally using academic resources like meeting rooms, and individual arrangements for travel monies from various academic departments.

10 The project – "The squatting movement in Spain and Europe: Contexts, Cycles, Identities and Institutionalization" (it becomes an acronym in Spanish– "el movimiento okupa en España y Europa") – is very ambitious, and includes the cities where SqEK researchers and others invited are working – Madrid, Barcelona, Bilbao, Málaga, Seville, París, Amsterdam, Rotterdam, London, Rome, Milan, and Berlin. This writer and Alan Smart are working on an anthology of cultural

to coordinate the project. I participated in this meeting after Miguel invited me to be a visiting researcher at his institution, Universidad Complutense. There was a burst of academic meetings in Madrid during early '12, with some attendant dramas. The 15M movement was reverberating within academic institutions, and some new configurations were emerging.[11] For me the Spanish discussions were obscure, due to my poor comprehension. But the same thing was happening in New York, where the situation was clearer, even though I was not seeing any of it in person. The new wave of organization was moving through institutions with which I was familiar – 16 Beaver Group, and City University Graduate Center, especially the Center for Place, Culture and Politics. David Harvey was working there, and the late Neil Smith was the director, the same who had supported SqEK holding meetings in the building. Both these renowned academics maintained close ties to activist groups and regularly hosted touring speakers from international land rights groups.

With the Movokeur meetings in February, squat research people were all over Madrid. Thomas Aguilera, Eli Lorenzi and I journeyed to a meeting of the neighborhood assembly of Tetuan, a few blocks from where Oliver Ressler had recently filmed some of its stalwarts.[12] On the day, some 30 or more people were standing around a public plaza, with children and dogs romping around, old people sitting on the benches, and folding stands set up for displays of political information. A few police stood nearby. (Later, the city would outlaw

practices in occupied spaces as part of the Movokeur project, forthcoming from the Journal of Aesthetics and Protest.

11 The one I followed was the meeting at the Spanish National Research Council (CSIC) in 2012 to which SqEK members were invited called Hacking Academy Studio. These meetings were convened by anthropologists Alberto Corsín Jiménez and Adolfo Estalella. They included architects, particularly members of two collectives, Zuloark and Basurama. Working with these groups, and others they had met through a "cultures of prototyping" workshop at the new media space MedialabPrado, Alberto and Adolfo later convened regular meetings of La Mesa Ciudadana (the citizens table) meeting at the contemporary art space Intermediae. La Mesa focusses on public space issues, consulting with experts in other cities, and finally, holding meetings with functionaries of the city of Madrid to discuss support for local citizen initiatives.

12 Elisabeth Lorenzi and I participated in the production of Oliver Ressler's video, *Take The Square* (88 min.; 2012). This is the backbone of a museum installation work that examines the participatory process of the assemblies in three urban centers of the 2011 movements, Athens, New York and Madrid.

such public meetings without special permits, driving many of the assemblies into the occupied social centers.) The principal business of the Tetuan assembly was dealing with housing problems. A special consultancy had been set up to help the evicted who showed up, explained their problem, and dropped off into consultation sessions along the sidelines. I fell in with a garrulous man who was organizing against the privatization of the water system in Madrid who told me of an upcoming event at Tabacalera.

As part of the organizing for the Movokeur project, Miguel arranged a public meeting with squatters at Casablanca, the center he worked with. Hans Pruijt and E.T.C. Dee took part, both visiting Anglophone researchers. Earlier, Miguel and Thomas had met with members of the Casablanca assembly in a long meeting at which there seemed to be some tensions. While I could not follow the talk, Miguel was doing most of it. The squatters seemed to be at pain to distance themselves from the academics, slouching, turning away, pulling regularly on their big bottles of beer, and stepping onto the balcony to smoke. I imagine that the squatters, who were dealing with a wave of evictions spurred by the recently elected right wing government, were not so enthusiastic about academic questions just then.

Opposite: The Bici Critica, the Critical Mass bike ride of Madrid, arrives at CSO Casablanca for a party and a meal, 2011. (Photo by the author)

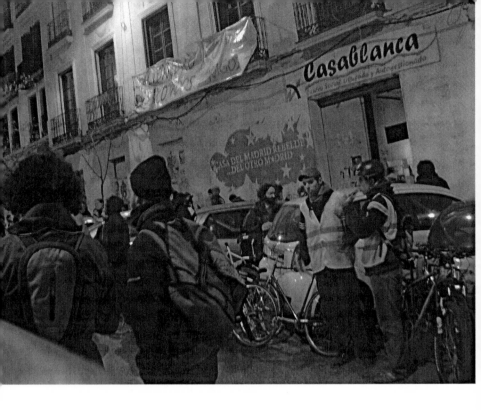

THIRTY-ONE
LINES OF FLIGHT

It would not be long before the Casablan-ca social center in Madrid, where SqEK members in town for the Movokeur meeting had met the public, would face eviction. The 15M movement of 2011 had not dissuaded the Spanish from electing a right wing government with sweeping powers – an absolute majority in the legislature. Soon, austerity measures began to take effect, with drastic cuts to social programs adding to the high levels of unemployment, and increasing numbers of evictions. Ministries changed; the department that had funded Miguel Martinez's Movokeur research program was folded

into another. As the cuts proceeded during 2012, union-coordinated protest marches proliferated. Campaigns of direct action accelerated. The PAH movement (PAH is Plataforma de Afectados por la Hipoteca, or the Movement of People Affected by the Mortgage),[1] moved beyond eviction defense, and began to squat apartments for some of the many thousands of evicted former homeowners. Activists of the 15M organized for big demonstrations in the fall.

The government was acting too. Police were moving against squatted centers of organization in Madrid.[2] In May my local center, the CSOA Salamanquesa, was evicted from an abandoned warehouse. In July, two more centers in Madrid were lost – La Osera, a former theater taken by the 15M assembly of the Usera neighborhood, and La Cantera in the Vicálvaro district. La Casika in Mostoles was threatened. Periodic eviction is a normal event in the life of squatters. The eviction of a social center disrupts all projects within it. This is always painful, although it calls for energetic resistance, and radicalizes many who experience it. All energies must then be directed towards preparing another squat. The movement slogan is: "un desalojo, otra ocupación" – "one eviction, another squat." Strong groups may take several buildings during their run of work. Around and through them float collective projects, which take space as they need it and as it becomes available.

Among the most mobile of all the practical and political projects in squats are those of the bicycle movement. Bikes and squats have gone together since the early days of organized squatting. Bicycle advocacy emerged as a political issue with the Provos of Amsterdam. Their set of proposals called the White Plans, which were both serious and utopian, aimed to ban cars from the city center and replace them with bike sharing systems. A seed group of unlocked bikes painted white were put out by the Provos. The white bikes were launched in 1965, at the same time as the White House Plan, which proposed to solve

1 Plataforma de Afectados por la Hipoteca (PAH) is a Spanish grassroots organization that campaigns for the right to a home. PAH began in Barcelona in 2009, in response to the real estate crisis of 2008, to support those who could not pay or faced eviction. After 2011, PAH worked closely with the 15M movement. (*The Journal of Aesthetics & Protest* published *Mortgaged Lives/Vidas Hipotecadas*, by Ada Colau and Adrià Alemany in a translation by Michelle Teran in 2014; download at: HTTP://WWW.JOAAP.ORG/PRESS/MORTGAGEDLIVES.HTML.) As I write, Ada Colau is running for mayor of Barcelona.

2 Similar campaigns were underway against squatted centers all over Spain, particularly in Barcelona.

the housing crisis by squatting. Amsterdam today is full of bike shops, as is Berlin. Many of Berlin's bike shops began in squats. The relationship continues today. No squat seems complete without a center for free or low cost transportation – a workshop where bicycles can be repaired, old ones recycled for use, and new ones created, modified for all sorts of uses.

Elisabeth Lorenzi, anthropologist and founding SqEK member, is a bicycle activist in Madrid. She participates in and writes about the Bicicritica, or Critical Mass bicycle rides. She and her comrades invited Chris Carlsson, one of the founders of the San Francisco Critical Mass to Madrid to talk about the anthology he edited marking the 20-year anniversary of the famous bicycle ride called *Shift Happens*. [Carlsson, et al., 2012] Chris and his friends started *Processed World* magazine in 1981, as the voice of temporary office workers doing something else with their free time. Like many of my friends in New York City then, these west coast university graduates were working "handling information" in corporate offices for a living (I was working as a freelance typesetter).[3] This was an early venture into the analysis of precarious labor – "a focus on work and its discontents," with the tagline "Are you doing the processing... or are you being processed?" Carlsson's 2008 book, *Nowtopia: How Pirate Programmers, Outlaw Bicyclists, and Vacant-Lot Gardeners Are Inventing the Future Today*, is rich with on-the-ground examples of activities, all of it framed in the terms of autonomist analysis, as an investigation of how the so-called middle class is actually recomposing itself as a new working class. I was excited to see Chris here in Madrid, talking at the occupied Patio Maravillas social center along with a group of authors who had essays in the *Shift Happens* book. The Critical Mass bike ride has been a gateway activist experience for thousands in cities all over the world, and the book records remarkable stories of the movement.

Elisabeth Lorenzi's essay lays out the close relation between squatted social centers in Madrid and the Bicicritica movement. In 2012, there were nine self-managed open door bicycle workshops operating

3 A rich and humorous history web page also relates the antics of Carlsson's action group, the Union of Concerned Commies (communists), doing street theater for the anti-nuclear movement in San Francisco. In the early '80s they hawked the *Processed World* magazine on the street, with slogans like: "Processed World: The Magazine With A Bad Attitude!"; "If You Hate Your Job Then You'll Love This Magazine!" (at: HTTP://WWW.PROCESSEDWORLD.COM/HISTORY/HISTORY.HTML). By the 2000s, *Processed World* online had linked up with activists of the precarious workers movement in Milan.

throughout the city in squatted and legalized social centers. They had grown up with the ride itself, as people joined the ride and began to participate in activities at social centers in their neighborhoods. City bike policy in Madrid is centered on recreational use, not commuter transportation. Bike routes go through parks, and along the newly developed Manzanares riverfront. When other Spanish cities have allowed bicycles to play a substantial role, growth in its use has been rapid and substantial. Madrid, however, has a massive infrastructure for automobile traffic, a legacy of modernization under the dictator Franco. Six and eight lane high-speed boulevards flow through circular hubs called plazas, although their manicured centers, often with sculptural ornaments, are practically inaccessible to pedestrians.

The ride has ballooned since 2004, when a small handful of cyclists set out in the rain from the Plaza Cibeles, in front of the city hall. Six years later the Bicicritica saw some 3,000 riders in a leisurely promenade around Madrid, to the sound of "music bikes" riding alongside.

Bici Critica, the Critical Mass bike ride, in Madrid, 2013. (Photo by Chris Carlsson)

Chris Carlsson rode along with the Bicicrítica during his visit, and blogged about the "long luxurious ride all over town." Hundreds of cyclists regularly stopped for pedestrians, and even some cars sneaked through the mass. He was surprised to see a "full-on bike wave," as riders paused, squatted down, then rose together holding their bikes in the air – "La Ola Madrileña." [Carlsson's blog, 2012]

Chris also noted that the Bicicritica in Madrid was far more integrated with the local radical political movements than it was in San Francisco. The monthly ride is organized online, in discussion lists that include other topics, and through the workshops in autonomous spaces. The rides usually end up in dinners and parties (the evening meal in Spain is late, around 10 p.m.) at the okupas housing bike workshops. The first of these was in CS Seco, a legalized center that has been around since its days as a squat in the early '90s. Two years later, Patio Maravillas had a workshop, the same okupa where Chris Carlsson talked about the *Shift Happens* book. For many participants, the Bicicritica and the linked bicycle workshops are the gateways to activism within the okupa movement. Before joining the rides that end up at okupas, 80% had no prior contact or experience with social centers. The close relationship bicycling has to the body – human energy powers the machine, and the bike is a platform for showing legs and butts in motion – have led to the formation of a feminist transgender and lesbian bicycle group, the Cicliátrico. [Lorenzi, 2012]

During the SqEK meeting in New York City, Eli stayed with Bill DiPaola, a longtime environmental activist and a perennial participant – never a leader! – in the New York Critical Mass. Bill and his fellow cyclists endured years of police repression. Their slogan was "Still we ride." I saw much of this struggle unfold, since it took place at a storefront on Houston Street near where I lived. The Time's Up group Bill ran was hosted by Steve Stollman, a carpenter with a business in vintage bars. My neighbor Steve is a longtime activist for bicycles and public space. He was a perpetual gadfly at city hearings on issues of public facilities like newsstands, toilets, signage, and bicycles. He supported bicycle messenger organizing and pedicab design and construction in his storefront studio during the '70s and '80s. He followed the machinations of government in regards to these issues, and put out regular idiosyncratic newsprint broadsides. Steve's brother Bernard ran ESP-Disk, which recorded jazz and countercultural music groups during the 1960s. Since Steve was a veteran of the 1960s

underground press, and a close friend of Yippie leader Dana Beal, there was little doubt that the many rambling conversations about new outrages and the sad state of the world that took place in Steve's aerie office were monitored by the law. Still, the dimensions of the surveillance, infiltration, disruption and repression directed against the Time's Up group and the Critical Mass during the '90s and '00s were a rude surprise when they were at last revealed.

In the *Shift Happens* book, Matthew Roth tells the story of the long struggle that New York Critical Mass riders had with the police. Legs were broken, bicycles were stolen, court orders were defied, and there were many arrests. Through it all, Bill DiPaola kept up his reasonableness, good cheer and a dead-ahead focus. The Time's Up crew also organized rides to the networks of community gardens, vacant land occupied by gardeners throughout the city. Sometimes the rides specifically coincided with eviction defense run by the More Gardens! group. [Time's Up, 2013] Roth writes of one meeting he had with top-level brass of the NYPD. [Roth, 2012] At the time, he didn't know police were spying on activists and innocents all over the east coast, spurred on by a new man from the CIA, trained in terrorism investigation, who was then in charge of domestic spying for the police. The leaderless anarchist nature of the Critical Mass seemed to drive these men crazy, and they incited their troops – the NYPD cops on the street – to brutality and confiscations, even in defiance of the courts.[4]

Cycling is a basic move towards environmental protection, against the total domination of modern cities by gasoline-powered, private automobiles. It can also be an exhilarating experience of free movement in the city. And it's cheap – once you own the bike you move around for free. Bicycles run like a thread through the story of many autonomous social centers and squatting scenes. But bicycle use isn't just the stuff of disobedient counter-culture. Government support for

4 The full extent of the NYPD's domestic spying, which rivaled the bad old days of their Red Squad, has only recently been revealed. (See Michael Powell, "On Reed-Thin Evidence, a Very Wide Net of Police Surveillance," *New York Times*, September 9, 2013, a review of Matt Apuzzo and Adam Goldman, *Enemies Within: Inside the NYPD's Secret Spying Unit* [2013], which quotes Bill DiPaola.) Already there were broad hints, however. (See Jim Dwyer, "Police Infiltrate Protests, Videotapes Show," *New York Times*, December 22, 2005.) The Critical Mass was a specific target, and the NYPD at last succeeded in extinguishing the ride. Even so, their activism took root; an extensive network of bike lanes throughout New York City was built under Michael Bloomberg's mayoral administration.

bicycle transportation is a key linchpin in the move towards more sustainable urban infrastructure in the face of global climate change. Indeed, many of the initiatives taking place in social centers – most commonly bike repair and design, urban gardening, and free shops of used clothing – are directly in accord with institutional and governmental programs intended to promote sustainable cities. (They also accord with the drive to cut social services, but that's another argument.) In NYC, during the 12 years of Bloomberg's mayoral administration, the road surface that cars in the city might use was significantly reduced, and replaced with pedestrian areas. In this sense, the global movement of political squatting is part of the avant-garde of progressive governance. It is little wonder that the forces of regressive governance should frequently be arrayed against it. Police and military technology is entirely dependent on oil. Without full motor vehicle access to all parts of the city, the power to police is considerably reduced. The police will always defend their roads.[5]

A story that illustrates the complex adversarial positions that form around bicycles also concerns the Laboratory of Insurrectionary Imagination, the group of John Jordan. The group was invited to be part of an event produced by the London-based environmental activist think tank, called Platform, at the Arnolfini contemporary art center at dockside in the seaport of Bristol. Platform's "100 Days" of events were planned as a lead up to the 15th global climate change conference in Copenhagen, COP 15. They called it "C Words," for "carbon climate capital culture," rendered by at least one group as "carbon, climate chaos and capitalism." The title of this education and cultural activist project was inspired by Joseph Beuys' 1972 "Information Office" at Documenta V, in which he spoke daily about direct democracy with visitors for 100 days. One of the "C Words" events was "experiment #10" of the Laboratory of Insurrectionary Imagination, described as a design workshop to prepare "an irresistible weapon of creative resistance, which will be unleashed during the COP 15 summit." [Platform, 2009]

While the Arnolfini was unafraid to work with artists in the global justice movement – at least so long as they were managed by another organization, and did their deeds out of town – the host art institution in Copenhagen was less enthusiastic. The Copenhagen

5 The interstate highway system in the U.S. was initially authorized as a military defense program, to enable the movement of troops and materiel within the country.

Contemporary Art Center (CCAC) dropped the project when they realized that the Labofii crew was going to use an accumulated store of discarded bicycles to construct tools of civil disobedience for use in street demonstrations. So the Labofii gang moved to the Candy Factory, the very same self-organized artists' center we visited for our SqEK conference two years after. There they worked with Climate Camp veterans on a non-stop construction binge using the models and plans they had devised in Bristol. We saw remnants of the "double double trouble" (DDT) custom bicycles welded up by the Labofii team from the carcasses of some 500 old machines. Police raided the Candy Factory, and seized many of these. Still, the Labofii was able to equip the Bike Bloc with some 200 of what the police called "war bikes," and swarm around the pedestrian demonstrations, drawing off police attention and inspiring the protestors.[6]

The feeling among authorities that unrestrained bicyclists pose a serious danger to civic order was confirmed in the Netherlands a few years later as police in Utrecht moved to shut down the fourth annual Bikefest there. Police issued an order, unsupported by any court, to the web hosting company of the Bikefest website to take it down. At the same time, city authorities ordered the building where the festival was to take place closed on grounds that it was unsafe. In this case, the Bikefest website was hosted by a collective of hackers – PUSCi, the Progressive Utrecht Subversive Center for Information Interchange – who did not fold to the bluff. Still, the festival had to be held on the fly in a public park that year.[7] Bikefest 2013 took place in Nijmegen, a Dutch town near the German border, most of it in and around a social center called De Grote Broek (the Big Pants). De Grote Broek was squatted from 1984 to 2008, now has a contract, and hosts various social, cultural and political initiatives, including an environmental center.

A planned response to climate change within the context of continually growing urban populations is an imperative for nearly all the

6 The Labofii plan is laid out in a peppy 1:30 minute video at: HTTPS://WWW. YOUTUBE.COM/WATCH?V=XZTUTK6IZ2E, posted with a project description at: HTTP://CHANGEASART.ORG/PUT-THE-FUN-BETWEEN-YOUR-LEGS-BY-THE-LABORA-TORY-FOR-INSURRECTIONARY-IMAGINATION/ (accessed July, 2014).

7 "Netherlands: Police threatens website host without court order," Squat.net, 2012, at: HTTP://EN.SQUAT.NET/2012/09/29/NETHERLANDS-POLICE-THREAT-ENS-WEBSITEHOST-WITHOUT-COURT-ORDER/#MORE-6963. See also Bikefest 2012 website at: HTTP://DIYBIKEFEST.PUSCII.NL/, and Bikefest 2013 information at De Grote Broek website.

professions responsible for the management of social life. Modeling and development of a sustainable city is more than simply designing green architecture, that is buildings that consume less energy, and are outwardly "greened" through vertical landscape design. A sustainable city will be one that minimizes pollution and uses land efficiently. This means discouraging urban sprawl and encouraging compact city design and an emphasis on proximity, things being close to each other. The car-free city with large pedestrian areas is a key part of the design model. The dominant model of a sustainable city is paced by the transition movement, with organized attempts to move away from fossil fuel dependence and towards a sustainable economy.

As North Americans know well, this is not in everyone's interest. Resistance, including demonization of the bicycle and its partisans as a symbol of unwanted change, can be expected to mount.[8]

8 The Toronto journalist Jordan Michael Smith writes that the electoral support base for the wild, coke-smoking mayor of Toronto Rob Ford, lies in the car-dependent suburbs. Ford is ripping up the city's bike lanes (J.M. Smith, "Conservatives' new enemy: Bikes," *Toronto Globe,* December 15, 2013, online). *Wall Street Journal* columnist F.H. Buckley warns: "We Have Not Yet Begun to Fight the Bike Lanes" in Alexandria, Virginia, which are coming soon to a city near you. Buckley discusses a mild kind of legal squatting, the brief occupation of public parking spaces by artists in the national "Park(ing) Day" movement. He writes, "they can be a lot of fun, bringing out the tiny anarchist in all of us. What's behind the movement, however, is an anticar political agenda. The Park(ing) Day Manual tells us the point of the movement is to let people know that 'inexpensive curbside parking results in increased traffic, wasted fuel and more pollution.'" (*Wall Street Journal,* November 8, 2013)

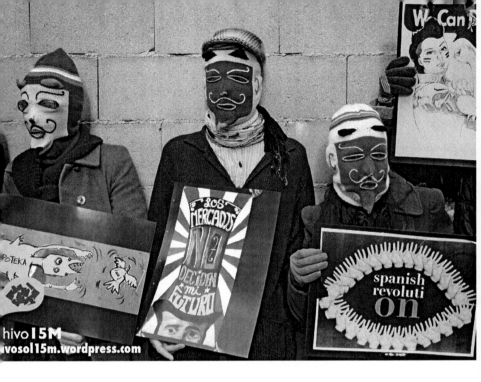

THIRTY-TWO
THE HOSTAGE ARCHIVE

Finally, the ax fell in the fall of 2012. The Casablanca social center in Madrid was evicted. It happened days before the big Rodea el Congreso demonstration ("Surround the Congress") on September 25th (25-S). While the eviction was not unexpected, it was a surprise since it was carried out by national police at the order of a special court. Casablanca's legal team had thought they were in the clear. [Martinez, 2012] Over the December holidays, a reoccupation of the building was attempted. Hundreds of activists supported what was to be a CSO called "Magrit," after an ancient name for the city of Madrid. The effort failed, however, and every window in the building was bricked up solid to the top. The extensive murals on the outside were painted white.

Casablanca had hosted organizing meetings for the 25-S action group, which organized the demonstrations that were at first called "Occupy Congress." The giant CSA Tabacalera, which is legalized, was closed throughout the period leading up to this demo. The right wing government reacted to the multi-day demonstration with a shocking display of force. Leaders later called it an attempted coup, and the congress passed stringent laws restricting public gatherings and demonstrations. This wasn't just paranoia – an opinion poll in early October showed that 75% of Spaniards were substantially in agreement with the demonstrators![1]

Over two years of operation, the Casablanca okupa in the city center had become an important locus of 15M activities. In particular, it contained the Bibliosol, the 10,000+ carefully catalogued books from the Puerta del Sol encampment library all nicely arranged on custom-built shelves. Bibliosol had been hosting events like new book receptions, poetry readings, and tertulias. This Spanish tradition is an "open framework that uses literature as a background for discussion."[2] With its regular concentration of librarians, archivists, writers and readers, Casablanca was becoming something of an information resource for the movement. On the day of eviction, a distribution and exchange of school textbooks was planned. Another resource that was lost in the bricked-up building was the Archivo 15M, a repository of signs, *objets d'art* and documents from the Puerta del Sol encampment.

Since I had worked there some of the time, I experienced the sadness of eviction when Casablanca was lost. Many projects came to an end.[3] I felt keenly all the opportunities that had yet to be realized

1 The communiques of the group coordinating the demonstrations are at: Plataforma ¡En Pie! Ocupa el Congreso, at: http://plataformaenpie.wordpress.com/. The group dissolved in early December, 2013. A nine-minute film telling the dramatic story of the demos (and others in other countries) by a peripatetic U.S. movement journalist is: "Madrid On The Brink: S25 → S29" at: HTTP://BRANDONJOURDAN.BLOGSPOT.COM.ES/

2 "Sin Bibliotecas No Hay Paraíso: Biblioteca Acampada Sol. Movimiento 15-M. Bibliosol" (no paradise without libraries) is at: HTTP://BIBLIOSOL.WORDPRESS.COM/. When I wrote this, the assembly did not have a physical location. They met weekly in a plaza, or if it was too cold, in the lobby of a nearby metro station. As of June, 2014, both the Bibliosol and the Archivo 15M have moved from the EKO squat into a legal space called Tres Peces Pes.

3 The communique from the Casablanca assembly listed the projects that were lost when the center was evicted. These included the Common House, cooperative infant care; Tartaruga education project for children two to six, Spanish

in a social center in the central city, so close to the Reina Sofía museum, academy of music, repertory cinema, etc. And of course, the rich research opportunities that were lost. SqEK member Sutapa Chattopadhyay had come to Madrid, staying at Eli Lorenzi's house. She didn't speak a word of Spanish, but nevertheless jumped into the squat scene here, interviewing a group of South Asian immigrants who were meeting in Casablanca. She recorded their harrowing stories of crossing numerous borders to finally reach Europe.

To retrieve the books and archival materials inside the bricked up building, the police demanded money to break the blocks. I thought this could be my chance to do something to help out. I approached the assembly of the Archivo 15M to try and arrange a solidarity exhibition of digital copies of their materials in New York City. It was a somewhat bedraggled group that met on the windswept plaza in front of the Reina Sofía museum, some blocks down the hill from the evicted Casablanca. These were not hardened squatters, but librarians and artists. They embraced the idea of a show at the Bluestockings radical bookstore on the Lower East Side of NYC.

First, they had a chat with visiting artist researchers from a school in France, students in a postgraduate program focused on the function of the document and the archive in the field of art and the social world. The artists had come to town to see a giant exhibition of Latin American political art and activist culture at the Reina Sofía museum. Called "Perder la forma humana" ("Losing the human form"), the show focused on the period after the dictators, the '80s and '90s, when artists were working to restore a sense of freedom and possibility to societies traumatized by authoritarian rule. The "Perder" show was based on documents reflecting the concerns of the museum in the new information age. It opened with an extraordinary gathering of activist artists flying over from America to join in a discussion.[4]

language classes for migrants, BiblioSol, Archivo 15M Sol, workshops in sewing, construction skills, silkscreen printing, photography, computers, theater (improv, the groups Timbuktu and Dystopia), yoga, dance (Queer Tango workshop, swing and hip-hop), film screenings, as well as social service and political projects: HIV Madrid Critique for people living with the disease, legal aid for migrants, a free store, consumer groups Tomarte Rojo and BAH, urban gardening, vegan cooking, and a bike shop among other projects ("Comunicado de la Asamblea de Casablanca ante el desalojo," September 19, 2012, at: HTTP://WWW.CSOCASABLANCA. ORG/COMUNICADO-DE-LA-ASAMBLEA-DE.HTML).

4 See Roberto Amigo Cerisola, et al., eds., *Perder la forma humana. Una imagen sístimica de los años ochenta en América Latina* (Museo Nacional Centro de Arte

One of the teachers in the program[5] was Stephen Wright, a Paris-based theorist I had met years ago. So many meetings in the art world are based on pure curiosity and speculation, and this was one of them. I thought it might be an opportunity for Madrileños to talk together about questions of research on radical movements, and the role that archives can play, as well as make links with artists who might be interested in animating the archive. Ramon Adell Argilés, a professor who has a personal archive of the social movements in Spain since the transition period, showed up. It was hard to hear in the noisy cervecería, but the artists and activist archivists had a good chat, with the artists more interested in practical political questions than in issues of the document.

As the U.S. movement's street action cooled down,[6] Occupy became hot stuff in the world of archives. Numerous institutions quickly became involved in collecting Occupy Wall Street materials. Both the Smithsonian Institution and the New-York Historical Society were johnny-on-the-spot. Students of library science and art became interested in what was happening before their eyes, and especially in the different traces the actions were leaving in digital media and communication. These pose a special set of challenges to archivists, and OWS was a compelling case study. The Occupy Archive at George Mason University was an effort to capture this activity, a carefully constructed online project largely dependent upon voluntary uploads. In early 2012, a report stated that this very democratic website "compressed

Reina Sofía, 2012). The show was a project of the Red Conceptualismos del Sur (network on conceptualism in the south; see HTTP://CONCEPTUAL.INEXISTENTE. NET/, "¿Quienes Sómos?" for a list of the participants). The museum is part of the RCdS through cultural programs head Jesús Carrillo. He discusses the group and their projects in an interview with Álvaro de Benito Fernández, "Latin American Conceptualism Bursts into the Institutional Arena Bringing New Management Models," in *Arte al Dia* online, February 3, 2012.

5 The students were from École européenne supérieure de l'image / European School of Visual Arts, at Angoulême and Poitiers. Stephen Wright worked with the Philadelphia group Basekamp on interviews for the "Plausible Artworlds" project of independent artists' group projects. House Magic was one of them.

6 The Occupy movement's "street action" cooled in the U.S., but continued in private meetings. In Spain, mass demonstrations of all kinds against government cuts and regressive laws happen continuously. As well, assemblies of the 15M formed almost immediately in various barrios of the big cities, and throughout the country with varying degrees of influence and activity. (*Madrid 15M*, the periodical of the assemblies, has published continuously since early on, and is distributed in the social centers. PDFs are at: HTTP://MADRID15M.ORG/.)

files of entire Occupy websites from around the country and hundreds of images scraped from photo-sharing sites." The venerable Internet Archive project, makers of the Wayback Machine, also opened an Occupy area on their site, collecting material from around the U.S. An overview of some of these early efforts at archiving the new social movements appeared on the blog of the U.S. Library of Congress. The writer spotlighted the work of the Activist Archivists, which spread information to help would-be self-archivers, and created a working group to save material history. The article wonks on about the challenges of archiving digital data, harvesting tweets and the like. The work of the Activist Archivists group continues, as they publish advice and guidelines on different aspects of archival preservation on their website.[7]

The Archivo 15M is 100% self-organized, extra-institutional, and precariously housed. An initiative in London, the Mayday Rooms, seeks to help archives like theirs. The group, funded by a black sheep supermarket heir, is nosing around the 56A Infoshop, a South London project that began as part of a squat. There are a number of these autonomous knowledge nodes floating around, historical refugees fleeing the dying stars of older movements – like the archive of the picturesque late Gramscian, anarcho-punk and bookseller Primo Moroni in the Cox 18 squat in Milan, and the grand, staid Archive of Social Movements (Archiv der Sozialen Bewegung) in the ever-resistant Rote Flora, with its trove of photos of the squat wars in Hamburg. Madrid's Archivo 15M is part of a network of Occupy libraries in Baltimore, Boston, Pittsburgh, Chicago, Washington, D.C., and Vancouver, Canada, all of them consorted. Scholars like to travel easy roads, ones marked out for them by earlier sojourners that lead through plentiful groves of archival materials. Movement activists and their sympathizers are planting their orchards now. The Occupy libraries, like their wild predecessors, may be growing on steeper slopes and in deeper valleys, but they can be reached.

In January 2013, the Archivo 15M solidarity show opened in the New York bookstore Bluestockings. Byron Maher, a member of the

7 Mike Ashenfelder, "Activist Archivists and Digital Preservation," *The Signal*, blog of the U.S. Library of Congress, October 1, 2012, at: HTTP://BLOGS.LOC.GOV/DIGITALPRESERVATION/2012/10/ACTIVIST-ARCHIVISTS-AND-DIGITAL-PRESERVATION/. See also HTTP://ACTIVIST-ARCHIVISTS.ORG/WP/, and HTTP://OCCUPYARCHIVE.ORG/. The Activist Archivists have also picked up on the XFR STN project I worked on with the New Museum, continuing this attempt to spotlight vanishing collections of analog video material.

group, designed a poster and arranged for printouts of the digital archive to be sent along. The show began with a discussion event, an online chat with the Archivo 15M group from an undisclosed location in Madrid, moderated by visiting academic Juan Escourido, and Amy Roberts of the Occupy Wall Street library in the bookstore. After two misses I finally met with Vlad Teichberg, a guy instrumental to live streaming of OWS from Zucotti Park, in a crowded popular cafè near his apartment on Calle Pez. I hoped to draw in him and Nikky Schiller to talk about their video work, but they weren't into it. Even so, the program in the bookstore began with their Global Revolution TV stream of the tail end of the #23F protests, the "tide of citizens against the coup of the markets."

The live streaming of major protests, demonstrations and riots is but one aspect of the impact of digital communications on contemporary political movements. In its extension of the traditional power of live television, it is also the most comprehensible. Less spectacular, mobile devices enabling text messaging brought major changes in the texture and composition of the demonstrations the live streamers cover.[8] Two urban anthropologists, Alberto Corsín Jiménez and Adolfo Estalella, wrote of the arising of over 100 popular assemblies in Madrid after 15M. Theirs is an ethnographic account of how these groups understood themselves and their barrios. They write of the "rhythmic and atmospheric production of space" through walking and talking – on mobile devices, and in camps and public assemblies. The 15M movement, they explain, was able to move into the neighborhoods by holding their assemblies in the local plazas. [Corsín and Estalella, 2012; Estalella and Corsín, 2013] This was something police soon tried to shut down by imposing fines on people for taking part in "unpermitted demonstrations." This drove the assemblies into the more protected social centers and out of sight.

Alberto and Adolfo also organized panel discussions of SqEK members during the Movokeur meetings as part of a series called "Hack the Academy."[9] The metaphor of hacking is apt. It's a contested term,

8 Text messages usually form part of the spectacle, however, as they are often streamed alongside livestreams in real time on both movement and mainstream journalists' websites. One then "reads" international demonstrations and popular revolutionary events through a rich array of media that shows them, as it were, coming into being.

9 I presented the House Magic project along with other members of SqEK at the duo's Squatting in Europe panel, Estudio de Hackeos de la Academia/Hack the

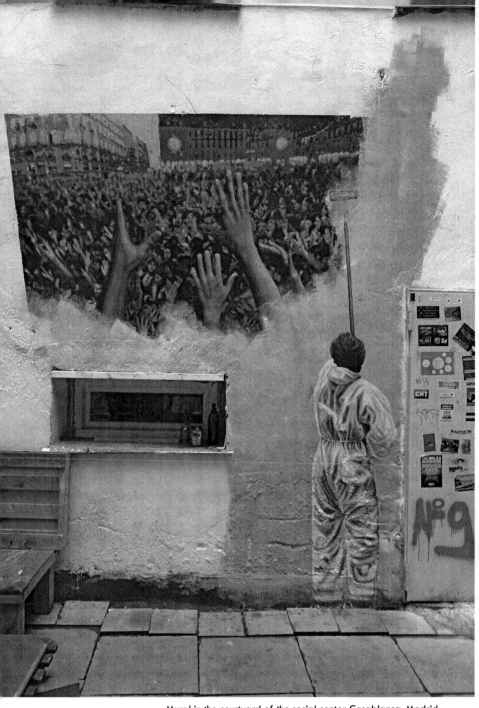

Mural in the courtyard of the social center Casablanca, Madrid, by an unknown artist. What is revealed by his "brush" is the assembly of 15M in the Puerta del Sol. (Photo by the author)

which may refer to either a clever computer programmer creating a "hack," a solution to a problem, or someone who breaks into a closed computer system with criminal or political intent. Over the summer, they organized a conference at the Medialab-Prado at Intermediae, a center dedicated to new technology, called "The City as Open Interface." ["City as Open," 2012] Their paper was titled "The interior design of the right to the city," referencing Henri Lefebvre's concept, spelled out in his 1968 book, *Le Droit à la ville*. Lefebvre's thought, and his naming of a new kind of right, has become basic to urban social movements. Right to the city has been refined by David Harvey, geographer and analyst of neoliberalism, as the common right of all to participate in the shaping of urban centers. Right to the City is also now the name of a global network of activists. The excluded masses in the evolving neoliberal city have a right to be there; they challenge their exclusion not through committing crimes, but by "hacking" the city's codes. In the sense that the city is a thick texture of codes, coded behaviors and architectural forms, "hacking the city" is an explanation of behaviors like squatting, graffiti tagging, skateboarding, bicycling, busking and music-making, dancing – all forms of behavior that are not explicitly provided for – or are forbidden – in the formal, legal and customary municipal codes.

Meanwhile, after the re-occupation of Casablanca, the hours-long "Magrit," failed the Casablanca assembly moved on. They took a building on the picturesque calle Mesón de Paredes. We went to visit, stopping for wine at the venerable Taberna Antonio Sánchez nearby, hung with yellowed bullfight pictures and apparently unreconstructed since the early 1900s. The newly occupied CSOA Raíces was also an antique. It had working stores on the street level, but the floors above were windowless, stripped to the walls during the interrupted redevelopment into luxury apartments. The owner was Bankia, the bailed-out Spanish consortium of banks. Despite the winter cold flowing unimpeded through the many holes in the wall, Raíces was buzzing. The assembly of Lavapiés was meeting in one part of a floor, while the other side held cartons and shelves of Bibliosol volumes recently recovered from Casablanca. Archivo 15M had mounted a show of digital images on the wall, and a poetry reading was scheduled to take place. (Today the building is a hostel.)

Academy Studio, Centro de Ciencias Humanas y Sociales del CSIC (CCHS-CSIC), Madrid, April 10, 2012.

As soon as the weather warmed up, they were kicked out and Raíces was no more. The collective quickly poured into another building during a day of actions called "Touch Bankia" ("Toque a Bankia").[10] The new place – called La Quimera – was in the still-abandoned building which had housed the Laboratorio 2, evicted in 2001. The Laboratorio project, a classic social center collective, bounced around different okupas from 1997 to 2003. [Charlon, 2003] Finally, many of the activists went on to participate in the legalized Tabacalera center. The wheel goes 'round and 'round. These people never stop. "Un desalojo [eviction], otra okupación. 10, 100, 1000 centros sociales."

In the end, however, Archivo 15M did not put their materials in La Quimera. Instead they took refuge with their boxes in a quieter part of town, the new ESLA EKO (ESLA for Espacio Sociocultural Liberado Autogestionado) in the barrio of Carabanchel. This old discount supermarket (a "low cost" economato) had been empty for 14 years when the Popular Assembly of Carabanchel decided to take it in January of 2013 with a public festival. This spacious, airy, light-filled concrete building holds yet another massive accumulation of books, the BibliotEko. Most projects taking place there are focused on economic issues, housing, and education, including barter and exchange of textbooks and school supplies. Supporting popular education has been a mission of the social centers since the early 20th century, when the Catholic Church controlled all education in Spain.

ESLA EKO took part in a week of film screenings and workshops called "Carabanleft" in February and March 2013. This event, which referred to a longtime film festival once taken place in the district, was held in several different spaces. "Carabanleft" combined nearby squatted social centers and private spaces, mostly artists' communal living lofts. EKO also hosted an assembly of squatted social centers, in a revival of the kind of networking activity that hadn't been seen in Spain for many years. I attended part of this daylong meeting as some 50 people representing various centers discussed the question of whether a social center should be open or closed. The meeting was

10 Information about this day of action is in the "15Mpedia," a movement wiki. See "Toque a Bankia," at: http://wiki.15m.cc/wiki/Toque_a_Bankia. The "hacktivism" which lay behind it – the web-based organizing and some online tactical interventions – was coordinated by the Gila group (Grupo de Intervención de Lavapiés, Los Austrias y La Arganzuela [districts of Madrid]), whose further adventures are also described at: http://wiki.15m.cc/wiki/GILA. I saw two of the group speak – masked – at a seminar on creative activism at La Prospe in Madrid, a center of sport and popular education, and a former squat from the 1970s.

conducted with great sophistication, as people on different sides of the issue moved around the room, grouping according to their points of view. Miguel Martinez took notes, reporting his summaries to the group. Soon after EKO had another fiesta. For this one, Archivo 15M Sol mounted an exhibition of their many materials, including large banners and puppets. The show brought the popular enunciations of the Puerta del Sol encampment into the social center.

Pasted paper on the streets of Granada, Spain, 2009. Text reads: "dictatorship of the automobile" and "culture of cement." (Photo by James Graham)

THIRTY-THREE

A SQUATTER MUSEUM

The New York MoRUS – Museum of Re-claimed Urban Spaces – was completely unexpected. In February 2012 I went to a meeting at ABC No Rio, which consisted of only Bill DiPaola and Laurie Mittleman. Later, Bill showed me the space these squat museum-makers had to work with. It seemed like a broom closet or a large bathroom. But their landlords, the legalized housing co-op known as C Squat, had in the end ponied up their entire common space. Clearly they were determined people. On opening day, the MoRUS had a storefront, a basement, and a two-story high performance area carved out of this

old tenement apartment building, which had been used in the past for squatter punk music shows. The MoRUS project survived NYC's most devastating storm in memory. Hurricane Sandy hit the place days before the show was scheduled to open. The place was totally flooded, but this didn't stop them from putting out human-powered electric generator bicycles for neighbors to recharge their cell phones during the weeks the Lower East Side was without power. Then open they did, and with a new-fashioned LES flair. Local businesses pitched in with a steady stream of food platters – Barnyard, the locavore food place nearby, sweets from the 4th Street Food Co-op (still not a commercial business), and pizza from Two Boots. You could tell the times had changed since those LES squats fought the law, because the food did not instantly disappear among the crowd. Left wing they may be, but this crowd is now no longer hungry.

Many other things have also changed since the times this museum commemorates. *The East Villager* community newspaper reported that a landlord notorious for evicting all his tenants so he could live in the building with his family is a frequent visitor to the museum. [Anderson, 2012] He has integrated into the neighborhood quite well. And why wouldn't he? The rents on the LES are some of the highest in the city. It is now a rich person's district, like it or not. Instead of diverse ethnic poor and immigrants from hostile countries often living together, a radically different income and class strata mixes there now.

The NYC squatters' movement is a strongly cohesive tribal subculture, an "elective family" of sorts. They won significant victories – territory for homes and gardens, and recognition of their social and cultural significance. All of this was carefully and painstakingly constructed over many years of grinding construction work, living amidst squalor, unsympathetic and often conniving neighbors, negotiating internal conflicts, battling police, gentrifying politicians and mainstream housing groups who thought the squatters would mess up their deals with the city. The squats and gardens were constructed in resistance. Their movement was also built through art – that is, continuously fronted, explained, and outwardly faced with representations. Music, stories, drawings and cartoons, fashion, inventive public actions, all played their role in making the Lower East Side squatter a familiar figure of the '90s, and a kind of urban legend.

I was in town for the MoRUS opening, but I almost didn't make it. In a very East Villag-ey sort of way, I had spent the night before

drinking with Michael Carter at the 11th Street bar. Michael is an old friend, living in a formerly squatted building. Back in the day, in the 1980s, he edited *Redtape* magazine and used a Basquiat painting as a bed sheet in his squat. His neighborhood bar is a great old Irish family-type joint. In the front a stone hangs carved by sculptor Ken Hiratsuka, a stalwart of the long-gone Rivington School artists' group that occupied numerous vacant lots with their welded metal assemblages. Ken's carving commemorates the Chico Mendez Mural Garden [Brown, 2011] that once flowered directly across the street from the bar. (Michael Carter's story about Ken's stone and a picture of it appears in *House Magic* #4.)

I spent the next morning in Brooklyn talking with my host Marc Miller, who a few years ago posted most of the ABC No Rio book we edited together in 1985 online. [Miller, "The Book," n.d.] Suddenly, it was too late to get to the museum opening on time. But I got lucky with the subway trains, which are notoriously unreliable on weekends. The train in Manhattan was packed with weekend people going places. A homeless guy was stretched out on the bench, taking up four seats. No one bothered him. In other parts of the city passengers would wake him and make him get up. Not in genteel Manhattan. At last he awoke and started to shout and howl. It was a good reminder of what things in NYC used to be like in the days when the buildings MoRUS commemorates were squatted.

In the end, I only missed the opening remarks by Councilwoman Rosie Méndez. For three hours I roamed amongst the jolly crowds in the big storefront, down the twisty stairs to the basement (turned into a coat check and bar), then into the grand two-story theater-like space the C squatters have carved out of their tenement apartment building. Much of the floor is painted with designs commemorating the LES squatting movement, as are the walls. Displays are well organized into different sections – squatter tech (videos and cell phones), community gardens, the Critical Mass bicycle wars – and enlivened by photos contributed by people in the community. The museum is staffed by young enthusiastic volunteers.

What were all these NYU students doing here? Could it be that the singular squatter subculture of New York City was in some way reproducing? What was drawing these young people in to work on this project of material remembrance of social movement activism that helped some people get cheap apartments and a community get

a precious garland of sometimes-open green spaces? I didn't ask. I was too busy greeting old friends and comrades.

Marlis Momber, the longtime Loisaida photographer and veteran of the '70s drug wars, was photographing the scene. Jeff Wright, a poet and ex-publisher of *Cover* magazine that I typeset for years, also showed up. While Jeff was not active in the squats, he has been a strong advocate for the community gardens, a vital part of this museum. While I was talking with Ben Shepard, the activist, writer and teacher, he was scheduled to be making an audience presentation downstairs. Clearly the schedule was kind of loose. Ben blogged the event fast and well, putting it in the context of other talks and Occupy events he'd attended that month. He stuck in a long account from his book, describing the notorious insect release that disrupted a city auction of community garden properties during the years of Rudolph Giuliani's mayoralty. [Shepard, 2012]

I saw the venerable, long-bearded zen master Adam Purple, whose amazing garden was destroyed in 1986. It was the victim of an early push by Mayor Giuliani to eliminate the Lower East Side counterculture. During his presentation, Adam talked only occasionally, doing inserts and glosses on a prerecorded talk about his lost garden and the two squatted buildings that adjoined it. I chatted with Frank Morales after his rousing short talk, bringing the politics of the squatter movement to bear on the present day crisis. It was Frank who organized the solidarity demonstration at the Spanish consulate uptown when the CSOA Casablanca was evicted. (Surely some bureaucrats' jaws must have dropped.) Frank and his partner Vanessa would soon join SqEKers for the meeting in Paris.

Seth Tobocman gave a slide show and a talk accompanied by jazz musicians. Fly Orr, the original "cement-mixin' squatter bitch," also talked (that's the title of one of her zines). Fly contributed a lot of material to the Squatter Rights Archive at the Tamiment Library of labor history at NYU. The late Michael Nash mentored the group of LES activists who worked on this project. MoRUS is the final result of a long series of moves by LES squatters to preserve their histories and disseminate their stories.

Paul Garrin was also drifting around the MoRUS opening. Paul is a computer programmer who has a company delivering wireless internet service on the Lower East Side. Garrin worked for video artist Nam June Paik. He chucked a fast track media arts career to become a

free information activist, waging a doomed struggle with ICANN (the Internet Corporation for Assigned Names and Numbers) on behalf of his name dot space project. He's now very much the businessman, with little patience for left political people. Lisa Kahane was taking pictures of course. She was the chief photographer for the innovative '80s art venue Fashion Moda, and an important documenter of many feminist art actions.

I had planned to interview the peripatetic Peter Missing, whose band Missing Foundation terrorized the bourgeoisie moving into the LES during the '80s and '90s. SqEKer Amy Staracheski was going to sit in. But it just wasn't an interview kind of day. After his days on the LES, Missing spent years in the German squat scene. He was among the last artists evicted from the famed Berlin squat Tacheles. I talked to Andre, the French-born squatter who supported the House Magic project when it first opened at ABC No Rio. I also sat with Sarah Ferguson, who wrote a great text on the Tompkins Square Park riot of 1988, published in Clayton Patterson's book *Resistance*. She is now active with her local community garden. She told me how she had salvaged copies of the 1985 ABC No Rio catalogue from a hurricane-flooded basement and dried them out in a microwave. They sat on a rack in front, pages all bloated and covers half-effaced. Hurricane Sandy made them worthless as rare books, but they can still be read.

Later in the afternoon, the event got crowded as students involved in the demonstrations at Cooper Union came pouring in. The one-time free school of art and engineering would soon see a drawn out occupation in protest of the end of the free tuition upon which it had been founded. (The administration finally backed down – two years later.) I didn't stay for the dancing. I was a little surprised not to see some people. Clayton Patterson didn't show, but he has issues with many squatters. Andrew Castrucci of Bullet Space, and Steven Englander, director of ABC No Rio also did not come. Steven was deeply involved with the LES squatting movement. His thumbnail account of how the squatters finally got their buildings is succinct:

"Because the city had a policy of not negotiating directly with squatters, a non-profit community development corporation called the Urban Homesteading Assistance Board sort of mediated it. The properties were turned over to UHAB, and UHAB, working with the squatters, did the required renovations to get them up to code. Then they were converted into low-income limited equity co-ops. The

official name is a housing development fund corporation. There are income restrictions on who can live in the buildings, and there are resale restrictions on what people can sell the units for. So we can't sell apartments at market rate. In my building sale is restricted to families at or below one hundred percent of the area median income. So the sale price is set at being affordable for somebody who is right in the middle of median in this census tract, assuming someone spends about a third of their income on housing. Once the renovations were completed the former squatters became shareholders in their building and self-manage them." [Kimball, 2012] This from the man who has led the nearly decade-long campaign to rebuild the ABC No Rio building, an anarchist expert in property.

Later that week, I took the subway into the city from my hostel in Queens to recover my bike. I'd left it parked at Lafayette and Bleecker, not far from the Yippie! Café. It had been closed for a long time, but now it was open with an installation of some 30 odd documents from the Yippie archives. This longtime venue of the counterculture movement linked to the late legendary activist Abbie Hoffman was reinventinig itself as a museum of resistance. When I lived around the corner in the late 1970s, it was the last citadel of hippie culture in New York City, the brain center of the marijuana smoke-ins called the "420." The Bleecker street storefront was always littered with young hitchhiking backpackers wearing rainbow-colored T-shirts. For a while, they held concerts in a larger city-owned space they had use of around the corner. At that time, the age difference – and the thick fog of reefer smoke – did not make me a regular of the place. But I recognized their mission, and helped out a little from time to time on their newspapers, *Yipster Times* and *Overthrow*. The pater familias of the Yippies is Dana Beal, a hard-bitten longhair and drug treatment activist who was serving time in a Wisconsin jail for pot possession. After decades of operating more or less openly as a countercultural hippie leader, it was simply sad that the law had finally caught up with Beal. Especially since the laws against pot were changing. Incarcerated people regularly lose their homes, and by the time Dana got out of jail, the 9 Bleecker building had been seized and sold off by the courts for default on mortgage payments.

In this last blaze of reinvention, Michael McKenzie was running the Yippie! Museum, "the museum of dissent." He told me some of the "kids" from OWS were meeting there. They read the Yippie manifesto.

One young man said in amazement, "This has all happened before!" Yes, it's the eternal recurrence of a U.S. movement aimed at liberation and against the depredations of capitalism. McKenzie said that people had been bringing things over to add to the Yippie museum. Old folks who'd been active in the '60s were slipping envelopes through the door and delivering shopping bags full of stuff. They also had a large uninventoried collection of videotapes documenting all sorts of Yippie-ish activities over the years, including Beal's own long running campaign for the plant-derived drug ibogaine as a cure for heroin addiction. Later, Interference Archive volunteers who were cleaning out the place said a lot of the material stored there was useless, moldering and soaked in cat piss.

THIRTY-FOUR
ART + SQUAT = X

Very few people attended the talk I gave at the Universidad Complutense in Madrid in mid-2012. Miguel Martinez, who invited me, came, as did another professor, and a couple of students who afterwards asked about street art. In the paper [Moore, 2012], I tried to systematize the relation between the squatting movements and the production of art. I abandoned that as a plan for this book. It was a kind of long apology for not being disciplinary, for not staying within academic bounds. I tried forlornly to climb back over the fence. I outlined a number of points relevant to the kind of study that did not seem yet to have been undertaken,[1] a formal examination

1 A rising generation of scholars are mining the anarchist and left-libertarian mainstream – which, in the era of state socialism, was a mere creek – for its cultural undergrowth. (A better analogy, since the great red trees have fallen.) This list, which is changing, and almost daily, will be a very long one, but I begin it with the generation of writers in English, many of whom are

of the relation between late 20th and early 21st century political re-
sistance – transgression, trespass, [McCormick, 2010] illegal direct
action – cultural expression, and creative processes themselves. This
chapter expands a little on the abstract of that talk.

At first I asked the general question how and why artists are in-
volved with squats and occupied social centers? The art world – which
I understand as the interlocked circuits of commercial art galleries
and institutional exhibition spaces, both fed by academies – is flex-
ible, but squatting is subcultural. Markets and institutions are com-
mitted to serving the interests of larger cultures, as determined by
sustained flows of capital and elected governments, respectively. To-
day we might say that, as attention is directed towards occupation,
subculture is becoming part of mainstream culture. This is a political
process, accompanying the rise of radical democratic movements. As
such, the institutions cannot ignore the emergent subculture. Simi-
larly, as street art became a marketable style, like graffiti and hip hop
culture in commercial art and fashion before it, the markets of art
have moved quickly to vend it. Two ways to think about the relation
between artistic practice and squatting are through themes of coun-
terculture and exodus, elaborated in influential texts.

The reason artists squat to live and work in squats is simply because
they can't pay rent. For most artists, making art doesn't pay, and most
artists don't come from rich families. Artists' economy, then, does not
fully accord with capitalism, nor is it in accord with the ordinary con-
ditions of waged labor. With the rising gentrification of urban centers,
artists have lost their low-rent homes in the traditional working class
districts of the city. They are therefore inclined towards the radical
solutions offered by squatting.

The 1970s "free cities" of Christiania (Denmark) and Ruigoord
(Holland) offer positive examples of squatting for artists. The history
of the broader movements of the '70s, though, is little known.[2] Artists

also artists and activists: first, Lucy Lippard; then Allan Antliff, Gregory Sholette,
Julie Ault, George McKay, Alice Echols, Susan Noyes Platt, and many others work-
ing in the vineyards of political art history; and in Europe, Peter Weibel, the IRWIN
group, Dmitry Vilensky, and far too many I don't know. Of the newer writers, I
name only Josh MacPhee, Nicolas Lampert (U.S.), Gavin Grindon (UK), Jakob
Jakobsen (Denmark), Luis Navarro and Julia Ramírez Blanco (Spain). The histori-
cal literature in other languages is more remote, but as we move towards universal
translation and online exchange, will come more into view.

2 These are starting to happen, however. Recently, the KW in Berlin [Proll, 2010]
 and the Vienna city museum (Martina Nussbaumer, et al., *Besetzt! Kampf um*

were closely involved in squatting in New York City in the 1980s and '90s. (This forms the basis of my approach to the subject, what I have called the New York model.) Who is an artist, and why might they choose to squat? Artists in squats are those who participate in social movement culture. (We might say further, artists who are comfortable with poverty, and/or who have no other opportunities; artists who are working class.) They can be committed activists or not. Punk, hip-hop, and experimental cultures all co-exist in squats. Cultural activities sustain squatting, both through the people who volunteer work in the squats, and by raising money.

Several successful and famous artists have been involved with squatting. (I discuss a few of these cases. It's important, since disciplined cultural history – art, music, theater, etc. – is almost entirely formed around proper names.) Mostly it is lesser-known artists who fully identify as squatters. Musicians also have been closely involved with squats. Performing artists are the most closely involved, and some theater groups have come from squats.

Squatters also continuously perform their activity for photographs, and in demonstrations. (This is the "everyone is an artist" part, an assertion that seemed a little crackpot in the '70s, very hippie – although some largely forgotten creative projects attempted to realize it then. With the rise of web 2.0 and social media, the vast continents of popular creative life have risen from the sea; what Gregory Sholette calls "dark matter" has been revealed.) Videos document the life and performances of squatters, especially their struggles and evictions. Sometimes this is spun into fiction,[3] and in one case, a situation comedy, "Our Autonomous Life."

Formally, a squat resembles an art exhibition – it requires a lot of work, and may be open for only a short time. Both art shows and squats serve a social function for the participants. Some groups of artists have used squatting as an element in their work, that is, as an art form. (After the Occupy movement, this is certainly becoming more

Freiräume seit den 70ern, Wien Museum, 2012) have mounted shows focussed on artists' squatting. (Thanks to Paul Werner for Vienna citation.) There have been others during earlier movement waves.

3 SqEKer Baptiste Colin, a historian, collects novels that feature squatters. It's almost a genre of literature as his collection of mainly French works shows. Edward collects squat videos, almost all documentary. (Most have been posted to squat.net.)

common and more self-conscious.)[4] Occupied social centers have been called "monster institutions"; [Universidad Nómada, 2008] they come together, and continue in the process of formation, as a result of popular collective initiative. When I began researching, I understood these "monsters" as aspiring to be human. That is, I saw squatted social centers as proto-institutions, collective formations on the road to some kind of permanent place in the social ambit. The social center has a very particular genesis, mainly in the Italian and Spanish context, which makes this seem true. However, many squat projects have no such intention or interest. To fit into the capitalist system of governance as some kind of an institutional cog, to understand oneself as yet another part of a general neoliberal urban economy – all of this is abhorrent to an antagonistic project.

Taking over urban space – occupation, can be considered not only as a political tactic, but also as a form of aesthetic work. Epic eras of social center squatting in the 1990s paralleled the rise of a vein of academic artistic practice called institutional critique [Alberro and Stimson, 2009]. The relation of squatting to institutional critique, however, is as a part of its secret history, its undercommons. The concept of institutional critique was elaborated in the academy with very little reference to its political formations by academics who were surely aware of precedent events like art school occupations. (As such, it can seem like a not-so-sly attempt to smuggle grenades into the university inside a potato sack.) Cultural projects launched in squats are perforce direct action, not critique.

Squatted social centers also relate to the emergent art form of social practice, as it is called in the U.S. Social practice art draws directly on a long legacy of community-based art, which in turn descends from militant political formations of cultural workers. [Goldbard and Adams, 2006] The form, which curator Nato Thompson, who is central to its contemporary elaboration, has admitted he could barely name, includes all manner of strategies of stimulation and generation of creative energies within social bodies that lie outside the field of the contemporary art world. No one at a social practice art event is likely to be holding a cocktail glass.

4 Jaime Idea, a U.S. artist, participated in a show in London called "Made Possible by Squatting" in September of 2013, a protest against the criminalization of squatting in England, and a reference to a Dutch campaign against the impending criminalization in that country. Matthew Enever, an English artist working in Brighton, describes himself as a conceptual squatter.

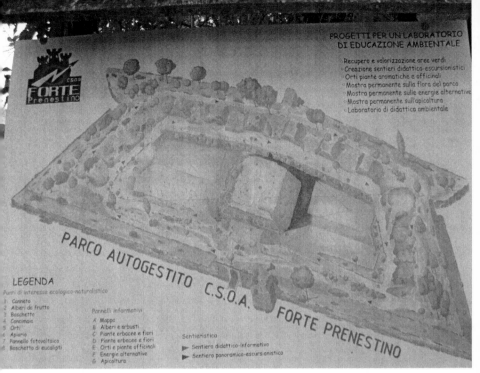

Plan of Forte Prenestino social center in Rome as an environmental park, 2014. (Photo by the author)

The bureaucratic negotiations that may lead a squatted social center to achieving a legalized status are boring or complex, so a lot of artists don't want to bother with them. Institutions, like those in cities managing their "brand," and private owners and developers of commercial complexes or districts they want to gentrify, occasionally imitate or evoke squatting strategies, and the countercultural image of squatting. (In advertising, they can call that "sizzle.") There are better ways for institutions to relate to the "monster institutions," and they are being explored, like the New Institutionality program of the Reina Sofia museum and its partners in a consortium of museums.[5]

5 New institutionality is a viewpoint and a set of initiatives elaborated in the context of the recent economic and political crisis that attempts in some way to bridge the yawning gap between ostensibly public cultural institutions of liberal democracy with the horizontalist culture of the social movements. If that sounds obscure, well – it is. So far, New Institutionality has had its main outcomes in heuristic projects like conferences, seminars and institutional self-study. In the Spanish case, high level cultural officials have supported some social centers. (See Jorge Ribalta, "Experiments in a New Institutionality," MACBA, 2010; and Manuel Borja-Villel, "Hacia una nueva institucionalidad," *Carta* 2, MNCARS, 2011.)

I hope this paper contributed somehow to the ongoing considera-
tion of cultural strategies and the very large presence of artists among
squatters in the work of other members of SqEK. Maybe it also stim-
ulated some people to think about how they might work at these same
questions. The aim of the House Magic project was to propagandize
European-style squatting in the U.S.A. The aim of "Art + Squat = X,"
and of this book, is to stimulate the writing of exciting and useful his-
tories of autonomous transgressive creative acts that can move urban
society forward.

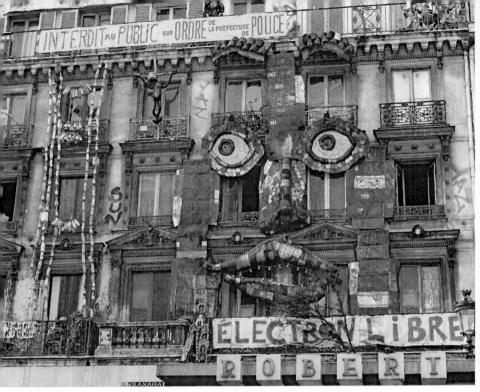

Sara Renaud, face on the art squat Robert Electron Libre (59 Rivoli), Paris, 2003-07. (Photo courtesy Sara Renaud)

THIRTY-FIVE
ART GANGS OF PARIS

The Paris meeting of the SqEK group in March of 2013 was our best yet, a spectacular success – or, more properly, an anti-spectacular revelation. We learned so much, saw so many places and heard so many stories some of us experienced blank attention passages, a kind of waking sleep where you know someone is telling you something interesting but all you really understand is that their mouth is moving and some sound is coming out. Our hosts pushed the schedule hard, and it was a real adventure: a five-day event that was at once scholarly, exciting, exhausting, passionate, enlightening, dehydrating, cold, ridden

with gremlins, and politically effective. It was also shot through with moments of rare beauty.

The show began in the garret of the university called Sciences-Po, a maze-like school of conjoined buildings in central Paris. Beneath the massive exposed oaken beams of the named attic meeting room, the SqEK group gloated over their first book, *Squatting in Europe*. [SqEK, 2013] Boxes of the new title had been carried from London by a few people who sacrificed their luggage allowances, and had to wear the same clothes all week. I brought proofs of the new *House Magic* #5, along with copies of all the other issues. They evaporated into the crowd, and I was only paid for one. I grouse all the time about the inconvenience of making zines on the run, and #5 was a typical nightmare. But as Mujinga of *Using Space* zine reminded me, print copies pass from hand to hand in a kind of bodily social transmission that the internet cannot match. They have a material reality, handmade items with a kind of gritty integrity that can shame items with slicker production values. They are literal building blocks of the movement. (Yeah, yeah, but such a hassle.) Frank Morales arrived from New York with his partner Vanessa. He brought a passel of propaganda, including issues of Chris Flash's newspaper *The Shadow* from the 1990s, catalogues from the Bullet Space squat art gallery, flyers from the MoRUS (Museum of Reclaimed Urban Spaces), and silkscreened posters by Seth Tobocman.

Despite that it is academic, the SqEK book is pretty great; it contains several of the papers presented at our meetings. The cover blurb from Paul Routledge, sums it up well: "In an era of austerity, capitalist accumulation by dispossession, and the criminalization of protest this excellent book serves as an inspiring and timely reminder of people's reappropriation of urban spaces in order to fashion alternatives to the status quo. Structured around a typology of squatting configurations – as anti-deprivation; entrepreneurial; conservational; political; and alternative housing strategies – this empirically-rich collection of essays by scholars and activists provides persuasive evidence of the creativity and politically transformative potential involved in such practices."

At nearly the same moment back in the States, Hannah Dobbz was touring with her new book *Nine-Tenths of the Law: Property and Resistance in the United States* (AK Press, 2012). I had the honor to blurb that myself. I tried to keep it punchy, since her book is more mass market than academic. "This is the thinking person's guidebook to urban and

suburban squatting. Hanna Dobbz' book is about property in America, this 'history which is happening all the time.' This book lays it all out, from the days when George Washington was an illegal land speculator, property rights were entwined with genocide, and the Great Proprietors always won, to the resourceful new movements that have recently emerged to help people take empty houses during the foreclosure age. Using her own life, recent news stories and generations of scholarly work, Dobbz waltzes through the bizarries of the U.S. property system, from the iron logic of property speculation to the madness of arson for profit, from lone wolf opportunists to political activists acting selflessly to house others. We read about the big city stories – from New York, Philadelphia, San Francisco – and navigate the entanglements of the foreclosure crisis, how 'people remain homeless as homes remain peopleless' in the doomed suburbs of America. Rent-free living is no bed of roses, as squatters become the new villains for U.S. media, face landlords setting fires and thugs doing evictions for hire. Learn why most of them don't care to own. For those who aren't quite ready for off-the-grid outlaw living, Dobbz explains land trusts and co-op ownership, along with the romance (and grime) of collective living." Hannah has since opened a distribution project, called SQ Distro, to circulate information about squatting in the U.S.

After some backslapping and book signing, the conference began. For the first time, it was bilingual, in English and French. Miguel Martinez described his conception of the "action research" collective which is SqEK – "Qu'est-ce qu'un collectif de recherche-action?" Conference co-coordinator Hédiman spoke about the Intersquat festival, an annual event during which the doors of the art squats in Paris are opened. The festival began as a collective response or follow-along to a show at the newly fledged Palais de Tokyo museum, then under the directorship of Nicolas Bourriaud, around the turn of the millennium. The squatters of Paris were invited to show in whatever manner they wished. The "art squatters" and their political compatriots are nothing if not multi-various and contentious, so this project generated a lot of noise and heat. (The influential radical teacher and theorist Jean-Claude Moineau weighed in on this with a text at the time, and talked about it when I met him with Michel Chevalier in 2010, although my French is such that he might as well have been talking to a tree.) The ever-smiling Hédiman has soldiered on with the organization of these festivals, despite catching a few tomatoes in

the face because of it. Next, Jacqueline Feldman spoke of her encounters with Paris squatters. She'd been blogging a lot of it at her blog "Rêve générale." Jacqueline also did a lot of translations throughout the week, earning the gratitude of all us French-less.

When the first day's talking concluded, Hédiman took us for a squatters' dinner – down to a food court near the Seine, where we bought chain-store vegetarian slop and beers at a supermarket. About a dozen of us encamped in the cold on the stony banks of the river in the veritable shadow of Notre Dame cathedral. We waved at the tourists riding wide boats as they came surging up the Seine, blasting the night with their bright lights. (The passengers aboard seemed more interested in us than the cathedral.) A drunken guy joined us, and cadged a beer (or two). I felt as if I were following in the clammy footsteps of Guy Debord during the days of the dérives…

Many SqEKers stayed in Paris art squats where they had intensive conversations with the artists, most at Gare XP, la Gare Expérimentale. (Not me, sigh). Hediman led us on formal tours through several

SqEK presentation at Gare XP (Gare Expérimentale), Paris; Frank, Miguel, Margot, Luca talking, Thomas watching, and unidentified. (Photo by Vanessa Zannis)

SqEK visit to Alice's Garden art squat. Hédiman, our guide, stands with sculptor Sara Renaud outside her studio. (Photo by Vanessa Zannis)

others. The standout was the Jardin d'Alice, a rundown 19th century house with a large garden behind it. The setting, the artists, the camera crew from somewhere which trailed along on our tour: it was all impossibly charming, like an art squatters' Potemkin Village. It was on the brink of eviction when we visited and now no longer exists.

We met metalworker Sara Renaud in her garage studio, working on a piece, her gamine face smudged with soot. She doffed her heavy gloves, and led us through the house where an elderly woman died apparently intestate. Adjoining her property is a medieval farmhouse; the cellar of Alice's house itself is of medieval vintage. At the time of our visit, a dozen artists lived there, and more came and went in the studios. A collective of five took the place four years earlier, coming from 59 Rue de Rivoli. Sara's work, *Giant Face*, made of tin cans and scavenged plates of steel, smiled down at passersby from the facade of that most famous of art squats on a main shopping street of central Paris from 2003-07.[1]

1 Sara Renaud's own website shows and describes the work on the squat called the

First we saw the garden, which the squatters opened to their neighbors. It is managed in common; no plots are given to individuals. The artists talked with city architects who were going to redevelop the area as social housing, and urged them to preserve the charm of the original garden so carefully tended by Alice. The future institutional project will include the garden, they said. Whatever. When you sign the contract agreeing to leave when you are told, Sara said, "you sign your own death in a way."

Sara toured us through the house, which was neatly kept, and included an installation in the stairwell of artfully displayed relics of bygone daily life discovered in the house. "This is the Alice stuff," Sara said. "You can see her bra. It's a Marilyn Monroe style." She described the process the collective had gone through in managing the house. At first they divided up the space into private areas, each to their own, according to the number of squatters. That didn't work. "We saw that we needed to divide the space based on the need, each week, each month, so it can change." They took out a lot of the doors. Now artists could come for one or two months and there would be a space free for them. "It demands a big effort from everybody because no space is really yours." At the same time, with the new arrangement "we were not prisoners of the place; we were free to leave and free to come back – it's a big trust."

Since Alice's house and her garden were due to be redeveloped, the collective planned to move on. "We want to share, we want to open the empty places," Sara said. "We also want to make money with our art and be recognized." Afterwards, SqEKers argued about why the Paris artists didn't defend their squats, but simply left when they were asked to. I was also indignant that these civic-minded artists seemed to be so openly used. The artists provide the city with free cultural services; property owners get free maintenance; the artists consulted with the architects, mediating community opinion that the garden should not be torn up. Yet the artists are charged money for rent instead of being paid, then evicted on short notice. That's what you

Electron Libre. She writes that 59 Rivoli was "The most famous and internationally mediatized artistic squat in Paris.... Many people went there, they saw and they did the same in their own countries, and cities. The place is now legal. It means more time and also more rules. But as long as artists will be able to create in this building, and resist against the real estate speculation, the fight of the beginnings will have an echo" (posted June 15, 2010, at: HTTP://SUPERVOLUM. COM/2010/06/15/ROBERT-ELECTRON-LIBRE-2003-A-2007/).

have to do to get a contract in Paris. It's a civic version of commercial anti-squatting.

Moreover, their artistic culture is exploited. The colorful, multi-generational crew of the Jardin d'Alice were featured in a video on the website of the Grand Palais in connection with the giant exhibition "Bohèmes." This show, at a new public cultural venue set up by the Minister for Culture and Communication, looked at 19th century cultural history through the hot topic question of immigration, reflecting on the relationship between artists and the Roma from the east who were emigrating to France throughout that period. "At some point in the early 19th century," writes Richard Dorment for *The Telegraph*, "artists stopped treating gipsies as either sinister or comical and began to identify with them." The "Bohèmes" exhibition "explained the complex question of how and when artists made the culture of an itinerant people from the east their own." [Dorment, 2012]

"Some of the city bureaucrats like what we do," Sara told us. "They like the alternative life and so on, and they fight against their own administration to get some new empty spaces," and make them available to be opened. "Everything about real estate in Paris is really political."[2] It seems clear that the Jardin d'Alice crew, like the 59 Rue de Rivoli

Armin presents "Sink Mediaspree" Berlin, anti-gentrification project, at La Gare Experimentale, Paris. (Photo by Vanessa Zannis)

bunch, are favored among the many art squatters of Paris. They are helping out "brand Paris" with artists, now that Berlin is remorselessly gentrifying. And, like the colorful nomadic gypsy vagabonds whom they love so well, the contracted squatter artists will move on nicely when they are told to do so.

We next rushed on to the Théâtre de Verre ("Theater of glass"), a building complex given over to festival-type entertainment. It was hung throughout with dense agglomerations of colored panes of glass, work of the middle-aged Chilean artist who had first squatted the place. This man did all the talking, while some others in his group, all younger than him, stood around watching. At some point it was explained to us he was like the papa, the guy who knew how to squat, and had connections with city officials. Some who worked with him went on to do their own squats. The next squat we visited was one opened by his disciples. It was called Jour et Nuit, a "collectif artistique tranquille," to reassure their conservative neighbors. This group had settled inside an abandoned electric company station. As we arrived in the evening, a circle of chairs was quickly formed up in the lobby, and the project was explained to us.

This art squat was a relatively new one. The kraker was a quiet earnest South American, a balding designer wearing a snow-white military style sweater. He had quit his job to become involved in this art squat, he said. He was tired of working all the time and wanted to do his own projects. He put his name down as president of the association the city requires when giving a contract. There was never any question whether or not they would take one if offered. He walked us through the building, constructed with offices above and technical areas below. These had been organized into collective workspaces and individual studios. The workspaces included some open rooms used as a theater and as multi-use space, and a cement-floored atelier with bicycles stacked up, including two pedicabs and a recumbent. There was also a partly built geodesic dome, which an architectural group had left behind them.

Another of the squatters, a dramatic young man with a long black ponytail, showed us around upstairs. He swigged from a bottle of wine, becoming more expansive, repetitive, and florid as he did so. Hédiman had brought a six-pack, and he peeled off beers for our crowd. Our guide took us to a row of studios opening off a long corridor. We went into his. On the wall hung a large-scale map of Paris. It

SqEK visit to La Miroirterie squatted music center. At right, Margot and Tisba. (Photo by Vanessa Zannis)

was marked with flags denoting vacant squattable buildings. Our host quickly covered it from view, lest one of us descry a location and beat him to it. As we walked down the hallway, young artists, almost all of them painters, emerged like sea monkeys from the floor of the aquarium, smiling and opening their doors for us to see. It was art school hell – a long corridor full of people waiting, and us exhausted after 12 hours of conferencing. A long night of partying with art squatters was looming, but we fled.

The big noise during our conference concerned La Miroiterie, the mirror factory, a 14-year-old squat in Belleville that was slated for eviction. SqEKers visited the venue for an evening concert of experimental jazz. Before it was a mirror factory, the place was the studio of a famously social painter who gave parties for the neighborhood. The district was the site of one of the last barricades of the Commune of 1871. Original squatter Michel Ktu claims an ancestor who died in that fight. The squatters there never wanted a contract with

the city because of all the controls that come with it.[3] "It's a kind of cultural dictatorship," Ktu told Jacqueline Feldman. La Miroiterie was as media-friendly as the Jardin d'Alice, but in a very different way. Its inhabitants are defiant and punky. La Miroiterie had an earned reputation as a wild party place, a DIY venue that wanted to stay that way. [Camus, 2013] Live free or die. For the latter part of its history, the place was a major underground music venue. The Stooges played there – very appropriate given the original Stooges' connection to the Detroit White Panthers and John Sinclair's artists' commune of the 1960s.

In her article on the place, Jacqueline describes the high romanticism and self-dramatization among the artists of La Miroiterie. She questions whether their resistant strategy provides the best conditions for artistic productivity, and notes the advantages of legalization. "The endless, chaotic partying at La Miroiterie could wear out any artist. And it is physically exhausting to live in a rapidly deteriorating building, where some of your roommates are addicted to substances and relationships are competitive and conspiratorial.... Dominique Pagès, a councilor for the Twentieth Arrondissement, told me a squat is a boîte noir, a black box, referring to its inscrutable inner workings.... Squatters occupied the empty building, and each filled it with whatever he or she required." One is reenacting Bohemia, being the new Duke of Ménilmuche (the nickname of the hard-partying artist who used to live there). Another is a self-styled vigilante, keeping order with a stick of wood under the bar, and fending off the drug dealers who come by the place. Another seeks beauty in the squat, and still another holds on to youth.

Consonant with the underlying Commune mythos of the pyrrhic victory of liberation in resistance, she quotes Swan Moteurs, who organizes rap concerts there. He predicts the arrival of over 100 police. The squatters gathered 10,000 petition signatures against their removal, and Moteurs said they could also call upon their supporters to man a barricade. "If we say, 'Come, wage war,' they'll come." [Feldman,

3 Some of the controls are mentioned in the article by Feldman and Camus cited below: Artists pay a modest rent, utilities and insurance; they can't live in, or sell their work in the building; and the city has a say in the artists who can participate. [Camus, 2013] "The city helps to select" the artists, and they must provide projects or events for their neighborhood. [Feldman, 2013] There is a very clear coincidence in these conditions with the policies of managed use in New York City. (See Chapter 26)

2013] All this bravado seems to be paying off with a little more time. As of summer 2014, the Miroiterie had still not been evicted.

Parisians, with centuries of artistic training and bohemian traditions behind them, are expert at striking mediatic poses that add up to the strong appearance of a subcultural scene. The centralized bureaucratic state, with its dense web of regulations and addiction to procedure, can be outwitted and outmaneuvered.[4] Moreover, it's riddled with sympathizers. While the art squats, like most squats, are ephemeral, the archive marches on, working so that these colorful characters will not disappear from cultural history. At our first meeting, Jacqueline introduced Solveig Serre, a researcher at the Centre National de la Recherche Scientifique (CNRS), who presented her work in French. She is creating an archive of La Miroiterie before it disappears. She works in theatrical history, and found that the present-day Opéra Comique of Paris came from a number of non-institutional groups and places that joined together during the 18th century to form the institution. This, she said, was an early example of the institutionalization of alternative culture, and the close, complex relation between subculture and political power. She had attended a concert at La Miroiterie of comic music by a group that was "quite famous," and normally plays large halls. That day 150 people were packed into a room that would hold 50 or so. (We were ordered off the rickety balcony during the concert we attended). Upon inquiring, she learned that there was "no data on this place, no archives," so she decided to collaborate with the people there to get the project off the ground.

Serre began by collecting the juridical documents, to understand the conflict between the owner and the squatters. Then she gathered

4 The UX group (for Urban Experiment) is a prime example. They gained subcultural fame through the covert renovation of the long-dead clock on the Pantheon, a major Paris monument. The group broke in; set up a restoration workshop, and over years fixed the clock. They also ran an underground pop-up cinema in the catacombs of Paris. Their exploits connected an existing tradition of urban exploration and raving – parties and murals and sculptures carved in the catacombs – with short-term occupation for cultural use. The group – (or groups; others named are Untergunther, and La Mexicaine de Perforation, or The Mexican Consolidated Drilling Authority) – is deliberately vague about their methods of work and organization. It's understandable. (See Jon Lackman, "The New French Hacker-Artist Underground," in *Wired*, February 2012, at: HTTP://www.WIRED.COM/MAGAZINE/2012/01/FF_UX/; and Kirsty Lang, "The underground art rebels of Paris," November 23, 2012, at: HTTP://www.BBC.COM/NEWS/MAGAZINE-20433321; see also Lazar Kunstmann, *La Culture en clandestins. L'UX*, Hazan, 2009.)

all the flyers and documents from the place, to make some statistics, to know where the music groups came from, and their career trajectories. She also conducted some 30 interviews with people living there to understand the place and the collective. "With this research I think we can show that music is a main issue for these kinds of alternative places, and that music is quite different from art and culture," she said, "and we can try to understand more these debates." In particular, "the question if a squat could be a cultural institution" when "the people who are creating and living there refuse to be named like that." Historians of the 18th century work from archives, so they don't have the opinions of the people living at that time.

She explained that the property had a number of owners, so the juridical process had been slow, and the squat survived for so many years because of that. To solve this problem of a divided property, finally one private investor bought everything, step by step, and in November 2012 succeeded in getting the order of eviction. In La Miroirerie there are workshops, ten to 15 artists live there, and since 2008 the place has been a venue for concerts, a heterogeneous program including punk music, rap and hip hop concerts, and a well-known open jam session for jazz players. The neighbors will be happy to see them go; they mobilized to support the eviction. Serre said this is shortsighted, because the concerts bring a lot of economic activity to the area.

La Miroiterie had been a squat since 1999. They did many activities; thousands of people came inside. They were allowed to stay because of these activities and the conflicted ownership situation of the different buildings in the complex. There was no subversive political discourse and activities coming from that place, so it was easier for power to allow them to stay. At the same time, she said, "there is no coherence to be able to struggle." Despite all the people who came there, there had been no demonstration, no direct action, and only one petition to preserve the place. What's more, the guy who initiated the place now says he wants a change, to begin a new project. Since there is no collective leadership, they cannot defend the squat against eviction and repression – but at the same time they can have diversity in the place.

One of the key questions SqEK engages is that of institutionalization of squatted places. Luca Pattaroni then queried Solveig on this. By institution, she said, we can understand that relations are stable; there is a reduction of risk and uncertainty. With stability in relations,

we begin to build an institution. An institution is not only about stabilization, Luca said, but also about who can say what is reality – the power to affirm and confer reality. If we want to give that legitimacy to alternative forms of organization, we have to consider them as institutions. Then there is a possibility to redefine the state. In the case of self-managed collective housing in Switzerland, there is a penetration within the various devices of the state with ideals promoted by urban struggles. At this point, a woman shook her head. "We need to find another word to describe what we are doing. 'Institution' is not right." An argument ensued, in French.[5]

Throughout this conversation and many subsequent, we were joined by a young man in a red hoodie who made frequent interjections from a strong anti-state anarchist position. He pointed out that the so-called "winter truce," which prevents the government from evicting squats during the coldest months, often did not apply to clearly political occupations. He was from Le Transfo, an enormous squat in the Bagnolet district outside Paris. We visited the place, another clump of buildings of the formerly public electric company that has been privatized. We walked up the wide ramp leading to the parking garage. Inside the garage a group was building mobile houses out of recycled wood. These heavy squat structures were due to be transported to the ZAD, the Zone A Défendre, near Nantes in Brittany, where construction of an airport was being resisted by an extended occupation in solidarity with the rural community.[6] The years-long

5 What is an institution? Can a squat be one? The word is used casually in the U.S., but in Europe it has more weight. With the crisis era austerities, across Europe cultural institutions have been looking for ways to adapt. Some of these include harnessing the popular energies of occupied social centers. As instances, the MNCARS in Madrid has helped in the legalization of some social centers, and the Van Abbemuseum in Eindhoven has opened spaces in its buildings for citizens' intiatives. The same kind of process of what Situs would call recuperation of radical initiatives by the state has unfolded in the past. In Switzerland, the Rote Fabrik and Shedhalle in Zurich have squatting roots; so does W139 in Amsterdam, and a number of other Dutch initiatives.

6 Activist artist John Jordan and his partner Isabelle Fremeaux have been active in the ZAD occupation, and in the permaculture movement. They are blogging it (at HTTP://LABOFII.WORDPRESS.COM/ for "Rural Rebels and Useless Airports: La ZAD – Europe's largest Postcapitalist land occupation," parts 1 and 2). The two also joined the "r.O.n.c.e., a collective of farmers, artists, mechanics, cooks, permaculturists, botanists, trainers," whom they met at ZAD with the "aim to experiment with a post-capitalist life and creative forms of resistance" in south Brittany in March of 2013.

ZAD actions have been instrumental in cohering activism among a network of rural squats, Margot Verdier told us.

We watched a fragment of the film *Les Sentiers de l'Utopie* (paths of utopia) by Isabelle Frémeaux and John Jordan, of a cantankerous sculptor walking the filmmakers through a squatted medieval village. Margot and Claudio Cattaneo spoke about the "neo-rural" movement in France and Europe, a European youth movement around issues of access to agricultural land. [Hamer, 2009] Rather than the government's focus on food safety, neo-rurals are interested in food sovereignty – how and by whom is food produced? One network linking neo-rurals and climate campers is called Reclaim the Fields.[7] Margot described the ZAD, which has moved from being a program of demonstrations to a defensive barricaded occupation. Construction is ongoing all over the zone, roads, and electrical infrastructure that is immediately sabotaged. Police are everywhere, controlling people continually, asking for identification, and detaining some. There are many trials against activists arrested in different actions, and a big street medic project, because many have been injured by the police. Over time, the ZAD has built an infrastructure, with some 200 collectives in support – there is a free shop, a cinema, and a mobile library on a bus. All involved go by the name Cammy – a unisex anonymous name.

The Transfo held a party for SqEK, which was a slight twist on a regular music night. We mingled with Paris punks of the classic variety, highly decorated with studs and leather. Our friend in the red hoodie sat patiently as a table covered with zines and pamphlets throughout the increasingly wild party. At one point I asked him how many of these punks would come out to support Transfo when it was evicted? "About ten or 20," he guessed.

Throughout the Paris meeting, the level of discussion was high – about specific local situations, the comparison of experiences and conditions in different cities (a principal objective of Miguel's Movokeur project), and theoretical and emotional reflection. It felt as if this study was coming of age. Everyone's research and perspectives seemed to have developed significantly, and it all made a lot more sense to me.

Since this book unfolds chronologically, from my initial position

7 The anarchist connection to this movement is exemplified in the well-known case of the Tarnac Nine, arrested in the small French village of Tarnac for sabotage in 2008. The group is assumed by many to be the Comité invisible which wrote the tract *L'insurrection qui vient* (the coming insurrection) in 2007.

of ignorance through increasing sophistication in terms of analysis and information, it's not been clear to me where to place certain discussions. Now, as the book expands, I see I have to bring it to press without discussing further meetings of SqEK and the many new publications that have appeared like mushrooms during the rain of prolonged economic crisis.

In Paris, there was a substantive presentation about Berlin, with an excellent succinct response from the Amsterdam perspective. Also a discussion from E.T.C. Dee and Deanna Dadusc comparing the "moral panic" campaigns to criminalize squatting in both England and Holland, a question I have chosen not to discuss in this book. We had large important meetings with the Droit Au Logement (Right to Housing) and Jeudi Noir (Black Thursday) groups, who squat for social housing on behalf of excluded groups. (I visited a squat of theirs on an earlier visit; see Chapter 18.) And, so much more... Where to discuss all of this? I don't think I can fit everything in this book. Instead, I remind the reader that a great deal of the material I am using for this writing, indeed most of it, exists online for closer consultation, on my blog and in the minutes of SqEK.

For the purposes of this book, Paris was important for illuminating some important conditions of artists' relation to the squatting movements. (I use the plural because in Paris there are a number of different groups and loose networks doing squatting, and they are not normally in agreement one with another.) The city administration seemed to be deliberately working to divide a unified squatting movement by favoring artist squatters over political squatters when it came to toleration and negotiation of different occupations.[8] To make clear the conflict engendered by the preferences of state power, I offer the example of the artists' squat 59 Rue de Rivoli, which was given a contract by the mayor and the building renovated at city expense. The activists at the Transfo, by contrast, were building infrastructure for the ZAD camp and expecting eviction any day.

In a post-conference reflection in his zine *Using Space*, Mujinga wrote about the artist/politico divide among squatters we had seen in Paris. (He also referred to a number of French zines where the issue

8 How has this policy developed and how does it operate? Is driving a wedge between segments of a squatting movement a conscious city policy, or does it reflect divisions within the government itself? Artists and their movements are nothing if not diverse; indeed, novelty and innovation are at a premium within them and in their evolution.

has been discussed.) One big question is whether squatters should negotiate for a city contract or refuse it, and stay resistant. Taking contracts puts a squat under the conditions set by the state, of course, but it also contributes to a division that the state and mainstream media makes between "good" squatters and "bad" squatters. The latter can then be more easily evicted, at a smaller political cost. Then, there are the issues that anarchists and political squatters have with the ways artist squatters operate. The culture is different. Unlike political squats and social centers, French art squats are not usually run by assembly. "These groups often appear to be led by one charismatic leader, as a sort of mini-dictator who runs the project." This kind of hierarchy is deeply repellent to anarchists – this is how fascist social centers in Italy are run. Further, political squats – anarchist or autonomous – have strong anti-money cultures: no one makes "money from the place or from the events which are always either free or prix libre, raising money for good causes." (You pay what you like rather than a fixed price.) "Infoshops are also prix libre and also sometimes the bar (a truly mind-blowing concept for me!)" Everyone is a volunteer and no one is paid to do anything.

By contrast, artists sell work out of their squats if they can. (It's not allowed at 59 Rue de Rivoli; it was a major part of the late Tacheles squat in Berlin.) And what is worse from the anarchist point of view, artists rent rooms in their squats to other artists. (As a condition of contract, the city of Paris makes them pay an aggregate rent.) "In one huge place, gangsters had taken over and appeared to be extracting a large supposed rent for utilities which in reality seemed to be going straight into their pockets. That's pretty sketchy," Mujinga writes in typical understatement. At the same time, he recognizes that people need money to live. They can scavenge and steal, but some squatters still need to take wage work to get by. "What then is the difference between working outside your squat and working inside it for money?" He advances some suggestions, like the micro-brewed "squatter beer" that supplied the scene in Amsterdam (and was later spun off as a private company).

Mujinga also pointed to what he saw as acceptance of exploitation, with artist squatters paying a higher rent than "anti-squatters" in Amsterdam. It seemed to him that one group, which was crowing about how the mayor of Paris visited them in person, "were happy to isolate themselves from others and enjoy their lovely situation whilst other

places were brutally evicted." Maybe the political squatters should pretend to be artists! Thomas Aguilera mentioned during our meetings that pictures posted in some political squats in Paris advertise "art therapy," and declare "we are artists – don't evict us." It's an effect of the paths the state provides to institutionalize squats. The lesson from Amsterdam's broedplaats (breeding place) program, Mujinga writes, is that it is possible for squat projects to institutionalize and remain radical. He argues for a kind of "flexible institutionalization," accompanied it seems by a flexible antagonism. [Mujinga, 2014]

When I began this project, I thought, that legalization or institutionalization were the best things that could happen to an occupied social center. This is why people do it – to create, through self-organization, the kind of cultural provision and support that they need to do their work in the way they want to do it. The problem is, the institutionalized 59 Rue de Rivoli is boring. It feels just like any other low-rent high density artists' studio complex anywhere else, full of artists beavering away and smiling as you pass by their stall. It's even more boring than Tacheles (was), with its backyard that at least smelled of danger, sweat and reefer. 59 Rue de Rivoli has no edge to it – it's utterly tame, even pettable. To be sure, the radical change in atmosphere that comes with being administrated is a problem that the artists at Le Miroirterie and the Jardin d'Alice recognize, and it informs their decisions as to how to continue their collective projects. Transfo feels utterly different. It's big, dirty, and full of serious politicos, but also drunken punks and immigrant kids. It is an open situation, engaged and unresolved. It's illegal, and that's fun. More than fun, it's interesting. It meshes with its social surroundings in ways that are formatted but unpredictable, uncontracted, unpoliced, uncontrolled. Lucrezia Lennert remarked at one point that there is a great interest in co-optation by both state and business, the capture of subcultural creativity so that value can be extracted from it. (Not so that people can make a living!) One way to fight these attempts at cooptation is to remain illegible, so that "we cannot be organized into distinct identities and value forms." Now I see that this is the condition, rather than an open road to institutionalization, that is the most valuable property of an art squat. And it is almost always temporary.

Opposite: Nicholas Albery at a meeting of the Frestonia squatters, London, 1970s. Albery went on to found the Institute for Social Invention.

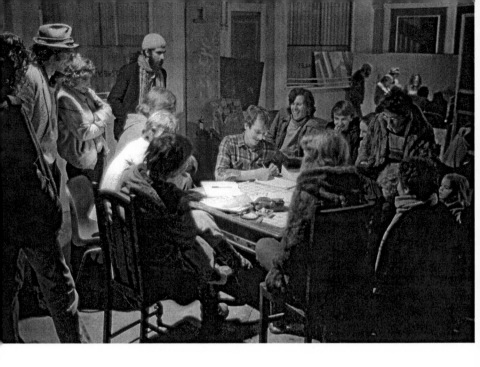

AFTERWORD AND ONWARD

The House Magic project from which this book proceeds has grown up with the SqEK group of researchers. Over the last few years, the traditionally subcultural and minoritarian squatting movements have been enlarged by new waves of activism, and new crowds of actors, that began to crest with the Arab Spring in 2011. SqEK is the most visible group among many of activists and researchers working towards creating and maintaining, as well as documenting and analyzing, autonomous spaces. These spaces are the prefigurative zones molten with dynamic change wherein a new society may be constructed. The upheavals of the 21st century have been driven by hope. Despite their many betrayals into war by

fearful afflicted powers, the optimists keep on finding cracks in which to hide, and places to grow as they await their next moment.

A strong, newly awakened consciousness of the commons is arising. This is quite specific – a deliberate, concerted effort to defend the natural and cultural resources we hold together as citizens of nations and inhabitants of the world. Holding my plastic water bottle on the streets of New York City because public water fountains have disappeared leads me to recognize, through this simple bodily need, the trends of contemporary economy and governance colluding to make people pay for what they need to stay alive. These are the novel modes of privatization, the endlessly new ways in which capital moves to enclose what used to be public, to take it away and make us pay for it. Still, mass resistance to these new enclosures is rising. This resistance is well informed by strong currents of research in historical resistance to enclosure. [Linebaugh, 2014] Squatting is coming to be seen as part of this resistance, as a direct action to secure housing, and an attempt at preservation of dwindling resources of culture and heritage.

As a researcher I try to play my part in this movement. My job is to find histories, the obscured and half-effaced lines of development of autonomous places. Every step along the way I find artists and creative citizens mixing with the fearless, the desperate and discarded – the usual inhabitants of the liminal zones of autonomy, the post-modernist enclaves of bohemia built in places that have been commonsed.

Thomas Aguilera presents his research at the New Yorck Bethanien squat during the 2013 SqEK meeting in Berlin. (Photo by Alan Smart)

This book was getting too big and I have to stop with Paris. But the journey didn't end there.

After Paris I went to London, Amsterdam and Berlin, the northern European cities where an English speaker has it easy. In The Hague I made another small art show, and near Amsterdam I sat on an advisory panel during a "Futurological Symposium." In Berlin I eavesdropped on a major conference of urbanists where global "informal settlements" were discussed. Before drafting this manuscript, I blogged the week-long SqEK meeting, taking place in Rome at "Occupations & Properties" in the spring of 2014. That event gave us a vista of an urban Italian movement of extraordinary variety and complexity, deeply imbricated with culture.

From these encounters – which, undoubtedly, it would take another book to fully describe – I gained an important historical perspective. Jordan Zinovich invited me to the annual symposium at the Ruigoord community, a village squatted alongside the port of Amsterdam. As a member of the Autonomedia publishing collective Jordan produced two books in English on the amazingly inventive Dutch squatting and arty political movements of the '60s and '70s, [Kempton, 2007; Riemsdijk, 2013] and played a prominent role in the symposium. The event coincided with the annual summer festival produced by the Ruigoord community, the Landjuweel, a key part of the community's identity. [Waalwijk, 2013] For 2013, Ruigoord published a 40th anniversary catalogue, and received "ambassadors" from other free spaces, including the Copenhagen free town of Christiania.

As a large-scale village of creative people, Ruiguoord, just like Christiania, is a significant collective accomplishment. Ruigoordians and Christianites both identify closely with indigenous cultures. (Tibetans were invited to the meeting, but were held up at some national border.) Such identification is part of the classical European hippie ethos and culture. They are also committed greens – both Ruigoord and a nearby squatted factory, ADM, have shown close interest in their natural environment. Their stewardship parallels the impulse of urban conservational squatting to preserve historic buildings from developers.

These are clearly hippies, not punks. As they developed a formal statement of purpose and intent, a manifesto of free spaces laying the basis for a network, the Ruigoordians scrupulously avoided all

references to contemporary politics. They don't want to struggle, they want to live. Theirs is a utopia imbued with exotic spirits, carefully separated from the real world of neoliberal capitalism, mass migration and neo-fascist gangs. In some ways Ruigoord seems classically modernist. The symposium showed that the consciousness of the autonomous movement, like that of the art world is split: the divide between art and politics runs very deep. The visit to Ruiguoord was a view into a major part of the movement for autonomous spaces that I had not seen before.

During this trip, I had two more glimpses of the complex institutionalization of Dutch art squats. I made a kind of kiosk for "House Magic" in a show of the Artcodex group in The Hague. Two compañeros from ABC No Rio, Vandana Jain and Mike Estabrook, were part of this art group invited to a residency at Quartair, a former bakery squatted by art students in 1992. The Hague, site of the Dutch royal palace, is a small town, and Quartair was a key part of the local art world. They had worked closely with Stroom, the local center for public art and architecture, and artists there had close ties to the Dutch avant garde. (We attended a charming performance art walk memorial for Henk Peeters, a Dutch animateur with the Zero group in the 1960s.)

I also returned to W139, the central Amsterdam art space squatted in 1979. Looking through their archive and conversing with Ad de Jong, one of the original group, I learned more about how the place came into being and evolved. A group of art students took over this former theater. It was a part of the old city slated to be redeveloped as an enormous parking garage. The crazed schemes that gripped Amsterdam's rulers at the time were a big reason why Amsterdam's sensible citizens supported mass squattings of the many vacant historic buildings marked for demolition. W139 was part of an entire block squatted in the 1970s, called the Blaulokkenblok, for the laundry often seen hanging there. The artists who then worked at W139 lived nearby, and their art space became a site of free experiment and music parties. Shows were announced by posters plastered on the facade of the building. Some of those were of enormous dimensions, as the bed-sheet-sized examples in the archives confirm. In a seedy neighborhood of junkies, hookers and crooks, their punk style seemed right.

Following almost nearly ten years of work, the W139's artists legalized and formalized. They received subsidies to renovate and continue

as a center for contemporary art. They set up a system of temporary directors, whereby one person would have control of the direction of the space for a certain number of years. The system combines the best of artistic direction – a wise autocracy beats committee work in aesthetics nearly every time – while avoiding the ossification that can follow with a permanent director.

Somehow the squatting culture of London has seemed the most obscure. Although once clearly rich, deep and complex, [Wates & Wolmar, 1980] today it reveals itself only in glimmers and flashes. Stories of the past include the legendary Frestonia, the squatted area of London consisting of some 20-odd houses. [Sleep] When threatened with eviction in 1977, Frestonia declared independence. In Tolmers Road, the fugitive RAF member Astrid Proll lived underground. [Proll, 2010] I touched this past during a visit to the city when I checked in with folks doing anti-gentrification work in the Elephant & Castle area. We took tea at a small cafe at the entrance to Iliffe Yards, a street of shops and studios that is part of a Victorian-era development called the Pullens Estate.

One morning there I read a 2004 pamphlet by the Past Tense history group, organized out of the 56A Infoshop. "Down with the Fences: Battles for the Commons in South London" tells of the 400-year struggle by Londoners to protect their historic commonses from enclosure and development. The buildings of the Pullens Estate were themselves protected from the kind of high-rise development that surrounds them by bands of squatters who took over vacant flats in the 1980s. About half of the buildings were saved. The 56A Infoshop, and the adjoining bike workshop and food coop, are the remnants of those days.

The holdings of the 56A Infoshop may be taken in hand by the Mayday Rooms, a project intended to organize discussions and work on the preservation of fragile countercultural and left archives. Its website describes it as "a safe house for vulnerable archives and historical material linked to social movements, experimental culture, and marginalised figures and groups." The careful design of the place in a refurbished Fleet Street building promises to create a kind of wired remembrance engine for what is all too easily forgotten. Iain Boal toured me through the project. He recently published a book of essays on California's communes entitled *West of Eden*, which recovers histories of those important collective social experiences. [Boal, et al.,

2012] The communal lives pioneered by the '60s generations offer both an ideal and many practical solutions for those who want to live in collective houses today.

Europe is different from North America of course. With its strong counterculture, and the broadly influential Italian autonomist movement, European activists in the '70s laid firm foundations for political squatting and free spaces throughout what would become the Eurozone. The squattings that led to the '70s free communities of Ruigoord and Christiania took place within a networked European counterculture that somehow seems to have been more fun loving, more liberated and free than its counterpart in the U.S. The struggle in the States was hard against the war-making state, with its Hooverian/Nixonian paranoia and repression, and almost all occupying efforts in U.S. cities were quickly crushed. The European '70s squats and occupations could also build on support from existing anarchist and occasionally communist configurations, left political parties proximate to the state socialist bloc. Without any significant mainstream political support, resistant countercultural communities in the U.S. could only survive in remote locations on privately owned land, like the Black Bear Ranch in the mountains of northern California.

Squatting in England does, of course, exist beyond London. [Social Centres Network, 2007] I spent time with ETC Dee in Brighton, visiting the Cowley Club, a legal social center where he works. ETC toured me through the town, pointing out sites of past squats. We watched films about raves in the 1990s – also called the "free party" scene – which he had in his library. He was a DJ then, and followed the huge gatherings that spread from the UK all over Europe and points east. The British government criminalized these parties in 1994, and also passed laws to curb the traveler culture of people living nomadically in fitted-out trucks and wagons.

I recall the campaign of the *Squall* magazine crew against these laws from issues of the journal I saw in New York. The ravers weren't very interested in fighting the government, they wrote, but preferred to move out of the country. This huge subculture mobilizing tens of thousands of people for a single surprise event, which could turn into a multi-day encampment, was strongly connected to the squatting scene, as we learned in Rome. The techno music and neo-psychedelic drugs that drove the raves must be added to punk and hip hop as an important cultural pillars of reclaiming space, or radical commonsing.

STOP THE CRIMINAL *IN*JUSTICE BILL

CRIMINAL INJUSTICE BILL

19th June BILL'S CARNIVAL
Hyde Park, Leeds
Record game of twister, music etc.
Forgive Us Our Trespasses-
0532 629 427

19th June PICNIC London Fields,
Hackney, London
"The state wants to criminalise us and the
council wants to trash our homes, but we
want a cultural explosion." Bring toys, drums
instruments and picnics

2nd July
"Forgive Us Our Trespass"
MASS TRESPASSORY ASSEMBLY
Twyford Down, Winchester
Contact Road Alert·
0703 237 809

PRESSURE ON - MOMENTUM GROWING

"Pressure On – Momentum Growing," the front of a four-page flyer from the Freedom Network, part of the mobilization against the Criminal Justice Act in Britain 1993-95. (Courtesy of Christoph Fringeli, Datacide website)

Rave parties have also been held in the catacombs of Paris, a vast network from which the stone to build the city was removed. For centuries these served as cemeteries. Georges Bataille notoriously proposed holding sacrificial ceremonies in these labyrinthian underground regions in the 1930s. In recent years, sculptors and *grafiteros* have made their way down there, to decorate many passages as bohemian palaces. The city government began a campaign of filling them in with cement slurry to put a stop to this newly emerging bohemia.

The raves of the free party movement and the related traveler subculture may have been well squashed by the state. Clearly it is hoped that squatters may soon follow. But legal repression didn't put an end to squatting in England. It did, however, make it more episodic, sudden, and effusive, and has driven it underground. Art and party squatting continues. The point is always to be free, to evade the vast entertainment machine that organizes leisure time for profit, following the capitalist logic of extraction of surplus value from sociality and fun.

While some tentative steps toward institutional recognition of the historical value of squatted space in England have been taken,[1] the problem of amnesia persists, abetted by the blackout of extra-legal spatial use from public media and archives. Fortunately, in our wired era, another history is possible. A recent "pop-up" show in a squatted space on Dock Street in September 2013 was called "Made Possible by Squatting." (The allusion is to a Dutch campaign against criminalization [Kaulingfreks, 2009] that included banners hung in numerous legalized ex-squats active as cultural centers with the legend "made possible by squatting.") The organizers pulled in a raft of groups connected to squatting. Two SqEK members animated a historical wiki project to map evicted squats in the city. Their aim with the "London Squats Archive" was to make a tool with which to learn and better understand the history of squatting culture in London.

The political tactic of encampment rolls on as well, and activists have been innovating. During the global Occupy movements, campers became squatters in the short-lived Bank of Ideas, an active and

1 Direct specific acknowledgement of squatting is still rare in English exhibitions. Besides European shows like the Kunstwerke exhibition which spotlighted the Tolmers Road history, [Proll, 2009] the 2012 Brighton Photo Biennial included an exhibition of squat images, [Burbridge, 2012] and the ICA's off-site show of London subculture of the 1980s, held in a gutted old hotel, looked specifically at different groups and scenes, many of whom lived, and/or held their activities in squatted spaces. [Muir, 2013]

highly visible occupation of a vacant UBS bank building in Hackney in late 2011. The building was squatted by Occupy London protestors, a group which encamped in the space in front of St Paul's cathedral in the City of London for eight months between 2011 and 2012. Like SqEK, a Protest Camps research group dedicated to this past and its presents has sprung up. [Feigenbaum, et al., 2013] It's clear that, as the title of Mujinga's zine has it, using space without permission, or even against uses which corporate or state interests intend, is a well-established broad-based practice in the UK. Political squatting and urban social centers are only a part of it.

In looking at squatting culture in its historical depth some understanding of the movements these actions were a part of, and the contexts in which they found their support, is necessary. Social centers supported the anti-globalization movement, and new squattings and resistant cultural stylings were associated with that turn of the century generation of activists. Now, the resistance to the global financial crisis and its attendant cuts in government services is building new affinities among people opening new spaces. The activism of web-based flows has dynamized and internationalized the new movements in ways that continually refine and redefine them and their connections to institutions of all kinds. [Castells, 2012]

"Made Possible by Squatting" exhibition in an occupied space in London, 2014. People are huddled over a computer displaying a growing map of the London squats, past and present. (Photo by Jamie Idea)

Within the swirl of the crisis-era movements of today, the power of art comes both from its own internal necessities – novelty and change, and its historical obligation to revolutionary politics which generates change in the social field. It can be no surprise that artists are in the front lines. As explainers, interpreters, and transmitters of perceptions, affects and information, they find their place in movements that can use them when the capitalist economy cannot.

Collective life and work in resistance – occupations, political squatting – is creative political culture. Creative culture is what the world wants to become. It is the flower of democratic civilization. Blooming, shaken off in high breezes, turning into fruit...

While I continue to learn more about the squatting and occupation movement, I no longer think that I can fully understand how it works. It is a living, breathing chimeric creature, changing its form with the surge of events and under pressure of conditions, opposing repression and strong and concerted efforts to put an end o the practice. In 2014, rapidly rising struggle in both north and south Europe have thwarted the repression of longtime social centers by large scale resistance: the Rote Flora in Hamburg and the Can Vies in Barcelona (although the latter was destroyed, it is being rebuilt).

At every step along this wild road, new primitive rebels against neoliberal control articulate new cries and invent new devices of resistance. Their resistant culture, if only in its constantly mutating telegenic spectacle, inspires emulation and synthetic imitation among more timid creative bystanders. There is a continual interchange and cross-fertilization between the world of activists and the expanded academy of thinkers and artists, including the regular purloining of terms from the movement's vocabulary by the latter. Many of the principles behind squatting today – both cultural, such as free information, free education, culture as a commons, and social, including housing justice, economies of solidarity – are being continuously elaborated and refined within the orbits of academic institutions. Squatting has come to represent a broader necessity of creating breathing spaces in the cracks of capitalist totality. It seems clear we have now entered what a headline in the Spanish newspaper *Diagonal* recently called a "golden age of self-organization." Direct action occupation is an integral part of it.

Mural painting inside the Roma village constructed in an abandoned salami factory, Metropoliz squat, Rome, 2013. (Photo by Miguel Martinez)

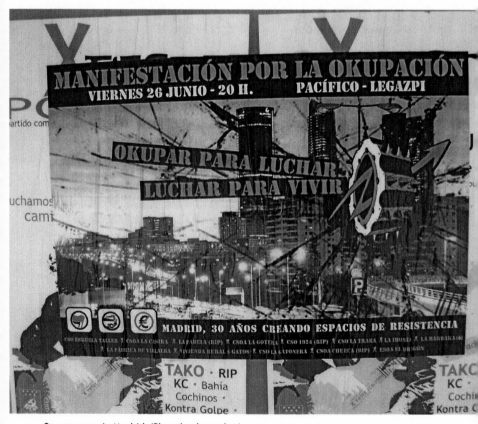

Street poster in Madrid. (Photo by the author)

CITED WORKS AND REFERENCES

A

Jacobo Jacobo Abellán, Jorge Sequera & Michael Janoschka, "Occupying the #Hotelmadrid: A Laboratory for Urban Resistance," *Social Movement Studies: Journal of Social, Cultural and Political Protest*, August 2012; online at: http://dx.doi.org/10.1080/14742837.2012.708831

ADIILKNO, *Media Archive: Adilkno: Foundation for the Advancement of Illegal Knowledge* (Autonomedia, 1998). (ADILKNO / BILWET [Foundation for the Advancement of Illegal Knowledge / Stichting tot Bevordering van Illegale Wetenschap] was a collective of five artists/authors, Geert Lovink, Arjen Mulder, BasJan van Stam, Lex Wouterloot and Patrice Riemens.)

a.f.r.i.k.a. group, *Manual de guerrilla de la comunicación* (Virus, Barcelona, 2000)

Alexander Alberro, and Blake Stimson, eds., *Institutional Critique: An Anthology of Artists' Writings* (MIT Press, 2009)

Gwen Allen, *Artists' Magazines: An Alternative Space for Art* (MIT Press, 2011)

Affinities journal, "Creating Autonomous Spaces," Vol 1, No 1 (2007), at: http://affinitiesjournal.org/

Thomas Aguilera, interview by the author, 2012

Thomas Aguilera, "Configurations of Squats in Paris and the Ile-de-France Region," in SqEK, eds., *Squatting in Europe: Radical Spaces, Urban Struggles* (Minor Compositions, 2013)

An Architektur 19-21: "Community Design. Involvement and Architecture in the US since 1963" September 2008, 172 pages (3 vols.; English)

An Architektur, "Ten Days for Oppositional Architecture: Discussing Post-Capitalist Spaces," NYC, November 2009: http://www.oppositionalarchitecture.com/

Anarchist Bookfairs of the World: A resource blog to help advertise and organise Anarchist bookfairs worldwide. URL: http://anarchistbookfairs.blogspot.com.es/

Lincoln Anderson, "Landlord who 'reclaimed' building a 'big fan' of new museum," December 19, 2012, East Villager, at: http://eastvillagernews.com/?p=4042

Jen Angel interviewer, "David Solnit and The Arts of Change," Journal of Aesthetics & Protest, web only, n.d., ca. 2008, at: http://www.joaap.org/webonly/solnit_angel.htm

"The Anomalous Wave Rebellion in Italy" (56a Infoshop, London, 2008), PDF at: http://www.indymedia.org.uk/en/2008/11/413258.html.

Matt Apuzzo and Adam Goldman, Enemies Within: Inside the NYPD's Secret Spying Unit (Touchstone Book/Simon & Schuster 2013)

Penny Arcade (see Susana Ventura)

Karen Archey, "Aggressive Artist Group Botches Occupation of SoHo Non-Profit, But What is to be Done?," blog at Blouin Artinfo, ca. October 25, 2011; at: http://www.blouinartinfo.com/blog/image-conscious/aggressive-artist-group-botches-occupation-of-soho-non-profit-but-what-is-to-be-done

Julie Ault, ed., Alternative Art New York 1965-1985 (The Drawing Center / University of Minnesota Press, 2002)

Dario Azzellini & Oliver Ressler, Disobbedienti (54 min.; 2002)

Dario Azzellini & Oliver Ressler, 5 Factories – Worker Control in Venezuela (81 min.; 2006)

B

Eleanor J. Bader, "In the Archives of Interference," Brooklyn Rail, October 4, 2012; at: http://www. brooklynrail.org/2012/10/local/in-the-archives-of-interference, accessed January 2014.

Abby Banks, Punk House (Abrams, 2007), photos by Banks, introduction by Thurston Moore

Basekamp, eds. (Aharon Amir, Liz Arnold, Michael Bauer, Henken Bean, Salem Collo-Julin, Tom DiNardo, Jaime Iglehart, Scott Rigby, Greg Scranton, Jonathan Simpson, Matthew Slaats, Adam Trowbridge, Jessica Westbrook, Stephen Wright), Plausible Artworlds (2013); at: http://plausibleartworlds.org/book.

Zanny Begg & Oliver Ressler, What Would It Mean To Win? (40 min.; 2008)

Alba Benavent, "'Las Agencias': From Project to Action," A*Desk online magazine, posted January 31, 2013, at http://www.a-desk.org/highlights/Las-agencias-from-project-to.html.

[collective], Berlin – Mainzer Straße (BasisDruck Verlag, Berlin 1992)

Berlin Biennale, "Solidarity Actions," 2012, at: http://www.berlinbiennale.de/blog/en/projects/solidarity-actions-20784

Claudia Bernardi, "Contaminating the University, Creating Autonomous Knowledge: Occupied Social and Cultural Centers in Italy: An Interview with Claudia Bernardi," Class War University website, September 24, 2012, at: http://classwaru.org/2012/09/24/contaminating-the-university-creating-autonomous-knowledge-occupied-social-and-cultural-centers-in-italy/

Hakim Bey [aka Peter Lamborn Wilson], T.A.Z.: The Temporary Autonomous Zone, Ontological Anarchy, Poetic Terrorism (Autonomedia, 1991)

Peter Birke, "Herrscht hier Banko? Die aktuellen Proteste gegen das Unternehmen Hamburg," Sozial.

Geschichte Online 3 (2010), S. 148–191 (http://www.stiftung-sozialgeschichte.de)

Julia Ramírez Blanco, *Utopías artísticas de revuelta* (Cuadernos Arte Cátedra, Barcelona, 2014)

"Blinzelbar in Frappant Building: a project space organised and curated by Judith Haman and Heiner Metzger," WSW#3, 2009-10; at: http://www.wirsindwoanders.de/files_2009/detail_memberE.php?seite=15&folge=00&id=34.

Iain Boal, Janferie Stone, Michael Watts, Cal Winslow, eds., *West of Eden: Communes and Utopia in Northern California* (PM Press, 2012)

Manuel Borja-Villel, Teresa Velázquez, Tamara Díaz Bringas, Lars Bang Larsen, Linda Nochlin, Lady Allen of Hurtwood, Rodrigo Pérez de Arce, Beatriz Colomina, Aldo van Eyck, Constant, Robert Filliou, Pier Vittorio Aureli, Marcelo Expósito, Graham St. John, *Playgrounds: Reinventar la plaza* (MNCARS, Madrid, 2014).

Boundless.com, "Value Neutrality in Sociological Research," online sociology textbook; https://www.boundless.com/sociology/sociological-research/ethics-in-sociological-research/value-neutrality-in-sociological-research/; accessed January 2014.

Andrew Boyd, *The Activist Cookbook: Creative Actions for a Fair Economy; A Hands-on Manual for Organizers, Artists, and Educators Who Want to Get their Message Across in Powerful Creative Ways* (United for a Fair Economy, Boston, 1996); PDF online http://andrewboyd.com/wp-content/uploads/2011/01/cookbook-core-smaller.pdf

Andrew Boyd, Dave Oswald Mitchell, eds., *Beautiful Trouble: A Toolbox for Revolution* (OR Books, 2012)

Colonel John R. Brinkerhoff (Ret), "The Role of Federal Military Forces in Domestic Law Enforcement" (December, 2009). URL: http://us-acac.army.mil/cac2/call/docs/10-16/ch_11.asp.

Bill Brown, *Fenced Off, Obscured or Painted Over: Photographs of Murals in Six Community Gardens in the Lower East Side of Manhattan* (Lulu, 2011)

Gavin Brown, "Mutinous eruptions: autonomous spaces of radical queer activism," *Environment and Planning A* 39, 2007; retrieved from academia.edu

Tino Buchholz, *Creativity and the Capitalist City: The Struggle for Affordable Space in Amsterdam* (55 min.; 2011)

Ben Burbridge, "Political Squatting: An Arresting Art," *Guardian* Culture Professionals Network blog, September 28, 2012, at: http://www.theguardian.com/culture-professionals-network/culture-professionals-blog/2012/sep/28/squatting-art-brighton-photo-biennial

Melissa Rachleff Burtt, "The Fantastic Dream: A Memorial to Jeanette Ingberman," Artnet e-zine, September, 2011, at: http://www.artnet.com/magazineus/features/burtt/rip-jeanette-ingberman9-9-11.asp

C

Elvire Camus, "For Enclave of Rebel Artists, Much in Life Was Free, but Not Real Estate," *New York Times*, March 13, 2013

Chris Carlsson's blog Nowtopian – http://www.nowtopians.com/

Chris Carlsson, LisaRuth Elliott, Adriana Camarena, eds., *Shift Happens! Critical Mass at 20* (Full Enjoyment Books, San Francisco, 2012)

C. Carr, *On Edge: Performance at the*

End of the Twentieth Century (Wesleyan University Press, 2008)

Carta, Spring-Summer 2011 No. 2; PDF at: http://www.museoreinasofia.es/publicaciones/revista#numero-2. See especially "Hacia una nueva institucionalidad," by Manuel Borja-Villel, and articles about Tabacalera and the Casa Invisible in Málaga.

Manuel Castells, *Networks of Outrage and Hope: Social Movements in the Internet Age* (Polity Press, 2012)

Andrew Castrucci, ed., "Your House Is Mine" tabloid, Bullet Space, NY, 1989

Andrew Castrucci, ed., "The Perfect Crime," gallery handout, Bullet Space, NY, 2010.

Center for Urban Pedagogy (CUP): http://www.anothercupdevelopment.org/.

"Centro Social La Salamanquesa," n.d.; at: http://www.okupatutambien.net/?p=654

Roberto Amigo Cerisola, et al., *Perder la forma humana: una imagen sísmica de los años ochenta en América Latina* (Museo Nacional Centro de Arte Reina Sofía, 2012)

Julien Charlon, *Labo 3: Centro Social Okupado Autogestionado, Lavapiés, Madrid* (Traficantes de Sueños, 2003)

Michel Chevalier, Hamburg projects: http://targetautonopop.org; and Culture and Social Movement Archive (German/English) at: http://www.archiv.glizz.net/

"The City as Open Interface" conference program, July 5-6, 2012, at: http://www.prototyping.es/city-open-interface-conference

Jo Clarke, et al., eds., *Not If but When: Culture Beyond Oil* (Platform, Art Not Oil and Liberate Tate, London, 2011)

"Colectivo Situaciones Residencias El Ranchito," May 2011, at: http://www.mataderomadrid.org/ficha/793/colectivo-situaciones.html.

Colectivo Situaciones, trans. Nate Holdren & Sebastián Touza, *19 & 20: Notes for a New Social Protagonism* (Minor Compositions, 2011)

"Communiqué from an Absent Future," 2009 at: http://wewanteverything.wordpress.com/2009/09/24/communique-from-an-absent-future/

Peter Conlin, "Neoliberalism out of joint: Activists and inactivists in London's social centres" *Subjectivity*, no. 7, 2014

Alberto Corsín Jiménez and Adolfo Estalella, "What is a neighbour? Notes on #Occupying the urban relation" (2012), online at their website: http://www.prototyping.es/

Counter-Cartography Collective (CCC, 3Cs), "precarity web-meeting in Rome," 2007; at: http://www.countercartographies.org/precarity-web-meeting-in-rome/.

Crimethinc, "Breaking and Entering a New World," 2011. URL: http://www.crimethinc.com/texts/recent-features/breaking.php.

CSO CasaBlanca, "Investigamos la propiedad: Monteverde," October 28, 2011, at: http://csocasablanca.org/-Investigamos-la-propiedad,18-.html

Cultural Workers Organize research project, "Messages of Rupture: An Interview with Emanuele Braga on the MACAO Occupation in Milan" (trans. Roberta Buiani), *Scapegoat* no. 4, February 2013, PDF at: scapegoatjournal.org.

Patrick Gun Cuningham, "'A Laughter That Will Bury You All': Irony as Protest and Language as Struggle in the Italian 1977 Movement," *International Review of Social History* (2007), 52; versions online at libcom, interactivist, etc.

Kristen Cure & Nicole Pagowsky, "Organizing Infoshop Libraries and Their Collections: Bringing the Community into Cataloging and Matching User Needs with Organizational Capabilities," 2009. URL: http://www.slideshare.net/v_gan/organizing-infoshop-libraries-and-their-collections-bringing-the-community-into-cataloging-and-matching-user-needs-with-organizational-capabilities-1503532.

Margit Czenki, *Park Fiction: Desires Will Leave the House and Take to the Streets* (60 min.; 1999)

D

Mike Davis, *Planet of Slums* (Verso, 2006)

Ashley Dawson, "Autonomy! A Recollection of Mainzer Strasse," *House Magic* #3, 2011

Guy Debord and Gil J. Wolman, "A User's Guide to Détournement" (1957) at: http://www.bopsecrets.org/SI/detourn.htm#1 (translation by Ken Knabb)

Guy Debord, The Society of the Spectacle; "Chapter 8: Negation and Consumption Within Culture" theses 205-208 (1967) at: http://www.bopsecrets.org/SI/debord/8.htm (translation by Ken Knabb)

Democracia, "Sin Estado" project – http://www.democracia.com.es/proyectos/sin-estadowithout-state/

Democracy Now, "Brad Will In His Own Words: Archival Footage of Slain Journalist and Activist Discussing the Importance of Community Media and the Struggle Against NYC Demolition of a Lower East Side Squat," October 30, 2006; transcript at: http://www.democracynow.org/2006/10/30/brad_will_in_his_own_words

Marco Deseriis, "Lots of Money Because I am Many: The Luther Blissett Project and the Multiple-Use Name Strategy," *Thamyris/Intersecting* No. 21 (2010); posted at: http://www.thething.it/snafu/pdfs/Deseriis_Blissett_Cultural_Activism.pdf

Andy Devane, "Drawing on walls," at Wanted in Europe e-zine, July 7, 2012, at: http://copenhagen.wantedineurope.com/news/2001448/drawing-on-walls.html

Okra P. Dingle, "Art Effects: Decadent Performance Era at ABC No Rio" (ABC No Rio, NY, 1998)

Hannah Dobbz, *Nine-Tenths of the Law: Property and Resistance in the United States* (AK Press, 2012)

Richard Dorment, "Bohèmes, Grand Palais, Paris, review," *The Telegraph* online, October 22, 2012, at: http://www.telegraph.co.uk/culture/art/art-reviews/9626263/Bohemes-Grand-Palais-Paris-review.html

Eric Duivenvoorden, ed., *Met emmer en kwast: Veertig jaar Nederlandse actieaffiches 1965-2005* ("with bucket and paste")

Steve Duncombe, *Notes from Underground: Zines and the Politics of Alternative Culture* (Microcosm Publishing, Bloomington, IN, 1997)

Jim Dwyer, "City Police Spied Broadly Before G.O.P. Convention," *New York Times*, March 25, 2007

E

[*Economist*], "The ghosts of Mexico 1968: A massacre that was hushed up to ensure a 'successful' sporting event," *The Economist*, Apr 24th 2008. At http://www.economist.com/node/11090825

Beka Economopolous, "occupied real estate: installation & workshops @ exit art," Not An Alternative

blog, posted May 1, 2012 at:
http://notalternative.com/blog/
occupied-real-estate-property-week

Edu-Factory collective, *Toward a Global Autonomous University: Cognitive Labor, the Production of Knowledge, and Exodus from the Education Factory* (Autonomedia, 2009)

Cicero Egli, Sophia Bulliard and Murièle Begert, *Rhino féroce: un squat a Genève* (30 min.; 2006; French with German subtitles)

Adolfo Estalella and Alberto Corsín Jiménez, "Asambleas al aire: La arquitectura ambulatoria de una política en suspensión," *Revista de Antropología Experimental* online (Jaen, Spain), no. 13, 2013, at:
http://www.ujaen.es/huesped/rae/

Experimental Jetset, 2011. At: http://www.experimentaljetset.nl/provo/

Marcelo Expósito, *Primero de Mayo (la ciudad-fábrica)* (First of May, the city factory) (61 minutes, 2004) Span./Engl.

F

John Feffer interviews Dirk Moldt, "Squat Paradise: East Berlin in the '90s," Feffer's blog "Slow Travel Berlin," posted June 24, 2013 at:
http://www.slowtravelberlin.com/squats-neo-nazis-friedrichshain-in-the-90s/.

Anna Feigenbaum, Fabian Frenzel, Patrick McCurdy, eds., *Protest Camps* (Zed Books, 2013).

Jacqueline Feldman, "Vive La Miroiterie," *Guernica: A Magazine of Art and Politics,*March 26, 2013, at:
http://www.guernicamag.com/daily/jacqueline-feldman-vive-la-miroiterie/

María Cecilia Fernández, "From labor precarity to social precarity," 2005 interview, at http://www.chainworkers.org/node/82, "edited from

the interview published in Spanish in the newspapers *Proyecto* 19y20 (Buenos Aires, March 2005) and in *Diagonal* (Madrid, March-April 2005); trans. Brian Whitener

Jeff Ferrell, *Tearing Down the Streets: Adventures in Urban Anarchy* (Palgrave, 2001)

Yevgeniy Fiks, *Communist Guide to New York City* (Common Books, New York, 2008)

Noah Fischer comment, retrieved from Andrea Liu's Facebook page, January 2014; at: https://www.facebook.com/andrea.liu.75/posts/480119498769268?stream_ref=10

Fly [Orr], *Chron!Ic!Riots!Pa!Sm!* (Autonomedia, 1998)

Fly [Orr], *Peops* series, self-published, various dates.

Nancy Foote, "The Apotheosis of the Crummy Space," *Artforum,* vol 15, no. 2, October 1976

Frikipedia "Perroflauta," at http://www.frikipedia.es/friki/Perroflauta. Accessed October 2013,.

G

Marina Galperina, "An Anarchist Film Fest Gets Free Promo from NYPD," April 15, 2010. URL: http://animalnewyork.com/2010/anarchist-film-fest-gets-free-promo-from-nypd/.

David Garcia and Geert Lovink, "The ABC of Tactical Media" (1997), at: http://www.nettime.org/Lists-Archives/nettime-l-9705/msg00096.html

Ter Garcia, "Spain: The Big Squat," *Counterpunch*, March 2012, at: http://www.counterpunch.org/2012/03/02/spain-the-big-squat

Getty Images, 1994; caption on Getty image #129017619 at www.gettyimages.com

Arlene Goldbard; Don Adams, *New Creative Community: The Art of Cultural Development* (New Village Press, 2006)

Claudia Gould & Valerie Smith, eds., *5000 Artists Return to Artists Space* (1998)

David Graeber, *Debt: The First 5,000 Years* (Melville House, Brooklyn, 2011)

David Graeber and Stevphen Shukaitis with Erika Biddle, eds., *Constituent Imagination: Militant Investigations, Collective Theorization* (AK Press, 2007)

A.G. Grauwacke, eds., *Autonome in Bewegung: aus den ersten 23 Jahren* (Assoziation A, Berlin, Hamburg, Göttingen, 2003)

Greene County Council on the Arts, "Wall Street to Main Street," 2012, at: http://www.greenearts.org/wall-street-to-main-street.

Rachel Greene, *Internet Art* (Thames & Hudson, 2004)

Dara Greenwald, "Tactical Tourist" (15 min.; 2008); http://vimeo.com/33695985

Dara Greenwald and Josh MacPhee, eds., *Signs of Change: Social Movement Cultures, 1960s to Now* (Exit Art & AK Press, 2010)

Gavin Grindon, "Carnival Against Capital: A Comparison of Bakhtin, Vaneigem, and Bey," *Anarchist Studies*, vol. 12, no. 2, 2004

Gavin Grindon, "Protest Camps and White Cubes," Protest Camps website, September 28, 2012, at: http://protestcamps.org/2012/09/28/793/

Grupo Autónomo A.F.R.I.K.A., *Manual de guerrilla de la comunicación* (Virus, Barcelona, 2000)

Libertad Guerra, "CHARAS," poster in *House Magic* #6, 2014

Sebastian Gutierrez, "Squats, Social Centers and Autonomous Spaces – I," the first of five part

documentation of the April 2011 discussion at http://www.youtube.com/watch?v=XMp1M55S3p4. Participants were: me, Howard Brandstein, homesteading organizer and director of the Sixth Street Community Center, Frank Morales, Episcopal priest, squatter and housing organizer, Marta Rosario, resident at Umbrella House Squat, and Ryan Acuff of Take Back the Land.

Kristen Gwynne, "Inside the Surprising World of an Urban Underground Collective of Artists, Punks and Non-Conformists," AlterNet, June 13, 2011, at: http://www.alternet.org/story/151278/inside_the_surprising_world_of_an_urban_underground_collective_of_artists%2C_punks_and_non-conformists

H

Asad Haider and Salar Mohandesi, "Workers' Inquiry: A Genealogy," *Viewpoint* online magazine, September 27, 2013, at: http://viewpointmag.com/2013/09/27/workers-inquiry-a-genealogy/

Rob Hamelijnck and Nienke Terpsma, *Italian Conversations: Art in the age of Berlusconi* (Fucking Good Art #29; Post Editions, Rotterdam, 2012)

Ed Hamer, "Reclaim the Fields," *The Land*, no. 8, Winter 2009, at: http://www.thelandmagazine.org.uk/articles/reclaim-fields

Stefano Harney and Fred Moten, *The Undercommons: Fugitive Planning & Black Study* (Minor Compositions, London, 2013)

David Harvey, *Rebel Cities: From the Right to the City to the Urban Revolution* (Verso, 2012)

Carlos Henrich, "Arte Ocupa Lisboa Paris...e tambem Hamburgo," 2010. Website at: http://www.arte-ocupa.

vipulamati.org/; includes PDF
catalogue
Brian Holmes, "The Flexible Personal-
ity: For a New Cultural Critique,"
Transversal 2002 (European Insti-
tute for Progressive Cultural Poli-
cies, Vienna), at: http://eipcp.
net/transversal/1106/holmes/en
Brian Holmes, *Unleashing the Collective
Phantoms: Essays in Reverse Imagi-
neering* (Autonomedia, 2008)

I

Margarita Rodríguez Ibáñez, "La Cul-
tura Localizada como respuesta
social a la Red: El caso de la Fábrica
de la Tabacalera en Madrid," *e-rph:
Revista de Patrimonio Histórico* (Uni-
versidad de Granada, Spain), no. 14,
June 2014
Indymedia.de, "Queeruption V in Ber-
lin 19.-26. Mai 2003" at: http://
de.indymedia.org/2003/03/46211.
shtml
Invisible Committee, "The Coming
Insurrection," 2009 English trans-
lation posted at: http://libcom.org/
library/coming-insurrection-invisi-
ble-committee
Isola Art Center, *Fight-Specific Isola: Art,
Architecture, Activism and the Future
of the City* (Archive Books, Berlin,
2013)

I

Margarita Rodríguez Ibáñez, "La Cultu-
ra Localizada como respuesta social
a la Red: El caso de la Fábrica de la
Tabacalera en Madrid," *e-rph* [revista
electronica de patrimonio historico],
no. 14, June 2014

J

Alberto Corsín Jiménez and Adolfo Es-
talella, "What is a neighbour? Notes

on #Occupying the urban relation"
(2012), online at their website:
http://www.prototyping.es/
Alberto Corsín Jiménez and Adolfo
Estalella, "The Atmospheric Person:
Value, Experiment, and 'Making
Neighbors' in Madrid's Popular
Assemblies," *HAU: Journal of Ethno-
graphic Theory* 3 (2), 2013

K

Femke Kaulingfreks, et al., eds., *Wit-
boek kraken* (the white book of
squatting) (Papieren Tijger, Breda,
Netherlands, 2009)
Richard Kempton, *Provo: Amsterdam's
Anarchist Revolt* (Autonomedia,
2007)
Grant H. Kester, *Conversation Pieces:
Community and Communication in
Modern Art* (University of Califor-
nia Press, 2004)
Grant H. Kester, *The One and the Many:
Contemporary Collaborative Art in
a Global Context* (Duke University
Press, 2011)
Mehdi Khansari and Minouch Yavari,
*The Persian Bazaar: Veiled Space of
Desire* (Washington, DC: Mage
Publishers, 1993)
Whitney Kimball, "The ABC No Rio
Interviews: Steven Englander," ArtF-
City, December 20, 2012, at: http://
www.artfagcity.com/2012/12/20/
the-abc-no-rio-interviews-steven-
englander/
Liza Kirwin, "It's All True: Imagining
New York's East Village Art Scene
of the 1980s," PhD dissertation,
University of Maryland at College
Park, 1999
Andrew Van Kleunen, "The Squatters:
A Chorus of Voices... But Is Anyone
Listening?" in Janet Abu-Lughod, et
al., *From Urban Village to East Vil-
lage: The Battle for New York's Lower
East Side* (Blackwell, 1994)

Olga Kopenkina, "Administered Occupation: Art and Politics at the 7th Berlin Biennale," *Art Journal* web-only, Spring, 2012, at: http://artjournal.collegeart.org/?p=3457#fn-3457-9

Geoph Kozeny, *Visions of Utopia: Experiments in Sustainable Culture* (vol. I, 94 min.; 2002; vol. 2, 124 min.; 2009), DVD (Rutledge, MO: Community Catalyst Project, 2004-09); part one, the historical background; part two, cohousing, ecovillages, and other experiments of group living

Natasha Kurchanova, "Lower East Side: The Real Estate Show Redux," May 9, 2014, at: http://www.studiointernational.com/index.php/lower-east-side-the-real-estate-show-redux

Streets," Elisabeth Lorenzi, in Carlsson, et al., eds., *op. Cit,* 2012. The essay is an English version of E. Lorenzi, "Centro social en movimiento. Los talleres de autoreparación de bicicletas en espacios autogestionados," in Mario Domínguez, Miguel Ángel Martínez, Elísabeth Lorenzi, eds., *Okupaciones en movimiento: Derivas, estrategias y prácticas* (Tierra de Nadie, 2011)

Lou Lou and Daniel Martinez, "Dada Changed My Life" (30 min.; 2004; English) [Zurich art squatting action in former Cabaret Voltaire]

Boris Lurie, Seymour Krim, Aragon, et al., *NO!art: Pin-ups, Excrement, Protest, Jew-art* (Edition Hundertmark, 1988)

L

Laboratorio 3, Ocupando el Vacio (66 min.; 2007; Spanish with English subtitles) ["Laboratory 3, occupying the emptiness," on Madrid squat]

LARC, "History"; London Action Resource Centre (2002). URL: http://www.londonarc.org/history

Peter Linebaugh, *Stop, Thief!: The Commons, Enclosures, and Resistance* (PM Press, 2014)

Lucy Lippard, "Too Political? Forget It," in Brian Wallis, ed., *Art Matters* (New York University Press, 1999)

Rik Little, *Rivington School* (58 minutes; 1999), at: https://archive.org/details/XFR_2013-08-08_1C_01

Andrea Liu, "Take Artists Space: Dissensus and the Creation of Agonistic Space," *Social Text* blog, April 23rd, 2012, at: http://socialtextjournal.org/take_artists_space/

London Squats Archive, at: http://londonsquatsarchive.org/

Elisabeth Lorenzi, "'Alegria Entre Tus Piernas': To Conquer Madrid's

M

Macao – The manifesto text I quoted was taken from the initial website of the Macao project's sponsoring group, accessed May, 2012, at: www.lavoratoridellarte.org. It is gone, although the text remains on the Translados site cited. The Macao website is at: http://www.macao.mi.it/ (February, 2014); their Facebook page is at: http://www.facebook.com/macaopagina.

Josh MacPhee, *Stencil Pirates: A Global Study of the Street Stencil* (Soft Skull Press, 2004)

Josh MacPhee, Erik Reuland, eds., *Realizing the Impossible: Art Against Authority* (AK Press, 2007)

Florian Malzacher, et al. *Truth Is Concrete: A Handbook for Artistic Strategies in Real Politics* (Steirischer Herbst Festival, Graz, Austria/Sternberg Press, 2014)

Beniamino Marini, "Macao in Milan," a series of updates on the website of Italian Vogue posted

May 15th 2012, the day of eviction, at: http://www.vogue.it/en/people-are-talking-about/obsession-of-the-day/2012/05/macao-in-milan

Bradford Martin, "Freedom Singers of the Civil Rights Movement: Delivering a Message on the Front Lines," in Martin, *The Theater Is in the Street: Politics and Performance in Sixties America* (2004)

Craig Martin, Anthony Spira, Thomas Hirschhorn, *Material: Public Works – The Bridge 2000* (Book Works, London, 2001)

Leónidas Martín, "Estamos cansados de mirar, hoy queremos vivir la imagen," interview in Diario Público, posted on the artist's website December 2, 2011, at: http://leodecerca.net/estamos-cansados-de-mirar-hoy-queremos-vivir-la-imagen-entrevista-diario-publico/

Miguel Martínez, *Okupaciones de viviendas y centros sociales. Autogestión, contracultura y conflictos urbanos* (Virus, Barcelona, 2002)

Miguel Martinez, "Tras las huellas de las okupaciones en New York City" (in the footsteps of the NYC squatters), March 2, 2012, at: http://www.miguelangelmartinez.net/?Tras-las-huellas-de-las&var_mode=calcul

Miguel Ángel Martínez, "Necessary Squats," posted September 22, 2012 at: http://www.miguelangelmartinez.net/?The-necessary-squats; also in *House Magic* #5, 2013

Miguel A. Martínez, "How Do Squatters Deal with the State? Legalization and Anomalous Institutionalization in Madrid," *International Journal of Urban and Regional Research,* Wiley online preview, October 2013

Paul Mason, "Twenty reasons why it's kicking off everywhere," blog post, February 5, 2011, at: http://www.bbc.co.uk/blogs/newsnight/paulmason/2011/02/twenty_reasons_why_its_kicking.html. This post was later expanded into a book

Paul Mason, *Why It's Still Kicking Off Everywhere: The New Global Revolutions* (Verso, 2013)

Liz Mason-Deese, "From Decomposition to Inquiry: Militant Research in Argentina's MTDs" [Movimientos de Trabajadores Desocupados], Viewpoint e-zine, posted September 25, 2013, at: http://viewpointmag.com/2013/09/25/from-decomposition-to-inquiry-militant-research-in-argentinas-mtds/

Ian Mayes, "Anarchist Controversies," March 2013. URL: http://parenthesiseye.blogspot.com.es/2013/03/anarchist-controversies.html.

Carlo McCormick, Marc & Sara Schiller, Ethel Seno, *Trespass: A History of Uncommissioned Urban Art* (Taschen, 2010)

George McKay, *Senseless Acts of Beauty: Cultures of Resistance Since the Sixties* (Verso, 1996)

Duncan Meerding, "The May-June 1968 revolt in France and its influence today (+ videos)," "Links International Journal of Socialist Renewal" at: http://links.org.au/node/491

Christopher Mele, Selling the Lower East Side: Culture, Real Estate, and Resistance in New York City (University of Minnesota Press, 2000)

Andrea Membretti, "Centro Sociale Leoncavallo: Building Citizenship as an Innovative Service," *European Urban and Regional Studies* 14 (2007)

Midnight Notes, "Fire and Ice: Space Wars in Zurich" (1981) at: www.midnightnotes.org/pdfspacn2.pdf.

MilanoX, "Skyscraper Squatted: The Precarized Cognitariat Rises in Milano" (original in English), posted

by alex, May 9, 2012 at: http://www.milanox.eu/skyscraper-squatted-the-precarized-cognitariat-rises-in-milano/

Marc Miller, "The Book: ABC No Rio Dinero: The Story of a Lower East Side Art Gallery," at: http://98bowery.com/returntothebowery/abcnorio-the-book.php. It is drawn from Alan Moore and Marc Miller, eds., *ABC No Rio Dinero: The Story of a Lower East Side Art Gallery* (Collaborative Projects, 1985).

Wu Ming 1 (Roberto Bui), "Tute Bianche: The Practical Side of Myth-Making (In Catastrophic Times)," text written for the "Make-World" festival in Munich, 2001, posted on the Wu Ming website at: http://www.wumingfoundation.com/english/giap/giapdigest11.html

ML, "Il silenzio di Macao. E' tempo di dare fisionomia alle idee," website of the mutual aid society ARCI, May 29, 2012, at: http://www.arcimilano.it/tag/lavoratori-dellarte/

Jordie Montevecchi, "Take Over" (30 min.; 2008; English)

Alan Moore and Marc Miller, *ABC No Rio Dinero: The Story of a Lower East Side Art Gallery* (Collaborative Projects, 1985)

Alan Moore and Clayton Patterson, eds., "Inside Out: The Artworld of the Squats," catalogue zine (Solo Foundation, NY, 1995)

Alan Moore, "General Introduction to Collectivity in Modern Art," paper for "Critical Mass" exhibition, Smart Museum, University of Chicago, April 2002, at: http://www.joaap.org/new3/moore.html

A.W. Moore with James Cornwell, "Local History: The Battle for Bohemia in the East Village," in Julie Ault, ed., *Alternative Art New York, 1965-1985* (University of Minnesota Press, 2002)

A.W. Moore, "Academic Entrepreneurialism: Eggheads Outside the Crate" (2007; for *Part* graduate student e-zine, City University of New York; and at Edu-Factory website edu-factory.org/, both de-mounted

A.W. Moore, "Free Lunch at the Hacienda," for Yale University Art Gallery conference on postwar art and the New York contemporary art market, 2008, unpublished

A.W. Moore, "A Brief Genealogy of Social Sculpture," 2008, at: www.joaap.org/webonly/moore.htm

A.W. Moore, "Bullet Soaked in Piss," 2010, at: post.thing.net/node/2872

A.W. Moore, *Art Gangs: Protest and Counterculture in New York City* (Autonomedia, 2011)

A.W. Moore, "Permanent Cultural Revolution," text for Rote Flora show, 2011; posted on the House Magic project website at: https://sites.google.com/site/housemagicbfc

A.W. Moore, "Circulating Movement Information in the Sphere of Art: A Report to SqEK in Copenhagen on the 'House Magic' Project," unpublished paper, 2011; posted on the House Magic project website

A.W. Moore, "Art + Squat = X," unpublished paper, June, 2012; posted on the House Magic project website

A.W. Moore with the artists of the Real Estate Show, "Excavating Real Estate," *House Magic* #6 supplement, 2014

A.W. Moore, "ABC No Rio as an Anarchist Space," in Tom Goyens, ed., *Radical Gotham: The Anarchist Tradition in New York City, 1870-2011* (University of Illinois, forthcoming).

Joan W. Moore, "Chicano Pinto Research Project: A Case Study in Collaboration," *Journal of Social Issues,* vol. 33, no. 4, 1977

Syeus Mottel, *Charas: The Improbable Dome Builders* (1973)

Colin Moynihan, "A Stirring Icon That Shook Things Up Turns 20," *New York Times,* April 29, 2002

Colin Moynihan, "A Tenement Transformed Tells the Lives of Its Squatters," *New York Times,* posted January 29, 2010, at: http://cityroom.blogs.nytimes.com/2010/01/29/squat/?_r=0

Colin Moynihan, "Film Fest Is on Police Radar, Anarchists Say," posted April 15, 2010, at: http://cityroom.blogs.nytimes.com/2010/04/15/film-fest-is-on-police-radar-anarchists-say/?_r=0.

Colin Moynihan, "Protesters Briefly Take Over a Gallery," *New York Times,* October 24, 2011

"MrDaveyD," "Feds & NYPD Fearing their Politics Violently Raid & Evict Rebel Diaz Artistic Collective," March 1, 2013. Posted at: http://hiphopandpolitics.com/2013/03/01/feds-nypd-fearing-their-politics-violently-raid-evict-rebel-diaz-artistic-collective/

Gregor Muir, curator, "ICA Off-Site: A Journey Through London Subculture: 1980s to Now," gallery booklet, ICA, Institute of Contemporary Arts, London n.d. [2013]

Mujinga, "'I've painted myself into a corner' – Learning from the divide between 'artistic' and 'anarchist' squats in Paris," Using Space #8, n.d. [January 2014]; zine can be found at: http://cobblebooks.wordpress.com/; the essay text is also at: http://pastebin.com/0x3Gv9Ac

N

Patrick Nagle, "Telestreet: Pirate Proxivision," on the pirate radio in Italian social centers, in *House Magic* #2, 2010.

Cary Nelson, ed, *Will Teach for Food: Academic Labor in Crisis* (University of Minnesota, 1997)

Robert Neuwirth, Shadow cities: a billion squatters, a new urban world (Routledge, 2005)

Amy Newman, *Challenging Art:* Artforum, *1962-1974* (Soho Press, 2000)

Nils Norman, *An Architecture of Play: A Survey of London's Adventure Playgrounds* (Four Corners Books, 2003).

Not An Alternative, "Picture The Homeless Tent City – parts 1 and 2" (15:55, 2009), at: http://vimeo.com/6129654

Not an Alternative, "Occupied Real Estate2 video" (2:12), 2012, at http://vimeo.com/115372152

Johannes Novy and Claire Colomb, "Struggling for the Right to the (Creative) City in Berlin and Hamburg: New Urban Social Movements, New 'Spaces of Hope'?," *International Journal of Urban and Regional Research,* vol. 37, no. 5, September 2013

O

"Occupy Bay Area," curator statement, 2012, at: http://ybca.org/occupy-bay-area.

"Occupy Museums and the 7th Berlin Biennale," June 1, 2012, at: http://occupymuseums.org/index.php/actions/43-occupy-museums-and-the-7th-berlin-biennale

Philipp Oehmke, "Squatters Take on the Creative Class: Who Has the Right to Shape the City?" (January 2010; translated from German); at http://www.spiegel.de/international/germany/0,1518,670600,00.html

Fly Orr, see Fly

Lynn Owens, *Cracking Under Pressure: Narrating the Decline of the Amsterdam Squatters' Movement* (Amsterdam University Press, 2009)

P

Clayton Patterson, Paul Bartlett, Urania Mylonas, *Captured: A Film/Video History of the Lower East Side* (Seven Stories Press, 2005; Federation of East Village Artists, NY, 2003)

Clayton Patterson, Joe Flood, Alan Moore, Howard Seligman, editors, *Resistance: A Social and Political History of the Lower East Side* (Seven Stories Press, NY, 2007); online at: patterson.no-art.info/books/2007_resistance.html

Picture the Homeless and the Hunter College Center for Community Development of CUNY, "Banking on Vacancy: Homelessness & Real Estate Speculation," 2012, at: www.picturethehomeless.org/.../Reports/PH01_report_final_web.pdf⊠

Planet Art, 2007. At: http://www.planetart.nl/vriendschap.htm#

Platform, London, "Events Season at Bristol Arnolfini," 2009, at: http://platformlondon.org/2009/10/29/c-words-events-season-at-bristol-arnolfini/#sthash.HBsQRiBm.dpuf

Will Potter, *Green is the New Red: An Insider's Account of a Social Movement Under Siege* (City Lights, San Francisco, 2011); blog at: http://www.greenisthenewred.com/blog/

Jenelle Porter, *Locally Localized Gravity* (Institute of Contemporary Art, Philadelphia, 2007)

Astrid Proll, ed., *Goodbye to London: Radical Art and Politics in the Seventies*, Hatje Cantz, 2010

Hans Pruijt, "Squatting in Europe" (2004) at: http://www.eur.nl/fsw/staff/homepages/pruijt/publications/sq_eur/. In Spanish, in: Miguel Martínez Lopez and Ramón Adell (eds) *¿Dónde están las llaves? El movimiento okupa: prácticas y contextos sociales* (La Catarata, Madrid, 2004); also in SqEK, eds., *Squatting in Europe* (Minor Compositions, 2013)

Rahel Puffert, Cornelia Sollfrank, et al., "New Art Practices in the Field of Political Decision-Making: A Process Report from Projektgruppe," *Afterimage*, September-December 2006

Andre Pusey, "Social Centres and the New Cooperativism of the Common," *Affinities*, Vol 4, No 1 (2010), at: http://affinitiesjournal.org/

Q

Queeruption Berlin, "Queer Is Hip, Queer Is Cool: Dogmas in the Queer Scene," 2003; at: http://www.lespantheresroses.org/auto-critique/queer-is-cool.html

R

Max Rameau, *Take Back the Land: Land, Gentrification and the Umoja Village Shantytown* (AK Press, 2013)

Gerald Raunig, *Art and Revolution: Transversal Activism in the Long Twentieth Century* (Semiotext(e)/MIT Press, 2007)

Rebel Diaz, "Reflections on #OccupyWallStreet," September 28, 2011; at: http://rdacbx.blogspot.com.es/2011/09/reflections-on-occupy-wallstreet.html

Oliver Ressler with Dario Azzellini, *Disobbedienti* (54 min., Ital./Ger./Engl., 2002)

Oliver Ressler, "Take The Square," 2012, installation; at: http://www.ressler.at/take_the_square/

Reuters, "Spaniards stomp their heels at bailed-out bankers," June 22, 2012, at: http://english.ahram.org.eg/NewsContent/3/12/45878/Business/Economy/Spaniards-stomp-their-heels-at-bailedout-bankers-.aspx

Jorge Ribalta, "Experiments in a New Institutionality," in *Relational*

Objects, MACBA Collections 2002-2007 (Barcelona: MACBA Publications, 2010)

Marjolijn van Riemsdijk, *Assault on the Impossible: Dutch Collective Imagination in the Sixties and Seventies* (Autonomedia, 2013)

Rob Robinson, "New York City: An interview with Rob Robinson from Picture the Homeless and Take Back the Land Movement," published in *Brisbane From Below* n°1 (Brisbane, 2011); accessed from Squat.net, at: http://en.squat.net/2012/01/02/new-york-city-an-interview-with-rob-robinson/

Lauren Rosati and Mary Anne Staniszewski, eds., *Alternative Histories: New York Art Spaces, 1960-2010* (MIT Press, 2012)

Martha Rosler, *Culture Class* (Sternberg Press, 2013)

Matthew Roth, "A Tumultuous Ride: New York City Critical Mass and the Wrath of the NYPD," in Carlsson, et al., *op. cit.*

Octavi Royo and Ignasi P. Ferré , "Okupa, Crónica de una Lucha Social" ["Squat: story of a social struggle"] (37 min.; 2006; Spanish and Catalan with English subtitles)

Ramor Ryan, *Clandestines: The Pirate Journals of an Irish Exile* (AK Press, 2006)

S

Roy San Filippo, ed., *A New World in Our Hearts: Eight Years of Writing from the Love and Rage Revolutionary Anarchist Federation* (AK Press, 2003).

Nathan Schneider, *Thank You Anarchy: Notes from the Occupy Apocalypse* (University of California Press, 2013)

Jack Schonewolf, "The Struggle to Breathe: ABC No Rio, Bullet Space and the Recovery of Utopia," 2011,

Harvard thesis presentation, at: http://isites.harvard.edu/fs/docs/icb.topic1276302.files/Schonewolf_%20MUP%20Thesis_2011.pdf.

Joost Seelen, *De Stad was van uns* ["It was our city"], film about the Amsterdam squatters' movement 1975-1988 (1996)

Ben Shepard, "From the Tenement Museum to Bluestockings, MoRUS and the Lower East Side's Radical History," from his blog "Play and Ideas," December 9, 2012, at: http://benjaminheimshepard.blogspot.com.es/2012/12/from-tenement-museum-to-bluestockings.html

16 Beaver group, "Sunday – 02.26.12 – Two Events – Two Collectives – Squat, Strike, Occupy, and Write To Tell All," at http://www.16beavergroup.org/02.26.12.htm.

Thomas Stahel, *Wo-Wo-Wonige: stadt- und wohnpolitische Bewegungen in Zürich nach 1968* (Paranoia City Verlag, Zürich, 2006)

Julian Stallabrass, "Cashing in," *New Statesman,* October 2, 2000; accessed online.

Steirischer Herbst, Florian Malzacher, et al., eds., *Truth is Concrete: A Handbook for Artistic Strategies in Real Politics* (Sternberg Press, 2014)

Gregory Sholette, "Urban Encounters" gallery handout (New Museum, NY, 1998)

Gregory Sholette, "A Collectography of PAD/D: Political Art Documentation/Distribution," 2001. Online at: http://www.gregorysholette.com/wp-content/uploads/2011/04/14_collectography1.pdf

Gregory Sholette, *Dark Matter: Art and Politics in the Age of Enterprise Culture* (Pluto Press, 2011)

Stevphen Shukaitis, *Imaginal Machines: Autonomy & Self-Organization in the Revolutions of Everyday Life* (Minor

Compositions, 2009)

Social Centres Network, *What's This Place? Stories from Radical Social Centres in the UK and Ireland* (2007?; download)

SqEK (Squatting Europe Kollective), SqEK, "The SQEK: Squatting Europe Research Agenda v. 0.9," November, 2009, at: http://www.miguelangelmartinez.net/IMG/pdf/2009_SQEK__7_Dec_.pdf

SqEK eds., *Squatting in Europe: Radical Spaces, Urban Struggles* (Minor Compositions, 2013)

SqEK eds., *The Squatters' Movement in Europe: Commons and Autonomy as Alternatives to Capitalism* (Pluto Press, 2014)

Squatting in West Berlin (Hooligan Press, London, 1987)

Tina Steiger, "Spaces of Autonomy in Copenhagen and Madrid" (M.A. thesis, UNICA Euromaster in Urban Studies 4 Cities; coordinated by Vrije Universiteit Brussel), 2011. The case studies in her thesis are the Candy Factory in Copenhagen and Tabacalera in Madrid. Miguel Martinez was her coordinator.

Todd Steiner, "*Battle In Seattle* – the movie," September 20th, 2008, at: http://seaturtles.live.radicaldesigns.org/article.php?id=1163

T

Tactical Media Files at: http://www.tacticalmediafiles.net/

Herb Tam, "Remembering Jeanette Ingberman," from his blog "Mind Spray," blog, January 12, 2012, at: http://herbtam.wordpress.com/2012/01/12/remembering-jeanette-ingberman/

Claire Tancons, "Occupy Wall Street: Carnival Against Capital? Carnivalesque as Protest Sensibility," *e-flux journal* #30, 2011

Marcello Tarì and Ilaria Vanni, "On the Life and Deeds of San Precario, Patron Saint of Precarious Workers and Lives," The Fibreculture Journal, issue 5, 2005 (on precarious labour), at: http://five.fibreculturejournal.org/.

Nato Thompson, Gregory Sholette, Arjen Noordeman, eds., *Interventionists: Users' Manual for the Creative Disruption of Everyday Life* (Mass MoCA/MIT, 2004)

Nato Thompson, "Nato Thompson in Conversation with the BDC" [Baltimore Development Corporation], 2009, at: http://www.baltimoredevelopment-co-op.org/index.php?/texts/interview-with-nato-thompson/

Nato Thompson, ed., *Living as Form: Socially Engaged Art from 1991-2011* (Creative Time/MIT Press, 2012)

Time's Up Records TAM.522, Tamiment Library, NYU, 2013; at: http://dlib.nyu.edu/findingaids/html/tamwag/tam_522/scopecontent.html

Seth Tobocman, *War in the Neighborhood* (Autonomedia, 1999)

Lucia Tozzi, "Macao: chronicle of an occupation," May 12, 2012, *Domus* online at: http://www.domusweb.it/en/art/2012/05/12/macao-chronicle-of-an-occupation.html

Translados website, "Macao Occupying Milano," posted May 5, 2012, at: http://www.translados.org/2012/05/macao-milano/

"2011–12 Spanish protests," Wikipedia, accessed December 2013

U

Universidad Nómada, eds., "Monster Institutions" issue of the Austrian e-zine *transversal*, May 2008, at: http://eipcp.net/transversal/0508

V

Mark Vallen, "Obey Plagiarist Shepard Fairey," December 2007, at: http://www.art-for-a-change.com/Obey/. (Accessed December, 2013.)

Susana Ventura (aka Penny Arcade), *Bad Reputation: Performances, Essays, Interviews* (MIT Press, 2009)

Nils Vest, *Christiania You Have My Heart* (62 min.; 1991; Danish with English subtitles)

Videoladen, et al., *Züri brännt* [Zürich is burning] (100 min.?; 1980; Swiss German)

Stephen Luis Vilaseca, *Barcelonan Okupas: Squatter Power!* (Fairleigh Dickinson University Press, 2013)

Dmitri Vilensky, "Activist Club or On the Concept of Cultural Houses, Social Centers & Museums," 2009, at European Institute for Progressive Cultural Policies, http://eipcp.net/transversal/0910/vilensky/en

B. Vanelslander, "Long Live Temporariness: Two Queer Examples of Autonomous Spaces," Affinities, vol. 1, no. 1, 2007; at: http://affinitiesjournal.org/index.php/affinities/article/view/3/41

W

Aja Waalwijk, "On Nomads and Festivals in Free Space," *House Magic* #4, Spring 2012

Stacy Wakefield and Grrrt, *Not for Rent: Conversations with Creative Activists in the U.K.* (Evil Twin, London, 1995, 2003)

Brian Wallis, ed., *If You Lived Here: The City in Art, Theory, and Social Activism* (The New Press, 1991); a document from Martha Rosler's exhibition of the same name

"Warcry (activist)," Wikipedia, accessed June 2014

Wiki.15m, "Lista de centros sociales de Madrid," at: http://wiki.15m.cc/wiki/Lista_de_centros_sociales_de_Madrid; accessed January 2014

Peter Lamborn Wilson; *see Hakim Bey*

Wir Sind Wo Anders, "Hamburg's Subvision is Trying to Coopt International 'Off' Projects" ("Hamburger Subvision ist bemüht internationale 'Off'-Kunstprojekte zu vereinnahman"; 2008; written by Anabela Angelovska and Michel Chevalier) at: http://www.wirsindwoanders.de/files/demo.php

Wir wollen alles – Die Hausbesetzungen in Hamburg, Häuserkampf II: Bibliothek des Widerstands, Band 22 (Laika Verlag, Hamburg, 2013)

Naomi Wolf, "The Shocking Truth about the Crackdown on Occupy," theguardian.com, 25 November 2011, at: http://www.theguardian.com/commentisfree/cifamerica/2011/nov/25/shocking-truth-about-crackdown-occupy

Caroline Woolard, "Ganas: The Persistent Anomaly," in *The Social Life of Artistic Property* (2014)

Wu Ming 1 (Roberto Bui), "Tute Bianche: The Practical Side of Myth-Making (In Catastrophic Times)," text written for the "Make-World" festival in Munich, 2001, posted on the Wu Ming website at: http://www.wumingfoundation.com/english/giap/giapdigest11.html

Y

"Yorck 59," Wikipedia (de.wikipedia.org), accessed November, 2013

Eddie Yuen, George Katsiaficas and Daniel Burton Rose, eds., *The Battle of Seattle: The New Challenge to Capitalist Globalization* (Soft Skull Press, 2001)

MINOR COMPOSITIONS

OTHER TITLES IN THE SERIES:
Precarious Rhapsody – Franco "Bifo" Berardi
Imaginal Machines – Stevphen Shukaitis
New Lines of Alliance, New Spaces of Liberty – Felix Guattari and Antonio Negri
The Occupation Cookbook
User's Guide to Demanding the Impossible – Laboratory of Insurrectionary Imagination
Spectacular Capitalism – Richard Gilman-Opalsky
Markets Not Capitalism – Ed. Gary Chartier & Charles W. Johnson
Revolutions in Reverse – David Graeber
Undressing the Academy – University for Strategic Optimism
Communization & Its Discontents – Ed. Benjamin Noys
19 & 20 – Colectivo Situaciones
El Martillo – Eclectic Electric Collective
Occupy everything! Reflections on 'why its kicking off everywhere' – Ed. Alessio Lunghi and Seth Wheeler
Punkademics – Ed. Zach Furness
[Open] Utopia – Thomas Moore & Stephen Duncombe
Contract & Contagion – Angela Mitropoulos
Squatting in Europe – Squatting Europe Kollective
Artpolitik: Social Anarchist Aesthetics in an Age of Fragmentation – Neala Schleuning

The Undercommons – Fred Moten & Stefano Harney
Nanopolitics Handbook – Nanopolitics Group
Precarious Communism: Manifest Mutations, Manifesto Detourned –
 Richard Gilman-Opalsky
FutureChe – John Gruntfest & Richard Gilman-Opalsky
Lives of the Orange Men – Major Waldemar Fydrich
State in Time – Irwin
Crisis to Insurrection – Mikkel Bolt Rasmussen

FORTHCOMING:
Micropolitics of Play – Ed. Dimitrina Sevova
Islam & Anarchism – Mohamed Jean Veneuse
A Very Careful Strike – Precarias a la Deriva
Art, Production and Social Movement – Ed. Gavin Grindon
Hypothesis 891 – Colectivo Situaciones
Learn to Listen – Carlos Lenkersdorf
*A Short Philosophical Dictionary of Anarchism from Proudhon to
 Deleuze* – Daniel Colson

As well as a multitude to come…

Lightning Source UK Ltd.
Milton Keynes UK
UKOW04f0253170615

253651UK00003B/20/P